A Garland Series

OUTSTANDING DISSERTATIONS IN THE

FINE ARTS

Greek Monumental Bronze Sculpture of the Fifth and Fourth Centuries B.C.

Caroline Houser

Garland Publishing, Inc., New York & London

1987

All volumes in this series are printed
on acid-free, 250-year-life paper.

Library of Congress Cataloging-in-Publication Data

Houser, Caroline.
Greek monumental bronze sculpture of the fifth and
fourth centuries B.C.

(Outstanding dissertations in the fine arts)
Originally presented as the author's thesis (Ph.D.)—
Harvard, 1975.
Bibliography: p.
1. Bronze sculpture, Greek. 2. Statues—Greece.
3. Classicism in art—Greece. 4. Bronze sculpture—
Technique. I. Title. II. Series.
NB140.H68 1987 733'.3 76-23628
ISBN 0-8240-2698-5

Printed in the United States of America

PREFACE TO THE GARLAND PUBLICATION

This dissertation appears in the Garland series more than a decade after it was written and announced because we waited for permission to publish the sculptures in Greek museums that had not been officially published by a Greek archaeologist.

I have reservations about presenting the dissertation without rewriting it, but major changes would mean that this work would no longer belong in the "theses" series. The Garland publication is the dissertation as originally submitted, except for the addition of this preface, the correction of some typographical mistakes, several clarifications, and the transposition of the identifying letters I originally assigned to the two statues found near Riace Marina. The letters of the Riace figures are switched because today those statues are still designated by the letters "A" and "B," but now everyone uses the excavator's designation, which reverses the letters as I had originally named them.

Interest in bronze monumental sculpture mushroomed since I began this thesis. Many scholars have done significant work in this field, and I continue my own study. If I were writing the dissertation now, I would, of course, make additions and changes reflecting recent discoveries. (When I studied the Riace statues for this dissertation, for example, marine incrustation still covered them.) I would also make some

modifications to reflect my newer interpretations of the evidence; for example, I now am confident enough about the evidence to name "The God from Artemision" as an image of Zeus, an identification I was hestitant to make a decade ago. I would also try to articulate the information differently than I did a dozen years ago. Nevertheless, those alterations would not change the main substance of the dissertation. My understanding of those extant large bronze statues that can be accepted without any reasonable doubt as authentic Greek art made during the Late Archaic and Classical periods remains what is presented in this dissertation, and the factual and descriptive material about them stands essentially as presented in it.

While several good monographs on individual statues existed, there were no books or articles on Greek monumental bronze statues as a genre when I wrote this dissertation. Then in 1978, Peter C. Bol published <u>Grossplastik Aus Bronze in Olympia</u>, a study of the large bronze sculptures, both Greek and Roman, discovered at Olympia. Claude Rolley's work on both figurines and large statues appeared as <u>Les Bronzes grec</u> in 1983; the English edition, <u>Greek Bronzes</u>, came out in 1986. In 1983 <u>Greek Monumental Bronze Sculpture</u> presented David Finn's photographs and my text. (For full references, see the bibliographical supplement at the end of this preface.)

Much of the information in my <u>Greek Monumental Bronze Sculpture</u> is drawn from my dissertation. That book, however,

was written for a general reader; none of the material in the footnotes and none of the technical information found here appear in that book. I organized Greek Monumental Bronze Sculpture by the places where the sculptures were discovered in modern times to indicate what we know (and don't know) about the original location of the sculptures. This dissertation is organized according to the chronological order in which I believe the sculptures were made, an approach planned to indicate the stylistic development of the statues.

When I began work on this dissertation, the bibliography about the subject was scant; now it is enormous. As a result, the last pages of this preface are devoted to a selected list of new literature. Many of the recent publications relate to the popular and somewhat controversial statues found near Riace Marina and to scientific examination of the materials and the techniques used in antiquity to make those statues. Essays about almost every aspect of the Riace figures appear in "Due Bronzi da Riace," Bollettino d'arte, special series 3; those essays also provide good sources for further references. Crucial evident from archaeological material now exists, too. In addition to identifying work specifically about Greek monumental sculpture, the bibliography supplement at the end of this preface also includes studies of related material, such as Greek small bronzes and both Roman and Etruscan monumental bronze statues.

I continue to be grateful to the many people acknowledged

in the original preface. In addition, I greatly appreciate
the generous and enlightening help of curators Evi Touloupa,
Katerina Rhomiopoulou, and Peter Kalligas. Also at the
National Museum in Athens Eliane Raftopoulou's hospitality
made my work easier and more pleasant. Generous permission
from Vassileios Ch. Petrakos for me to publish in the Garland
series the statues discovered in Piraeus makes this volume
possible. Homer A. Thompson's thoughtful comments on the
dissertation give me ideas for future explorations; his keen
reading also saved this publication from some of the
typographical errors that crept through the original. The
name of C. K. Williams II was omitted by mistake from those
people who gave important assistance while I was a student in
Athens. Brunilde S. Ridgway's lively ideas keep me on my toes
and provide a stimulation that I truly appreciate. The debt
acknowledged to Evelyn B. Harrison in the original preface is
inadequate; she has taught and continues to teach me so much
about Greek sculpture that I will never be able thank her
fully enough. In addition to thanking Phyllis Williams
Lehmann for our conversations, I now also owe her deepest
appreciation for support, advice, and friendship.

Skillful typing and proofreading by Bernice Florek helped
put this manuscript in shape. The patient persistence and
encouraging interest of Ralph Carlson and Gary Henderson at
Garland made this publication a reality.

Selected Bibliography
of Studies Published between 1975 and 1987

Peter C. Bol. "Grossplastik aus Bronze in Olympia," Olympische Forschungen, IX. Berlin: Walter De Gruyter and Co., 1978.

_____. Antike Bronzetechnik: Kunst und Handwerk antiker Erzbildner. Munich: C. H. Beck, 1985.

Hermann Born, ed. Archäologische Bronzen, antike Kunst, moderne Technik. Berlin: Reimer for the Staatliche Museen Preussischer Kulturbesitz Museum für vor- und Fruhgeschichte, 1985.

A. Busignani with photographs by Liberto Perugi. Gli eroi di Riace--Daimon e techne. English edition, The Bronzes of Riace, translated by J. R. Walker. Florence: Sansoni, 1981.

Beth Cohen. "Kresilas' Perikles and the Riace Bronzes: New Evidence for Schinocephaly" (abstract), AJA, 90 (1986), 207-208.

Paul T. Craddock. "The Composition of the Copper Alloy used by the Greek, Etruscan and Roman Civilisations, II: The Archaic, Classical and Hellenistic Greeks," Journal of Archaeological Science, 4 (1977), 103-123.

Mauro Cristofani with contributions by Edilberto Formigli and Maria Elisa Micheli. I Bronzi degli Etruschi. Novara: Istituto Geografico De Agostini, 1985.

"Due Bronzi da Riace." Bollettino d'arte, Serie speciale 3. Rome: Ministero per i Beni Culturali e Ambientali, 1984. 3 vols. in 2.

Edilberto Formigli. "Bemerkungen zur technischen Entwicklung des Gussverfahrens griechischer Bronzestatuen," Boreas, 4 (1981), 15-24.

G. Foti and F. Nicosia. I bronzi di Riace. Novara: Istituto Geografico De Agostini, 1981.

Werner Fuchs. "Zu den Grossbronzen von Riace," Boreas, 4 (1981), 25-28.

_____. "Zu den Grossbronzen von Riace," Praestant Interna. Festschrift für U. Hausmann. Tübingen: Verlag Ernst Wasmuth, 1982. 34-40.

_____. "Zu den Grossbronzen von Riace in Reggio Calabria," Gymnasium 92 (October 1985), 465-469.

Kurt Gschwantler. Guss+Form: Bronzen aus der Antikensammlung. Vienna: Kunsthistorisches Museum, 1986.

Sybille Haynes. Etruscan Bronzes. London: Sotheby's, 1985.

Evelyn B. Harrison. "Early Classical Sculpture: The Bold Style," Greek Art: Archaic into Classical, A Symposium held at the University of Cincinnati April 2-3, 1982. C. G. Boulter, ed. Leiden: E. J. Brill, 1985. 47-56.

W.-D. Heilmeyer. "Antike Werkstattenfunde in Griechenland," AA, 96 (1981), 440-453.

Caroline Houser. "The Riace Marina Bronze Statues: Classical or Classicizing," Source: Notes in the History of Art, I, no. 3 (1982). 5-11.

_____. "Silver Teeth: Documentation and Significance" (abstract), AJA, 91 (1987), 300-301.

_____, with photographs by David Finn. Greek Monumental Bronze Sculpture. New York/London: The Vendome Press/Thames & Hudson, 1983.

Horses of San Marco. Catalogue of The Metropolitan Museum of Art exhibition, translated by John and Valerie Wilton-Ely. Milan and New York: Olivetti, 1977 and 1979.

Arielle P. Kozloff, Bruce Christman, Hero Granger-Taylor, and Michael Pfrommer. "The Cleveland Bronze," The Bulletin of The Cleveland Museum of Art, 74, no. 3 (March 1987), 82-143.

Carol C. Mattusch. "Molds for an Archaic Bronze Statue from the Athenian Agora," Archaeology, 30 (1977), 326-332.

_____. "Bronze- and Ironworking in the Area of the Athenian Agora," Hesperia, 46 (1977), 340-379.

_____. "Corinthian Metalworking in the Forum Area," Hesperia 46, (1977), 380-389.

_____. "Bronzeworkers in the Athenians Agora," Excavations of the Athenian Agora, Picture Book No. 20. Princeton: American School of Classical Studies at Athens, 1982.

_____. "The Berlin Foundry Cup: The Casting of Greek Bronze Statuary in the Early Fifth Century B.C.," AJA, 84 (1980), 435-444.

Joan R. Mertens. "Greek Bronzes in the Metropolitan Museum of Art," The Metropolitan Museum of Art Bulletin, 43, no. 2 (Fall 1985).

Brunilde Sismondo Ridgway. Fifth Century Styles in Greek Sculpture. Princeton: Princeton University Press, 1981.

Claude Rolley. Les Bronzes grec, 1983. English edition, Greek Bronzes translated by Roger Howell. London: Sotheby's Publications/Chesterman Publication, 1986.

_____. Musée de Delphes: Bronzes. Athens: École Française d'Athènes, 1980.

W. Rostoker and E. R. Gebhard. "Metal Manufacture at Isthmia," Hesperia, 49 (1980), 347-363.

Ernst-Ludwig Schwandner, Gerhard Zimmer, and Ulrich Zwicker. "Zum Problem der öfen griechischer Bronzegiesser," AA, 98, (1983), 57-80.

Gerhard Zimmer. "Geissereieinrichtungen im Kerameikos," AA, 99 (1984), 63-83.

Northampton, Massachusetts
June, 1987

GREEK MONUMENTAL BRONZE SCULPTURE

of the Fifth and Fourth Centuries B.C.

A thesis presented

by

Caroline Mae Houser

to

The Fine Arts Department

in partial fulfillment of the requirements

for the degree of

Doctor of Philosophy

in the subject of

Fine Arts

Harvard University

Cambridge, Massachusetts

May, 1975

TABLE OF CONTENTS

Guidelines by which statues were selected for inclusion
in this study are narrow in order to establish a body of
material as firmly-accepted as possible. One of the criteria
of selection is that the statue be one that I have been able
to study in person. A monumental bronze statue excluded from
this collection may well be an authentic Classical Greek work,
but I have not yet been able to establish that it is so.

Since studies of small bronzes usually are concerned
with objects less than a meter in height, this study is
devoted to figures over a meter in height and ones that can be
reconstructed to an original size of over a meter high. In
addition to complete figures, the dissertation includes three
heads now severed from the bodies to which they belonged
(the Athenian Strategos, the Chatsworth Apollo, and the Cyrene
"Berber") and the fragments of the Agora Horseman monument.

This project is restricted to statues, so it does not
contain studies of other objects made of bronze, such as
tripods, cauldrons, candelabra, or armor.

Bronze apparently is the only metal in which monumental
statues were made in Classical Greek times, although the last
statue in this series, the Agora Horseman, was originally
gilded bronze. The time span covered is generally the fifth
and fourth centuries B.C. "Greek" is interpreted to mean the

Greek world.

There are two obvious exceptions to these guidelines. First is the Piraeus Apollo, which is controversial and which I believe to be from the late sixth century B.C. It is included, nevertheless, because I think it should be accepted as a legitimate creation of the Late Archaic period and because, as the only surviving Greek monumental statue made before the actual beginning of the fifth century, it should properly be considered with this group of statues. The other exception is the Youth from Selinus, which is less than a meter high. It is included because it is a unique example of its size from the Greek colonial cities on Sicily and because of its relatively complete state of preservation.

There are pieces that might be missed by those interested in Greek bronze sculpture. Excluded from this group because I believe them to be Hellenistic are the Olympia Boxer in Athens, the Arundel "Homer" in London, and the "Lady from the Sea" in Izmir. Pieces not included in this group because I am not certain of their origin are the Piombino in Paris, the Idolino in Florence, the Ephesos Ephebe in Vienna, and the Bearded Elder from the Straits of Messina assigned to the Reggio Calabria museum but now temporarily in Rome (see note 8.1). Also missing is the important head usually

identified as "Arkesilas IV" from Cyrene (see note 10.2),
which is smaller than those considered here.

The results of this research would be strengthened by
various laboratory examinations, which unfortunately could
not be made. Additional useful information undoubtedly also
would have been gained if it were possible to look inside
the statues that are mounted or if restoration records for
them were available, but this is usually not the case.

Every statue in the project is discussed in an individual
essay. I have brought together existing information about
these statues and have been able to observe at first hand
every statue in this project. More attention is given to the
physical evidence seen in the statues themselves than to
earlier bibliography, in an effort to let the statues "speak
for themselves". No uniform length was imposed upon any essay;
they vary according to the amount of information I have about
the statue that is being discussed.

From these separate essays, some characteristics of
Greek monumental sculpture in bronze have become apparent.
These conclusions are discussed at the end of the individual
studies.

Except for the Chatsworth Apollo, the statues are
identified by names which include their finding places. These

place names do not necessarily represent the places where
the statues stood (see "Original Settings", pp. 289-298).
The Chatsworth Apollo takes its name from the house of the
Duke of Devonshire, to whose collection the head once belonged;
the name is so well established that changing it would lead
to confusion. When I suggest a general identification for a
statue (e.g., Athenian Strategos) or a specific identification
for one of the representations of divinities (e.g., the
Piraeus Apollo and the Piraeus Artemis I), I so designate the
figure. In the cases of specific identifications of individual
people that I suggest (e.g., the Athenian Strategos, the
Delphi Charioteer, and the Agora Horseman), however, I have
left the primary title the more general one.

Some of these statues are well-known and are included
in almost every book on Classical Greek art; however, in
many cases the statues are categorized or labelled with
surprisingly little explanation. Other statues in this
group are virtually unknown except to specialists. Bibliographies
for the individual statues, therefore, vary dramatically
in length. There are more than fifty entries in a complete
bibliography of the Charioteer Monument at Delphi; on the
other hand, published information about the "Generals" found
near Riace Marina and the Horseman found in the Athenian

Agora is virtually non-existent. Since the literary sources
for the statues studied are so individual, the bibliography
has been arranged according to each work and placed with
the related essay. Bibliographies included here for each
statue are selected to include recommended reading for a
serious study of the statue: the basic studies and any
additional factual information, and discussions with special
sensitivity and insights. Other important publications
consulted are identified in notes where relevant.
Bibliographical abbreviations are listed on pp. 359-361.

I am grateful to the German Archaeological Institute
in Athens for many of the good photographs used here. In
some instances, however, good photographs are not available
nor is permission granted to take photographs of some
statues. Photographs of those statues now only poorly
illustrated will become available after the official
publication of each statue is made. References for comparative
visual material are made to standard books most likely to be
easily available.

I am grateful for help in many ways to George M.A.
Hanfmann, my advisor, whose encyclopaedic knowledge is
combined with wisdom and kindness.

David Mitten, in whose class I first learned about

Greek sculpture and who has been a constant source of encouragement in my work ever since, served as second reader and generously shared his vast bibliographical knowledge with me. Evelyn Harrison has read parts of this dissertation, and I am grateful to her for perceptive comments and advice.

I should like to take this opportunity to express my gratitude to the many people at Harvard who have assisted me during my study at the Fogg Museum, especially James Ackerman, Sydney Freedberg, John Rosenfield, Seymour Slive, and Emily Vermeule, in their various roles as professor and department chairman.

My research was made possible by the Charles Eliot Norton Fellowship and the Kingsbury Fellowship which allowed me to study these statues first-hand in Athens as well as in Cambridge.

For assistance while I was in Athens, I am grateful to Nicholas Yalouris, Director of the National Museum; James McCredie, Director of the American School of Classical Studies; as well as to D. Amyx, N. Bookides, J. Camp III, C.J.W. Eliot, V. Grace, R. Gordon, P.W. Lehmann, F. Mitchell, T.L. Shear, Jr., R. Stroud, H. and D.B. Thompson, E. Vanderpool, Jr., and N. Winter. I had many interesting and rewarding discussions with Carol Mattusch, who is studying ancient

Greek foundry material; looking at bronze sculpture with her in Greece, Italy, and Turkey was a pleasure.

In Cambridge, Arthur Beale, Eric Hostetter, and Arthur Steinberg have taught me much about technical aspects of bronze working. In Boston, W.J. Young, F. Whitmore, and E.V. Sayre of the Research Laboratory at the Museum of Fine Arts have been generous with their time and information.

In Athens, many conversations with Lucy Weier about the conservation and restoration of bronze were helpful and interesting.

I have learned a great deal from both Denys Haynes and Bernard Ashmole in conversation as well as through their exemplary written work. Dietrich von Bothmer graciously discussed the Piraeus Apollo with me. My debt to the work of the late G.M.A. Richter is enormous.

Production of this manuscript has been facilitated by Melissa Marsh, who typed it with thought as well as with skill; by Elizabeth Gombosi, who gave of her linguistic and artistic talents to read proof and affix photographs; to Tim McNiven, who read proof with a sharp eye and questioning mind; and to Sally Rutter, who made some of the drawings.

My family has supported me in tangible and intangible ways, and my gratitude to them is immense.

Special appreciation is due to Eugene Vanderpool,
Professor Emeritus of Archaeology at the American School of
Classical Studies in Athens, whose "News Letter from Greece"
in the 1960 AJA about the Piraeus find first suggested this
subject to me. E.V. has been a constant source of information
and assistance during my work on this project, which has been
one of great joy to do.

INTRODUCTION

Bronze was the most important medium of freestanding
sculpture in Classical Greece. Every important sculptor
in the fifth and fourth centuries B.C. seems to have worked
in bronze; even such artists as Pheidias and Praxiteles who,
usually are remembered for their marble or chryselephantine
statues, were prolific bronze workers.

Every sanctuary was filled with bronze statues. At
Delphi, for example, there apparently were so many bronze
statues that Pausanias reports Nero was able to rob "five
hundred bronze statues of gods and men" from the sanctuary
of Apollo.

Destruction during times of riots and wars have left us
precious few examples of original bronze sculpture. In 1958
only six complete—or virtually complete—monumental bronze
statues of undisputed Classical Greek origin were known to
survive.[1] Most of our knowledge about freestanding Classical
Greek sculpture, therefore, has been based on later copies,
usually Roman ones.

Most of the copies of Greek sculpture are freehand ones.[2]
When we have more than one copy of an original, invariably
there are differences, illustrating that copies generally
are an imperfect mirror of the original in design as well as
quality. For example, none of the 39 known replicas of the

Meleager attributed to Scopas are identical.[3] The pitfalls
of studying works of art only through copies are obvious.

No longer is it necessary to depend upon copies for
the study of freestanding Greek sculpture. Important newly-
discovered material includes enough Classical Greek bronze
statues[4] so that now a study of Greek sculpture can be made
from original works.[5] The first step of such a project is
the purpose of this dissertation.

By suggesting which statues can be accepted with
confidence as being the product of Classical Greece, I hope
to form a solid nucleus of material. Once this basis is
established, information from it should further our knowledge
of Classical Greek large, freestanding sculpture and also
be helpful in evaluating those statues whose origin is
uncertain or controversial. Most importantly, consideration
of the corpus of these original statues may add to our
understanding of ancient Greek art.

Notes

[1]These statues are the Delphi Charioteer, the Artemision
God (called "Zeus" by some and "Poseidon" by others), the
Young Man from Antikythera wreck, the Youth found in the
Bay of Marathon, the Poseidon discovered in the Livadhostro
Bay, and the Youth from Selinus. In addition, three heads
from large statues have been known during the 20th century:
the Athenian Strategos, the Chatsworth Apollo, and the
Cyrene "Berber".

[2]Archaeological evidence for the Roman practice of
taking plaster casts of Greek sculpture also exists; see
G.M.A. Richter, "An Aristogeiton from Baiae", AJA 74 (1970),
296-297 and pl. 74.

[3]Steven Lattimore discusses copies of the Meleager
statue and gives previous bibliography in "Meleager: New
Replicas, Old Problems", Opuscula Romana IX:18 (1973), 157-166.

[4]The four statues from the Piraeus were discovered in
1958, and the two from the sea near Riace Marina were found
in 1972. Another monumental bronze statue, rumored to be a
fourth-century B.C. work and perhaps by Lysippos, was
recently found by fishermen in the sea off the northwestern
coast of Italy. It is on the art market, in the hands of H.
Herzer, a dealer in Munich; Mr. Herzer kindly agreed to
my request to see the statue, but when I arrived in Munich,
he was unable to show it to me.

[5]Although a considerable amount of marble relief and
architectural sculpture has survived, the number of
uncontested freestanding marble statues from Classical
Greece known today is even smaller than the number of
extant bronze statues. Fifth-century examples include the
Kritios Boy from the Athenian Acropolis and the Nike by
Paionios at Olympia (illustrated by Charbonneaux, Classical
Greek Art, pls. 102-103 and 192). For a fourth-century
example see the Demeter from Knidos (illustrated by
Charbonneaux, Hellenistic Art, fig. 218).

THE PIRAEUS APOLLO

Temporarily in the National Museum in Athens, to be
transferred to the Piraeus Museum when it reopens. Museum
number not yet assigned. Found July 18, 1959, by workmen
digging a sewer ditch in the Piraeus. Left leg broken off
below the knee and re-attached. Major cracks on left arm
and left leg. Attributes missing from both hands. Green
patina. H.: 1.91 m. Th. of bronze: 0.01 m. Figs. 1.1-1.9.

Description

The nude male figure stands frontally with an almost
imperceptible turn to his right in a self-contained, simple
columnar composition. Proportions are within both realistic
human ratios and Greek sculptural ones.[1] Muscles are defined
in low swelling forms which flow together smoothly. The head
is more stylized than the rest of the body.

The head is large and rounded above but flattened at the
lower face, especially at the cheeks. It is inclined
forward so that the gaze makes about a 40 degree angle to the
body. The eyes are incised, worked much the way eyes of
marble kouroi are. The whites of the eye were cast as part
of the head; the irises are redder than the surrounding
eyeballs and look as though they might have been inset in
copper, although this color change could simply reflect
the way in which they were cleaned. The long nose is typical

of Archaic kouroi. His lips curve upward in an Archaic
smile; the lower lip follows the curve of the mouth as a
band, but the top edge of the upper lip arches on both sides
and curves down at the center. His chin juts forward.

His high-set ears are relatively large and protrude as
though pushed outward by the thick hair pulled behind them.
The fillet around the top of his head is expressed as a
volume, not by incision. Two fat ringlets on each side of
his forehead wave over the fillet and end symmetrically in
curls spiralling to the center. He has short, straight
sideburns in front of both ears. Two sausage-shaped tresses
behind each ear fall forward to rest on the front of his
shoulders. Six equally fat tresses lie on his back. All
are divided into globular "beads" in the Egyptian manner
below the fillet; above the fillet the hair is smooth.

His short and very wide neck flares into a full, broad
chest. Sharply-defined nipples are inset, probably in copper.
His arms hang beside his body from the shoulders to the
elbows, where they are bent to stretch horizontally toward
the viewer. Remains of a broken shaft in his left hand
suggests it once held a bow, now missing. A curved band
still attached on his extended right palm appears to be
a fragment left from a lost phiale.

The smooth curve of the hips and thighs is similar to that of the Strangford kouros,[2] and so is the lack of a strongly-developed iliac crest. The top edge of the pubic hair follows the curve of the crotch rather than pointing up in the star pattern often found in Archaic kouroi.

The subtle twist of the body to the right is reflected in the kneecaps, which point slightly in that direction. The calf muscles are well developed. His weight is distributed equally on both legs. His right foot is advanced about 0.135 m. ahead of the left, more in an "at-ease" stance than a step. Both feet point slightly outward, his left heel is actually behind his right one; and the inside ankle bones are in the same axis. His feet are carefully observed and represented in a naturalistic way, the nails clearly defined by incision. All toes arch, the eight smaller ones more so than the two big ones. The bottoms of the feet are hollow beginning underneath the toes and going to the back of the heels, which would allow the insertion of tangs to attach the statue to its base. The feet are almost identical with those of Aristodikos.[3]

Smooth transitions between all parts of the body give the effect of a unified organism. The modelling is generalized but reflects a fairly good understanding of anatomy.

The columnar composition is broken now only by the
outstretched lower arms and his gaze, but reconstruction of
attributes in both hands would move the composition much
further into space. A bow held vertically in his left hand
would increase his space considerably, and a phiale in his
right hand would give greater emphasis to that hand,
intensified by the subtle turn of his body in that direction.

Although the muscles are full and firm, they are not
taut; the body is relaxed. The generalized, smooth forms
and lack of specialized tension in them give a soft, gentle
appearance. The balanced, self-contained composition and
serious facial expression produce an attitude of reserve.

Unlike the orthodox, stiffly-erect kouroi who stare
straight ahead, the Piraeus Apollo stands with his shoulders
forward, his head inclined with his stare directed down as
well as out, and his arms outstretched toward the spectator.
He makes contact with the viewer.

Discovery

During the summer of 1959, workers digging a sewer
trench in the Piraeus chanced upon the largest cache of intact
monumental bronze statues yet discovered.[4] Salvage excavation
recovered four large statues in bronze: the Apollo, an Athena,

and two Artemises. Three other bronze objects were also
found: a large tragic mask and fragments of two shields, one
plain and one with repousse relief. With the bronzes were three
sculptured marbles: a small statue identified as Artemis
Kindyas[5] and two herms.[6]

The sculpture was found lying in an orderly fashion,
side by side or on top of each other, in the location of
ancient shops and warehouses. It appears, therefore, to have
been stored, perhaps on large shelves, in a warehouse at the
seaport.

Evidence of burning was found on top of the objects,
indicating that the building in which they were stored was
destroyed by fire. The only other archaeological evidence from
the salvage excavation was a coin and a cup. The cup, a Megarian
bowl with relief decoration showing Iphigeneia at Aulis, was
found some distance away from the statues, so it might not
belong with them. The coin, of Mithridates the Great (120-63
B.C.)[7] came from the stratum of the sculpture and indicates a
first century B.C. date for the destruction of the warehouse.

Restoration and Technique

The statue was restored at the National Museum in
Athens, as were all the bronzes from the 1959 Piraeus find.
The inside was cleaned through an opening near the proper
left knee (fig. 1.8) before the broken leg was mechanically

re-attached with rivets and braces. The restorers made a
long-armed mirror (using an automobile rear-view mirror),
angled like a dentist's tool, to help with their difficult
task. Pieces of clay core, iron rod, and broken pottery were
removed from inside the statue.[8] The Apollo was soaked in
distilled water for several years to remove the salt which
had permeated it during its burial. Round raised bubbles
on the surface when the statue was discovered (fig. 1.7)
have been removed.

The Apollo was cast by the direct lost-wax process in
at least four pieces: the head, the torso, and the two arms.
The shoulders and upper biceps are cast with the torso; the
separate arm pieces begin just above the upper arm at about
the middle of the biceps. The head joins the torso about
mid-neck, so the bottom of his hair is cast with the torso.
The hands are said to be solid and may represent separate
castings. The pubic area—penis, scrotum, and hair—also
appears to have been cast separately. With their special
mirror, the restorers were able to see solder at the neck
join; rough surface at the arm and neck joins indicates
they also are metallurgical rather than mechanical joins.

Considerable amount of clay core was recovered from
inside the statue, including a form which fits directly

behind the thorax and another which fits just under the
left shoulder. The soft clay was built up in layers; deep
grooves made by the modeler's fingers are clearly visible.
The layers, which sometimes look more like globs, vary in
shape; it is difficult to generalize about the shapes since
most of them had to be broken before they could be removed
from the statue through the leg opening. The layers are of
uneven thickness, usually ranging from 0.02 to 0.05 m.,
although some of the smaller pieces which were near or on
the surface are only 0.005 to 0.01 m. thick. The greatest
thickness of joining layers which remains is about 0.02 m.,
but the fragments indicate that the core was solid in the
torso.

Core from inside the head, not now identifiable, is
reported by the restorers to have been approximately 0.02
to 0.03 m. thick. They believe that the core inside the
head was originally solid but that the center was scooped
out after it was cast and before it was soldered to the
torso. Cleaning clay away from the edges undoubtedly would
have facilitated the join. The hollow core could also
represent a working technique different from that of the
torso: it could reflect the indirect casting process. Or,
the central part of the core could have come out by accident
in antiquity. Unfortunately, there now is no way to determine

this without extensive examination, which is not now
possible.

Corroded remnants of large iron chaplets, apparently
originally square in cross-section, can still be seen in
the core.

An irregular-shaped, unworked flat piece of bronze,
roughly 0.12 m. at its greatest length and 0.08 m. at the
narrowest width and ranging from 0.005 to 0.02 m. thick, was
found in the area of the neck. There is no indication that
it joined any other piece of metal. Its purpose is not yet
explained. It appears to be the same bronze as that of the
statue. Samples have been taken of it for metallurgical
analysis by the Greek Archaeological Service.

Pieces of badly corroded iron rod, broken and battered,
were also found inside the Apollo.[9] The irregular diameter
of the larger fragments--from the torso--now varies from
approximately 0.03 to 0.06 m., the red core suggests that
the rod originally was approximately 0.02 m. square in cross-
section. At least three of the pieces seem to join, making
one shaft roughly 0.7 m. long. A few smaller iron fragments
--said to be from the arms--are about 0.01 m. in diameter
and 0.03 or 0.04 m. long. There is no evidence that the

rod or rods were made with any angles or crossbars or
that the thicker rod from the torso joined the thinner
fragments from the arms. I was unable to find any piece of
either core or iron rod which proved that the iron rod
served as an armature upon which the core was built,
although that would be the logical assumption for its
purpose. Perhaps at least one reason for the metal rod was
to strengthen the standing position of the statue.

The most surprising find inside the kouros is a group
of sherds from the area of the upper neck and lower head.
Black glaze (but no design) can be seen on five of
approximately fifteen which have been saved; the others are
unpainted. They come from many different pots. The smallest
piece is about 0.005 m. in diameter and the largest is
approximately 0.06 m. long. The red-orange clay is a color
usually identified as Attic.

Despite the size and condition of the sherds, three
of them are identifiable:

Fragment A. A painted wall fragment with black glaze on
both inside and out is from an open pot, probably a krater
or a large skyphos. The high quality black glaze is slightly
metallic. Examples of both kraters and skyphoi with similar
walls and glaze include finds excavated in an undisturbed,

firmly-dated deposit in the Athenian Agora. A volute krater
of the third quarter of the sixth century B.C. (Agora Museum,
P1251)[10] has walls of the same thickness and general shape
as Fragment A, and also has black glaze inside and out,
although the glaze has a slightly greener cast than
Fragment A. An extremely close parallel to Fragment A is
the group of seven fragments which mend to four (Agora
Musuem, P2708 a, b, c, and d) from a higher level of the
same shaft in fill dated 480-490 B.C. The excellent black,
slightly metallic glaze of these fragments is virtually
identical to that of Fragment A; other characteristics are
also alike. The date of the fill of the shaft in which
these fragments were found is closely fixed by ostraca, re-
enforcing stylistic dating. The top level of the shaft shows
that it was last used in the period of the Persian destruction
of Athens in 480 B.C., so everything lower down in the shaft
—including these parallels to Fragment A—was thrown away
by the early fifth century.[11]

Fragment B. The other notable painted fragment is also
of red fabric; its thin, nearly eggshell wall has excellent
black glaze on inside and out. Even though it is very small,
enough remains to indicate that it may be from a kylix or,
more likely, a skyphos like the ones of the late sixth

century from the Athenian Agora, exemplified by pots
numbered P8834 and P1182 in the Agora Museum.[12] Stylistic
and archaeological dating place both these pieces before
480 B.C.

Fragment C. The third important fragment is the largest
of all the extant sherds found inside the statue (roughly
0.09 m. long and 0.05 m. wide). It is from an unglazed
micaceous jar of the special category called "beater and
anvil".[13] This type of pot is distinctive in not having
been made on a wheel; instead of wheel marks, there are
"hammered" marks on the inside. Pots made by this method
appear in the seventh century, are common in the sixth
century, and continue into the fifth century B.C. Comparable
examples in the Athenian Agora are numerous.[14]

The time to which all of these comparisons can be
fitted most comfortably is the late sixth century B.C.,
which seems to be the most likely date to assign to the
sherds found inside the statue. The parallels are Attic, as
all the sherds from inside the statue themselves appear to
be.

Several of the smallest sherds are of a size which
could have been used for temper, but most of them are much
larger than would be expected as temper. Except for one small

sherd, there is no trace of gray- or any other discoloration-
in the clay, as we might expect to find from reduction if
the pottery had been refired as part of the core. Perhaps,
therefore, the sherds came from the "hollowed-out" space
inside the head, rather than from the core itself.

Since the statue was found intact except for the
broken-off leg, measuring the thickness of the metal wall
throughout the statue would have been difficult even when
the leg was detached; it cannot be done now while the
statue is mounted for display without special equipment.
Thickness of the bronze is about 0.01 m. at the big cracks
in the left leg and arm.[15] Judging from other early bronze
sculpture- such as the Chatsworth Head and the Delphi
Charioteer- the thickness undoubtedly varies throughout
the rest of the statue.

Technically, the statue differs from other monumental
Greek metal sculpture in several ways. Although it appears
to be cast in at least four pieces, the divisions do not
play a part in the design; in fact, they are so difficult
to see that the statue has been described as cast in one
piece. The clay core found inside the statue is the only
certain core from a large Greek statue. (Clay or compressed
coarse soil has been found in other statues, but in such

poor condition that it is virtually impossible to tell whether
it once was core or simply is silt). It is one of only
two monumental Greek metal statues in which parts of an
"armature" were found; iron rods from the other, the Delphi
Charioteer, are smaller and fewer. Except for the insertion
of the nipples and possibly the irises, virtually no cold
work appears on the statue. On every other monumental Greek
statue at least some lines have been distinguished by a
burin or other engraving tool. Although the eyes of Greek
statuettes were usually cast with the rest of the face, all
other extant monumental Greek bronze statues have, or did
have, inset eyes. Evidence of another large Archaic bronze
statue with cast eyes, however, has just come to light by
the study of an Attic mould for a bronze statue dated to
the mid-sixth century B.C.[16]

Thickness of the bronze in some areas of the Delphi
Charioteer group (especially the horse legs), particularly
in places of stress or where added strength would aid
support, compares with that of the walls of the Piraeus
Apollo; however, the bronze in the Apollo is uniformly
thicker than necessary, suggesting that the designer was
not yet completely at ease with the technique of casting
large metal sculpture. In general, however, the workmanship

is highly skilled and suggests a good command of bronze
technique, probably developed from making small bronze
statues, armor, or utensils. It is what might well be
expected as an early example of monumental metal sculpture
cast by master bronze-workers.

Two chemical analyses of the bronze in the Apollo have
now been made.[17] The copper content of the alloy is
indicated as ranging from 91 to 86 percent, the tin content
tests in the 10 to 8 percent range, and the lead percentage
appears as 1 or zero.

Style

Since the Piraeus Apollo is a mixture of characteristics
that we consider Archaic and those we classify as Classical,
it has been called Archaistic.[18] Fuchs[19] reconciles the
stylistic mixture by suggesting that the statue is a bronze
copy of an older cult statue, which probably was carved in
wood. A story told by Pausanias (x.19.2) about a face made
of olive wood found in the sea by fishermen, who honored
it "with sacrifices and prayers, but sent a bronze copy
of it to Delphi" supports the possibility of an older
wooden statue being copied in bronze. There can, however,
be little doubt that the Piraeus Apollo is an original work

since the modelled core and iron rods were found in it,
although there is still the possibility that this original
is based on an older representation. The statue does not,
however, have any extant Archaistic parallels nor does it
fit into a generally-accepted understanding of Archaism.[20]

The high quality of the metallic black glaze on the
sherds found inside the statue is of a kind sometimes
associated with later pottery, but the firmly-dated parallels
of the late sixth century B.C. give solid basis for using
the sherds as archaeological evidence for assigning a late
Archaic or very early Classical date to the statue.[21]

Stylistically, the Piraeus Apollo is firmly related to
the Archaic convention for representing young men by his
nude frontal pose, level hips, one leg forward, weight
distributed on both legs, and a varying mixture of stylization
and realism. Yet the statue is puzzling because it breaks
several conventions thought to be Archaic canons. Most
dramatic is the advanced right leg: an advanced left leg,
the tradition adopted from Egyptian art, was standard until
shortly before 480 B.C. when the "Kritios Boy" stepped from
the Archaic into the Classical style with his right leg
forward. This rule, however, turns out not to have been
absolute; a sizeable number of kouros statuettes, most of

them from the Peloponnesos, and also the Poseidon from
Livadhostro (figs. 1.1-3) step forward on their right legs.[22]

Secondly, he deviates from the normal kouroi in that
his arms bend at the elbows to extend toward the viewer
rather than drop to his sides with hands stiffly clenched.
Again, however, there are parallels for this position.
Kanachos made a statue of Apollo for the sanctuary of Didyma
which we know from Pliny's description (NH, xxxiv.75) and
from copies on coins, on reliefs, and in small bronzes[23]
to have held his arms in the same pose as the Piraeus Apollo.
Kanachos' statue, called the "Apollo Philesios", also held
a bow in his left hand; in his extended right hand was a small
animal, usually described as a stag. The "Piombino Apollo"
in the Louvre[24] also has arms in the same position, although
his date and origin are still too controversial to be used
as a basis for other identifications. The pose also fore-
shadows that of the Delphi Charioteer, where the slight
turn to the right is more developed. We also have smaller
statues and statuettes with arms held out in the same way.[25]
Most of these comparisons are in bronze, which helps explain
the pose since it would, of course, be easier to execute in
bronze than in marble, especially on a large scale. The
medium alone, however, does not fully explain the pose since

the arms of the marble Archaic kouroi often extend forward
from the elbows. Since positioning the arms in front of the
body enables the figure to hold attributes, the pose
probably was used for that purpose; traces of attachments for
objects or remains of the objects themselves can still be
seen in almost all of the figures with extended arms, while
Archaic free-standing statues with arms held stiffly at the
sides seldom hold an object.[26]

While canonical kouroi hold their heads straight for-
ward, the head of the Piraeus Apollo is inclined considerably.
Furthermore, canonical kouroi display an Archaic delight
in patterning that is missing in the Piraeus figure. Compared
with typical kouroi, his form is simplified and the rendering
of his anatomy is subdued. Despite his lingering Archaic
smile, he has an attitude of seriousness not usual in
Archaic kouroi. These appear to be carved from the outside
and are expressionless except for the ubiquitous Archaic
smile, while the Piraeus Apollo has a soft and gentle
expression which begins to come from within. These variations
move the Piraeus Apollo away from the Archaic kouroi,
toward the characteristics of Early Classical or Severe
Style sculpture.

Although he clearly comes at the end of the kouroi

series, an attempt to place the Piraeus Apollo more
precisely in the chronology of Greek sculpture re-emphasizes
his relation with early sculpture. There are striking
similarities between his head and those of both the Kerameikos
Sphinx (ca. 575-545 B.C.) and the Anavyssos Kouros (ca. 540-
530 B.C.),[27] as well as with the Peplos Kore (ca. 540-530 B.C.).
The body, however, is more naturalistic and organic, as can
be seen most easily by comparison with the Anavyssos
Kouros. Even the head is more developed than representations
on the frieze of Siphnian Treasury at Delphi (ca. 525 B.C.).[28]
The marble statue of Aristodikos (fig. 1.10; ca. 500-
490 B.C.), which also has a head more stylized than its
body, shows a larger degree of organic unity although a less
subdued anatomical rendering. In simplicity of form and
degree of tension, the Piraeus Apollo is closer to the
figures on the west pediment of the Temple of Aphaia on
Aegina (ca. 500-490 B.C.) than to the east pediment (ca.
480 B.C.).[29] Close relation with Antenor's Kore (ca. 520
B.C.) and the pedimental sculpture of the Peisistratid
Temple of Athena (ca. 520 B.C.)[30] suggests that the Piraeus
Apollo was made near the end of the sixth century B.C.,
probably ca. 520-510 B.C. It is the oldest extant monumental
statue in metal from ancient Greece.

Attribution

 Not enough information is now known about the work of
individual artists who might have made this statue to
attribute it to a specific person.

 Although the question of localized stylistic schools
in Greece is especially tenuous in the case of major
sculptors, whose mobility is well known, the Apollo does
show strong relation with sculpture from a general area.
A poros fragment found near the Temple of Apollo at Corinth
has a remarkable resemblance to the Piraeus Apollo.[31]
Thick, widely-spaced spiral curls on the forehead of the
fragment are tighter versions of those on the Apollo. The
same soft plastic mode and generalization of forms also
relates the earlier kouros from Tenea[32] with both the
Corinth fragment and the Piraeus Apollo. (The Tenea kouros
is generally considered to be Corinthian since Tenea and
Corinth are only seven miles apart.) Comparisons with
Antenor's Kore and the pedimental sculpture of the Old
Athena Temple of the Peisistratids indicate that the work
is not far from that produced in Attica. These stylistic
similarities, the frequent Peloponnesian depiction of an
advanced right leg, the master craftsmanship of the bronze-
working, the soft buff clay of the core, points toward a

northern Peloponnesian origin for the statue, perhaps
Corinth, Argos, or Sikyon—famous for bronze-work. On the
other hand, the sherds and the close relation of the statue
to the pedimental sculpture of the Peisistratid Athena
Temple and to Antenor's Kore argue in favor of Attic origin.
Analysis by spectographic and neutron activation might be
helpful in determining the place where it was made.

Identification

The proposed identification of the statue as Zeus
Soter rests only on the recording by Pausanias that a cult
statue of Zeus Soter existed in the Piraeus.[33] Since our
statue appears simply to have been in the Piraeus in transit,
there is virtually no reason to believe that it ever stood
in the port city of Athens. Even in the unlikely event that
it was erected there, this is insufficient reason to
identify it with a male statue seen there by Pausanias. The
Zeus Soter proposal is further weakened by evidence that the
statue was buried in the first century B.C., so Pausanias
could not have seen it in the second century after Christ.
Furthermore, Zeus is unlikely to have been depicted as a
beardless youth. The Zeus Soter identification, therefore,
cannot be accepted.

It was fashionable in early modern scholarship to
identify any young nude male statue as "Apollo",[34] a
practice which has rightly given way to the generic term
"kouros". This statue, however, can claim identification
as Apollo on the basis of the remains of the bow in his
left hand, as well as his youth. His pose can be connected
with other representations of Apollo (see note 25); it is
virtually identical with that of a statue of Apollo on a
sherd now in Amsterdam (fig. 1.12).[35]

Conclusions

All the evidence—stylistic, technical, ceramic, and
chemical—points to a legitimate late sixth century origin
for the Piraeus Apollo. The lack of an exact parallel for
the statue, which rightly led to skeptical scrutiny,
emphasizes its importance. It fits comfortably into the
general scheme of Late Archaic Greek sculpture, and it
relates equally well to other monumental bronze statues to
stand as the earliest extant Greek monumental statue in
bronze. The mixture of Archaic characteristic with fore-
shadowings of Early Classical elements demonstrates the
transition from Archaic to Classical sculpture, and the
Piraeus Apollo is one of the best illustrations of this
creative period.

Notes

[1]For a study of Greek sculptural ratios which includes this statue, see Rüdiger Wagner, Harmonikale Proportionsstudien an griechischen Statuen, (Icking: Ora-Verlag, 1971), 23-25, fig. V, pl. 11.

[2]London, British Museum, B 475. Illustrated in Richter, Kouroi[3], figs. 461-463.

[3]Athens, National Museum, 3938. Illustrated in Richter, Kouroi[3], figl 492. For further information, see the monograph by Christos Karouzos, Aristodikos (Stuttgart: Kohlhammer, 1962).

[4]For the most thorough accounts of the discovery, see Eugene Vanderpool, "News Letter from Greece," AJA 64 (1960), 265-7 and pls. 65-74; A.K. Orlandos, Ἔργον 1959, 161-9; Georges Daux, "L'Activité Archéologique in Grèce, Attique," BCH 84 (1960), 647-655; M.S.F. Hood, "Archaeological Reports for 1958," JHS 79 (1959), 23; Hans-Peter Drögemüller, "Bericht über Ausgrabungen in Griechenland, II", Gymnasium 68 (1961), 205; Miltis Paraskevaidis, Ein Wiederentdeckter Kunstraub der Antike? Piräusfund 1959 (Berlin: Akademie-Verlag, 1966).

[5]The possibility that the marble statue might be a representation of Artemis was proposed almost as soon as it was discovered (Hood, JHS 79, Addendum 23), but not widely accepted until Ines Jucker connected the statue with representations of a cult statue of Artemis that stood in the ancient sanctuary at Kindyas on the Carian coast, a site annexed to Bargylia by Hellenistic times. See Jucker, "Artemis Kindyas", Gestalt und Geschichte: Festschrift Karl Schefold zu Seinem sechzigsten Geburtstag, Antike Kunst, (1967),133-145 and pls. 47-50.

[6]Evelyn Harrison identifies the herms as Archaistic versions of the Alkamenes type; see Archaic and Archaistic Sculpture, The Athenian Agora XI (Princeton, New Jersey: The American School of Classical Studies, 1965), 127. The Hermes Propylaios by Alkamenes is identified and discussed by Richter in Sculpture and Sculptors[4], 182.

[7]Irene Varoucha-Christodoulopoulou, "Acquisitions du Musée Numismatique d'Athènes, BCH 84 (1960), 500 and pl. X.5.

[8]For permission to see material found inside the statue, I am grateful to Dr. N. Yalouris, Acting Director of the National Museum. For information about the restoration, I am endebted to Mr. Stavros Kassandris, National Museum Restorer, and to Dr. Yalouris. Professor Eugene Vanderpool, Professor Darrell A. Amyx, and Mr. Charles K. Williams II gave generously of their time and knowledge to discuss the material with me.

[9]The armature inside the Metropolitan horse (and the horse itself) is now accepted as ancient. Part of Carl Blümel's persuasive argument in favor of the authenticity is based on the iron fragments from the Piraeus Apollo; see "Zur Echtheitsfrage des Antiken Bronzepferdes im Metropolitan Museum in New York", Archäologischer Anzeiger 84 (1969), 208-216. For Chamoux's discussion of iron rods in the Delphi Charioteer, see L'Aurige, 57-59.

[10]Eugene Vanderpool, "The Rectangular Rock-cut Shaft and Its Lower Fill", Hesperia VI (1938), 363-411, no. 36 on pp. 400-401, fig. 23 on p. 387,

[11]Eugene Vanderpool, "The Rectangular Rock-cut Shaft: the Upper Fill", Hesperia XV (1946), 265-336, no. 53 on p. 287, pl. XXXVII; archaeological dating is explained on pp. 266-267.

[12]These skyphoi are number 310 and 311 respectively in Brian Sparkes and Lucy Talcott, Black and Plain Pottery of the sixth, fifth, and fourth centuries B.C. The Athenian Agora XII (Princeton: The American School of Classical Studies at Athens, 1970), part 1, 256; part 2, pl. 14.

[13]Sparkes and Talcott (Black and Plain Pottery, 34-35) describe the "beater and anvil" work thusly:

> Briefly, the method consists in
> hammering out the pot wall with
> the aid of two simple tools, a
> wooden paddle or beater and an
> anvil, most likely a rounded
> stone. The paddle is struck against

the exterior at the point where
the anvil is held close to the wall
on the inside. The action of the
two, as they are moved round the pot,
inside and out, pulls out the wall
and reduces the thickness of the
fabric. The interior surface which this
method produces and the marks which
could be left by the edges of the
anvil when it slipped in the potter's
fingers may be seen at actual size
in the photograph of the kados
fragment, 1602, pl. 99a.

The micaceous character of Athenian pottery is discussed by
Marie Farnsworth in "Greek Pottery: A Mineralogical Study".
AJA 68 (1964), 221-228, especially 222-223.

[14]Examples include those catalogued by Sparkes and
Talcott, Black and Plain Pottery, as numbers 1589-1596, part
1, 348; part 2, pls. 70-71.

[15]B.S. Ridgway says that the bronze of this statue
varies from ca. 5 to 8 mm.("Bronze Apollo from Piombino",
Antike Plastik VII, 70).

[16]The mould is part of a study being made by Carol
Mattusch of the foundry material in the Athenian Agora.
Ms. Mattusch's research will appear in her doctoral
dissertation for the University of North Carolina.

[17]Analysis made by G. Varoufakis and E.C. Stathis is
published by them in, "Corrosion of ancient bronze",
Metallurgia 83, no. 499 (1971), 141-144. The wet chemical
analysis done by Bruno Bearzi is published by Arthur
Steinberg, "Joining Methods on Large Bronze Statues: Some
Experiments in Ancient Technology", Application of Science
in Examination of Works of Art (Boston: Museum of Fine
Arts, 1973), 108.

[18]E.g., Ann Perkins, "The Piraeus Kouros", a paper
presented at the A.I.A. 69th General Meeting in December,
1967; noted in AJA 72 (1968), 170. The opinion that the
Apollo is Archaistic has also been expressed "off the

record" by several other leading scholars in private
conversations.

[19]Werner Fuchs, Die Skulpturen der Griechen (Munich:
Hirmer Verlag, 1969), 42.

[20]I am grateful to Professor E.B. Harrison for
discussion of Archaism, both in person about this statue
and in her excellent book, Archaic and Archaistic Sculpture,
The Athenian Agora, vol. XI (Princeton, New Jersey: The
American School of Classical Studies at Athens, 1965).

[21]The assistance of Professor Vanderpool has been
invaluable with this point.

[22]Examples in the National Museum in Athens include
five from the Peloponnese (nos. 14807, 14809, 15270 and
15271) and one from Dodona (no. 8).

[23]For coins, see Leon Lacroix, Les Reproductions de
Statues sur les Monnaies Grecques (Liege: Bibliotheque de
la Faculte de Philosophie et Lettres de l'Universite de
Liege, 1949), pl. XVIII, figs. 6-13. The relief from
Miletus, now in Berlin, and the small bronze from the Payne-
Knight Collection, now in the British Museum, are both
illustrated in Enciclopedia dell'Arte Antica, IV, s.v.
"Kanachos" by G. Carettoni, 308, fig. 360, and 309, fig. 362.

[24]B.S. Ridgway, "Bronze Apollo from Piombino", Antike
Plastik VII, 43-75. Also see review by M. Bieber, AJA 74
(1970), 85-88 and Richter, Kouroi, 152-153.

[25]Smaller statues are the Louvre "Piombino Apollo"
(see note 24 and Richter, Kouroi[3], 144, 152-3, no. 181,
figs. 533-540, 641) and the "Castelvetrano Apollo" from
Selinus (Richter, Kouroi[3], 157, no. 192a, figs. 651-656).
Bronze statuettes include National Museum in Athens nos.
7381 and 6445 (Richter, Kouroi[3], 135, no. 157, figs. 467-
469; Richter, Kouroi[3], 138, no. 162, figs. 474-477), Delphi
Museum no. 1663 (Richter, Kouroi[3], 104, no. 106, figs. 330-
333), three from Samos in the Vathy Museum (Richter, Kouroi[3],
55, no. 22, figs. 117-119; Richter, Kouroi[3], 56, no. 23,
figs. 120-122; and Richter, Kouroi[3], 71, no. 52, figs.
187-189), Staatliche Museum in Berlin nos. 7976 and 7383

(Richter, Kouroi[3], 68, no. 45, figs. 166-168; Richter,
Kouroi[3], 142, no. 175, figs. 515-517), one from near
Miletus (?) now in the Cabinet des Médailles in Paris
(Richter, Kouroi[3], 72, no. 55, figs. 196-197), and Boston
Museum of Fine Arts Nos. 03.996 (Richter, Kouroi[3], 86, no.
76, figs. 261-263; Comstock and Vermeule, MFA Bronzes, 31,
no. 28).

[26]Unfortunately, the hands once extended are now
broken away from many statuettes. Of the six statuettes
listed above in note 25 which have extant extended arms, all
have a hole suitable for a bow through the clenched left
hand (Athens National Museum nos. 7381 and 6445, Berlin
Staatlich Museum nos. 7976 and 7383, and Boston Museum of
Fine Arts 03.996 and 99.488; see above, note 25, for
references). Two of them (Athens 6445 and Berlin 7976) have
holes in their right hands, too; the others seem to have
held an object on their right palm. Two of these figures can
definitely be connected with Apollo: Berlin 7383 is inscribed:
Δειναγο/ ρης ν' ἀνεθεκεν ἑ/ κηβολοι / 'Απολλονι δεκατ/ ην
(Deinagores dedicated me to far-darting Apollo as a tithe)
and Athens 7381 is from the Sanctuary of Ptoan Apollo. The
larger Castelvetrano "Apollo" and the Piombino "Apollo" also
hold their arms in the same way, left hand gripped as if
around a now-lost bow and right palm out as if to hold a
now-lost object (phiale?). It may, therefore, be that the
pose with extended arms is especially appropriate for Apollo,
although it cannot be used as a rule of thumb to identify
him since he also is represented with his arms held down at
his sides. The Archaic standing, frontal nude young male
with extended arms, however, had not been identified with a
mortal or with a god other than Apollo.

[27]This has previously been illustrated by N.M. Kontoleon,
"Zur archaischen Bronzestatue aus dem Piraeus", Opus Nobile,
Festschrift zum 60. Geburtstag con Ulf Jantzen, ed: Peter
Zazoff (Wiesbaden: Franz Steiner Verlag, 1969), 91-98 and
pl. 15.

[28]Lullies and Hirmer, Greek Sculpture[2], pls. 48-55.

[29]Sculpture from the west pediment at Aegina is
dated 505-500 B.C. by Ohly and ca. 490 B.C. by Ridgway;
sculpture from the east pediment is dated 485-480 B.C. by

Ohly and 480-470 B.C. by Ridgway. See Dieter Ohly,
Glyptothek München: Greichische und römische Skulpturen
(Munich: C.H. Beck, 1972) and Ridgway, Severe Style, 15.
The sculpture is illustrated by Ohly and Ridgway; for
additional photographs, see Lullies and Hirmer, Greek
Sculpture[2], pls. 72-77, 82-87.

[30]"Antenor's Kore" is illustrated in G.M.A. Richter,
Korai (London: Phaidon, 1968), no. 110 and figs. 336-340.
For the pedimental sculpture of the Peisistratid Temple,
see Humfry Payne and Gerard Mackworth Young, Archaic
Marble Sculpture from the Acropolis (London: Cresset Press,
1936), pls. 36-37.

[31]Corinth Museum, S-1402. Published by Nancy
Bookides, "Archaic Sculptures from Corinth", Hesperia 39
(1970), 315-317 and pl. 77.

[32] Illustrated in Richter, Kouroi[3], figs. 245-250.

[33]Reference to Pausanias' mention (i.1.3) of a
temple in the Piraeus which was dedicated to Zeus and Athena
was made almost as soon as the statues of the Piraeus cache
were discovered; e.g., G. Daux, BCH 84 (1960), 647.
Identification of this male statue as Zeus the Saviour was
made by A.A. Papjannopulos-Palaios in Πολέμων, Z' (1958/1959), 41.

[34]E.g. Waldemar Deonna, Les Apollons archaiques
(Geneva: Librairie George, 1909). For further discussion,
see Richter, Kouroi[3], 1-2.

[35]Amsterdam, Allard Pierson Museum, no. 2579. See
A.D. Trendall, Frühitaliotische Vasen (Berlin/Leipzig: H.
Keller, 1938), 42, no. 97.

Select Bibliography

Orlandos, A.K. Ὑροσθηκη, Πειραιεύς." Τὸ Ἔργον.
 1959: 161-9.

Papjannopulos-Palaios, A.A. "Πειραϊκή, Ἀρχαιολογία."
 Πολέμων, Ζ' (1958-59): 41.

Vanderpool, Eugene. "News Letter from Greece". AJA 64
 (1960): 265-6.

Daux, Georges. "Chronique des Fouilles". BCH 84 (1960):
 646-648.

Karusos, Christos. Aristodikos. Stuttgart: Kohlhammer for
 the Deutschen Archäologisches Institut Abteilung
 Athen, 1961: 73.

Meletzis, Spyros and Papdakis, Helen. National Museum of
 Archaeology, Athens. Munich and Zurich: Schnell and
 Steiner, 1964.

Harrison, Evelyn. Archaic and Archaistic Sculpture. The
 Athenian Agora, XI. Princeton, New Jersey: The
 American School of Classical Studies at Athens,
 1965: 13, 127.

Paraskevaidis, Miltis. Ein Wiederentdeckter Kunstraub der
 Antike? Piräusfund 1959. Aus dem Neugriechischen
 übertragen von A. Malina; Lebendiges Altertum, 17.
 Berlin: Akademie-Verlag, 1966: 22-29.

Homann-Wedeking, E. Das archaische Griechenland. Baden-
 Baden: Holle, 1966. Available in English as Archaic
 Greece, translated by J.R. Foster (London: Methuen
 (1968?): 145-6, 148.

Schefold, Karl, ed. Die Griechen und ihre Nachbarn.
 Propyläen Kunstgeschichte I. Berlin: Propyläen
 Verlag, 1967: 85, 106, 171; fig. 43.

Ridgway, Brunhilde S. "Piombino". Antike Plastik VII:
 43, 49 (notes 41, 43), 54, 70.

Perkins, Ann. "The Piraeus Kouros", Paper given at the A.I.A.
 69th General Meeting, 1967; noted in AJA 72 (1968):
 170.

Fuchs, Werner. Die Skulpturen der Griechen. Munich:
 Hirmer Verlag, 1969: 42.

Kontoleon, N.M. "Zur archaischen Bronzestatue aus dem
 Piräus." Opus Nobile, Festschrift zum 60. Geburtstag
 von Ulf Jantzen. Peter Zazoff, ed. Wiesbaden:
 Franz Steiner Verlag GMBH, 1969: 91-98.

Richter, G.M.A. Kouroi[3]: 136-7, no. 159 bis; figs. 478-480.

Ridgway, Brunilde S. Severe Style: 20.

Wagner, Rüdiger. Harmonikale Proportionsstudien an
 griechischen Statuen. Icking: Ora-Verlag, 1971:
 23-5, pl. 5, fig. 11.

Kallipolitis, V.G. and Touloupa, E. Bronzes of the National
 Archaeological Museum of Athens. Athens: Apollo
 Editions, (1971?): 22, no. 19.

Varoufakis, G. and Stathis, E.C. "Corrosion of ancient
 bronzes". Metallurgia 83, no. 499 (1971): 141-144.

Steinberg, Arthur. "Joining Methods on Large Bronze Statues:
 Some Experiments in Ancient Technology." Application
 of Science in Examination of Works of Arts, edited
 by William J. Young. Boston: Museum of Fine Arts,
 1973, 108.

POSEIDON FROM THE BAY OF LIVADHOSTRO

give an attitude of strength and nobility. The rounded
forms of the body are generally naturalistic, but the high-
chested torso has a stiff, self-conscious quality which
makes the figure look as if he were holding his breath.

Even though the body is fragmented and the arms are
lost, enough remains to tell that it is in the general
frontal pose of Archaic kouroi. Like the Piraeus Apollo
and a few small bronze statuettes, however, the Livadhostro
Poseidon stands with his right foot forward, instead of the
canonical left foot.[3] Instead of following the Archaic
practice of balanced weight, the Poseidon figure stands with
most of his weight on his left leg. The position of the
shoulders indicates that the arms were not held close to the
body, as were those of earlier, freestanding extant monumental
statues. Stumps of the shoulders show that the left arm was
held nearly straight up from the torso while the right arm
hung down and forward from the body.

Large almond-shaped holes cut into the face were
made for inset eyes, undoubtedly similar to those of the
Charioteer at Delphi and the Head of an Athenian General
from the Acropolis at Athens. Purer copper used for both
lips and eyebrows still makes an effective color contrast
with his skin, and it is well preserved on the lips and

left brow. The inset piece of the right eyebrow, however,
has fallen out, which enables us to see the channel cut
into the bronze and the small ridges that frame it to
hold the inlay. Preserved outlines on the outer sides of
both nipples show that they, too, were inset.

Hair is expressed by incised lines radiating from the
crown out to the plain band, which encircles the head. In
back, the long hair below the headband is twisted into a
roll at the nape of the neck. In front, two rows of fourteen
right, stylized curls frame his forehead; each curl ends
in a lively peak that looks like the tip of a whipped
cream or frosting decoration. The curls continue down his
face, ending on top of the front part of his ears, which are
quite naturalistic. The spade-shaped beard is a solid form
into which incised lines were cut to indicate the individual
hairs and hair patterns in a manner like that of the hair
on top of the head. A long mustache clears his full lips,
covering only their outer corners. A small goatee of shorter
hair in the beard forms a rounded triangular design that
hangs from the outer corners of the mouth and falls a little
less than half way (0.25 m.) down the beard, which is much
like that of the Head of an Athenian General, even to the
goatee.

Inscription

An inscription is cut into the top of the base around
what probably was the viewer's right-hand corner (fig. 2.3).
It reads, "τô ποτειδ&ονος: hιαρός " or "sacred to Poseidon,"
in Boeotian dialect.

A precise date cannot be given to the inscription with
accuracy, although it can be placed epigraphically in the
late sixth or early fifth century B.C.[4]

The inscription definitely connects the statue with
the god of the sea. The regal and mature figure with beard
and long hair suggests that the statue is meant as an actual
representation of the god himself, although the question
of whether dedications made to a god in either Classical
or Archaic times represent the deity, or the dedicator,
or either of them has not yet been solved to everyone's
satisfaction. This figure has been known as "Poseidon"
ever since it was found, and the name is a good identifying
one for the statue, which was dedicated to the god of the
seas if not actually meant to represent the god himself.

Base

The statue stands on a flat rectangular base or plate
of thin bronze,[5] to which it apparently was attached by

tangs that were secured in holes in the base plate by means of lead solder, some of which is still visible. The thin base has legs at the four corners that are roughly three or four centimeters high and somewhat less in width. The legs are about the same thickness as the thin base.

A round hole, probably less than a centimeter in diameter, is centered in each of the legs. These holes must have been used to attach the platform to a more substantial base, which is now lost.

Comparable thin bronze bases are frequently found attached to bronze statuettes, but this is the only known extant example of one attached to a large statue that is firmly accepted as being ancient Greek.

Findspot

Bronze statues found in the sea usually come from shipwrecks, but this might not be so in the case of the Livadhostro Poseidon. The statue was found in water less than a meter deep, too shallow for a normal shipwreck site, and no trace of shipwreck debris was found with the statue.

Since the inscription is Boeotian and since there are two ancient sites in the bay of Livadhostro—Kreusis (near

or at the modern town of Livadhostro) and what probably
was the port of ancient Plataea (at or near the modern
Agios Basileios)--the statue may have come from a local
sanctuary.[6] In the original publication of the statue,
Philios suggested that an ancient sanctuary to Poseidon,
in which this statue could have been housed, may have
toppled into the sea from the point where the present
chapel of Agios Basileios now stands, not far from where
the villagers found the statue. Such a sanctuary might well
have been erected by the Plataeans, especially if this were
the area of their ancient port. The sea level in this area
has risen since ancient times, strengthening the theory of
Philios.

Perhaps an earthquake and tidal wave of the type which
drowned the ancient city of Helike in 373 B.C. destroyed
the sanctuary of Poseidon from which this statue may have
come and washed the statue out into the bay. Perhaps,
since Helike was just south across the Gulf of Corinth from
Livadhostro, that very same tidal wave drowned this statue
of Poseidon; or perhaps that same earthquake, which also
ruined the Temple of Apollo at Delphi just to the northwest
of Livadhostro, threw this statue of Poseidon into the sea.

Preservation and Reconstruction

The nineteen major fragments do not all join, and many
parts of the statue are missing, so reconstruction was
difficult. The head was broken off from the body at midneck
in ancient times, and the edges of the break were smoothed
in several areas, apparently to facilitate the rejoining
of the head and torso. There still are areas, however, where
the original broken edges are extant; the jagged joins of
these edges prove that the head and torso belong together.
Fortunately the head is nearly complete except for the
missing eyes. A large section of the chest is missing. Much
of the lower left leg is broken into pieces and many parts--
including the upper thigh and the heel--are missing. Most of
the right leg is gone between the knee and the foot.

Philios suggested that the left arm was raised with
the hand holding a trident as if it were a staff and that
the right arm was extended forward from the elbow with that
hand holding a fish.[7] Coins from Boeotia provide examples
of representations of Poseidon with his hands in such a
position with these attributes.[8] No further evidence has
yet been found to propose a reconstruction more likely than
the one originally suggested by Philios.

Style

Many of the stylistic characteristics of the Poseidon
are those considered Early Classical, but there are also
traits more common in Late Archaic sculpture.

Archaic characteristics of the statue are clearly
evident in the hair, where a decorative and stylized
system of organization and expression is apparent. Similar
full spade-shaped beards and forhead curls can be seen on
other Late Archaic heads such as the "Lunging Warrior"
from the west pediment of the "Temple of Aphaia" on Aegina
(fig. 2.5), the terra cotta Zeus from Olympia, and the
bronze head of Zeus(?) from Olympia (fig. 2.4).[9] The practice
of confining the hair at the back in a roll or braid seems
to be a Late Archaic and Early Classical style, moving
away from the long, flowing hair favored by earlier Archaic
men toward the shorter fashion of the Classical period.
Pubic hair is described in the three-pointed star pattern
found on many Archaic figures including the late Archaic
Aristodikos kouros (fig. 1.10) and the "Lunging Warrior"
from the Aegina temple (fig. 2.5). Absence of emotion or
action and the faint trace of an "Archaic smile" also
link the Livadhostro Poseidon to the Archaic tradition.

Except for the hair design, the closest comparisons for

the head are the Head of an Athenian General (fig. 3.1)
and the God from Artemision (figs. 5.1-5.3); all three
heads have generalized features, large eyes which are (or
were) inset, eyebrows prominently inlaid in copper, full
spade-shaped beard, and naturalistic ears. The God from
Artemision and the Poseidon from Livadhostro also were made
with inlaid lips that probably were of copper, and the
General may have had such redder lips.

Stylistic parallels for the body can be seen in the
latest examples of Archaic sculpture, such as the Aristodikos
kouros (fig. 1.10), and in the earliest examples of Severe
Style sculpture, such as the "Kritios Boy". Comparison with
the God from Artemision, which breaks the "Archaic law of
frontality",[10] illustrates the earlier, less adventuresome
pose of the Livadhostro Poseidon. In frontal pose, size,
tight curlicued curls, and swelling yet stiff forms of the
body, the Livadhostro Poseidon is closely related to the
controversial "Apollo from Piombino".[11]

The structure of the body is more firm and the muscles
expressed with more specific modulations than are those of
the Piraeus Apollo, which can be considered an earlier
monumental bronze statue; but the body is less clearly
articulated than those of the Delphi Charioteer or the God

from Artemision, which can be considered later monumental statues in bronze. A relative date can be assigned to the Livadhostro Poseidon of ca. 490-480 B.C. to indicate that it is in the transitional period between Late Archaic and the first part of Early Classical stylistic definition.

Because the statue was found in the sea off the south coast of Boeotia, it has been thought to come from a Boeotian workshop.[12] This suggestion is re-enforced by the Boeotian dialect of the inscription (discussed above, p. 4). The statue also has been connected with other work attributed to Sikyonian artists,[13] and to an Attic sculptor,[14] but there is not enough firm understanding of differences in style or technique in these areas to identify the Livadhostro Poseidon as the product of one of them. The findspot and the inscription do indicate that the statue was made for a southern Boeotian site, but the statue fits well into our understanding of the mainstream of early fifth century B.C. Greek sculpture. Undoubtedly there were differences due to individual sculptors and to local standards, but visual evidence available to us stresses the difficulty in sorting out work of any specific region within the general area of central mainland Greece and the Peloponnesos during the early fifth century B.C. and

indicates the artistic unity of the development of monumental sculpture in this place at this time.

Notes

[1] No better photographs have yet been published than those in the original publication by D. Philios, "Χαλκοῦν ἄυαλμα Ποσειδῶνος 'εκ Βοιωτίας." Εφημερίς Αρχαιολογική, 1899, cols. 57-74, pls. 5-6.

[2] Announcement of the statue's appearance in the galleries was made by G. Karo, "Archäologische Funde vom Sommer 1935 bis Sommer 1936," AA 51 (1936), 115.

[3] The unusual stance of the right leg forward is discussed on p. 40-41.

[4] The Boeotian character of the inscription was recognized soon after it was discovered; see Perdrizet, Comptes rendus de l'Academie des Inscriptions et Belles-Lettres, 4th ser., vol. XXV (1897), 172-5. Philios, Εφημερίς Αρχαιολογική , 1899, col. 67 reports the inscription as Archaic lettering, around the time of the Persian wars. The inscription, which was discovered after the I.G. volume in which it would have been included, does not appear in L.H. Jeffrey's The Local Scripts of Archaic Greece (Oxford: Clarendon, 1961). I am grateful to Professors Ronald Stroud and Eugene Vanderpool for help with the inscription.

[5] The measurements of the thin bronze base, as reported by Philios, Εφημερίς Αρχαιολογική , 1899, cols. 63-4, are L.: 0.41 m.; W.: 0.235 m.; and Th. 0.01 m. Bases of comparable shape but smaller size are described by A. de Ridder, Catalogue des Bronzes trouves sur l'Acropole d'Athenes (Paris: Thorin for l'Academie des Inscriptions et Belles-Lettres, Fond. Piot, 1896), nos. 603-613, pp. 216-8.

[6] This suggestion has been made previously by L.R. Farnell in The Cults of the Greek States (Oxford: Clarendon, 1907), vol. IV, 62, who follows the belief of Philios, Εφημερίς Αρχαιολογική , 1899, col. 59.

[7] Ibid., col. 66. Philios would reconstruct the tip of the trident in the small hole on the base. A less convincing reconstruction by W. Roscher in Ausfürliches Lexikon der griechischen und römischen Mythologie, vol. III, part 2 (Leipzig: Teubner, 1897-1909), 2875, fig. 10, places

a horizontal trident in Poseidon's upraised left arm.
Roscher's reconstruction, which would make the god left-
handed or ambidextrous, depends upon coins of faraway
Poseidonia and does not explain the hole on the base.

[8]Boeotian representations of Poseidon in a mirror
image of the pose proposed by Philios can be seen in third-
century B.C. coins thought to be from Thebes; see Barclay
Head, Catalogue of Greek Coins, Central Greece (London: The
British Museum, 1884), 40 and pl. VI: 6-7; also see Sylloge
Nummorum Graecorum, Danish National Museum, Aetolia-Euboea
(Copenhagen: Einar Munksgaard, 1944), pl. 8, nos. 380-4. The
Poseidon represented on these coins definitely is Late
Classical or Hellenistic in style and there is no possibility
that it could represent the statue found in the Livadhostro
Bay; the coins simply attest the pose as one of Poseidon in
Boeotia.

[9]For illustration of the terra cotta Zeus at Olympia,
see Lullies and Hirmer, Greek Sculpture2, V and 105. For
the small bronze head of Zeus(?) from Olympia (now in Athens,
National Museum,, inv. No. 6440), see Adolf Furtwängler, Die
Bronzen und die übrigen kleineren Funde von Olympia, Die
Ergebnisse der von dem Deutschen Reich veranstalteten
Ausgrabung, IV (Berlin: Asher, 1890), 9-10, no. 1; for a
color illustration, see V.G. Kallipolitis and Evi Touloupa,
Bronzes of the National Archaeological Museum of Athens
(Athens: Apollo, n.d.), no. 21.

[10]Ridgway (Severe Style, 40) defines the "law of
frontality" as requiring "an imaginary line drawn vertically
through the center of a figure (which divides) it into two
equal halves" and says that the "Breaking of the 'law of
frontality' in the Severe period seems almost a new law in
itself."

[11]For differing opinions about the Apollo from
Piombino, see Ridgway, "The Bronze Apollo from Piombino in
the Louvre," Antike Plastik VI (1967), 43-75, and pls. 24-
34, and Richter, Kouroi3, nos. 181, 145, 152-3.

[12]Lippold, Handbuch, 113.

[13]Langlotz,Fruehgriechische Bildhauerschulen

(Nuernberg: Frommann, 1927), I, 39.

[14]Philios, Εφημερίς Ἀρχαιολογική , 1899, col. 72.

Select Bibliography

Philios, D. "χαλκοῦν 'ἄναλμα Ποσειδῶνος." Εφημερίς 'Αρχαιολογική.
 1899, cols. 57-74, pls. 5-6.

Perdrizet, Paul. Comptes rendus de l'Academie des Inscriptions
 et Belles-Lettres. 4th ser., vol. XXV (1897), 172-5.

Roscher, W.H. Ausführliches Lexikon der griechischen und
 römischen Mythologie, vol. III, part 2. Leipzig:
 Teubner, 1897-1909, 2875, fig. 10.

Farnell, L.R. The Cults of the Greek States. Oxford:
 Clarendon, 1907; vol. IV, 62 and pl. IV.

Bulle,Heinrich. Der schöne Mensch im Altertum. Munich and
 Leipzig: G. Hirth, 1912, pl. 39- right.

Langlotz, Ernst. Fruehgriechische Bildhauerschulen.
 Nuernberg: Ernst Grommann, 1927; vol. I, 39; vol. II,
 pl. 22-h.

Karo, G. "Archäologische Funde vom Sommer 1935 bis Sommer
 1936" AA 51 (1936), 115.

Lehmann-Hartleben, Karl. Drei Entwicklungsphasen griechischer
 Erzplastik. Stuttgart: Kohlhammer, 1937, 2-3, note 10.

Lippold, Georg. Handbuch, 113 and pl. 37:1.

Charbonneaux, Jean. Greek Bronzes. 95.

Karusos, Christos. Aristodikos. Stuttgart: Kohlhammer for
 Deutsches Archäologisches Institut, Abteilung Athen,
 1961: 78, pl. 15-c.

Ridgway, B.S. "The Bronze Apollo from Piombino in the Louvre"
 Antike Plastik VI; 51, note 53.

_____, Severe Style, 24, 40.

Athens, National Museum, no. 6446. Found in 1886 on the
Athenian Acropolis near the Propylaia. Broken off at the
neck; helmet missing. Dark, dull green patina with patches
of red color. H.: 0.27 m. Th. of visible bronze wall varies
from 0.015 to 0.008 m. Fig. 3.1

Description

The frontal head is an elongated oval, enlivened
by generalized but strongly articulated facial features.
About half of the neck remains below the rough break; it
shows a subtle movement to the figure's left.

Above a narrow rim of hair framing the face, the crown
of the head is slightly depressed and is domed up toward
the back to give a firm foundation for a helmet. Two small
holes can be seen at the center in the back, just above the
narrow band of hair that would have been visible; and the
round head of a rivet remains above the left side of the
figure's forehead. Both the holes and the extant rivet
could have been used to anchor the helmet.[1]

Hair is indicated by forms of increased volume, which
seem to be of somewhat rougher texture than the representation
of skin. Fine parallel lines engraved in the areas
representing hair are now difficult to see because of the
corroded condition of the surface. They are similar in size

and arrangement to the more easily seen lines on the
Archaic "Zeus" from Olympia (fig. 2.4). The bottom edge of
the mustache is sharply delineated, and a slight ridge
outlines the little goatee under the lips. The edge of the
short hair on top of the head is expressed in small zig-
zag notches which look as though they might have been cut
with pinking shears.

The style of the moustache and spade-shaped beard is
virtually identical to that worn by the Livadhostro
Poseidon, even to the small tongue or goatee of shorter
hair which forms a rounded triangular design that falls from
the outer corners of the lips to a point more than half
way down the larger beard. With flowing ends that clear all
but the outer corners of the lips, the moustache also is
shaped like that of the Poseidon. The style of the beard is
a widespread one for mature men in the early fifth century
B.C. It can also be seen on the bronze God from Artemision
(figs. 5.1-2) and the figure of Oinomaos from the east
pediment of the Temple of Zeus at Olympia as well as on
contemporary red-figure vases.[2]

Simple arched ridges indicate the General's eye-brows.
Their precise outline, simplified form, and raised surface
suggests that they are a metal inset, but closer examination

than that now permitted in the gallery would be necessary to
be certain. Likewise, the full lips may be a metal inset.

The heavy-lidded, almond-shaped inset eyes are badly
damaged now. A pasty material indicates the white of the
left eye, but the iris and pupil are missing from their
hole. The statue's right eye is in even worse condition; it
is filled with a material which looks resinous and which
has an indentation where the pupil was. The strange
appearance of the right eye might be due to modern restoration.[3]
Remnants of fringed bronze eyelashes are still evident.

Technique

The uneven thickness of the metal wall at the jagged
bottom edge indicates that the break occured at a casting
edge and that part of what we now see there is soldering
metal. The heads of most ancient Greek monumental statues in
bronze were cast separately, so we could expect a join at
midneck.´

The head is mounted in such a way that it is impossible
at the present time to see for more than several centimeters
into it. Where we can see, the metal wall varies in thickness
from 0.008 to 0.015 m., with one centimeter being an
approximate average. An uneven flange projects from the right

side of the neck into the center for ca. 0.03 m.; it could
be either part of the bronze or some of the welding material.

The lost helmet obviously was cast separately, and the
area designed to be under it was not meant to be seen. The
roughly finished surface of this area with impressions in
the positive represents the actual modelling on the wax
original itself and indicates that the sculpture was made
by the direct method of casting.

Marks of a narrow chisel visible on the surface that
would have been covered by a helmet are similar to tool
marks frequently found on Greek monumental bronze sculpture
in areas not meant to be seen. In this instance, the marks
seem to represent work on the model, although similar tool
marks in other instances--especially in areas of overfitting
parts in later Greek sculpture, as can be seen on the Agora
Horseman and the Izmir "Lady from the Sea"—often appear as
coldwork on the cast bronzes. This kind of mark can easily
be made on a wax model and does not in any way prove—or
even suggest—that the model was carved from wood, as
Kluge suggested.[4]

The wavy parallel lines indicating strands of hair are
so precise and delicate that they probably were cut into
the soft medium of the wax model rather than the hard

surface of cast bronze. They appear to have been made by
a narrow comb.

Date

Although the Head of a Strategos is similar to that of
the Livadhostro Poseidon, it does not have a comparable
archaism in hair patterning. While the Livadhostro statue
has close parallels in the sculpture from the west
pediment of the Temple of Aphaia on Aegina, the head of the
Strategos is closer to the style of figures from the east
pediment of that temple, such as the "Fallen Warrior" (fig.
3.2). The Head of an Athenian Strategos can be placed later
than the Poseidon from Livadhostro and earlier than the
God from Artemision. It can be assigned a date of approximately
480 B.C. to indicate its relative position in early fifth
century Greek sculpture. This stylistic date might be
moved forward or backward a few years depending upon what
dates are accepted for the pedimental sculpture of the
Aegina Temple, but ca. 480 B.C. is compatible with both
Ridgway's and Ohly's Aegina dating.[5]

Early reports of the discovery of the head describe
the finding place simply as "near the Propylaia". If the
statue to which the head belonged stood on the Acropolis in

480 B.C., it surely would have been destroyed by the Persians.
Unfortunately, virtually no evidence remains about the destruc-
tion of the head or its burial. Records of its excavation are
scanty; we don't know whether other objects were found with
it, and the excavators did not note stratigraphy. Since there
are no records that identify other objects found with the
Strategos head, it probably did not come from one of the mass
burials made after the Persian destruction. In short,
archaeological evidence gives little definite information use-
ful for dating the Strategos head.

We need to rely on the stylistic evidence to assign a
date in the very early fifth century, ca. 480 B.C.

Aeginetan Attribution

Close stylistic comparisons with the pedimental
sculpture of the Temple of Aphaia on Aegina, especially
that of the east pediment, and the high reputation reported
by ancient authors of the bronze worked on that island have
led scholars to classify this head as "Aeginetan".[6] This
theory is attractive; however, we do not yet know enough
about the bronze work from Aegina or from any other specific
place. This head might well have been modelled by an artist
who worked on the Temple of Aphaia on Aegina, but that
artist might have been from Attica or yet another place.

Although Aegina had a reputation for fine bronze-working,
Archaic and Early Classical sculpture certainly was not
limited to that island. As early as the sixth century B.C.,
for example, large-scale bronze sculpture was made in
Athens.[7]

Reconstruction

The compressed and domed shape of the crown of the
head and the holes and rivets that are still visible were
designed to support a helmet, which was cast separately
from the head and is now lost. The helmet probably was a
Corinthian model, similar to the one on the "Fallen Warrior"
from the second phase of pedimental sculpture of the Aegina
temple (fig. 3.2). The helmet was worn in noncombatant
position (fig. 3.3) like the one on the portrait of Pericles
known from Roman copies (fig. 3.4), the warrior from the
earlier phase of pedimental sculpture at the Aegina temple
(fig. 3.5), and the bronze Piraeus Athena (figs. 13.1-2).

Since the head is frontal but the neck is slightly
twisted, the original position probably was a break from
the rigid axial composition of Archaic sculpture into a
more relaxed frontal pose comparable to that of the so-
called "Kritios Boy".

Heads of comparable contemporary statues are about
one-seventh--or a little less--of the height of the rest
of the body. Applying this formula to the Strategos
would make a figure about 1.5 m. tall. Except for his
helmet, he probably was nude.

Identification

Harmodios and Aristogeiton, the tyrant-slayers,
were honored by bronze statues, but Demosthenes (xx, Leptinis,
70) reports that the Athenians did not so honor individuals
again until the fourth century B.C. This means that the
city of Athens did not do so with publicly financed statues.
Privately financed representations of individuals could be
made--and were made--in Athens during the fifth century B.C.
at approved places under certain circumstances.[8]

Especially notable are statues of the elected
strategoi. The office of strategos can be translated roughly
as "commander" or "general," although in fifth-century Athens
there also were political aspects to the position.[9] In
describing the destruction of the herms (415 B.C.), Andocides
(On the Mysteries, 38) mentions a bronze statue of a
strategos that stood near the gateway to the temple
of Dionysos (on the south side of the Acropolis.)

Among the dedications on the Athenian Acropolis recorded

by Pausanias (i.25.1) are three statues of fifth century

men: two strategoi (Xanthippos and Pericles) and a poet

(Anakreon). F. Poulsen[10] points out that:

> The importance of their (the strategoi)
> office is clear from the fact that
> they had the right to set up their
> own statues after its completion
> (i.e., completion of their term of
> office). The statues of the strategoi
> were not memorials erected in their
> honour by the people, for Athens
> did not dedicate a memorial statue
> to anyone at all before Conon,
> but they were dedications--and this
> is true even of such a strategos
> as Pericles, who erected his own
> statue on the Acropolis where the
> statue of his father Xanthippus
> was already standing.

Statues of strategoi, often known now through Roman copies,[11]

are most easily identified by a helmet worn on the back of

the head. Even on Attic men, these helmets are the so-called

"Corinthian" type, widely used throughout Greece in the

fifth and fourth centuries B.C.

Since strategoi were one of the major groups of

individuals who were permitted to erect statues and since

this head was designed for a helmet, as were other statues

we know of strategoi, it probably is the dedication and

representation of a strategos. Since the head was found

on the Athenian Acropolis, the statue from which it came
probably stood there; it would seem, therefore, to represent
an important general or strategos. Since the statue can
be dated ca. 480 B.C., it probably represents a leader of
that time, the time of the Persian invasion.

The most likely candidates for the strategos represented
by this statue, therefore, would be Themistokles, Aristides,
Xanthippos, or perhaps the earlier Kallimachos or Miltiades.
Pliny (xxxiv.57) tells us that Panainos included portraits
of both Kallimachos and Miltiades in his painting for the
Stoa Poikile of the Battle of Marathon, but the painting was
made nearly thirty years after the death of both these
strategoi. There are no other recorded representations of
Kallimachos, who was killed in 490 B.C. at Marathon, although
fragments of a dedication on the Athenian Acropolis--probably
a statue of a Nike or Iris--have been connected with him.[12]
Three statues of Miltiades are recorded in ancient literature,
but they probably were set up after his lifetime;[13] and a marble
herm in Ravenna probably was a contemporary portrait. Miltiades
is unlikely to have been financially able to erect a bronze
statue; he was imprisoned for inability to pay a fine of
50 talents and died in prison in 488 B.C. None of the
portraits mentioned in ancient literature of Themistokles
have been securely identified, and none of the Roman copies

we have of portraits of him has been firmly accepted as
contemporary representations.[14] No bronze statue, that stood
in Athens, however, is likely to represent either Miltiades
or Themistokles since Demosthenes (xxiii, Aristokrates, 196)
specifically says that the Athenians erected no bronze
statues of either leader.[15] No record exists in ancient
literature of portraits of Aristides, and no portraits are
identified as his.[16]

We do know from Pausanias (i.25.1) that a statue of
Xanthippos "who fought the Persians at Mykale" did stand on
the Athenian Acropolis. Does the bronze head of a strategos
that is now in the National Museum come from that statue?

A prominent and progressive statesman in his own right,
Xanthippos married an Alkmaeonid so his influence was
considerable. He was ostracized in 484 B.C., probably because
of a political difference with Themistokles and perhaps
with Aristides. He was recalled in 480 B.C. as the threat
of war with Persia increased, and public confidence in him
is confirmed by his election soon thereafter as strategos.
Xanthippos led Greek troops on land and sea against the
Persians and was in charge of the important victory at
Mykale in 479 B.C. Little is known of his activities after
479, although he retained fame as the father of Pericles.

Several Roman copies have been identified as portraits

of Xanthippos,[16] but they are all of a mid-fifth century
style or later. The head in the Conservatori Museum and that
in the Ny Carlsberg Glyptotek,[17] which are the most likely
to represent Xanthippos, are also of a man with full beard
who wears a Corinthian helmet pushed back on his head, but
this pose is a frequent one for strategoi portraits. If the
bronze Head of an Athenian Strategos, found on the Athenian
Acropolis and now in the National Museum in Athens, does
represent Xanthippos, it must be a contemporary statue. If
the Roman copies connected with Xanthippos also represent
him, they must be based on a later statue or statues,
perhaps a posthumous portrait commissioned by his son.

Conclusion

Whether or not this head of a strategos does in fact
represent Xanthippos, father of Pericles, it does represent
the artistic progenitor of the High Classical likeness of
Pericles that are known to us through inscribed Roman copies
(fig. 3.4).[18] It is an important example of a major private
dedication made on the Athenian Acropolis about the time of
the Persian invasion and is an important original example of
early fifth century portraiture.

Notes

[1]In 1887 T. Sophoulis described one hole at the back, which he identified as a casting vent; see " Χαλκή Κεφαλή Αρχαϊκης Τέχνης," Εφημερίς Αρχαιολογική 1887, col. 44. The size and shape of the two holes, however, do not conform to more recent understanding of ancient Greek casting vents or chaplets.

[2]For an illustration of the Oinomaos figure, see Ashmole, Olympia, pl. 18; for an example of the hair style on a contemporary vase, see the portrayal of Ajax by the Kleophrades Painter on a hydria now in Naples (Museo Nazionale, no. 2422), illustrated in P.E. Arias and M. Hirmer, A History of Greek Vase Painting (London: Thames and Hudson, 1962), pl. 125.

[3]At the time the head was restored, the eyes were described as made of glass paste, only a little of which is preserved. See Sophoulis,"Χαλκή Κεφαλή Αρχαϊκης Τέχνης." col. 44.

[4]Kurt Kluge, "Die Gestaltung des Erzes in der archaisch-griechischen Kunst", JdI 44 (1929), 15-17.

[5]Sculpture from the Aegina west pediment is dated 505-500 B.C. by Dieter Ohly and ca. 490 B.C. by Brunilde Ridgway; east pediment sculpture is dated 484-480 B.C. by Ohly and 480-470 B.C. by Ridgway. See Ohly, Glyptothek München: Griechische und römische Skulpturen (Munich: C.H. Beck, 1972) and Ridgway, Severe Style, 15.

[6]For examples of "Aeginetan" classification of this head, see Ernst Langlotz, Fruehgriechische Bildhauerschulen (Nuernberg: Fromann, 1927), 99; Lippold, Handbuch, 100; and Picard, Manuel II-1, 73.

[7]Evidence for ancient Greek bronze-working is being collected and studied by Carol Mattusch, to whom I am grateful for this information. Her dissertation, which is being written for the University of North Carolina, is Large-scale Bronze Casting Technique in Greece from the Sixth Century B.C. to the Hellenistic Period: Foundries and Foundary Remains from the Athenian Agora, with Reference to

Other Ancient Sources.

[8]The abundant evidence for privately-dedicated
statues is outlined in Richter, Portraits, I, 5. For specific
reference to statues of the strategoi, see Frederik Poulsen,
"Iconographic studies in the Ny Carlsberg Glyptothek",
From the Collections of the Ny Carlsberg Glyptothek, I
(1931), 16-18.

[9]For discussions of strategoi, see C. Hignett, A
History of the Athenian Constitution (Oxford: Clarendon,
1951), 169-173, 244-251, 347-356; K.J. Dover, ΔΕΚΑΤΟΣ ΑΥΤΟΣ,"
JHS 80 (1960), 61-77; A.M.H. Jones, Athenian Democracy
(Oxford: Basil Blackwell, 1969), 124-128; and D.M. MacDowell,
"Strategoi", OCD², 1017-8.

[10]"Iconographic studies", 16.

[11]See Richter, Portraits, I, XVII and figs. 426-447.

[12]A.E. Raubitschek, Dedications from the Athenian
Akropolis (Cambridge, Mass.: A.I.A., 1949), 94-97.

[13]Richter, Portraits, I, 94-97.

[14]Ibid., 97-99. For further discussion of the Ostia
bust, see Andreas Linfert, "Die Themistokles-Herme in Ostia",
Antike Plastik VII (1967), 87-94 and pls. 39-46.

[15]As Richter (ibid., 5 and 95) previously observed,
the passage from Demosthenes only means that no public bronze
statues of these men were erected by the citizens of Athens.
It does not mean that there were no contemporary portraits
of them. Portraits of Themistokles and Miltiades are
discussed by Richter, ibid., 94-99.

[16]Richter, ibid., 101-2.

[17]For bibliography and a summary with illustrations of
portraits identified as being Xanthippos, see ibid., 101.

[18]Ibid.

[19]Ibid., 102-4, pls. 429-448.

Selected Bibliography

Sophoulis, T. "Χαλκή Κεφάλη Ἀρχαϊκης Τέχνης." Ἐφημερίς Ἀρχαιολογική , 1887, cols. 43-48.

Brunn, H., Bruckmann, F., Arndt, P., and Lippold, G. Denkmäler griechischer und römischer Sculptur, Munich: Bruckmann, 1888, no. 2.

de Ridder, A. Catalogue des Bronzes trouvés sur l'Acropole d'Athenes. Paris: Libraire Thorin for the Bibliothèque des Écoles Françaises d'Athènes et de Rome, 1896, no. 768, p. 290-2, figs. 276-7. Includes earlier bibliography.

Bulle, Heinrich. Der schöne Mensch im Altertum. Munich and Leipzig: G. Hirth's Kunstverlag, 1912, 493 and pl. 226.

Langlotz, Ernst. Fruehgriechische Bildhauerschulen. Nuernberg: Fromann, 1927, p. 99, no. 8.

Kluge, Kurt. "Die Gestaltung des Erzes in der Archaisch Griechischen Kunst". JdI 44 (1929), 15-17 and figs. 9-10.

Poulsen, Frederik. "Iconographic studies in the Ny Carlsberg Glyptotek". From the Collections of the Ny Carlsberg Glyptotek, I (1931), 15-28.

Picard, C. Manuel, II-1, 73 and fig. 33.

Lippold, G. Handbuch, 100.

Richter, G.M.A. The Portraits of the Greeks. London: Phaidon 1965, 4-6, 94-99, 101-104, and pls. 405-8, 426-447.

Kallipolitis, V.G., and Touloupa, Evi. Bronzes of the National Archaeological Museum of Athens. Athens: Apollo Editions, (1971?), no. 20.

Ridgway, B.S. Severe Style, 24.

Delphi Museum, inv. 3484, 3520, and 3540. Excavated in
1896 at thenorthwest area of the sanctuary with other
pieces of a monument. Green patina. Right arm missing below
sleeve; otherwise, good condition. H.: 1.8 m. Th. of bronze
varies from 0.008 to 0.025 m.[1] Figs. 4.1-10.

The Charioteer of Delphi is uniquely important since it is

the only monumental Classical bronze statue found at the

site where it stood, with enough of its base to identify and

closely date it.

Description of the Charioteer

The Charioteer was discovered in three pieces: the

skirt with both feet attached to it, the upper body and

head, and the right arm with three reins still in the hand.

These pieces join to make a statue virtually complete except

for the left arm.

The composition is basically a vertical cylinder,

broken by outstretched arms. The figure stands stiffly

erect, his head turns toward his right at about a 30 degree

angle from the front plane of his dress. His feet, however,

point a little to his left, making a subtle counter

twist to the direction of his head and glance. The over-all

geometric scheme of the composition, reflecting concern

for order, is also seen in the parts, especially the head

and drapery. The idealized naturalism of his arm and feet,
like the subtle swing of his body, give organic character
to those parts.

The head is an elongated oval, strong in its simplicity,
animated by short volumetric curls (cast separately) in front
of and immediately around his small ears, which protrude
slightly. In contrast to these plastically modelled locks,
hair on the top of his head is described in a series of flat
flame-shaped tongues, made by engraving, radiating from the
crown. A headband runs across his forehead and is tied at
the back; the ribbon is decorated with a simple meander and
Greek crosses and is similar to ones on Archaic statues
such as the ribbon loosely tied around the hair hanging
down the back of the statue of Phrasikleia.[2]

Translucent chestnut-brown eyes of stone and glass
paste transmit the new philosophical concepts of the "inner
light of the soul,"[3] giving a spirit of life and intensity
to the figure never achieved when the eyes are cast with
the head. The eyes are somewhat asymmetrical, partly from
damage; the right eye is now open wider and protrudes more
than the left one.

Slightly parted, full lips seem to have been inlaid
in another metal for color contrast, probably in a purer

copper alloy to give a reddish hue.

The head is inclined and the wide open eyes stare at a point somewhat below his eye level. Photographs of the head often position it in a strictly perpendicular pose, which gives an incorrect idea of the design by making the beardless chin appear fuller and the modelling appear flatter than it is in the more sensitive, inclined position.

The Charioteer is dressed in a chiton with armholes open from the side in the Archaic style, rather than from the top of the garment as was the later fashion.[4] A cord, fashioned around both shoulders and across his back in a figure-eight, kept the sleeves and bodice in place. The cord was made separately and has been lost, but the grooves modelled into the chiton to hold it remain an important part of the design. His chiton was belted above his waist, about Empire level, with a band of metal, hammered and cut from a bronze sheet rather than cast. This garment is the traditional dress of ancient Greek charioteers.

The chiton falls over the figure, hiding rather than revealing the body inside. The sculptor has abandoned the Archaic convention of indicating folds by use of decorative grooves incised into the figure in favor of modelling the folds in both negative and positive plastic volumes. The

gathers appear to fall realistically, although the artist
has arranged them in a more balanced, careful composition
than would occur naturally. Heavy soft drapery above the
waist blouses into the belt and curves toward the center
of it. So regular are the drapery folds below the belt and
so simple is the erect form that the statue has been
compared to a "fluted column" ever since it was excavated.
A consideration in the simple design of the vertical folds
may have been their relation to the horizontal chariot
railings that would cross the skirt since the chariot, as a
racing vehicle, undoubtedly would have been an open frame.
The hem of the skirt curves upward into arcs at center front
and back, echoing the upward arc of the belt at center front,
which lightens the other-wise solid, static effect of the
skirt.

Both arms were held slightly forward from the shoulders.
His right arm is bent at the elbow and extended horizontally,
and remnants of reins remain in his hand. The left arm is
lost below the sleeve.

In comparison with the more geometrically controlled
and compartmentalized head and chiton, the modelling of the
exposed arm and bare feet appears thoroughly realistic
for an ideal young man. Stylistic inconsistencies between

the stylized drapery and head and the idealized but
naturalistic feet and arm are in keeping with late Archaic
and early Classical practice seen in such figures as the
Piraeus Apollo and the Aristodikos Kouros (figs. 1.1-10),
which show more Archaic characteristics in their heads than
in the rest of their bodies, especially feet and arms.

Linked to the kouros tradition of young men standing
erectly and following the Piraeus Apollo and the so-called
"Kritios Boy", the Delphi Charioteer shows a logical
development away from the strictly frontal position with the
twist from his feet pointed left to his head turned to the
right. The composition is more self-contained and stylized
than that of the later pedimental sculpture of the Temple of
Zeus at Olympia (ca. 460 B.C.)[5] or the free-standing bronze
God from Artemision (figs. 5.1-9).

Although the dedicator, Polyzalos, was from Sicily as
we shall see, there is no evidence that his monument was
made there or by a Sicilian artist. While the work fits
Early Classical Greek style, there is no special stylistic
connection with contemporary sculpture from Magna Graecia,
except perhaps for the acrolithic head of Athena now in the
Vatican.[6] In addition, Sicily did not have the well-developed
bronze working facilities or the experience in making monumental
sculpture in bronze that would be necessary to produce

such a monument. Furthermore, tyrants are, as Ashmole has
pointed out, "apt to employ the best artists that money can
buy irrespective of nationality."[7] Pausanias tells us that
chariot monuments dedicated by Polyzalos' brothers at
Olympia were made by well-known Greek artists.[8]

Since the Charioteer wears the victor's ribbon,[9] the
scene is after the race, yet his appearance is calm and
controlled without sign of physical or emotional effort or
involvement. Rather than an instant of dramatic action, the
time chosen for the representation is a quiet and dignified
moment after a successful contest, a time in which man is
in calm command.

By representing the young man in an erect and closed
composition, the artist conveys an impression of aristocratic
self-control, re-enforced by the geometrically-ordered
head and emotionally-controlled face with serious and
reserved expression. Aristocratic composure does not become
arrogence; by inclining the figure forward and directing the
gaze downward, the artist brings it into closer contact with
the spectator both physically and psychologically. Tectonic
emphasis of drapery conveys a sense of stability and broad
shoulders imply strength; youthful slenderness and large
translucent eyes soften the expression.

Stylistically the Charioteer embodies most of the character-
istics of the period from approximately 480 to 450 B.C.:
simplicity of forms, seriousness and control of emotion,
idealized naturalism, precise and definite lines.[10] It has
been attributed enthusiastically to almost every major
sculptor who worked in that period, but there is insufficient
evidence to accept any of them. Nor is there even solid
basis for attributing the statue to any regional school since
major artists-poets, architects, and painters, as well as
sculptors-travelled where commissions and patronage would
support them.

The Monument

A major difference between the Charioteer and the line
of kouroi from which he is descended is his position as
part of a monument rather than a single statue. Excavated
with the Charioteer between the Apollo Temple and the theatre
were three groups of bronze sculptural fragments and part
of a stone base.[11]

1. From the base:

An inscribed trapezoidal gray stone block.

2. From horses:

a. Two rear legs, one right and one left.

b. Front left hoof, which fits onto the extant
block from the base.

c. Upper part of a tail.

d. Two bundles of reins, one group of three from
the Charioteer's right hand and another bunch,
which also is of only three.

3. From a chariot:

a. Part of chariot pole or shaft.

b. Two pieces of the yoke.

c. Half of a protective cushion.

4. From another person, smaller than the Charioteer:
A left arm, apparently of a boy, broken away from
the body near the shoulder.

There has been no serious doubt that the pieces of the
Charioteer, the fragments of the chariot and horses, and
the inscribed block belong together. The left arm of the
smaller person has occasionally been questioned because of
the difference in scale between it and the Charioteer, but
it is now generally accepted as the arm of a smaller person,
an attendant. Another horse leg found nearby originally was
thought to be part of the group, but it is no longer considered
so because of its larger size and different technique.[12]

Another part of a stone base, signed by the Boeotian

artist Sotades of Thespiai (Delphi Inv. 2638) and found in
1895 near the south wall of the theatre, has been proposed
as being from this monument, but differences from the block
with Polyzalos' name both in lettering style and the material
of the stone itself has led everyone except Hampe to reject
it now.[13]

The charioteer's costume, the victor's headband, and
the pieces of horses and chariot show that the monument
commemorates a victory in the chariot race. Since the
monument was found in the sanctuary at Delphi, the victory
must have been in the Pythian Games.

Inscription and Identification

Precise identification can be made from the inscription
on the block which belongs to the base:[14]

[- ‿‿.‿‿-‿ η]ολύζαλός μ' ἀνεθηκ [εν]
[- ‿‿. ‿‿-] ον 'αεξ', εὐόνυμ' 'Απολλ[ον]

The missing first and last letters can be reconstructed as:

[Νικάσας "ιπποισι η]ολύζαλός μ' ἀνέθηκ[εν]
[ηυιὸς Δεινομένες, τ]ὸν 'αεξ', εὐόνυμ' 'Απολλ[ον]

"For his victory in the chariot race Polyzalos, the son of
Deinomenes, set me here: prosper him, glorious Apollo".[15]

The first line originally was different, but the

erasure was not complete so that it can still be read
faintly under the present inscription: (fig. 4.11). A
convincing restoration can be made of the original inscription
as:

Μνᾶμα Πολύζαλός με Γέλας ἀνέθεκεν ἀνασσον

Added to the unchanged second line, this would be, "As a
memorial, Polyzalos the King of Gela, son of Deinomenes, set
me here: prosper him glorious Apollo".[16]

This Polyzalos is the son of Deinomenes and younger
brother of the more famous Gelon and Hieron, tyrants in
Sicily during the early fifth century B.C. Even though little
definite information is known about Polyzalos himself,[17]
his power at Gela can be placed within a span of less than
12 years, 478-467/6.[18] Polyzalos' name does not appear
in the list of known victors in the chariot races at the
Pythian Games, but the victors' names are lost for the
contests of 478 and 474 B.C.

Why this inscription was changed is a puzzle. All the
letters are dated to the first half of the fifth century
stylistically.[19] Someone obviously wanted to delete
Polyzalos' use of the title "King of Gela" since that is the
erased section, but there is no evidence of wanting to
destroy his name nor the record of his victory. In fact,

care was taken to replace the erased title with an honorable
phrase. Use of the title was unusual: although Polyalos
was the least powerful of the Deinomenides, he is the only
one who is known to have styled himself as "king", and this
is the only record that he did so.[20] Perhaps the citizens
of Gela had the title erased when the tyranny was overthrown
in 466 B.C.[21] An even more likely possibility is that
Polyzalos' powerful and jealous brother Hieron was responsible
for having it erased to keep the younger brother in line,[22]
perhaps as one of the terms demanded by Hieron in the
armistice between the brothers, ca. 476 B.C.[23] (see note
18 above), which would explain the care taken to retain
family honor.

Certainly the earliest possible date for the monument
must be between 478 and 467/6 B.C., the years when Polyzalos
could have been ruler of Gela. The victory must have taken
place in either 478 or 474 B.C. (or both years), the only
slots in the first half of the fifth century where his
name could be inserted into the victors' list. The monument
probably was commissioned soon after the victory, which narrows
the date to the '70's of the fifth century. The youthful
appearance of the central figure, if it is meant to represent
Polyzalos himself (see below) suggests an early date in

his career. His political problems and subsequent loss of power plus the early re-writing of the inscription suggest a date before 476 B.C., which points to 478 B.C. as the year of the victory honored by this dedication. Considering time needed to make such a monument, it can comfortably be dated ca. 477 B.C.

In the ancient games, the winner of a chariot race was the owner of the chariot, not the driver. Does this statue represent Polyzalos himself or his charioteer? We have no known portraits of Polyzalos for comparison. Since the statue is dressed in the costume of a charioteer and holds the reins, it usually is simply identified as "the Charioteer". Charbonneaux would restore the monument with another figure to represent Polyzalos;[24] however, information about contemporary chariot monuments does not support the idea of two major or adult figures; for example, Pausanias' description (vi.12.1) of the chariot monument dedicated by Polyzalos' brother, Hieron, at Olympia includes only one central figure, not both charioteer and owner. Arguing against the representation being an actual portrait of Polyzalos at the time of his victory is Miller's proposed date of ca. 518 B.C. as his birthdate,[25] which would make him 40 years old in 478 B.C.; the representation is of a

much younger man. Other evidence, however, strongly supports
identifying the Charioteer as a representation of Polyzalos
himself. In the usual reconstruction of one adult figure, it
is more probable that a new tyrant would glorify himself
rather than someone else in an expensive monument. The
dedicatory epigram refers only to Polyzalos. Pausanias
(vi.9.5) clearly believed that the figure in the chariot
monument of Polyzalos' brother, Gelon at Olympia, was a
representation of Gelon.

Convincing identification of the statue as representing
Polyzalos can be made by the victor's fillet worn by the
Charioteer, because an anecdote told by Pausanias (iv.2.2)
indicates the prohibition against the winner giving the
fillet to the charioteer: Lichas was whipped by the umpires
for doing so at Olympia in Olympiad 90 (420 B.C.). Since
Polyzalos chose to have himself represented as the driver in
the monument, the smaller arm may belong to a boy who
actually was the charioteer, depicted holding the bridle.
Or perhaps Polyzalos, from both family and area famed for
horsemanship, did drive his own chariot, which would explain
the charioteer's dress, the reins, and the victor's ribbon
all on one figure. In either case, the figure wearing the
victor's ribbon represents Polyzalos, idealized as a youth.

Reconstruction of the Monument

Letters missing from the inscription show that the
extant block was probably the second section of the base.
If a piece were added to this stone to make it rectangular,
the front face would be increased 0.123 m. at the right
side, which would be enough room to restore the missing
letters at the end and make the inscription complete on two
blocks. The right side has been trimmed so that it is
difficult to know from the block whether it originally was
an end block or not; re-use of the block is shown by the
large circular cutting in it (fig. 4.12). Holes for clamps
on the right side show that another piece was joined to it
in ancient times, but there is little way of knowing whether
the adjoining stone was a small piece to make the extant
block rectangular or another large block or blocks.[26] There
seems to be no rule about the position of inscriptions on
statue bases, but a majority of them seem to traverse most
of the base.[27] It is possible, therefore, that the base was
only as wide as one other block and enough stone to fill out th
the right corner to make this block rectangular.

The usual position for an inscription is at the front
of the base, where it could be easily read. One of the
horse hooves fits one of the extant holes on the base at a

right angle to the inscription, so we can assume that the

horse and, therefore, the chariot faced straight ahead

toward the viewer. The position of the Charioteer's arms

indicate that he was standing in the chariot as the driver.

Pausanias wrote about numerous chariot monuments, most

of which were dedicated by a victor at the site of the

contest. He specifically spoke of chariot groups set up

at Olympia for Gelon and Hieron, brothers of Polyzalos. The

most complete description (vi.12.1)[28] is of the monument

which can be dated ca. 466 B.C., vowed to Zeus by Hieron:

> ...a bronze chariot with a man mounted on
>
> it, and race-horses stand beside the chariot,
>
> one on each side, and boys are seated on the
>
> horses...The chariot is a work of Onatas the
>
> Aeginetan; but the horses on each side and the
>
> boys on them are by Kalamis.

References to chariot races can be found in the histories

and dramas as well as the victory odes,[29] but surprisingly

little definite information is known now about them or

monuments connected with them.

Vases[30] and coins[31] provide so many representations of

drivers with chariots that parallels can be found for

innumerable compositions.Most relevant ones agree on a

driver often in an ankle-length (usually white on vases) chiton, standing erect in a chariot. Early fifth-century linear designs show a profile view more often than a frontal one, but both are used; diagonal, foreshortened compositions are rare this early.

Enough pieces of the chariot of this monument are extant to indicate that it was a relatively standard Classical chariot, much like the one represented on coins of Gela contemporary with the monument.[32] Not enough of the chariot exists, however, to determine its exact size.

A four-horse chariot has been assumed for the monument, however, extant fragments indicate at least two horses, but not more. Because of the numerous well-known examples of four-horse chariots, we associate <u>four</u> horses with ancient chariots so often that "quadriga" is sometimes erroneously used as a synonym for "chariot", but there were two-horse ones (συνωπίς) as well, for which there is abundant visual evidence. In fact, the earliest known Panathenaic amphora, the Burgon Vase in the British Museum,[33] ca. 560 B.C., shows a two-horse chariot. Contemporary with the Delphi monument are the famous coins of Sicily, especially those of Gela itself,[34] which represent both two-and four- horse chariots. Fifth-century gems also attest pair-horse chariots.[35]

Furthermore, if the inscription covered most of the width
of the base in the usual manner, there would scarcely be
room for a four-horse chariot. On the other hand, the three
extant holes for the feet of the horses show one horse
standing further forward than the other, which is a position
more likely to occur with four horses than two. A chariot
of four horses is, therefore, likely, but the possibility
of only two remains.

No traces of drapery remain on the smaller arm found
with other pieces of the monument, but the end of a thick,
wide strap bends in the clasp of the hand with the fexibility
of leather; the bottom of the strap is finished but the top
edge is broken. Suggestions have been made that the arm
belonged to a woman, a Nike or a boy. The size, however, is
too small for a woman in the same scale as the Charioteer,
while a Nike that large seems unlikely. The scale is right
for a child and the presence of a boy as a groom or young
chariot-driver is likely. A boy might have been on horseback,
like the boys described by Pausanias in Hieron's monument at
Olympia, or he might have been standing near the front of
the chariot to help with the horses, like the figures on

the lower Tarentine monument at Delphi.[36]

A two-step base has been proposed for this dedication by M. Jacob-Felsch as standard for contemporary chariot monuments.[37]

A reconstruction proposed by Hampe[38] places the groom with a fifth horse on another base and positions both monuments so that the figures are seen in profile. Chamoux has suggested a reconstruction[39] which is a frontal composition of the Charioteer standing in a four-horse chariot with a groom near the right flank of the lead horse. Both restorations make good use of the extant pieces, arranging them within the compositions outlined by literary and visual sources. The same material could also be used to reconstruct a monument different enough to have only two horses, to be only two base blocks wide, or enlarged to add a race horse or even two. The basic concept, however, of the Charioteer standing in a horse-drawn chariot is quite firm.

In summary, the bronze monument consisted of a driver standing in a chariot drawn by two or—more likely—four horses, with at least one child attendant, probably a groom. The group stood on a stone base, probably frontally (fig. 4.13); the base carried an inscription identifying it as the dedication of Polyzalos, ruler of Gela. There is insufficient

evidence for assigning the monument to a particular artist
or even to a geographic center within Greece; it is quite
possible that it was the work of more than one artist, as
Pausanias (vi.12.1) tells us was the case for a comparable
monument dedicated by Polyzalos' brother Hieron. Historical
evidence is strong enough, however, for accepting a date of
ca. 477 B.C. which fits well stylistically.

Technique

The Charioteer figure was cast in seven major pieces:
head, upper torso to the belt, skirt from belt to ankles,
two arms, and two feet.

Solder was used to hold the pieces together,[40] over-
lapping fittings, such as the flange at the top of the skirt,
strengthened some joins. Arms, too, fit into sleeves which
overlap their ends. Joins made where edges of cloth overlap
skin give a greater degree of naturalism and, of course,
provide a logical reason for overlapping fittings. Inside
the Charioteer's left sleeve, where the arm piece probably
would have ended, a constricting ledge of bronze stands at
a right angle to the arm and encircles it (fig. 4.6).

Separate castings were also made for some secondary
items, including the thick curls around the Charioteer's

ears and the free ends of his headband. Other small separate
parts, including his belt and the reins, appear to have
been made by a hammering and cutting process. Necessary joins,
such as the curls to the head, were made metallurgically;
there are no readily apparent indications of mechanical means
of joining, such as rivets. Smooth transition between the
three-dimensional curls, cast separately, and the low relief
sideburns, described primarily by coldwork engraving, displays
a highly developed artistic and technical ability to make
metallurgical joins.

Remnants of clay core and iron armature were reported
inside the Charioteer figure when the statue was found;
unfortunately, the clay and the armature were cleaned out
and thrown away before the importance of that material was
understood.[41] Gray clay which appears to be part of the
original core still fills the arm which belonged to the
smaller figure; the feet of the horses still have some
similar gray material in them, which is most easily seen
in the hoof (inventory no. 3597) where it surrounds rust-
colored remains which seem to be corroded iron armature,
apparently a double rod at this place. Presence of both
core and armature indicate that the sculpture was made by
the direct method of lost wax technique,[42] a unique casting
from the model.

Dowels set into the open spaces on the bottoms of the Charioteer's feet would have affixed him to the chariot floor. One of these square dowels is still in place at the front of the Charioteer's left foot.[43] The bronze statue of the Polyzalos monument was fastened to the base by dowels extended from the sculpture, fitted into holes in the stone and secured with lead. Remains of bronze dowels and lead are visible on the stone.

Thickness of the bronze walls of the Charioteer vary between 0.008 and 0.013 m. in most places, but expand to as much as 0.025 m. at points of greatest stress. The bronze walls of the horses are ca. 0.01 to 0.015 m. at the leg breaks and approximately the same at the broken edge of the tail. Chamoux proposes that the thick walls were necessary because the monument was an open-air dedication.[44] Walls of virtually the same thickness, are seen in the Piraeus Apollo, which is also nearly the same height as the charioteer. Since the body of the Athenian Strategos is lost, it has no comparable measuring points available. The small Livadhostro Poseidon has somewhat thinner walls.

The broken finger of the smaller person shows that the finger and probably the entire hand was cast solid; the same may be true of the Charioteer's hands, as it is of the hands of the Piraeus Apollo.

Color variation was created by insetting different
metals. A purer copper compound probably was used for the
lips, which still appear redder than the surrounding bronze.
Silver was placed in the meander and cross pattern cut into
the headband. The Charioteer's belt may also have been given
a color different from that of his chiton by varying its
alloy or simply by shaping it through hammering rather than
casting.

Naturalistic eyes set into almond-shaped openings in
the bronze skin undoubtedly were the most striking variation
on the statue, both in color and material, as well as effect.
The eyes are made in a way which became standard for
monumental metal Greek sculpture in Classical times: a metal
folder, fringed at the edges to form eyelashes, encloses a
black pupil (of unidentified stone) set in a brown iris (prob-
ably onyx), which is set in a white eyeball (made of glass
paste).[45] A band of lead solder that previously has been
unexplained most likely held marble white teeth in place
behind the slightly open reddish lips, giving the represent-
ation the potential for speech as well as sight.

Other coldwork is seen in the carefully engraved lines
of hair, both on the Charioteer's head and the horse's tail.
The Charioteer's hair, however, is done in a combination of

technique: on the crown, it is represented only by incised
line; below the fillet, it is described by both modelling
and engraving.

In short, the Charioteer and other parts of the same
monument were hollow cast in pieces by the direct lost-wax
method (except, perhaps, for the hands, which may be solid).
Some smaller pieces were cast and others were hammered. Joins
were made by soldering and, in some cases, by overlapping
fittings. Color was varied by insets of different metals;
insertions of stone and paste varied texture as well as
color. Most forms are defined by modelling rather than by
incised line, except for the hair which is a combination
of glyptic and plastic techniques.

Conclusions

Many questions about the Charioteer and the monument
still are unanswered. When was the stone base re-used, when
was the circular cutting made? How badly was the monument
damaged before or by its burial? If it was not destroyed by
the 373 B.C. earthquake, what did happen to it and when?
Why are so many pieces completely missing when those that
remain are so well preserved? If clamps on the base are
indeed Hellenistic, do they represent repair to the original

monument or a later use of the stone?

Do these questions make it necessary to reconsider
the parts, especially the re-used block with the Polyzalos
inscription, which have been accepted as part of one
monument? Could the inscription we have be from the dedication
—four round bases, each supporting a golden nike and tripod,
with one unifying inscription and four separate ones for each
base—made by Polyzalos and his brothers after the Sicilian
victory over Carthage in 480-479?[47] It has been established
that Polyzalos of Gela was active in the first quarter of
the fifth century B.C. and that the inscription lettering
style of the inscription is also of the first part of the
fifth century B.C. The nature and placement dowel holes
still visible on the base have established that it was
used for a monument with horses and, therefore, should not
be identified with the nike and tripod dedication. Although
the inscription could be reconstructed in other ways, it is
especially well suited to a chariot monument. The pieces
of sculpture which we have assigned to the monument, which
are similar in style, scale, subject, and technique, do
seem to belong together. Since one of the extant hooves is
said to fit exactly into a cutting in the base,[48] the sculpture
and base which we have assigned to the Charioteer monument

can continue to be accepted as parts of one and the same
monument. A review of the information, therefore, indicates
that our identification of the monument and its parts is
strong enough for a good understanding of the sculpture
even though there remain unanswered questions.

In its controlled form, the Charioteer expresses belief
in a rational and controllable world, a Pythagorean cosmos
of geometric concept and order. In its reconstructed size,
the monument illustrates high artistic and technical
achievements as well as the wealth necessary to produce it.
It indicates the elaborate kind of monument which was
numerous at important sanctuaries, for this was only one
of many. It reminds us of the extent of the Greek world
and the continued importance of the mainland games, gods,
and sanctuaries to Greek people in far-lying places.

Polyzalos dedicated the monument to Apollo, undoubtedly
vowed to the god for the victory in his games as a religious
act just as Hieron did to Zeus for victory at Olympia in a
vow so serious that the son fulfilled it when the father
had not time to do so before his death. In its sincere and
solemn expression, the monument reflects wholehearted belief
in the gods and mankind. The victory enhances the dignity
and glory of the winner whom the god aided, as the recent

victories of the Athenians over the Persians at Marathon
and Salamis and the Sicilians over the Carthaginians at
Himera enhanced the Greeks, whom the gods favored. Although
the monument represents a personal victory, the dedication
represents recognition of the gods' power.

The identity of Polyzalos as an individual was important:
his name was a conspicuous part of the dedication and the
figure with a victory fillet is probably a representation of
Polyzalos himself. The facial features, however, may not
be a precise copy of the man's own; they are more controlled
by geometric order than would be expected of a realistic
human head. In an attitude toward realistic portraiture which
seems similar to that of Michelangelo toward portraits in
the Medici tomb and in an attitude toward youth which seems
similar to that of our own time, Polyzalos was made to stand
forever youthful, forever a victor.

Notes

[1]Measurements are based on those given by Francois Chamoux, L'Aurige de Delphes, Fouilles de Delphes IV:5 (Paris: Boccard for the École Française d'Athènes, 1955).

[2]The preliminary publication of the Phrasikleia statue is E.I. Mastrokostas, "Ἡ Κόρη Φρασίκλεια Ἀριστίωνος τοῦ Παρίου καὶ Κοῦρος Μαρμάρινος ἀνεκαλύφησαν ἐν Μυρρινοῦτι," AAA V (1972), 298-324. Unfortunately the ribbon does not show in the photographs which have been published; permission for other photographs has not yet been given.

[3]George M.A. Hanfmann, Classical Sculpture, 314.

[4]Difference between Archaic and Classical chitons is discussed by M. Bieber, "Der Chiton der ephesischen Amazonen", JdI 33 (1918), 49-75 and G.M.A. Richter, Sculpture and Sculptors[4], 57.

[5]B. Ashmole, N. Yalouris, and A. Frantz, Olympia (London: Phaidon, 1967).

[6]Ernst Langlotz and Max Hirmer, Die Kunst der Westgriechen in Sizilien und Unteritalien (Munich: Hirmer, 1963), no. 118/119; Bernard Ashmole, Late Archaic and Early Classical Greek Sculpture in Sicily and South Italy, Proceedings of the British Academy, 20 (Oxford: Oxford University Press, 1934), 30-31 and figs. 43-44.

[7]Ibid., 9.

[8]Glaukias of Aegina made Gelon's chariot monument (Pausanias vi.9.4-5); Hieron's was the work of Onatas of Aegina and Kalamis, whose home city is unknown but whose works were throughout Greece, especially Attica (Pausanias vi.12.1).

[9]Fillets as symbols of victory are discussed by G.M.A. Richter in "Another Copy of the Diadoumenos by Polykleitos", AJA 39 (1935), 51-52, and by Walter Woodburn Hyde in Olympic Victor Monuments and Greek Athletic Art (Washington: Carnegie Institution of Washington, 1921), 149-155.

[10]As the only firmly dated freestanding bronze statue of this time, the Charioteer of course has been instrumental in understanding and describing the style of the period. The two basic studies of the period--called "Early Classical", "Severe", or "Transitional"--are Brunilde S. Ridgway, The Severe Style in Greek Sculpture (Princeton: Princeton University Press, 1970) and V.H. Poulsen, "Der strenge Stil, Studien zur Geschichte der griechischen Plastik 480-450 v. Chr.," Acta Archaeologica 8 (1937), 1-148.

[11]Inventory numbers of the pieces of the monument:

Inv. 3484. Lower part of the Charioteer statue. H.: 1.28 m. (Chamoux, L'Aurige, pl. XII).

Inv. 3520. Upper part of the Charioteer statue. H.: 0.52 m. (ibid., pls. XIII-XIV).

Inv. 3540. Right arm, below the sleeve, of the Charioteer statue. (ibid., pls. VII-IX).

Inv. 3517. Base block (ibid., fig. 1 (with measurements), pl.II).

Inv. 3485. Left hind leg of a horse. H.: 0.71 m. (ibid., pl. III)

Inv. 3538. Right hind leg of a hose. H.: 0.695 m. (ibid., pl. III).

Inv. 3597. Foot (left rear?) of a horse. H.: 0.298 m. (ibid. pl. IV).

Inv. 3541. Upper part of a horse tail. L.: 0.415 m. (ibid., pl. V).

Inv. 3542. Chariot pole fragment. L.: 0.42 m.; Th.: ranges from 0.055 to 0.045 m. (Roland Hampe, Der Wagenlenker von Delphi [Munich: Bruckmann, 1941], fig. 5).

Inv. 3543. Chariot yoke fragment. L.: 0.45 m. (ibid.).

Inv. 3598. Chariot yoke fragment. L.: ca. 0.19 m. (ibid.).

Inv. 3618. Part of a protective cushion from the chariot.
L.: 0.18 m. by 0.12 m.; Th.: ca. 0.02 m. (ibid.).

Inv. 3535. Left arm of a person, third finger missing. L.:
0.17 m. (Chamoux, L'Aurige, pl. VI).

 Gray clay, thought to be core material, was found inside
the bronze pieces; it completely fills the smaller arm (inv.
no. 3535). Rust-colored areas in the gray clay inside the
feet indicate corroded armature.

 [12] The larger horse leg is inv. no. 3675. See
Theophile Homolle, "Statue du Bronze decouverte a Delphes",
CRAI 24, ser. 4 (1896), 364, and Chamoux, L'Aurige, 37.
 Various other bronze fragments found nearby, listed by
Chamoux (p. 39), include tripod parts (inv. nos. 3566,
3615, and 3595-6), a double axe (inv. no. 3669), a handle
(inv. no. 3691), and the left foot of a man (inv. no. 3563).

 [13] Information and opinions about the stone with
Sotades' name are compiled by Chamoux, L'Aurige, 34-38.
Hampe expresses his continued belief that the stone is part
of the Charioteer monument in his review of the Chamoux
monograph, Gnomon 32, (1960), 65-66.

 [14] Extensive examination has been made of the
inscription; it is compiled and reviewed by Hampe, Wagenlenker,
27-29, and Chamoux, L'Aurige, 26-31.

 [15] Translation and reconstruction by H.T. Wade-Gery,
"Classical Epigrams and Epitaphs: the Delphic Charioteer",
JHS 53 (1933), 101-104, and H.T. Wade-Gery with C.M. Bowra,
Pindar: Pythian Odes (London: The Nonesuch Press, 1928), 161.

 [16] Ibid.

 [17] In addition to the Charioteer inscription, Polyzalos
is known from another dedication at Delphi, which was made
with his brothers after the Sicilian victory over Carthage
in 480/79 (Scholia, Pindar, Pythia, I.152b; Simonides, trans.
J.M. Edmonds, Lyra Graeca, Cambridge: Loeb Library, 1964 ,
III, p. 384, frag. 170;and Anthologia Palatina VI.214) of four
round bases, each supporting a golden Nike and tripod. Diodoros
of Sicily writes about him (xi.48.3-5,8); other ancient
references are scattered, usually only a phrase as part of

a discussion of his more famous brothers, Gelon and Hieron.
For modern discussions of Polyzalos' historical role see
the works of Wade-Gery and Bowra cited in note 15; T.J.
Dunbabin, The Western Greeks (London: Oxford University
Press, Clarendon, 1948), 404, 414, 427, 430, 432-433; Colin
Kraay, Greek Coins and History (London: Methuen, 1969),
19-42; and Molly Miller, The Sicilian Colony Dates, Studies
in Chronology, I (Albany: State University of New York
Press, 1970), 51-53. Kraay's newer chronology and Miller's
genealogical chronology do not change the view and dates of
Polyzalos' political career as outlined by Dunbabin. Miller
suggests that Polyzalos was born ca. 518 B.C.

[18]Gelon took over his name city about 490 B.C., then
moved on the Syracuse in 485/4, leaving Gela to Hieron.
Gelon died in 478, and Hieron succeeded him as tyrant of
Syracuse; it is likely that Polyzalos followed in fraternal
succession as sub-tyrant of Gela at that time. Diodorus
of Sicily reports that Hieron became jealous of his popular
third brother because he suspected Polyzalos of wanting to
displace him as tyrant of Syracuse. Polyzalos does not
seem to have been strong enough to raise or lead forces
himself; his neighboring tyrant and father-in-law, Theron,
took charge. The conflict was settled by arbitration ca.
476, but Polyzalos never again appeared as a political
figure of note. He had completely faded from the scene by
467/6, when Hieron died and was followed in fraternal
succession by their fourth and final brother, Thrasybulos,
which indicates that Polyzalos was dead--at least politically
dead-- by that date. Polyzalos could, therefore, have been
ruler of Gela no earlier than 478 and no later than 467/6.

[19]Chamoux, L'Aurige, 26.

[20]Dunbabin, Western Greeks, 427.

[21]Chamoux, L'Aurige, 31.

[22]Homolle, CRAI (1896), 380 and R. de Launay,
"Polyzalos vainqueur", Revue Archeologique 21, ser. 4
(1913), 385-6.

[23]Wade-Gery and Bowra, Pindar, 162.

[24]J. Charbonneaux, R. Martin, and F. Villard, Grêce

Classique (Paris, Gallimard, 1969), 106.

[25]Miller, The Sicilian Colony Dates, 52.

[26]The clamps are described by G. Roux in the volume
he co-authored with J. Pouilloux, Enigmes a Delphes (Paris:
Boccard, 1953), 9-12. Roux believes these clamps are a
Hellenistic repair. If so, the widely accepted belief that
the monument was buried by destruction caused by the 373
B.C. earthquake must be reviewed.

[27]Examples of contemporary inscriptions are given
by A. Raubitschek, Dedications from the Athenian Acropolis
(Cambridge: Archaeological Institute of America, 1949),
82-162, especially nos. 84, 85, and 86.

[28]Other references by Pausanias to the chariot
monuments of Polyzalos' brothers are:
viii.42.8-10: A chariot monument (the same one listed in
 vi.12.1) was vowed to Zeus by Hieron for winning a
 team race and two riding races; Hieron died before he
 could make the offering, so it was done by his son.

vi.9.4-5: The chariot of Gelon was made by Glaukias of
 Aegina (Pausanias was confused about Gelon's dates
 and mistakenly thought that this dedication belonged to
 a different Gelon). Three blocks of the inscribed base
 of this monument have been found; for a recent
 discussion of it, see Felix Eckstein,
 Studien zu den Weihgeschenken strengen Stils im
 Heiligtum von Olympia (Berlin: Gebr. Mann Verlag,
 1969), 54-60. In v.23.6, Pausanias uses Gelon's chariot
 as a site reference for another Sicilian dedication

[29]Chariots are referred to by a wide range of ancient
authors including Pindar,Bacchylides, Sophocles, Thucydides,
and Pausanias, but there is not enough specific information
to give us a complete idea of chariots in either races or
monuments. E.N. Gardiner says that a "pair-horse chariot race
($\sigma\upsilon\nu\omega\pi\acute{\iota}\varsigma$) " the oldest of all chariot events, existed

in the sixth century at some time (unspecified) and was
revived at Olympia in 408 B.C. and at Delphi in 398 B.C.
(Greek Athletic Sports and Festivals, London: Macmillan
& Co. 1910, 210). Other references by Gardiner to chariot
races include ibid., 133, 210-211, 451-460, and in Athletics
of the Ancient World (London: Oxford Press, 1930), 225-228.

[30]A survey of chariots represented on vases is given
by T.B.L. Webster, Potter and Patron in Classical Athens
(London: Methuen, 1972), 189-195.

[31]Representations of chariots on coins can be studied
most easily by looking at the fifth and fourth century
money of Sicily, where that motif was especially popular. A
general survey is given by Walther Giesecke, Sicilia
Numismactica: die Grundlagen des griechischen Münzwesens
auf Sicilien (Leipzig: Karl W. Hiersemann, 1923). For coins
specifically from Gela, see C. Kenneth Jenkins, The Coinage
of Gela (Berlin: Walter de Gruyter for the Deutsches
Archäologisches Institut, 1970).

[32]Jenkins, Coinage of Gela, pls. 7-8.

[33]P.E. Corbett, "The Burgon and Blacas Tombs", JHS
80 (1960), 54, pl. II.

[34]For specific examples of coins from Gela which have
representations of two-horse chariots, see Jenkins, The
Coinage of Gela, pl. 7, nos. 108-115; pl. 8, nos. 122-131A;
pl. 9, nos. 132-146; pl. 10, nos. 155-158; pl. 13, nos.
203-214; and pl. 14, nos. 215-221, 224-228.

[35]See, for example, a chalcedony scaraboid in Boston
(Museum of Fine Arts, inv. 23.582), illustrated in Cornelius
C. Vermeule III, "Chariot Groups in Fifth-century Greek
Sculpture," JHS 75 (1955), 112, fig. 16; G.M.A. Richter,
Engraved Gems of the Greeks and the Etruscans (London:
Phaidon, 1968), no. 338; and John Boardman, Greek Gems and
Finger Rings (London: Thames and Hudson, 1970), pl. 561.
Another example is a mottled red jasper scaraboid in New
York (Metropolitan Museum of Art, inv. 42.11.19), illustrated
in Richter, Engraved Gems, no. 334, and Boardman, Greek
Gems, pl. 790.

[36]For reconstructions of this Tarentine monument, see

W.B. Dinsmoor, "Studies of the Delphian Treasuries", BCH 36
(1912), 443, fig. 1, and Heinrich Bulle, "Über Gruppenbildung",
Antike Plastik, Walther Amelung Festschrift (Berlin and
Leipzig: Walter de Gruyter, 1928), 45, fig. 2.

[37] Margrit Jacob-Felsch, Die Entwicklung griechischer
Statuenbasen und die Aufstellung der Statuen (Waldsassen/
Bayern: Stiftland-Verlag, 1969), 130.

[38] Hampe, Wagenlenker, 42.

[39] Chamoux, L'Aurige, 25.

[40] It was not possible for me to examine the interior
of the statue so information about the solder and pieces is
based on Homolle, CRAI (1896) and MonPiot (1897), and
Chamoux, L'Aurige, 61.

[41] Homolle, CRAI (1896), 368-9, and Chamoux, L'Aurige, 61.

[42] As Chamoux has explained (L'Aurige, 63), this
evidence completely refutes Kluge's theory that the Charioteer
was sand-cast from a wooden model.
Nevertheless, Kluge's opinion prevailed widely and is the
basis for the continued mistaken belief that bronze sculpture
represents a glyptic technique (e.g. Rhys Carpenter, Greek
Sculpture (Chicago: University of Chicago Press, 1960),
76-80).

[43] This dowel can be seen in photographs in Chamoux,
L'Aurige pl. II-I and pl. II-2,3. The hexagonal dowel on
the right foot is a modern addition; the photograph of it
in Chamoux, L'Aurige, pl. XX-4 is misleading since the print
is reversed and, therefore, appears to be of the left foot.

[44] Chamoux, L'Aurige, 62-63.

[45] Ibid., 53.

[46] Georges Daux noticed a band of lead behind the
mouth, which has not been explained; it is described by
Chamoux, L'Aurige, 61-62 and fig. 7. We now know that teeth
were inset in other monumental Greek bronze statues with
slightly parted lips.

[47]Ancient references to the dedication made by the four brothers are given in note 28. See also Dunbabin, Western Greeks, 430.

[48]Chamoux, L'Aurige, 20 and 40.

Select Bibliography

Homolle, Theophile. "Statue du Bronze découverte à Delphes",
 CRAI 24, 4th series (1896), 178, 186-188, 362-384,
 and pls. I-III.

_____. "L'Aurige de Delphes". Monuments et Mémoires,
 Fondation Eugène Piot, IV (1897), 169-208, pls. XV-XVI.

Wade-Gery, H.T. and Bowra, C.M. Pindar: Pythian Odes. London:
 The Nonesuch Press, 1928, 64-5, 161-3.

Wade-Gery, H.T. "Classical Epigrams and Epitaphs: the
 Delphic Charioteer". JHS 53 (1953), 101-4.

Hampe, Roland. Der Wagenlenker von Delphi. Munich: Bruckmann,
 1941.

Chamoux, Francois. L'Aurige de Delphes. Fouilles de Delphes,
 IV:5. Paris: Boccard for the Ecole Française d'Athènes,
 1955. Includes previous bibliography.

Hampe, Roland. Review of L'Aurige de Delphes by F. Chamoux.
 Gnomon 32 (1960), 60-73.

Lullies, R. and Hirmer, M. Greek Sculpture. 2nd rev. ed.
 London: Thames and Hudson, 1960, 71-2, pls. 102-4, IV.

Jeffery, L.H. The Local Scripts of Archaic Greece. Oxford:
 Clarendon, 1961, 266-7.

Pouilloux, J. and Roux, G. Enigmes à Delphes. Paris: Boccard,
 1963, 9-12.

Hanfmann, G.M.A. Classical Sculpture, no. 99.

Jacob-Felsch, Margrit. Die Entwicklung griechischer
 Statuenbasen und die Aufstellung der Statuen. Waldsassen/
 Bayern: Stiftland-Verlag, 1969.

Ridgway, Brunilde S. The Severe Style in Greek Sculpture.
 Princeton: Princeton University Press, 1970, 33-34,
 38, 42, 48, 53, 64, 75, 97, and 121.

Athens, National Museum, no. 15161. Found in the sea
off the north coast of Euboea, near Cape Artemision, in
1926 and 1928. Dark green patina. Good condition;
numerous breaks are mended, and both arms are reattached.
Attribute missing from right hand. H.: 2.09 m. Span of
arms: 2.1 m. Figs. 5.1-5.9.

Description

The "law of frontality" observed by most Archaic
freestanding sculpture is dramatically broken by the God
from Artemision with a widespread expansion to both left
and right and movement toward the viewer's right. The
amount of space occupied by the statue is broadened sideways
by his outspread arms to a width greater than his height;
and when the attribute--thunderbolt or trident--was still
in place in his right hand, the breadth would have been
even greater.

With Archaic statues, the principal viewing position
from the front was not in doubt. With the God from
Artemision, several principal viewing posibilities can
be considered.[1] One viewpoint, however, still is the
most satisfactory and probably was meant as the primary
one: that in which the nude torso is nearly frontal, the

arms are seen at greatest expanse, and the head is turned
about three-quarters to the god's left (fig. 5.1). From
this view, we see the left arm stretched horizontally to
the god's left with palm down. The right arm continues
the horizontal line of the left in an axis 180 degrees from
center front. It is bent nearly 45 degrees at the elbow;
the palm is turned up and the fingers are curved to hold
the cylindrical shaft of the attribute now lost (fig. 5.6).
The god's left leg is seen in profile, turned to his left
side. The foot is flattened at the bottom to stand directly
on the base, but now it is bent up at the end. The right
leg is almost frontal, stepped to the god's right; the
heel is raised.

This striding pose of an avenging god was well
established by the sixth century B.C. in painting, relief
sculpture, and statuettes.[2] In monumental sculpture, the
god from Artemision is the earliest original example we
have in which a sculptor dared to construct the pose in
a freestanding figure, although we know from copies of
the figure of Aristogeiton in the Tyrannicide group made
by Kritios[3] that comparable freestanding compositions
were made as early as 477 B.C.

Even in its present damaged condition, the god's

face is powerful and intense. Originally, with eyes of
translucent stones set into the eyeholes cut through the
bronze, it must have been nearly hypnotic. The eyes
gazed out beneath inset brows of a different alloy, probably
silver or copper for most effective color contrast. A
ridge outlining the lips indicates that they, too, were
made of a different alloy, most likely purer copper for
its ruddy hue.[4]

The front half of the god's hair is combed forward
into bangs around his forehead, while the long hair from
the back half of the head is plaited into two braids that
are wound around the head like a fillet and knotted
together above the center division of the bangs. Popularity
of this hairstyle during the first half of the fifth
century B.C. is indicated by numerous other examples in
sculpture, contemporary originals and also Roman copies
of Early Classical originals.[5]

Similarities between the Poseidon dedication from
Livadhostro and the God from Artemision are strikingly
close, but the resemblance emphasizes the important
differences between the Late Archaic god and the Early
Classical god. Both have broad shoulders and mature
muscular bodies described in naturalistic forms, but the

Artemision god stepped out of the canonical frontal pose
of the Archaic kouroi, where the Livadhostro Poseidon
remains even though his arms were reaching out of it.
Both have long hair carefully pulled into a tidy coiffure
that brings the hair close to the head except for shorter
locks which frame the forehead and upper head, but the
tight curlicues around the forehead of the Livadhostro
statue have been replaced by freer, looser strands expressed
in more naturalistic forms on the Artemision statue. Both
beards are full with flowing moustaches and goatees under
the lip, but the Artemision god's is freer and has lost
the geometric patterning of the Livadhostro god's beard.
Pubic hair, too, shows the same change from geometric
pattern to emphasis on organic volume although the forms
are still carefully ordered, well groomed and controlled.
Both statues had eyes of a different material set into
almond-shaped holes cut through the bronze skin, but the
eye holes of the Livadhostro Poseidon are made by two smooth
arcs while those of the Artemision god have considerable
variation in both upper and lower arcs. Both statues have
serene but powerful faces with features typical of
ancient representation of Greeks, but the features of the
God from Artemision are specific while those of the

Livadhostro dedication are generalized. Ideals of strength
and control are evident in both gods, but the Livadhostro
god illustrates an Archaic interest in expressing external
forms in geometric patterns, while the Artemision god
illustrates a Classical emphasis on rational construction
and organic unity.

The moment depicted is one of calm equilibrium, when
the missile--thunderbolt or trident--was aimed but before
it was hurled. Although the design is widely extended it
looks stable because it is composed in one general plane
and has a triangular base, formed by the legs, supporting
the solidly erect, perpendicular form of the torso. The
steady horizontal line of the arms reinforces the balanced
expression of the composition. Stability of expression
is paralleled by stability of construction: the sculptor
successfully supported the statue on three dowels, two
from the god's left foot and one from his right. No marks
of stress or break are evident to indicate that the
sculptor misjudged his design.

Restoration and Technique

Technical construction of the statue had not yet been
studied at the time of the basic publication of the

statue,[6] and no information of either the observations
about the original technique that could have been made
from a view inside the statue or about the technical
aspects of the restoration have yet been made available.

External cleaning obviously was necessary to remove
the marine incrustations (compare figs. 5.1 and 5.8),
as were patches, made to repair holes in the corroded
bronze. Both arms had been broken off and were reattached.
(The left arm was recovered from the sea in 1926, two
years before the rest of the statue was raised from the sea.
It is difficult to tell from the report whether the arm was
found detached or whether it was broken away by the sponge-
fishermen who found it in an attempt to free the statue.)[7]

The statue undoubtedly was cast in several pieces,
but it is difficult to tell where the joins are without
examining the inside. Separate castings can be observed
for the bangs, parted in the center of the forehead; the
locks to the left of the part were made in one casting and
those to the right in a separate mold. No mechnaical means
of join is visible for the hair, so the locks are probably
attached metallurgically as are the sidelocks of the Delphi
Charioteer.

The practice of inserting different materials for the

eyes, eyebrows, nipples, and probably the lips is easily
observed and appears to be the same as that used in the
Delphi Charioteer and the Head of an Athenian General.

Identification

A monumental statue of such fine quality must have
been well known in Early Classical times. Its size and
quality suggest a considerable expense, probably requiring
a public commission. The statue, however, has not yet
been identified successfully with any monument known to
us from ancient literary, epigraphical, or visual records.[8]

The majestic monumental statue is universally recognized
as a god.[9] The well developed muscular body and full beard
indicate a mature and powerful god, so the general
identification as either Zeus or Poseidon can be made with
confidence, especially since they are the two male deities
often depicted in a striding pose with weapon raised in
the right hand. But the controversy remains between those
who believe it represents the god of the heavens and those
who believe it represents the god of the seas, and much of
the literature about the statue is devoted to the debate.[10]
A summary of the important arguments, some of which have
not been answered before, follows.

Examples from other works of art can be used to
support either a Zeus or a Poseidon identification. There
are many representations of Zeus in such a striding pose,
ready to strike. An important sculptural example is the
early sixth-century high relief depiction from the west
pediment of the Temple of Artemis on Corfu, of Zeus slaying
a giant (fig. 5.13). Even more impressive are the numerous
Late Archaic bronze statuettes of Zeus, a fine example of
which was found in Dodona in 1956 (fig. 5.14).[11] Vase
paintings also represent Zeus in this composition; for
example, see the Early Classical red-figure lekythos in the
Cabinet des Medailles (fig. 5.15),[12] which is about
contemporary with the Artemision statue. Coins show
Poseidon, as well as Zeus, as the striding, avenging god
ready to strike. The pose, in virtually the same design,
was used on a stater of Boeotia (ca. 387-374 B.C.) to
portray Poseidon, on a nearly contemporary stater of
Messene in the Peloponnesos to portray Zeus, as well as on
a fifth-century tetradrachm minted at Zankle (also known
as Messene) in Sicily to portray a figure identified by
some modern scholars as Zeus and by others as Poseidon.[13]
A tradition from the sixth through fourth centuries B.C.
in Poseidonia depicts the patron god of that Magna Graecian

city in the striding, potentially striking pose on their
handsome coins, although the Posedonia figure wears a
chlamys draped across his shoulders and over both arms.[14]
Drapery, however, cannot be used for a certain argument
identifying either god since it also appears occasionally
on representations of the striding Zeus(fig. 5.15).

Although figures on coins have often been identified
as copies of sculpture, there is no evidence that these
numismatic depictions of a striding god depend upon the
Artemision statue--or any other statue--as a specific
model. The visual evidence--coins, vases, statuettes,
the Corfu pediment figure, and the Artemision statue--
does attest to the popularity of the pose and type, but
none of the examples (including the statue itself) can
be identified as the "original" or even the major monument
from which the other representations are copied.

No fragment of the attribute itself remains in the
right hand (fig. 5.6). An overall study of Classical bronze
statues indicates that the attribute is likely to have been
cast separately from the hand, then fitted into it.
Examples in monumental Classical sculpture of parts being
fitted together with little or no trace of mechanical or
soldering or gluing aids are common: the reins in the

hands of the Delphi Charioteer and the blouse fitted onto
his skirt; the helmet (now lost) placed on the head of
the Athenian General; and various objects of bronze
added to marble figures of the Siphnian frieze of the
pediment sculptures from Aegina, and of the Parthenon
pediment, frieze, and metope figures. Mylonas proposes
a wooden handle for the thunderbolt, which could have had
bronze flames on both ends;[15] however, it is not necessary
to explain the absence of traces of metal in the hand since
we have so many examples of bronze articles fitted to both
bronze and marble sculpture that have not left traces of
metal at their point of attachment. Extensive use of lead
solder to hold attributes on bronze statues does not
become apparent until the fourth century B.C.[16] A metal
shaft, therefore, need not be ruled out, and the absence
of a trace of the attribute is not surprising.

The cylindrical hole in the grip of the right hand
(fig. 5.6) that held the missing weapon is of interest but
of amazingly little assistance in determining exactly what
was held. There is no doubt that it is of a size suitable
for a trident shaft. Since thunderbolts flare on both
sides of the "handle", it is difficult to know the diameter
of the shaft of a thunderbolt as it was envisaged by

ancient Greeks. The proportions of the bronze statuettes
are different from those of monumental sculpture so
cannot be used for scale. In virtually all representations
of a thunderbolt, however, it is obvious that Zeus's hand
closes around the shaft. A fragmentary representation of a
thunderbolt now in the National Museum in Athens (fig.
5.12),[17] probably life-size or a little larger, has about
the same diameter as that of the tunnel made by the hand
of the god from Artemision. The cylindrical grip, therefore,
is appropriate for either trident or thunderbolt.

A major problem would be encountered if the weapon
were a trident since the shaft must have crossed in front
of the statue's face, detracting from its effect (fig. 5.10).
The awkwardness of the composition with a trident is
illustrated on coins representing Poseidon, most of which
use artistic license to move the shaft behind the god's
head in an impossible three-dimensional construction
(fig. 5.16). An alternate solution was chosen by the modeller
of a coin of Demetrios Poliorketes minted at Salamis in
Cyprus ca. 300 B.C.; the god was shown from the rear (fig.
5.17). A thunderbolt, therefore, would fit the composition
better than would a trident since it would not hide the
god's face if the statue is indeed meant to be seen with

the torso nearly so frontal (fig. 5.11). The problem,
however, points out the close connection between the
questions of the attribute and the principal viewing point.
Reconstruction of the statue with a trident could re-open
the question of the principal viewing point. The possibility
of a nearly head-on view (fig. 5.9) would be increased if
the statue held a long shaft, a possibility strengthened
since the comparable Aristogeiton of the Tyrannicide
group probably is meant to be seen head-on.[18] Or, perhaps
the sculptor had begun to think of a truly three-dimensional
composition, in which one viewpoint--even if the primary
one--was not allowed to dictate the design. Another
possibility is that a shaft in front of the face did not
bother the artist, as it did not bother the painter of
the Foundry Vase who painted a spear across the head of
a monumental statue of a striding warrior (fig. 5.18).
In short, although the composition of the statue seems
better suited to a thunderbolt, a trident cannot be ruled
out.

No evidence of additions of any kind can be seen on
the outstretched left arm (fig. 5.5b). This absence of an
attribute has been used as a weak argument against an
identification as Zeus since some representations of Zeus

include an eagle on his left hand; however, not all of them
do.[19] The lack of attribute could also be used as a weak
argument against a Poseidon identification since there is
no indication of a fish, a frequent attribute of the god
of the sea. Again, however, the attribute is not constant.

Argument has been made that the outstretched arm is
more apporopriate for Poseidon than for Zeus.[20] Numismatic
representations show the right arms of both gods bent in
order to fit the round field, so they should not be used
as evidence for identification in other media. Some
representations on vases of Zeus with his thunderbolt
show his arm bent but others show it nearly straight—
even straighter than the nearly 45 degree angle at which
the arm of the Artemision statue is bent[21]—so the
argument is not a valid one.

A Roman Archaistic head, modelled in relief on a terra
cotta tile from a villa at Porcigliano, has been entered
in the identity question since it resembles the head of the
god from Artemision and since it can be recognized as
Poseidon (or Neptune) by a trident behind it.[22] Namely the

representation on the tile, however, does not provide the
name of the statue from Artemision since the head on the
tile is not a direct copy--and probably not even an indirect
copy-- of the statue.[23] The only evidence that the head on
the tile might be based on the statue is that the heads of
both are shown with the same style of coiffure and beard,
but these hair arrangements can be seen on many Early
Classical representations, so the hair is not sufficient
evidence to connect the tile to the Artemision statue. The
trident cannot be considered a copy of one that the
Artemision statue might have held since it is pointed to
the god's rear and is placed behind his body; if the
Artemision statue held a trident, it would have been pointed
in the direction the statue faced and would have been in
front of his body when he was seen in profile to the right.
In addition, figures in the group of Porcigliano tiles are a
pastiche of various forms and types,[24] so there is no reason
to expect the Poseidon/Neptune tile to be a copy of any
specific model. The tile, therefore, is unreliable evidence
in the case of the Artemision statue and must be dismissed
from the controversy.

 To summarize: from the evidence we now have, we can
identify the statue as a representation of a powerful,
mature god--undoubtedly Zeus or Poseidon. Visual representations
from all media show that Zeus in a position of a striding,

avenging god was well established and widespread in
Archaic and Early Classical times, but only coins of
Poseidonia and Boeotia show representations of Poseidon in
the pose of the Artemision statue. The size of the cavity
for the missing attribute could hold either trident or
thunderbolt and the position of the arm is appropriate for
either weapon, but a thunderbolt seems to fit the
composition better. The lack of other attributes or drapery
is not significant since they are often missing in other
representations of these gods. Evidence, therefore, favors
identifying the statue as a representation of Zeus but
does not rule out the possibility it represents his brother,
Poseidon, instead.

Attribution

Firmly within the mainstream of Early Classical Greek
sculpture, the God from Artemision must have been made by
a leading sculptor of mainland Greece. Credit for the
statue has been given to almost every major sculptor of the
first half of the fifth century B.C., especially Onatas,
Kalamis, and Myron. There is not yet enough evidence,
however, about the style of any particular Early Classical
sculptor to accept any of these attributions as more than

interesting speculations.

Marble Roman copies of the "Omphalos" Youth group[25]
have been widely recognized as similar to the God from
Artemision, so the Greek original upon which these Roman
copies are based has frequently been attributed to the
sculptor who made the God from Artemision. We have, however,
even less solid evidence for identifying the sculptor of
the original "Omphalos" Youth statue than we have for
knowing the name of the sculptor who created the God from
Artemision. In addition, the relationship between the
original of the "Omphalos" group and the God from Artemision
is not clear; the fact that their hair styles are the same
has been the most frequently cited reason for connecting
them, but we have seen that their coiffure was not unusual
in the early fifth century B.C. and certainly not thought
of as the creation of one particular artist. Our knowledge
of the relationship between Greek originals and Roman copies
needs further study before we can make stylistic attributions
on the basis of copies.

The high quality of the statue does suggest that it is
the work of an artist whose name we know--probably Onatas,
Kalamis, or Myron.

Where the statue originally stood is still a mystery.

Since it was found in a shipwreck without its base, it
certainly was being transported from one site (probably its
original site) to another (probably as plunder to a conquering
city or country). The ship could have been sailing north
(perhaps for Pontus or Constantinople) or south (perhaps
for Rome). Finding the wreck near Cape Artemision does not
establish the original site of any of the cargo from that
area.

Further investigation of the shipwreck might provide
clues about the original location of the statue and about
the ship's route if more were learned about the cargo and
the date of the wreck, which has been described as early
as the fourth century before Christ and as late as the
fourth century after Christ.[26]

Closely related to the question of original site is
the question of original purpose. We usually assume that
monumental statues of gods were cult statues, votive
offerings, or commemorative dedications. It is possible
that the statue found near Cape Artemision was designed
as a cult statue,[27] but Ridgway correctly points out that
an Early Classical cult figure probably would be frontal.[28]
She sees it as an open-air monument and believes it stood
on a promontory similar to Cape Artemision--if not that

spot itself.[29] The dramatic outline made by the striding
composition does seem designed for display out-of-doors,
and the avenging stance implies a special concern with the
god's physical power. The statue is, therefore, especially
appropriate for a votive or commemorative dedication, which
suggests that it came from a place associated with an import-
ant battle[30] or a site sacred to the god's active role in
victory.[31]

Although the style of the statue indicates the work-
manship of a major sculptor from mainland Greece itself, the
original site of the statue would not be pin-pointed by
attribution to a particular artist since major artists of the
Early Classical period travelled throughout the Greek world
for important commissions. And even if we could establish
the original site of the statue, we would not be able to
project a regional style for that area since, for example,
the statue might have been made by a sculptor whose home was
on Aegina even though it was commissioned and actually made
in Thrace or Euboea.

Conclusions

We cannot be certain whether the statue represents
Zeus or Poseidon; we do not know the name of the Early
Classical sculptor who made it; and we can only speculate

about the original purpose and site of the statue.
Nevertheless, the God from Artemision provides us with an
expression of Early Classical Greek thought and religion
that is invaluable. As a god in the realistic form of man,
unquestionably on the side of the Greeks whom he protects
and avenges, the statue illustrates a sincere and
optimistic faith in both men and gods, as well as in the
god's concern for the Greeks as a chosen people. In the
powerful body in militant pose, it illustrates concern for
physical power. In the calm and serene expression, it
illustrates admiration for thoughtful use of power and
self-control.

Notes

[1] For further discussion of the viewing point or points for this statue, see p. 131.

[2] Zeus and Athena are often represented in militant, striding pose, and occasionally Poseidon is. Apollo has been identified in a representation of a comparable pose, carrying a branch, on coinage of Kaulonia, but the stance is not typical of him. Representations of Zeus and Poseidon are discussed below, pp. 126-134. Examples of this type of Athena are included in figures of Athena collected by A. de Ridder, Catalogue des Bronzes trouvés sur l'Acropole d' Athènes (Paris: Thorin for l'Academie des Inscriptions et Belles-Lettres Foundation Piot, 1896); see, for example, p. 312, no. 6447. Representations of Apollo on coins of Kaulonia, are published by L. Lacroix, "L'Apollon de Caulonia," Revue Belge de Numismatique 105 (1959), 5-24; for a good illustration, see Kraay and Hirmer, Greek Coins, pl. 90, no. 259. The format is close to that used for warriors--both divine and human--in Archaic and Early Classical art, which differs in that the typical warrior's left arm is bent to hold a shield; see, for example, gods and men represented as warriors on the east and north friezes of the Siphnian Treasury at Delphi and the "Lunging Warrior" from the west pediment of the "Temple of Aphaia" on Aegina (illustrated in Lullies and Hirmer, Greek Sculpture², figs. 48, 50-51, 53-55, and 76).

[3] For a thorough discussion of the Early Classical Tyrannicide statues, see The Tyrant-Slayers of Kritios and Nesiotes by Sture Brunnsåker (Lund: Håkan Ohlssons Boktryckeri, 1955). Copies of Aristogeiton are also illustrated in Richter, Sculpture and Sculptors, figs. 609-611. For further discussion see W. Fuchs, "Kritios e Nesiotes," Enciclopedia dell'Arte Antica Classica e Orientale IV, 410-415. The pose of the figure of Aristogeiton, whose extended left arm is closer to that of the striding, avenging saviour god than to that of the typical warrior who carried a shield; Kritios probably chose the position for the obvious connotation.

[4] Stanley Casson identified the brows as silver, which could be appropriate for a mature god who might have white hair. Casson, however, tends to follow Kluge's belief that metal insets for lips and eyebrows on Greek statues in general were silver rather than copper, an

opinion which seems weak because whenever color--other than green oxidation--is apparent on lips and brows, it has a reddish cast. Casson noticed "no signs of any kind that the lips of the Zeus of Artemision were so covered;" however, the ridge characteristic of inset lips can be seen upon close examination and is evident in figures 5.3 and 5.8. Casson's opinions are published in The Technique of Greek Sculpture (Oxford: Clarendon Press, 1933; reprint edition, New York: Hacker Art Books, 1970), 162.

[5]A good selection of other examples of this hair style on other statues can be found in Ridgway, Severe Style; see the Corinth head, the Capitoline youth, the Cyrene youth, the Cyprus youth, and the Cleveland youth (Ridgway figs. 75, 78-91). The Blond Boy and the Volo head (Ridgway figs. 74, 76-77) vary only in that the braids are tied under the bangs. Roman copies of the style include the "Omphalos" youth (and variations of it, such as the Choiseul-Gouiffier youth) and the Conservatori "charioteer" (Ridgway figs. 96-7, 172-3).

[6]Christos Karouzos, "Ὁ Ποσειδῶν τοῦ Ἀρτεμισίου," Δελτιον 13 (1930-31), 42.

[7]Ibid., 41.

[8]C.A. Robinson proposed that the statue may be the Zeus Ithomatas made by Ageladas for the Messenians and described by Pausanias (iv.33.2-3); see "The Zeus Ithomatas of Ageladas," AJA 49 (1945), 121-7. There is not enough evidence to prove or completely disprove this theory, but it is unlikely since the size of the statue seems much too large to be stored in a priest's house, as Pausanias says the Zeus Ithomatas was; Robinson's proposal has not been accepted.

[9]Julius Juthner's proposal that the figure represents a victorious athlete and that the attribute was a javelin ("Die Grossbronze von Artemision," AM 62 (1937), 136-148) has been successfully refuted by George E. Mylonas in "The Bronze Statue from Artemision," AJA 48 (1944), 143-149.

[10]The most important and complete discussion of the Poseidon identification is by Karouzos in Δελτιον 13 (1930-1931), 41-104. Identification as Zeus was proposed by George P. Oikonomos, in "Ἀρχαιολογία," Πρακτικα της Ακαδημιας Αθηνων, 1928, 750-3. The Zeus identification was expanded and strengthened by Mylonas, AJA 48, 143-160.

[11]Athens, National Museum no. 16546. A good
selection of bronze statuettes of Zeus from the sixth
and first half of the fifth century is illustrated by
G.W. Elderkin, "Bronze Statuettes of Zeus Keraunios,"
AJA 44 (1940), 225-33.

[12]The red-figure lekythos in Paris, Cabinet des
Medailles, no. 489, is listed in Beazley, ARV[2], 490 and
1655, as Hermonax 114.

[13]See Kraay and Hirmer, Greek Coins, for
illustrations: the Boeotian stater is shown in pl. 146, no.
460; the Messenean stater in pl. 159, no. 511; and the
tetradrachm of Zankle in pl. 17, no. 53. A discussion of
the identifications made of the controversial figure on
the coins of Zankle is published by C.A. Robinson, Jr.,
"The Zeus of Ithomatas of Ageladas", AJA 49 (1945), 121-7.

[14]Kraay and Hirmer, Greek Coins, nos. 217-222, pls.
77-78 and VIII.

[15]Mylonas, AJA 48, 155. Such a construction is
quite possible and would have the advantage of lightening
the attribute, as G.P. Oikonomos observed in "Le Nouveau
'Zeus' du Musée d'Athenes," MonPiot 30 (1929), 23.

[16]The changing practice in the use of lead solder
is discussed on p. 331.

[17]The unpublished thunderbolt fragment in the
National Museum in Athens is inv. no. Kar.267. It will
be published by Dr. Evi Touloupa in a study of small bronze
objects.

[18]See note 3 above for references to the Tyrannicides.

[19]In the Peloponnesos, the practice of adding the
eagle is common, but the bird is usually absent in
representations from northern Greece. See Mylonas, AJA
48, 152-3.

[20]R. Lullies, Greek Sculpture,[2] 75.

[21]For examples of Zeus with his right arm even
straighter than that of the Artemision statue, see the

red-figure lekythos by Hermonax in the Cabinet des
Médailles, no. 489, and the black-figure column krater in
the Athenian Acropolis collection, no. 631a, which is
listed in Beazley, ABV, 108, Lydos 6, and is illustrated
by B. Graef and E. Langlotz, Die antiken Vasen von der
Akropolis zu Athen (Berlin: Walter de Gruyter, 1952-53),
pl. 39.

[22]The Poseidon/Neptune tile, together with others
from the villa at Porcigliano, was once in the Munich
Glyptothek but apparently was destroyed during World War II.
It is illustrated in Ridgway, Severe Style, pl. 144. For
discussion of the Porcigliano tiles, with earlier
bibliography, see ibid., 111-3, 127.

[23]For a contrary opinion, see ibid., 113.

[24]The free borrowing of motives seen in the
Porcigliano tiles was pointed out by Mylonas, AJA 48, 159.

[25]For a discussion of the "Omphalos" Youth copies
and bibliographical references, see Ridgway, Severe Style,
61-62, 74.

[26]Karousos dates the wreck as Hellenistic; see
Δελτιον , 1930, 94, note 1. Robinson says the sherds could
be of any date between fourth century B.C. to the fourth
century of our era; see AJA 49, 125. George Bass says the
wreck is about the time of Christ; see Archaeology Under
Water (London: Thames and Hudson, 1966), 78, and "Eighteen
Mediterranean wrecks investigated between 1900 and 1968,"
in Underwater Archaeology: a nascent discipline (Paris:
UNESCO, 1972), 37-39.

[27]W. Schwabacher believes that the cult statue of
Zeus at Olympia was in a striding position before the
Zeus made by Pheidias. Since the Artemision statue is one
of the bases for his theory, the argument would be circular
in indicating that the Artemision statue is a cult one.
Schwabacher's theories are proposed in "The Olympian
Zeus before Pheidias," Archaeology 14 (1961), 104-9,
"Olympischer Blitzschwinger," Antike Kunst 5 (1962), 9-17,
and "Nochmals der olympische Blitzschwinger," RömMitt.
72 (1965), 209-12.

[28]Severe Style, 62.

[29] Ibid., 62-63.

[30] R. Lullies describes the statue as a votive offering from a sanctuary; he believes it represents a thank offering to Poseidon for the destruction of the Persian fleet off Cape Artemision. His theory may be appealing at first glance, but it is influenced by his mistaken belief that an outstretched arm was not appropriate for Zeus and by the weight that he gives to the shaky connection of the findspot to the original site, so his theory can be considered only as an interesting speculation.

[31] Homer A. Thompson points out that the statue found off Cape Artemision might have come from the sanctuary of Zeus Eleutherios in the Athenian Agora, where an image of Zeus was erected after the danger of Persian conquest past. For archaeological evidence of bases in that area sacred to Zeus Eleutherios, see pp. 56-59 of Thompson's study of the Stoa of Zeus Eleutherios in "Buildings on the West Side of the Agora," Hesperia 6 (1937), pp. 1-226. A reconstruction drawing in Thompson's article (fig. 34 on p. 54, executed by John Travlos) places The God from Artemision on a round base, where Thompson suggests the statue might have stood. Since the Early Classical God from Artemision is earlier than the High Classical construction time of the Stoa of Zeus Eleutherios, the statue would antedate the building. On first consideration, that possibility may seem unlikely, but Thompson brought my attention to a nearby parallel for a statue antedating the building with which it became associated: the statue Kalamis made of Apollo, which Pausanias saw in front of the Temple of Apollo Patroos, probably antedated the 4th century temple of Apollo Patroos. I am grateful to Thompson for discussing with me the evidence that makes his suggestion a viable possibility.

Select Bibliography

Karouzos, Christos. " Ο Ποσειδων Τοῦ Αρτεμισιου, " Δελτιον
 13 (1930-31), 41-104.

Mylonas, George E. "The Bronze Statue from Artemision".
 AJA 48 (1944), 143-160.

Beyen, H. G. "Le Poseidon d'Artemision et l'Ecole de Sculp-
 ture de Sicyone" in H. G. Beyen and W. Vollgraff,
 Argos et Sicyone. The Hague: Martinus Nijhoff,
 1947, 41-95. Includes previous bibliography, p. 41.

Curtius, L. Interpretation von sechs griechischen Bild-
 werken. Bern: Francke, 1947, 69-82.

Lullies, R. and Hirmer, M. Greek Sculpture. Revised and
 enlarged edition. Translated by Michael Bullock.
 New York: Abrams, 1960, 75 and pls. 130-2 and VI.

Hanfmann, G. M. A. Classical Sculpture, no. 109.

Ridgway, Brunilde S. The Severe Style in Greek Sculpture.
 Princeton: Princeton University Press, 1970, 23, 40,
 62-4, 74-5, 82, 85-6, 88, 111-3.

Castelvetrano, City Hall; presently in Rome at the Istituto
Centrale del Restauro. From Selinus. Various old repairs not
yet fully analyzed. Damaged by thieves between 1962 and
1968; repairs in progress. Attributes missing from both
hands. H.: 0.842 m. Figs. 6.1-4.

The statue was stolen from Castelvetrano, where it had

been displayed, in 1962. In 1968 it was recovered and taken

to the Istituto Centrale del Restauro in Rome for repair.

Restoration has not been completed, so the statue is not

now on public display.[1]

Restoration is a major problem because extensive amounts

of cement and a metal framework were found inside the

statue. Both the cement and the framework can be easily

seen where the arm is broken off, as well as in x-rays that

show the framework extending all the way across the upper

chest. Neither the cement nor the framework are mentioned

in the original restoration report[2], although the conservators

at the Istituto Centrale believe they were added during the

early restoration. The cement and the metal framework should

be removed to enable proper restoration of the statue, but

doing so without damaging the bronze will be a challenge.

Description

The pose of the Youth from Selinus is remarkably close

to that of the Piraeus Apollo: a nude young man standing
nearly frontally in the general attitude of a traditional
kouros, but with the right leg advanced; his right arm is
extended and apparently held an object (probably a phiale)
now lost; the cylindrical grip of his left hand suggests
that it once held a bow.

Much greater freedom of movement in space, however,
is evident on the smaller figure from Sicily. The limbs of
the Selinus Youth are more relaxed than those of the
Piraeus Apollo, which appear static and motionless in
comparison. A turn to the right, almost imperceptible in
the Piraeus Apollo, is strongly articulated in the Selinus
Youth.

Tectonic solidity of an Archaic kouros is replaced by
the potential for movement, as most of the weight of the
body is shifted from both legs to one. In the manner of
the "Kritios Boy", the right leg is bent at the knee and
the left hip is thrust outward. Distinct muscles are
represented by swelling forms in a way that also invites
comparison with the "Kritios Boy". Greek statues similar to
the "Kritios Boy" clearly serve as models for this artist in
Sicily, but the proportions of his statue create an awkward
and disjointed expression, and he does not fully understand

the tectonic disposition illustrated in the Attic master-
piece.

Like those of other Early Classical Greek statues, the
eyes of the Youth from Selinus were made separately——of
glass, in this case—— and are set into the head. Like the
God from Artemision and the Youth from the Athenian Acropolis
(fig. 6.5)[3] the eyebrows of the Selinus Youth are indicated
by strips of a different alloy sunk into slots in the bronze
to articulate the hair in both form and color.

The long hair is neatly twisted into a roll that
encircles the head at the edge of the hairline. This hairdo
is seen on other male figures of the early fifth century,
as Ridgway point out,[4] and the Youth from the Athenian
Acropolis (fig. 6.4).

It is the head of the Youth from the Athenian Acropolis
that is the closest parallel for the head of the Youth from
Selinus, but a comparison of the two heads vividly illustrates
the provincial expression of the statue from Magna Graecia.
Both the Athenian head and the Sicilian statue can be dated
approximately 470 B.C., near the time the God from Artemision
was created.

Relationship to Other Greek Monumental Bronze Statues

Although the Youth from Selinus is smaller (0.842 m.)

than the guideline accepted for the "large statues" considered
in this study (one meter), it is of special value because
of its relatively complete state of preservation. There are
other Greek bronze heads from statues that would have been
about the same size,[5] somewhat less that a meter in height,
but the bodies of these other statues have not survived.

While the statue found at Selinus does not contribute
directly to our knowledge of the mainstream of Greek
monumental sculpture in bronze, it is an interesting
counterpoint to major developments and reflects an awareness
of and a concern for monumental bronze sculpture, even in
far-lying areas of the Greek world where bronze-working
on a monumental scale was not a strong tradition.

When the present work at the Istituto Centrale del
Restauro is completed, the Youth from Selinus undoubtedly
will reveal new information about bronze-working techniques on
Sicily in the fifth century B.C., which may be an interesting
comparison with mainland workmanship--as in the style--and
certainly will be valuable in the light it sheds on bronze
workmanship in the Greek colonies on Sicily.

Notes

[1]I am grateful for the warm reception I received at the Istituto Centrale del Restauro, where I was able to examine the Youth from Selinus.

[2]Dr. Alessandra Vaccaro Melucco was extremely helpful in explaining restoration problems encountered at the Istituto Centrale del Restauro, and I am thankful to her for this information.

[3]Athens, National Museum inv. no. 6590. See Boardman, Dörig, Fuchs, and Hirmer, The Art and Architecture of Ancient Greece, 281 and pl. 182, and Ridgway, Severe Style, 41 and pl. 178.

[4]Ibid., 60 and 136.

[5]E.g., the head of a Youth from the Athenian Acroplis, National Museum 6590 (see note 3 above), the head of Zeus (?) from Olympia, National Museum 6440 (see p.71 , note 2.4),the head of a Nike from the Athenian Agora, Agora B30, which may or may not be from a statue (see D.B. Thompson, "The Golden Nikai Reconsidered," Hesperia 13 (1944), 173-209), and the head usually identified as representing Arkesilaos IV of Cyrene, Museum of Cyrene C 17141 (see G.M.A. Richter, Portraits of the Greeks, II, 104-105, and figs. 453-5, and G.M.A. Hanfmann, Greek Sculpture, no. 151).

Selected Bibliography

Arndt, P. and Amelung, W. Einzelaufnahmen antiker Bildwerke,
 569-572.

Pace, Biagio. Arte e Civiltà della Sicilia Antica, II.
 Milan: Editrice Dante Alighieri, 1938, 56-58.
 (2nd edition, 1958).

Marconi, Pirro. L'Efebo di Selinunte. Opera di Arte, I.
 Rome: Istituto poligrafico dello stato, 1929.

Langlotz, Ernst. Review of Marconi's L'Efebo di Selinunte.
 Gnomon 6 (1930), 429.

Bernabò Brea, Luigi. Musei e monumenti in Sicilia. Novara:
 Istituto geografico de Agostini, 1958, 124-125.

Langlotz, Ernst and Hirmer, Max. Ancient Greek Sculpture
 of South Italy and Sicily. New York: Abrams, 1963?,
 p. 273 and pl. 81. (Also available in German as
 Die Kunst der Westgriechen and in Great Britain as
 The Art of Magna Graecia.)

Richter, G.M.A. Kouroi[3], no. 192a, p. 157, and figs. 651-656.

Ridgway, B.S. Severe Style. 24, 28, 40-41, (no. 10), 60,
 74, 136, and fig. 93.

London, The British Museum, reg. No. 1958.4-18 I. Broken
off at the neck. The complete statue of which this head was
a part was discovered in central Cyprus in 1836; only the
head survived destruction in the 19th century. Curls lost at
the left side, and an irregular-shaped hole at the back of
the head. Mottled dark green bronze. Preserved height of the
head and neck: 0.316 m. Th. of the bronze varies from 0.013
to 0.003 m.; average thickness of the complete statue
probably was ca. 0.01.[1] Figs. 7.1-3.

Description

The strong simple oval of the over life-size head is
enlivened by thick tresses of hair knotted above the center
of the forehead and by a cascade of separate curls falling
around the neck. Although the pose was generally straight
forward, the twist of the thick neck indicates that the head
was turned slightly to the right.

The thick tresses that are pulled to the top of the
forehead begin just in front of the ears, enframing the
forehead as though they were a diadem. The plastic curls
fall around the back of the head, beginning at the same
point at which the thick tresses start forward. Shorter in
front than in the back, the three-dimensional locks fall
forward over and hide the ears. The left ear is now fully
exposed since the locks that covered it have been lost.

The large almond-shaped eyes have fallen out. Sheet
metal lining survives in the right eye, suggesting that the
technique for insetting the eyes was similar to that of other
Greek monumental statues, in that the eye--probably made of
glass and stone--was fitted into a metal envelope with fringed
edges that served as lashes. The serrated edge still shows,
although the metal lashes are considerably corroded. Unlike
those of the fourth century goddesses from the Piraeus,
however, the eye sockets of the Chatsworth head taper
inward, so the eyes probably were fitted in from the front,
as were the eyes of the Boxer from Olympia.

The eyebrows are indicated by delicate lines incised
in the bronze to represent individual hairs. Strands of hair
on the crown of the head are rendered by grooves combed into
the mass.

Color variation could have been achieved by representing
the full lips in reddish copper, to contrast with the golden
bronze skin. A faint line is incised around the outline of
the lips, in about 0.002 m. from the edge, suggesting that the
lips were plated with a sheet of different metal. Modelling
lips in a purer copper alloy to indicate color change is a
common characteristic of other Classical Greek monumental
bronze statues.

The serious mood and regular features of the face create an austere expression, which is intensified by the simplicity of the modelling of the flesh. The smooth, taut surface is similar to that of the Poseidon of Livadhostro, but shows a lesser degree of subtle movement than is evident in the Artemision God or the pedimental sculpture from the Temple of Zeus at Olympia.[2]

Discovery

According to the stories told by the peasants who discovered the statue in central Cyprus,[3] the male figure was complete when they found it in 1836 while digging for water in the dry bed of the river Pidias (the ancient Pediaios), near the ancient site of Tamassos. In order to pull the statue from the river bed, the peasants hitched it to a team of oxen. Under the stresses of the drag across the rocky terrain, the statue broke into pieces. The arms, the legs, and the head separated from the body. Afraid of what action the Turkish authorities might take against them and unaware of the actual value of the statue, the peasants sold the various pieces--except the head--for scrap metal. They reported that the metal weighed 80 okes (ca. 125 pounds), which seems surprisingly light. The head came into the

possession of a man named Bondiziano, who lived in Larnaca,
who sold it to H.P. Borrell, a merchant in Smyrna who was
interested in antiquities, especially numismatics. In 1838
the head was purchased from him by the sixth Duke of Devon-
shire; it takes its present name from the Duke's ancestral
home, where it was ensconced before it was acquired by the
British Museum.

The peasants who discovered the statue said that it
stood with the left leg slightly forward and the arms
hanging down at its sides. That description places the statue
in the traditional kouros pose. The peasants also reported
that the figure was nude except for a large belt at the
waist, which they identified with their ammunition belts.
Although a nude body is standard for canonical kouroi, a
belt is not typical of standard Attic kouroi. A wide belt
is worn, however, by a number of surviving Archaic kouroi. A
fragment of a marble statue found on Delos[4] is represented
wearing one, as are at least four statuettes from widely-
scattered sites.[5] The wide-belt "costume" was in fashion as
early as the Bronze Age, as is attested by the frescoes from
Knossos and the small bronze "Horned God" statue found on
Cyprus,[6] but the body of the Chatsworth Head is an extra-
ordinarily late figure on which to find such a depiction.

Identification

In the fall of 1889, Max Ohnefalsch-Richter began
excavating in the place where the villagers told him the
statue was found. He reports working 100 days with 16 men
before being halted by the rains; he identified the area as
a temenos sacred to Apollo, although he did not establish
the geographic boundary of the precinct or complete the
unearthing of the many treasures he believed are still there.
If the temenos definitely were related to Apollo, the
identification of the Chatsworth Head as a representation of
that god would be re-enforced although still not proven,
but a decision must await renewed exploration at Tamassos.
The pose of the body, as it was described by the villagers
who saw it, could well be that of a figure of Apollo (see
p. 46 for a discussion of representations of Apollo in
the kouros pose.) The identification of the statue as Apollo
cannot be clinched,but it may be accepted as most probable.

Technique

The destruction of the body of the statue sharply
limits the amount of knowledge that might have been gained
if the complete statue were available. Nevertheless, the
Chatsworth Head has yielded more information about ancient

bronze-working technique than any other single statue of its
size. The knowledge and interest of Mr. Denys Haynes,
supported by the excellent staff of the British Museum
Research Laboratory, has resulted in a brilliant, reliable
discussion of the way in which the Chatsworth Head was made.[7]

The peasants who found the statue told Ross[8] that it
was cast in separate pieces,which were soldered together.
Haynes' examination of the head supports their story by
establishing that the head was cast separately and joined to
the torso by hard solder.[9] Masses of surplus soldering
material show that the head was broken in a jagged edge near
the original join, above it in some places and below it in
others and--in a short (ca. 0.015 m.) distance at the back--
just at the ancient casting edge.

Analysis of the bronze shows an alloy containing 10
percent tin, 89 percent copper, 0.09 percent silver, and only
traces of lead, iron, antimony, nickel, gold, and arsenic.[10]
The composition of the alloy is almost identical with that
of the Piraeus Apollo (see above, p. 39).

Examination of the inside of the head shows the
configuration of strips used to line the mould from which the
casting was made. These "lasagna" strips prove that the
mould could be opened. As Haynes points out, however, the

examination does not shed light

> on the crucial question of the medium
> in which the figure was modelled.
> All that can be said for certain of
> the model is that the separately-
> cast clusters of curls must have
> been modelled in wax to be cast by
> the direct lost wax process, for
> they are too intricate to have
> been cast by any process calling
> for an openable mould.[11]

The use of both openable moulds and the direct lost wax

technique indicates the combined use of processes which may

seem to be separate ones to people in our age of specialization

and mass assembly-line production, but the various methods

of working reflect the pragmatic approach to construction

seen in ancient Greek sculpture and architecture.

After the casting was made, the separately-cast pieces

of hair would have been soldered to the head, the eyes would

have been inserted, and the fine lines of hairs in the eye-

brows would appear to have been engraved into the bronze.

Little other coldwork is evident in the head. The grooves

that indicate hair on the crown as well as on the separately-

cast pieces of hair are executed with a freedom of line that

suggests that they were combed into the soft model rather

than the cast metal, and the dendritic structure of the

bronze[12] supports this observation. Finishing touches would

be required, of course, to smooth the transitions between the separately-cast pieces and to close holes, such as that at the top of the head, which were left from the casting process.

Discussion of the Chatsworth Apollo that relied upon Kluge's oft-repeated theories of Greek bronze-working techniques led to misunderstanding of the sculpture.[13] Kluge's speculation that carved wooden figures served as models for monumental bronze statues is not supported by evidence in any monumental sculpture itself, and the thorough examination that has been made of the Chatsworth Head indicates that the wooden-model theory cannot be accepted as a description of the Greek working process.[14]

Relationship to Other Greek Sculpture

The characteristics of the Chatsworth Apollo definitely fall within the general outline of Early Classical Greek monumental sculpture in bronze, although the execution seems somewhat less sophisticated and the composition rather more archaizing than major monuments made in the artistic center of Greece during the first half of the fifth century B.C. Archaic Greek styles continued in Cyprus throughout the fifth century B.C.,[15] so conservative characteristics are in keeping with probable specifications of a local commission.

There is no reason to believe that the statue was made else-
where than Cyprus.

Both style and technique of the Chatsworth Head indicate
that the artist who made it was a Greek familiar with the
mainstream of Greek art, so he surely travelled between
mainland Greece and Cyprus, which would have been easy and
likely during the second quarter of the fifth century B.C.
Between 478 and 448 B.C. there was a large amount of traffic
between Athens and Cyprus, much of it directed toward
chasing away the Persians and bringing the island under
direct Athenian hegemony. In 478 B.C., Greeks occupied one-
third of Cyprus, but were quickly ousted by the Persians.
Another major Attic Expedition landed on Cyprus in 460 or
459 B.C., and Greek forces remained on the island until 448
B.C., at which time the Persians gained control again and
kept it until 411 B.C. Throughout Persian-Attic disputes over
the island, Greek inhabitants continued to live on Cyprus.[16]
Excavations at Vouni[17] give evidence that the palace there
was rebuilt about the middle of the fifth century B.C. by
Greek forces or people strongly allied with the Greeks, and
at least four pieces of Classical Greek sculpture besides
the Chatsworth Apollo have been excavated on Cyprus.[18]

The form and technique of the Chatsworth Apollo suggest

that the statue was made in the first half of the fifth
century B.C.

The frontal pose with slight turn to the right is in
keeping with the tradition seen in the Piraeus Apollo and
the Delphi Charioteer. Evidence of casting the statue in
parts relates it to the Delphi Charioteer, the earliest
monumental statue which clearly displays the Greek practice
of casting large statues in separate pieces. The hair of the
Chatsworth Apollo, however, shows a greater unity than that
of the Delphi Charioteer, especially in the design of the
hair lying flat on the crown.

The Artemision God provides a close parallel for the
conception of hair as continuous undulating lines radiating
from the center of the crown combined with loose locks at
the temples. The austere simplicity of the face of the
Artemision god is related to the Chatsworth Head, although
the subtlety in modelling of the Artemision God is missing
in the head from Cyprus.

Close similarities can be seen between the Chatsworth
head and the head of the "Kassel Apollo", especially the
version in the National Museum in Athens (fig. 7.5). The
original of the "Kassel Apollo", known only through Roman
copies, is usually attributed to Pheidias and generally

accepted as a work of ca. 460 to 450 B.C.[19] Although the design of the two heads is remarkably similar, simplification of modelling is greater in the head from Cyprus than is recorded in the Roman copies of the Attic work.

Unity of design, the style of hair, and the degree of twist seen in the neck can scarcely be dated much earlier than the second quarter of the fifth century B.C. Archaic compositional elements and the simplification and stylization of forms make it difficult to think of the Chatsworth Apollo as later than the mid-fifth century B.C., unless it is Archaistic, which is unlikely.[20] An approximate date of 460 to 450 B.C. can be assigned to the head, indicating its stylistic affinities with the Artemision God and the marble head that may reflect early work by Pheidias (fig. 6.5), while keeping in mind that work in Cyprus may be somewhat later in date than comparable styles in the artistic center of the Greek world and that the sculptor of this conservative form was not an innovator.

Political events support such a date, as Gjerstad has previously observed,[21] since the strongest fifth-century ties between mainland Greece and Cyprus existed from 460 to 450 B.C., when Athenian forces actually occupied Cyprus.

Notes

[1]Denys Haynes. "The Technique of the Chatsworth Head." Revue Archeologique 1968/1:104.

[2]For extensive illustrations of high quality, see Alison Frantz's photographs in B. Ashmole and N. Yalouris, Olympia (London: Phaidon, 1967).

[3]Ludwig Ross, Reisen auf der griechischen Inseln, IV (1852), 161-3.

[4]The large marble fragment is in the Delos Museum, inv. No. A-333. See Richter, Kouroi[3], no. 17 and figs. 94-95.

[5]See Richter, Kouroi[3], figs. 6-8 for illustrations of a bronze figurine from Olympia (now in the Olympia Museum), figs. 9-11 for illustrations of the bronze figurine dedicated to Apollo by Mantiklos (now in the Boston Museum of Fine Arts), figs. 14-16 for illustrations of a bronze Daedalic figurine from Delphi (now in the National Museum in Athens), and figs. 17-19 for a wooden figurine found at Samos.

[6]The bronze statue, sometimes known as "The Horned God" because of horns on his helmet, is in Nicosia, Cyprus Museum, inv. No. 19. See Hans-Günter Buchholz and Vassos Karageorghis, Altägäis und Altkypros (Tübingen: E. Wasmuth, 1971), p. 163 and fig. 1740, with previous bibliography.

[7]Denys Haynes' report, "The Technique of the Chatsworth Head", supersedes the discussions by A.B. Wace, "The Chatsworth Head", JHS 58 (1938), 90-95, and by Herbert Maryon, "Fine Metal Work", in A History of Technology (ed. by C. Singer), II (1956), 476-478.

[8]Ross, Reisen, 161-163.

[9]Haynes, "Chatsworth Head", 104.

[10]Ibid.

[11]Ibid., 108.

[12]Ibid., 112.

[13]Karl Kluge's theories about ancient Greek bronze-casting technique appear in "Die Gestaltung des Erzes in der archaisch-griechischen Kunst", JdI 44 (1929), 1-30; they are summarized with clarity by Haynes in "Chatsworth Head", 106.

[14]Haynes, "Chatsworth Head", 106.

[15]For a perceptive and careful discussion of sculpture on Cyprus during the Classical period, see Einar Gjerstad, The Swedish Cyprus Expedition, IV-2, especially pages 210, 338, and 488-489.

[16]Ibid., 484.

[17]The Swedish Cyprus Expedition, III.

[18]Gjerstad, Swedish Cyprus Expedition, IV-2, 338.

[19]Athens, National Museum 47. For a discussion of the various copies of the "Kassel Apollo", see Eva Maria Schmidt, Der Kasseler Apoll und seine Repliken, Antike Plastik V (1966), in which the Athens head is discussed on pages 20-22 and illustrated in plates 20-22.

[20]W. Schuchhardt considers the Chatsworth Head to be an example of Hadrianic classicism, "Zum Akrolithkopf von Cirò", AJA 66 (1962), 317-8. There are, however, no stylistic parallels that support his suggestion; furthermore, Haynes' analysis of the technique (described in "The Technique of the Chatsworth Head") is convincing evidence that the statue is Early Classical. Brunilde S. Ridgway asks (but does not deal with) the question, "Could the 'closed' eye-sockets point to a late date?" See her Severe Style, 40. Rather than pointing to a "late date", I believe the tapered eye-sockets are simply an alternative solution to a design for inserting eyes from inside the head. The tapered eye-sockets seem more closely related to those used for solid bronze statuettes and might suggest an early solution, although they are also evident on the Boxer from Olympia, which probably was made in the third century B.C. There simply is not yet sufficient evidence available to make a generalization about the tapered eye-socket design; but it is certain that Greek techniques, like designs, were not always uniform.

[21]Gjerstad, Swedish Cyprus Expedition, IV-2, 338.

Selected Bibliography

Ross, Ludwig. Reisen auf der griechischen Inseln, IV (1852),
 161-163.

Wace, A.J.B. "The Chatsworth Head". JHS 58 (1938), 90-95.

Gjerstad, E. "The Story of the Chatsworth Head". Eranos 43
 (1945), 236-242.

Masson, O. "Kypriaka, Recherches sur les Antiquités de
 Tamassos". BCH 88 (1964), 212-213.

Hanfmann, George M.A. Classical Sculpture. Greenwich,
 Connecticut: New York Graphic Society, 1967.

Haynes, Denys. "The Technique of the Chatsworth Head". Revue
 Archeologique 1968/1"101-112.

Ridgway, Brunilde S. Severe Style: 40, 144.

Haynes, Denys. Fifty Masterpieces of the British Museum.
 London: The British Museum, 1970.

Steinberg, Arthur. "Joining Methods on Large Bronze Statues:
 Some Experiments in Ancient Technology". Application
 of Science in Examination of Works of Art. Proceedings
 of the seminar conducted by The Research Laboratory
 of the Museum of Fine Arts, Boston, Massachusetts,
 June 15-19, 1970. William J. Young, editor. Boston:
 Museum of Fine Arts, 1973, 104.

Two statues, both at Reggio di Calabria, in the Museo
Nazionale. Found in the Ionian Sea in the region of Riace
Marina, at the southeastern coast of Italy, on August 14,
1972. Life-size. Heavily encrusted with marine sediment;
being cleaned at the Museo Nazionale di Reggio Calabria.
Objects held by all four hands and the shields from both
left arms are missing. H. of both: 2.06 m. Photograph
available of only one statue: fig. 8.1.

Two remarkably similar statues of standing, nude men
were discovered by a dentist, scuba-diving for sport in the
Ionian Sea near Porto Forticchio. A few broken amphoras were
nearby in the sandy floor of the sea, but there was no other
easily-visible evidence of a shipwreck in the shallow water.
No ancient site in the immediate area is known. No bases were
found with the statues,[1] so the bronze figures were in transit.

So alike are the statues in size, pose, and style that
they would seem to be designed for the same monument, perhaps
of the type described by Pausanias (x.10.1) at Delphi of gods
and heroes dedicated from the tithes of Marathon and sculpted
by Pheidias.

When the statues are restored, they will be published by
Giuseppe Foti, Sopraintendente of the Reggio Calabria area
and Direttore of the Reggio Calabria museum. Prof. Dott. Foti
kindly allowed me to see the statues in March, 1973, in the

Reggio Calabria museum,[2] where they are being cleaned and
restored. The following descriptions are based upon my
observations at that time; more complete and detailed study
undoubtedly will be possible when the statues are cleaned.

To distinguish between the two statues, I arbitrarily
designated one as "A" and the other as "B". I chose to use
letters rather than numerals in this case to imply the strong
similarity of the statues since numbers connote difference
in time.

"General B "

When I saw the statues, "General B " (fig. 8.1) had been
washed but not yet cleaned, and there was little place where
the bronze surface was not covered by marine incrustation.
His pose, however, is clear. The helmeted man stands frontally
with his left foot forward and his weight on his right leg, in
a strong contrapposto position.

His right arm is relaxed and hangs down at his side,
bent forward. Each hand clasped a cylindrical object now
lost, although some of the solder that held the objects in
place remains.

His left arm is bent at the elbow and held forward
almost horizontally from the elbow; a shield strap is still

attached to the arm but the shield itself is lost. The
shape of the shield strap is the typical Classical Greek
one: a wide band with large flat tubes at either end to attach
it to the shield.[3] The edges of the strap, mirror images of
each other, have two symmetrical concave curves that meet in
an ogee point at the center. The same form appears in numerous
visual representations; particularly clear ones include a
painting by Polygnotos of the Lapith Kaineus fighting the
Centaurs[4] (fig. 8.2) and pedimental sculpture from the Temple
of Aphaia on Aegina[5] (fig. 8.3).

When the layers of incrustation are removed from the
high helmet, which is worn pushed back on the head of "General
B", the headpiece probably can be identified.

The high-domed form of the head clearly is that of a
helmet, and the figure is identified as wearing such a head-
piece. I could, however, not see the actual helmet under the
marine incrustations. Perhaps, when the statue is cleaned, a
domed head shaped to support a helmet-- like that of the Athe-
nian Strategos-- will be revealed rather than a helmet itself.

The eyes certainly were inset with a different material.
The right eye survives, apparently with the pupil, but it
cannot be easily identified until it is cleaned. The left eye
is completely gone. The bronze around the opening for the
left eye is about three-tenths to one-half a centimeter thick.

A seam running along the inside of "General B's"
right calf is identified by the restoreres as an ancient mend.

Tangs or dowels would have been used to hold the statue
to its base. Holes in the bottom of the right foot are
similar to, but somewhat smaller than, those in the bottom
of the left foot of the Marathon Youth (fig. 14.9). The
forward hole in the foot of "General B" is about ten centimeters
long and eight centimeters wide, and the one at the heel is
approximately eight centimeters long and two centimeters wide.

In strength and nobility of form, as well as in style
and composition, "General B" is strongly reminiscent of the
bust of Pericles by Kresilas, known to us through various
Roman copies (fig. 3.4). Definite opinion about the origin
of "General B" should await completion of the cleaning.
Nevertheless, even through the encrustations, affinities with
Classical Greek sculpture of the mid-fifth century B.C.,
especially with the work of Pheidias, are so strong that
"General B" may be tentatively attributed to the circle of
Pheidias.

"General A"

Like his comrade, "General A" stands straight in a simple
pose with his left leg forward, but he turns to his right
at about a 45 degree angle. His nude body is that of a well-

developed muscular man in his prime.

His right arm, like that of "General B ", is relaxed
and hangs at his side; he also held a cylindrical object in
both hands. The strap for his shield, still attached to his
arm, is the same form as that of "General B's" strap.

He wears a fillet that is smooth in front but is roughened
at the sides and back; a small depression just below the
band appears to be designed so that something (perhaps a
helmet?) could be fitted over it. His hair is described in
the same general manner as that of the God from Artemision
and the Chatsworth Apollo: above the fillet, wavy lines
radiate from the top of the crown; below the fillet,
individual curls fall free from the head in front of and over
his ears.

Careful attention has been given to the articulation of
veins, especially in the feet and arms. Distinct ridges
define the edge of muscles in the calves and upper arms. The
genitals, especially the large uncircumcised penis, are
rendered with greater precision than are those of the God
from Artemision. The smaller right testicle clearly shows
the figure's contrapposto stance as it is tilted up, following
the right, higher weight-carrying hip.

Both feet are open at the sole, including the bottom

of the big toe.

Inset work was apparent even in preliminary stages of
cleaning. The whites of the inset eyes survive, but I could
not see the irises and pupils. Sheet metal lashes frame the
eyes. The outline form of the nipples, which still display a
redder hue than the body, is visible. Incision around the
lower lip indicates it was keyed for an inset; the top lip
is hidden under a moustache.

Despite differences of sex, the face of "General A" is
so strongly reminiscent of the copies of the Athena Lemnia
that the two figures might be brother and sister, perhaps
creations of the same sculptor and certainly made about the
same time.

Notes

[1] These "Generals", found offshore from Riace Marina
and near Porto Forticchio in 1972, should not be confused
with the fragments of two bronze statues found in the Straights
of Messina near the village of Porticello in 1968, which
also are listed as being in the Reggio Calabria Museum. At
the present time, the Porticello fragments are in Rome at
the Istituto Centrale del Restauro, where I saw them.

The Porticello fragments include the head of an old
bearded man and various pieces of male bodies: a left foot
broken at the mid-instep into two parts, a hand, (too small
to belong with the bearded head), a left and a right buttock
of a man in his physical prime, and male genitals that may
belong with the buttocks. The head of a younger man in Late
Archaic or Early Classical style is rumored to have been
looted from the wreck and taken to Switzerland.

For information about the Porticello wreck and its
cargo, see David Owen, "Picking Up the Pieces", Expedition
13:1 (1970), 24-29; Owen, "Excavating a Classical Shipwreck",
Archaeology 24:2 (1971), 118-122 and color photograph on
the cover; Giuseppe Foti, Il Museo Nazionale di Reggio
Calabria (Naples, di Mauro Editore, 1972), no. 56; Owen,
"Ausgrabung eines Schiffwracks aus dem 5. Jahrhundert v.
Chr. in der Strasse von Messina", Antike Welt 4:1 (1973),
3-10; Cynthia Jones Eiseman, "Amphoras from Porticello
Shipwreck (Calabria)", International Journal of Nautical
Archaeology and Underwater Excavation 2 (1973), 13-23.

Cynthia Eiseman, who also spoke about the sculpture at
the AIA meetings in Philadelphia in 1973, is working on the
shipwreck material for her dissertation at the University of
Pennsylvania. She dates the wreck to the early fifth
century B.C. on the basis of the pottery found in it.

Although this sculpture is directly related to my
project and of great interest to me, I do not yet feel
confident about accepting it as Classical Greek sculpture.
There are examples of life-size naturalistic portraiture by
about the mid-fourth century B.C. (the Cyrene "Berber") and
there may be a mid-fifth century example of individualistic
portraiture in the small head also from Cyrene that is
tentatively identified as representing Arkesilas IV; however,
I know of no parallels for comparable portraiture in Greek
art as early as Mrs. Eiseman dates the Porticello wreck. Of
course, the lack of such a parallel does not exclude the
possibility that this Bearded Old Man might be our first
such example, but it does require an especially thorough

examination of the head. Secondly, the technique in which
hair is represented is completely different from that of the
other statues in this project. The hair on the top of the
head seems to be made separately, like a thin wig, and
applied to the skull, instead of being cast with it. Thirdly,
the metal is so much grayer than that of any firmly accepted
Classical Greek statue that I have seen that I wonder
whether there might be a considerable amount of lead in
the alloy; this question should be settled as soon as
chemical analysis of the metal is made.

[2] Josef Schmitz Van Vorst, "Standbilder aus dem
Ionischen Meer", Frankfurter Allgemeine Zeitung, October 31,
1972, 28.

[3] I am grateful to David Mitten, who wrote to Prof.
Dott. Foti requesting permission for me to see the statues,
and to Dr. Claudio Sabbione of the Reggio Calabria museum,
who met with me on behalf of Dr. Foti.

[4] See A.M. Snodgrass, Arms and Armour of the Greeks
(Ithaca, N.Y.: Cornell University Press, 1967), 53-55, 68,
71-73.

[5] Arias, P.E.; Hirmer, Max; and Shefton, B.C., A
History of 1000Years of Greek Vase Painting. New York:
Abrams, 1962, no. 190. Also, Beazley, ARV2, 1027, no. 1.

[6] Ohly, Dieter. Glyptothek München: Griechische und
römische Skulpturen (Munich: C.H. Beck, 1972).

Bibliography

Van Vorst, Joseph Schmitz. "Standbilder aus dem Ionischen
 Meer". Frankfurter Allgemeine Zeitung, October 31,
 1972: 28. Two photographs of "General A".

Foti, Giuseppe. Il Museo Nazionale di Reggio Calabria.
 Naples: di Mauro Editore, 1972, no. 57.

London, British Museum, 268. Excavated in 1861 under a
mosaic floor in the ruins of the Apollo Temple at Cyrene,
a Greek colony on the North African coast, in what now is
eastern Libya. The rest of the body is missing. H.: 0.305 m.
Th. of bronze: 0.005 m. Figs. 10.1-2.

Strong forms of the distinctive life-size head are
described in naturalistic terms. The sturdy thick neck
indicates that the head was erect, turned slightly toward
the right.

Facial hair--eyebrows, moustache, and short beard--
is indicated primarily by short, precise lines incised into the
metal. The head is capped by a thick mass of curls, which are
clearly defined three-dimensional separate locks. Individual
hairs are suggested by linear incision on the plastic curls,
giving added texture to the hair.

A groove around the lips outlines an inset of copper.
Behind the parted lips, a mass now gray is the residue of
silver teeth.[1]

The inlaid eyes were made of glass, some of which
survives. Lashes made of sheet metal frame the eyes.

The artist carefully observed and understood actual
physiognomy. Beneath the skin, the bony structure of the
skull is clearly articulated. Fatty pads above both eyelids

and small bags below the eyes are modelled with sensitivity.
Creases at the outer corners of the eyes curve upward in a
naturalistic recording seldom seen in earlier Greek art.

With facial features unlike those typical of ancient
Greeks, the head may represent a man of North African descent,
many of whom lived in Cyrene. The head, therefore, is
generally known as the "Berber" or the "North African". Both
his high cheek bones and the tradition of realistic sculpture
relate him to the small bronze head generally identified as
"Arkesilas IV",[2] probably of the mid-fifth century B.C., also
found at Cyrene. His short beard follows the chin line but
does not cover a large part of his face, his high cheek
bones, and his prominent brows are similar, too, to those of
"Mausolus" from the Mausoleum.

Even though the facial features are not typically
Greek, the technique in which the head is made is in full
accord with other Greek monumental bronze statues except for
the use of silver (instead of stone or ivory) to represent
the teeth. Stylistically, the "Berber" also relates well to
other mid-fourth century Greek sculpture. The head does,
however, represent a gigantic stylistic jump from the "Generals"
of Riace Marina, reflecting almost a century--from the mid-
fifth to the mid-fourth century B.C.--that is still a gap

in our corpus of original Greek monumental sculpture in bronze.

The jagged edge of the neck tells that the head was broken away from a body. Since the head seems to have been disposed of under a mosaic floor,[3] it may have been broken off in later--probably Roman--times so that the head of a later person could be attached to what surely must have been a magnificent, strong body.

Although earlier Greek monumental bronze statues represented mortals, the Cyrene "Berber" is the earliest extant realistic, life-size head in bronze. There is no iconographical clue to the "Berber's" name nor the reason he was honored with such an important statue. The artist has, however, clearly given us a portrait of an individual man, whose personality is expressed in his distinctively-identifiable head.[4] The "Berber's" strong features, composed in controlled stability, express solemn nobility and strength of character in a distinct person.

Notes

[1] Denys Haynes, *Fifty Masterpieces of Classical Art* (London: The British Museum, 1970), no. 37. Mr. Haynes' description of the lips as copper and the teeth as silver is supported by recent analysis in The Research Laboratory of The British Museum. H.B. Walter's suggestion that the lips are silver, which has been accepted by others (e.g., Lullies, Greek Sculpture[2], No. 210), is mistaken.

[2] G.M.A. Richter, *Portraits*, II, 104-105 and figs. 453-5, and G.M.A. Hanfmann, *Greek Sculpture*, No. 151.

[3] The excavators clearly established that the mosaic floor is Roman, although they did not date it precisely. See R. Murdock Smith and Edwin A. Porcher, *History of the Recent Discovery at Cyrene* (London: Day & son, 1864), 41-43.

[4] For a perceptive discussion of personality expressed in portraiture, with previous bibliography, see G.M.A. Hanfmann, "Personality and Portraiture in Ancient Art", *Proceedings of the American Philosophical Society*, 117/4 (August 1973), 259-270.

Selected Bibliography

Smith, R. M. and Porcher, E.A. History of the Recent
 Discovery at Cyrene. London: Day & son, 1864:
 42-43.

Rayet, Olivier. "Tête en Bronze Trouvee a Cyrene".
 Monuments de l'art antique. Paris: A. Quantin,
 1884: II, unpaged.

Walters, H[enry] B[eauchamp]. Catalogue of the Bronzes.
 London: The British Museum, 1899: 34-35, no. 268.

Lullies and Hirmer. Greek Sculpture2, no. and pl. 210.

Lippold, G. Handbuch, 262.

Laurenzi, Luciano. Ritratti Greci (3-5). Florence:
 Sansoni, 1941: 98, no. 29, pl. 10.

Haynes, Denys. Fifty Masterpieces of Classical Art in
 the British Museum. London: British Museum,
 1970, no. 37.

Athens, National Museum, Br. 13396. Recovered in 1901 from
an ancient shipwreck off the coast of Antikythera. Pieced
together from many fragments; numerous small restorations.
H.: 1.94 m. Figs. 11.1-15.

 The figure of a young man, slightly over life size,
stands in subtle rotation to his right. The body follows
the general composition of the Polykleitan canon, as we
know it from copies; but a more complicated rhythm is
established in this form by turning the head in the opposite
direction of the weight-bearing leg, giving greater movement
to the design. Unlike the self-contained stance common to
the Polykleitan pose, the Young Man from Antikythera leans
forward, directing attention outward to the front of the
statue.

 His weight-bearing left leg is straight; his right leg
is bent at the knee and stepped to the back with the heel
raised off the ground. His left arm hangs at the side. A
glob of solder survives above the last joint of the little
finger of his left hand, which once held something the size
of a sword or spear. His right arm reaches out from the
shoulder, up from the elbow; the fingers of that hand are
spread as if to grasp a round object about the size of an
orange. Since the fingertips are straight, they may be

reaching rather than grasping.

The nude body is so maturely developed that the title often given to the statue, "The Antikythera Youth", seems misleading with its connotation of adolescence. Individual parts of the muscular body flow together smoothly. The rotating rhythm of the S-curve is continued toward the head, which is turned to the right at an angle of about 45 degrees from that of the main axis of the body.

Thick, short hair caps his round skull with a profusion of curly locks sculpted in strongly three-dimensional forms. Attention is drawn to the face, particularly the eyes, by emphasizing the hair that frames the forehead. This hair is depicted in thicker locks that stand away from the scalp, although the hair in the center of the hairline above the forehead is cut almost to the skull.

The deep-set eyes stare in the direction of the figure's right hand. The inlaid eyes are outlined by lashes made of sheet metal; the light brown corneas are still set into the whites, but the pupils are missing. More than two thousand years after the eyes were made, even though they are now damaged, their intensity is still magnetic.

The full, slightly parted lips are relaxed, with no indication that the figure is communicating with words. A

groove outlining the lips and their redder hue are evidence
of an inlay made of purer copper, adding warmth and variety
of color to the face.

The Young Man from Antikythera's classical Greek profile
is strikingly close to that of Artemis I from the Piraeus
find. (Compare figs. 11.2 with 12.3).

Although his face has the firm and unlined smoothness
of youth, the statue reflects a definite personality and
intense psychological state of mind. His concentration is
focused on the object he sees. The intensity of his gaze
is emphasized by the slackened tension in the other muscles
of his face--such as the relaxed, parted lips--as though
they were forgotten in his concentration. The tilt of his
head to the right and his sensitive, rather apprehensive
expression indicate a gentle personality. His strong, mature
body shows a potential force, but physical strength is not
the important aspect of the figure; the statue certainly
is not a glorification of brute power. The upright stance of
the figure implies courage and resolute facing of his task,
although the bent right arm tells of a gentle approach rather
than a forceful imposition of will. The same expression is
found in the face as in the rest of the body, emphasizing
the unity of the complete person.

Discovery and Site

Greek sponge divers from Syme made the first major underwater discovery of ancient Greek sculpture in 1900 between Crete and Kythera, near Antikythera, a small rocky island of little importance now or in antiquity.

Venturing to a depth of about 30 meters, Elias Stadiatis was frightened by ghostly forms of human beings and horses. His incoherent story of naked women and other figures, whose flesh was rotted by syphilis, sitting on the ocean floor, might have been dismissed as a case of nitrogen narcosis had he not returned with an arm. It proved to be an over life-size arm from a bronze statue. The captain, also a diver, explored the site and identified the ghostly figures as statues in a shipwreck.

With the aid of A. Oikonomu, professor of archaeology at the University of Athens and also a native of Syme, the divers brought their find to the attention of the Greek Minister of Education. Under the auspices of the Greek Government and with the aid of the Greek Navy, six of the sponge divers were commissioned to retrieve the treasures under the direction of Professor Oikonomu. The recovery process began in November, 1900, and continued through September, 1901.

This oft-repeated version of the discovery, which
stresses the high-minded patriotic sentiments of the sponge
divers, is based upon the official account published by
Svoronos.[1] Peter Throckmorton[2] tells another version--based
on his examination of the site, his knowledge of sponge
divers' habits and routes, and upon the stories of the divers
from Syme and their families--suggesting that other treasures
from the Antikythera wreck may have gone into the art market
in the early years of the twentieth century.

Criticism of the way in which material from the ship-
wreck was recovered is understandable since a controlled
excavation made today would give us much more information
about the ship and its cargo, but this pioneering underwater
"excavation" is remarkable for the success with which it
recovered material spread around the floor of the sea. The work
was done at dangerous depths; one diver was killed and two
others were permanently crippled with the bends as the
result of the project.

In 1953 the site was revisited by the renowned under-
water explorer, Frédéric Dumas, who reports that he saw
many small remnants of the wreckage and one extraordinarily
large rock, apparently the result of dynamiting by the
scavengers at the first of the century. According to local

lore, the stone covers other bronze statues, including
figures of horses, women, and children.[3]

Recent examinations of the various finds from the site
firmly establish the date of the wreck as the first century
B.C., probably close to 80-70 B.C.[4] These archaeological
studies deny connection of the ship with Athens, but do
show a tie with Ephesos and certainly establish strong ties
with Kos and Rhodes.[5] It is logical to assume, therefore,
that the ship was wrecked on a voyage to Rome from islands
in the eastern Sporades and perhaps from the coast of Asia
Minor.[6]

Sculpture seems to have been the primary cargo of the
vessel. The numerous marble statues of the find appear to be
first-century copies of earlier masterpieces of the sort
that might well have come from workshops active in the first
century on Delos and Rhodes.[7]

Generalization about the bronze sculpture is more
difficult to make since it appears to range from the fourth
to the first centuries B.C. in date and is not uniform in
style, size, or other easily distinguishable criteria. In
the absence of evidence that the ship came from mainland
Greece and with the strong indication that the rest of the
cargo originated in Asia Minor or the nearby islands, a

logical assumption would be that the bronze sculpture, also
represents art that existed in the Greek East. Apparently,
therefore, the bronze sculpture is a relatively random
gathering of Greek art that appealed to a first-century
Roman collector or merchant.

Restoration and Technique

Sculpture from the Antikythera wreck suffered severe
damage. Pieces of at least five different large statues in
bronze were found in the wreckage,[8] but only the Young Man
of this study could be restored as a complete figure.

The original restoration was made immediately after
the pieces were recovered. A thick layer of black resin
(colophony) painted over the surface of the statue during
the early 20th-century restoration was removed in 1947-48,
and a completely new restoration was made in the 1950's under
the supervision of Dr. Christos Karusos, who was then
Director of the National Museum.[9] Fortunately, the early
20th-century restoration was easy to remove (unlike that of
the Ephesos Youth now in Vienna, restored about the same
time), so the statue could be taken apart to the pieces in
which it was discovered.

Material inside the statue, identified by Karusos as

the original core, was removed. A modern armature was built
as a framework on which to reassemble the bronze pieces.
The most extensive change made from the early 20th-century
restoration by the mid-20th-century restoration were in the
surface appearance, the focus of the eyes, the configuration
of the abdomen, and the position of the right arm. After
the coating of dark resin was removed, the surface was
further cleaned by the removal of incrustations; the bronze
now appears shinier and smoother. Damage to the eyes made
them appear focused in an unnatural way; they now are
straightened. Some of the pieces restored to the abdomen in
the early 20th-century restoration were found to fit in the
shoulder; as a result, the configuration of the front torso
is reworked. The lower abdomen, between the pubic hair and
navel, is largely restoration. A careful rejoining of the
pieces of the right arm brings that extended limb to a
lower, more horizontal position.

Since many of the bronze fragments of the statue were
bent and others lost when the statue was buried at sea, the
parts no longer join exactly so the process of reassembling
them was complicated. The sophisticated rhythm and balance
of the statue was difficult to recapture.

From their examination of the statue during the
restoration process, Dr. Karusos and the restoration staff

of the museum could affirm that the head, the arms, and
the legs were cast separately, then welded to the torso.
They also confirmed that the eyes and lips were made
separately and set into the head after it was cast, although
they must have been in place before the head was joined to
the torso. Clear, informative drawings of the inset system
of the lips and the support for the teeth behind them, as
well as for the teeth themselves, are included in the
restoration report (figs. 11.9-11),[10] but not discussed in
the text.

Analysis of the bronze, made soon after its discovery,
reports that the alloy is 84.74 percent copper and 14.29
percent tin.[11]

The Young Man from Antikythera provides the easiest
accessible view of the system used by Classical Greek
sculptors for attaching monumental statues to their bases.
Protruding from the right foot of the statue is a dowel that
could be placed in a hole cut into a marble base and held
in place by lead solder (fig. 11.8). The foot may now be
bent from its original design, causing the dowel to be
more visible now that it was originally.

The bronze-working technique displayed in the Young
Man from Antikythera is clearly that of a master craftsman.

Identification

Although most of the statue survives, the attributes
that would identify the figure are lost. A spear or sword
could be reconstructed in the left hand, but neither one
would give little further clue to the figure's identity.

The pose with raised right arm is a traditional one
for Perseus, as Svoronos observed soon after the statue was
discovered.[12] Similarity of the pose of this statue and the
figure of Perseus on a South Italian bell krater now in
Bonn[13] is an argument for identifying the statue as Perseus.
Cellini's large Perseus in the Loggia dei Lanzi is an obvious
parallel.[14] A drawing illustrating such a reconstruction,
however, shows that the hand is poorly suited for holding the
head of Medusa.[15] In addition, the arm is held nearly
horizontally (unlike that of Cellini's Perseus), so is not
built for holding an object as heavy as a head in bronze
would be. Further, a reconstruction of the Young Man from
Antikythera as Perseus places a sword in his left hand and
the Medusa head in his right, indicating that he was left-
handed. Perseus is shown as holding his sword in his right
hand in most ancient representations.[16] It is possible
that this statue might be a left-handed Perseus, but it
is unlikely.

The unusual spherical grip of the right hand is suitable
for holding or throwing a ball, but the absence of a victor's
wreath or fillet and the lack of knowledge of important ball
contests in the Greek Games does not support identification
of a larger-than-lifesize bronze statue as a ballplayer.
Furthermore, the pose of the arm is languid for a ballplayer.

More probable are the suggestions that the statue is
reaching for a Golden Apple. He might then be either Paris
or Heracles. An identification as Paris would be especially
interesting since the statue would then be the representation
of the Greek man reputed to be the most handsome; only the
size of the right hand grip, however, supports the "Paris"
identification.

Chamoux sees the figure as Heracles,[17] picking a
Golden Apple. The age of this man, however, might be too
young since gathering the Golden Apples was Heracles'
penultimate or final labor,[18] as is evident in the metope
from the Temple of Zeus at Olympia that depicts the story.[19]

All the proposed identifications are engaging possibili-
ties, but none can yet be accepted as convincing.

Dating

Although the Young Man from Antikythera lifts one

heel from the support and rotates his body in a spiral to
the right, the only major break from a self-contained
composition is the outstretched right arm. The composition
is comparable to that of the Marathon Youth and the goddesses
from the Piraeus find.

The Antikythera Young Man wears his hair in a shortly-
cropped style similar to that of the Cyrene "Berber", but it
appears even more unruly and strongly three-dimensional than
the relatively closed composition of the hair on the head
from North Africa. The mode of representing hair, completely
in plastic terms, is comparable to that seen on the Marathon
Youth (ca. 350 B.C.; figs. 14.1-4) and the young man
depicted on the Attic funeral monument (ca. 340-330 B.C.)
found in the Ilissus river bed.[20] The hair, however, is not
quite as free and dramatic as that of the figure of Agias
at Delphi (ca. 335-325 B.C.) or the Apoxyomenos in the
Vatican (ca. 330-320 B.C.), recognized copies of bronze
statues by Lysippos.

Facial features of the Young Man from Antikythera,
especially the profile and the shape of the forehead and
hairline, are so close to those of Piraeus Artemis I that
the statues might represent siblings. They also share an
expression of solidity and strength, tempered with gentleness.

These comparisons all point to a date in the middle
part of the fourth century about 350-330 B.C., for the
creation of the Young Man from Antikythera.

Attribution

Scholars who see the statue as a representation of
Paris,[21] usually attribute it to Euphranor. The argument
that Pliny (xxxiv.77) records a statue of Paris is not
sufficient evidence, however, for connecting that sculptor
with this sculpture, since there is no reason to believe
that Pliny was referring to this statue, lost at sea in the
first century B.C. Nevertheless, Pliny (xxxiv.77) does
establish Euphranor in the 104th Olympiad (364 B.C.), which
places him in the same general time to which this statue
can be assigned. Similarities between the Young Man from
Antikythera and the two large goddessses from the Piraeus
find (Artemis I and Athena) provide another thread of
attachment to Euphranor since these goddesses can be
compared with the Apollo Patroos in the Athenian Agora,
generally attributed to Euphranor (see below, p. 224-225).

Lippold, who knew the early twentieth century
restoration of the Young Man from Antikythera, described it
as a copy of a statue by Lysippos.[22] After the second

restoration, Vagn Poulsen suggested that the statue be considered an early work by Lysippos himself.[23]

Certainly the statue is a masterwork and probably was made by a sculptor whose name we know. At the present time, however, there is not sufficient evidence to attribute it to any particular fourth-century Greek artist.

Evidence that the statue came from the Greek East is an illustration of the unity of the Greek world. Virtually every major sculptor who worked on the Greek mainland is also known to have worked elsewhere, usually in the east, particularly during the second half of the fourth century B.C.

As both artists and patrons travelled back and forth throughout the Greek world, the provincial and regional differences dissolved. The Young Man from Antikythera could have been made in Asia Minor by a Greek sculptor born in Argos, who lived in Athens. Or the artist might have been born in Asia Minor, working in Argos, and made this statue in Athens. As the boundaries of the Greek regions were cut by travel, so were the confines of regional schools of monumental sculpture.

Notes

[1] J.N. Svoronos, Εφημερις Αρχαιολογικη 1902, col. 105, and Das Athener Nationalmuseum (Athens: Beck and Barth, 1908).

[2] Peter Throckmorton, Shipwrecks and Archaeology (Boston: Atlantic Monthly: Little, Brown, 1970), 113-168.

[3] Frédéric Dumas in Marine Archaeology, Joan du Plat Taylor, ed. (London: Hutchinson, 1965), 38-39.

[4] Three valuable publications have recently appeared about cargo recovered from the Antikythera wreck. Gladys Weinberg edited a collection of articles on various categories of material, entitled "The Antikythera Shipwreck Reconsidered", published in Transactions of the American Philosophical Society 55, 3 (June 1965) with discussions of amphoras by Virginia Grace, Hellenistic pottery by G. Roger Edwards, Early Roman pottery by Henry S. Robinson, glass vessels by Gladys Davidson Weinberg, the ship itself by Peter Throckmorton, and carbon-14 dating of the ship's wood by Elizabeth Ralph. These specialized studies agree on a date of 80-50 B.C. for the shipwreck; the carbon-14 dating indicates that the wood of the ship was cut about a century earlier.
Derek de Solla Price's study of the geared mechanism found aboard the ship establishes the device as a calendar computer, datable to ca. 80 B.C. Price's work, which revolutionizes our concept of Greek science, is published as "Gears from the Greeks: the Antikythera Mechanism--A Calendar Computer from ca. 80 B.C.", in Transactions of the American Philosophical Society 64.7 (November 1974), with previous bibliography.
A thorough study of the sculpture is published by Peter Cornelius Bol, "Die Skulpturen des Schiffsfundes von Antikythera", MdI, 1972. Bol's study of the numerous marble statues and parts of statues represents a convincing case for accepting them as first-century B.C. copies of earlier Greek sculpture.

[5] Pottery connects the wreck with Rhodes, Kos, and Ephesos. Price suggests that the computer came from Rhodes. Bol believes the marble sculpture came from an eastern Greek island, probably Delos. See references in the preceeding note.

[6]Throckmorton describes the geography and the weather conditions of the area, which makes a shipwreck quite understandable in that place. He also describes a plausible route for the ship, increasing the probability that it was sailing from the Sporades or Dodecanese islands or from the area around Ephesos to Rome.

[7]Bol, "Skulpturen", MdI, 1972.

[8]Ibid. and Svoronos, Das Athener Nationalmuseum.

[9]Christos Karusos, "Τό χρονικόν τῆς ἀναστυστάσεως τοῦ χαλκίνου Νέου τῶν 'Αντικυθήρων," ArchEph. 1969, 59-79.

[10]Ibid.

[11]O.A. Rhousopoulos, published in P. Diergart, Beiträge aus der Geschichte der Chemie dem Gedächtnis von Georg W.A. Kahlbaum (Leipzig and Vienna, 1909), 187. The publication does not state that the analysis is of the Young Man from Antikythera, but the illustration published with it and the timing of the article identify it. See also Earle R. Caley, "Chemical Composition of Greek and Roman Statuary Bronzes", Art and Technology: A Symposium on Classical Bronzes (Cambridge, Mass.: M.I.T. Press, 1970), 39.

[12]Svoronos, Das Athener Nationalmuseum, 18-29.

[13]Akademisches Kunstmuseum 79. See Konrad Schauenburg, Perseus in der Kunst des Altertums (Bonn: Rudolf Habelt, 1960), pl. 34, 1.

[14]See John Pope-Hennessy, Italian High Renaissance and Baroque Sculpture (New York: Phaidon, 2nd ed. 1970), III, 47-49, and pls. 70-71.

[15]Svoronos, Das Athener Nationalmuseum, fig. 2.

[16]For surveys of visual representations of Perseus, see Ernst Langlotz, Perseus (Heidelberg: Carl Winter, 1951) and "Der triumphierende Perseus", Arbeitsgemeinschaft für Forschung des Landes Nordrhein-Westfalen, 69 (1956) and Konrad Schauenburg, Perseus in der Kunst des Altertums (Bonn: Rudolf Habelt, 1960).

[17]Francois Chamoux, "L'Heracles d'Anticythera", Revue Archeologique, 1968, 161-170.

[18]For a discussion of the labors of Heracles and different versions of their order and number, see H.J. Rose, A Handbook of Greek Mythology (London: Methuen, 1958; reprint ed., University Paperbacks, 1972), 209-219, and Edward Tripp, The Meridian Handbook of Classical Mythology (New York: Meridian: New American Library, 1970), 278-288.

[19]B. Ashmole, N. Yalouris, and A. Frantz, Olympia, pl. 188.

[20]Lullies and Hirmer, Greek Sculpture[2], no. 226.

[21]See S. Karouzou, National Archaeological Museum, A Catalogue of the Collection of Sculpture (Athens: National Museum, 1968), 160-161, and C. Karouzos, Εφημερίς Άρχαιολογική 1969, 59-79.

[22]Lippold, Handbuch, 264.

[23]Vagn Poulsen, Griechische Kunst: Bildwerke, Vasen, Bauten. (Königstein im Taunus, Lengewiesche Nachfolger, Köster, 1963), pl. 82.

Select Bibliography

Svoronos, J.N. Εφημερίς Ἀρχαιολογική
 1902, col. 105.

————. Das Athener Nationalmuseum. Athens: Beck and Barth,
 1908.

Lullies, R. and Hirmer, M. Greek Sculpture[2], nos. 218-220.

Karo, George. "Art Salvaged from the Sea". Archaeology 1:4
 (1948), 179-182.

Dumas, Frédéric. "Antikythera". In Marine Archaeology,
 edited by Joan du Plat Taylor, pp. 38-39. London:
 Hutchinson, 1965.

Karouzou, S. National Archaeological Museum, Collection of
 Sculpture, a Catalogue. Athens: National Museum,
 1968, 160-161.

Chamoux, François. "L'Héraclès d'Anticythère". Revue
 Archeologique 1968, 161-170.

Karusos, Christos. "Τό χρονικόν τῆς ανασυστάσεως τοῦ χαλκίνου
 Νέου τῶν 'Αντικυθήρων." Εφημερίς Ἀρχαιολογική 1969, 59-79.

Throckmorton, Peter. Shipwrecks and Archaeology. Boston:
 Atlantic Monthy: Little, Brown, 1970, 113-168.

Bol, Peter Cornelis. Die Skulpturen des Schiffsfundes von
 Antikythera. Berlin: Gebr. Mann Verlag, 1972.
 Mitteilungen des Deutschen Archäologischen Instituts,
 Athenische Abteilung.

Temporarily in the National Museum in Athens; will be moved
to the Piraeus Museum when it reopens. Museum number not
yet assigned. Found July 18, 1959, by workers digging a
sewer ditch in the Piraeus. Right arm broken off and re-
attached. Attributes missing from both hands; quiver missing
from back; device missing from strap across chest. Green
patina. H.: 1.94 m. Bronze thickness ranges between 0.003 and
0.005 m. Figs. 12.1-3.

Description

 A self-contained composition enlivened by innumerable
subtly contrasting planes, this full-bodied figure is larger
than life size. Now the principal extension into space is the
right arm, bent at the elbow and held up and out to the right;
the left arm is slightly inclined to the front. Originally
the composition would have related to the surrounding space
by the attributes once held in both hands.

 Tectonic stability is emphasized by wide center drapery
folds on both the overfold and the skirt as well as by the
straight right leg, which carries her weight like a column.
The left leg bends at the knee and is stepped out to the
side.

 The statue's head is tilted sideways to the right, giving
her a soft, thoughtful expression. Her profile, with its
long straight nose, is typical of Classical Greek physiognomy

seen in both sculpture and painting; it is especially close
to the profile of the Antikythera Youth.

Parted into sixteen sections converging from the hair-
line to the crown, the hair is twisted and pulled back to
the crest of the head, where the ends are combined into two
large tresses that are coiled around the crown of the head.
The sculptor fully understood this complicated style and
makes it clear to the viewer. Modified by placing the coil
at the back instead of the top of the head, this hair style
continues to be popular for Hellenistic terra cotta figurines
and Roman portraits; it is called the "melon" hairdo because
of its similarity to ridges on a cantaloupe. Seldom do later
artists describe its construction well enough for the viewer
to understand it.

Unfortunately, damage to the eyes makes them now appear
to be focused in different directions, but we can tell that
she originally gazed slightly down, toward the right. The
eyes are chestnut brown stone (onyx?) irises surrounded by
white marble; each eye is set in a bronze envelope with
fringed edges which serve as eye lashes. The pupils are
missing, as is the right iris. A brace inside the head holds
the eyes in place.

The outline of the inset lips can be distinguished

easily. This separate piece probably is copper to make the lips redder, but it is so badly corroded now that it is difficult to tell by looking. Corrosion and general damage also make it difficult to see the teeth behind the slightly parted lips. The teeth, upper row only, are carved of marble and suspended in place, like those of the Piraeus Athena, through an oval wire support which fits under the projecting marble struts which extend from the teeth. The original expression of white teeth behind red lips set in gleaming bronze skin must have been quite lively.

One piece of fabric is folded into her simple, sleeveless peplos. Fasteners over each shoulder are hidden by the over-fold which falls just below her hips. Round weights are on the three corners still extant at the right side, and one can be reconstructed on the bottom rear corner now broken away. The fabric simulates the weight of wool and drapes with a well-designed naturalism. Toes of her right, weight-bearing foot break the floor-length skirt in front as does, at the left side, the forepart of that foot which has its heel raised inside the skirt. Soles of her sandals are thick (0.025 m.); their lacing device is gone.

Over her peplos, she wears a diagonal strap passing from her right shoulder across her chest and under her left

breast. Another arm of the belt comes around under her right
breast, joining the rest of the strap between the breasts.
Construction of the belt—as we see it——is clear there,
where the arms of the harness meet: the band coming from her
left side curves around and down over the lower right band,
then ends. Actually, that is the end of the separate piece
of metal which is finished this way in order to form a
support for an ornament placed over the join of the harness
arms. The ornament, of course, would hide the join now
visible, which we were not meant to see. The patina here is
redder than elsewhere. In the back, the straps look like
two separate ones: a belt encircling her waist and a quiver
strap crossing her back diagonally from right shoulder to
waist at the left. A trace of lead soldering near the middle
of the back diagonal strap indicates where her quiver was
attached and is convincing evidence for identifying the
statue as Artemis.

Other evidence for her identification is the cylindrical
space formed by her left hand, which is shaped and positioned
like that of the other bronze Artemis from the Piraeus and
surely once held a bow, which would have extended horizontally
both in front and behind the body, inclined down a little in
the front. Globs of lead solder used to hold it in place can

still be seen around her fingers. Her curved middle finger
is extended further than the other fingers, perhaps to hold
an arrow parallel with her bow.

The damaged right arm was broken off but lying next to
the statue when it was excavated; it has been repaired and
re-attached. The break was a jagged one at the mid upper arm
where the extended arm began to clear the body. The hand
and several fingers were badly damaged, but fortunately
almost all the pieces were found so that the repair is
virtually complete and the composition known certainly. The
arm is extended from the elbow; the hand is relaxed and the
palm falls loosely toward the viewer in a pose unusual for
Greek sculpture but also seen in a 45 degree turn on a bronze
Athena in Florence (fig. 12.6) that is generally considered
to be a Roman copy of a fourth century Greek original, some-
times attributed to Praxiteles.[1] She held something in her
hand; two small bronze fragments of it are still attached at
the upper edges of the bases of her thumb and first finger.
The muscles show no sign of tension and the hand position is
not designed for holding a large or heavy object. Severe
damage to the hand and the break of the arm itself, however,
raise the possibility of an object too heavy for the hand to
hold having been attached to it, although the damage to this—

the most extended part of the body——could easily have
happened when it was buried. Perhaps the object in her hand
was a phiale, held as does the statue of Artemis on the
Oinomaos krater in Naples and the representation of Artemis
on a gem in Leningrad (fig. 12.6-7).[2]

Technique and Restoration

Cast in separate pieces fitted and soldered together,
the statue conveys much more naturalistic impression than a
single hollow-cast form would. For example, the peplos over-
fold is fitted over the skirt and stands out from it in a
realistic overlap which, for structural reasons, would be
virtually impossible to achieve in a one-piece construction.

On the inside of the statue, the presence of seams and
globs of lead soldering material clearly shows where the
pieces joined, but the craftsmanship is of such extremely
high quality that the joins are difficult——often impossible——
to see on the outside even if one knows where they are. Pieces
which make logical units are cast as such; for example, the
head and neck unit joins the torso where the upper peplos
begins.

Some clay, thought to be part of the core, was found
inside this large Artemis. Much of the core may have been

cleaned out in ancient times in order to facilitate the
welding; the head had to have been thoroughly cleaned so
that the struts could be attached and the eyes and teeth
inserted, which was done from inside. The clay found was
removed during restoration. The restorers report that they
were able to see fragmented chaplets of iron in the clay.[3]

In addition to making the mends, the conservators had
to dehumidify the bronze. For this lengthy process, they
constructed a large oven in their laboratory; it was also
used for drying out the smaller Artemis and the Apollo from
the Piraeus find. Before it was put on display, the statue
was coated with an cellulose acetate solution.

Identification

When it was first found, the statue was identified as a
muse, probably Thalia or Melpomene, because a bronze mask
found near it was thought to have been held in her hand.
Masks are held by many figures in ancient art; the Vatican
Melpomene is one example from large sculpture.[4] When the
arm was repaired, however, it became apparent that the hand
could never have supported such a heavy object. Furthermore,
a closer look at the mask shows that its flattened and tilted
edges were designed to hang against a wall; it is not part of

a statue composition.

An attractive case was presented by Helga von Heintze for identifying the statue as Sappho by connecting it with a bust in the Getty Collection which is inscribed ΣΑΠϕοΝ. By comparison with the Korinna from Compiegne[5] she proceeded to ascribe the bronze statue to Silanion, who is known from Cicero (Verrine, II, IV, 57, 125-126) to have sculpted a statue of the poetess for Syracuse. She is right in recognizing a connection between the Getty bust and this bronze Piraeus statue; however, the precise kind of relation is debatable. The bust is not identical with—and so need not be a specific copy of—this Greek statue; therefore, even if the prototype for the Sappho bust were known to represent Sappho, this statue may not be it. The bust, however, cannot even be considered an actual portrait type since it is unlike other inscribed representations of the poetess.[6] The Getty bust undoubtedly is an example of the frequent Roman practice of copying a Greek original in whole or part, adapting it to a new identification. One later Roman use of this statue's head—or perhaps only one quite like it—is not solid enough reason to identify this statue as Sappho.

Although both the muse and Sappho labels are good
suggestions, neither can be accepted. The identification as
Artemis can be substantiated by the quiver strap with solder
indicating location of the quiver itself and the cylindrical
space in the grip of her left hand, which is appropriate for
a bow.

Roman Copies or Variations

Whether the Getty bust, two similar Roman bronze busts
from Herculaneum and Perinthos, and a related marble head in
Leningrad[7] are actual free copies based on this statue or are
close copies of a statue much like this one is a fascinating
and important question, but one difficult to answer. General
likeness is apparent in the oval face, Classical profile, and
hair style. Drapery on the Herculaneum and Leningrad busts,
however, does not follow that of the Piraeus statue. The wavy
hair of all the Roman heads is gathered away from the hair-
line more freely than on the Greek head, although hair on the
Leningrad version nearly separates into sections at the top
suggesting that it might be based on a segmented model. The
coils of hair are braids in all the Roman versions but are
twisted tresses or ropes in the Greek original. Whether or
not these Roman busts are copies of this particular statue,

they demonstrate the popularity of this fourth century type
as late as the first century B.C.

Style

Composition of the figure is in the well established
Classical Greek tradition for free-standing sculpture, the
mode of the Athena Parthenos. A marble Artemis in the Vatican
and a statuette in Venice stand in a pose comparable to that
of this bronze Artemis; perhaps they both are copies of the
Dresden type, which is also like this Piraeus figure except for
the arms.[8] An unidentified marble figure in the Metropolitan
Museum[9] stands in a pose even closer to this Piraeus Artemis.
Drapery is rendered similarly on all these figures and they
wear the peplos in the same way although the New York and
Venice figures also wear a chiton underneath.

The closest parallels for composition in every way—
pose, drapery style, dress style, thoughtful and quiet
attitude, graceful design, and construction technique—are
the bronze statues of Athena and the other Artemis found
with this Artemis. Size, technique, drapery, and the strong
yet gentle expression of the Athena are virtually identical
with the corresponding features of this Artemis, perhaps
made by the same artist, who might have been Kephisodotos or

even more likely, Euphranor.

In view of the scarcity of firmly dated, freestanding
sculpture of the fourth century, it is difficult to ascribe
an exact date to this statue. Originals of the Venice and
Vatican Artemis copies are recognized as "fourth century",
but without concensus of more definite date. Although the
composition of the original statue of an unidentified woman
in New York is like this Piraeus Athena, the head in New
York probably is later; in addition, the New York figure
cannot be used as a firm dating point (see note 9). The other
Piraeus statues have no firm dates either.

Comparison with copies of Kephisodotos' "Peace and
Wealth" ("Eirene and Plutos") points to a date later than
ca. 370 B.C. for the more attenuated Piraeus figure. Comparison
with the mid-fourth century "Apollo Patroos" in the Athenian
Agora speaks strongly for dating this Piraeus Artemis to
the same time. Comparison with draped figures of the late
fourth and early third century, such as the Tyche of Antioch,[10]
emphasize the difference between the graceful but clear,
simple rhythms and closed form of the Piraeus composition
and the Early Hellenistic use of overlapping axes and
complicated, opposing rhythms.

Conclusions

The "Piraeus Artemis I" fits comfortably into the mid-
fourth century, but a more specific date cannot be assigned
to her yet. As a masterpiece, she probably is the creation
of a sculptor whose name we know. Perhaps she may be by
Praxiteles, who is so often considered to be the author of
work reflected in the copies similar to this Artemis and who
is well known to have favored Artemis as a subject for his
draped statues. Euphranor and Kephisodotos also are candidates,
especially because of their possible association with the
Piraeus Athena. Until we know more about the oeuvre of mid-
fourth century sculptors, however, we can only guess who
made Artemis I. Whether or not we ever are able to identify
the sculptor of this Artemis, the statue will stand as an
important work of art and as a valuable expression of mid-
fourth century Greece.

Notes

[1]Athena of Arezzo in Florence, Museo Archeologico
A 248; ill. in Rizzo, Prassitele, pls. CXXXIX-CXLI and in
Bieber Hellenistic Age, fig. 47.

[2]The krater is the name piece of the Oinomaos
Painter in Naples, Museo Archeologico, 2200 (Beazley, ARV[2],
1440); the blue chalcedony scaraboid in Leningrad is
published by J. Boardman, Greek Gems and Finger Rings (London:
Thames and Hudson, 1970), 290, pl. 533.

[3]I am grateful to Dr. N. Yalouris, who kindly made
it possible for me to talk with the conservators at the
National Museum in Athens who restored this statue.

[4]The Vatican Melpomene is illustrated in Adolph
Furtwängler and H.L. Urlichs, Denkmäler, Griechischer und
Römischer Skulptur (Munich: Bruckmann, 1911), pl. 30. Numerous
other illustrations of a dramatic mask being carried can be
seen in Margarete Bieber The History of the Greek and Roman
Theatre (Princeton: Princeton University Press, 1961), and
A. Pickard-Cambridge, The Dramatic Festivals of Athens
(Oxford: Clarendon Press, 1953), and the 1968 edition of
Pickard-Cambridge (revised by J. Gould and D.M. Lewis,
Clarendon Press) which has a different selection of illustrations.
illustrations.

[5]Helga von Heintze, Das Bildnis der Sappho (Mainz
and Berlin: Florian Kupferberg, 1966).

[6]Representations of Sappho are discussed by Richter
in Portraits of the Greeks (London: Phaidon, 1965), I, 71-2;
the Getty bust is listed in her Supplement to Portraits
(1972), 5. In most depictions Sappho wears a sakkos or
fillet around her head.

[7]Ibid. for information about the Getty head; the
bust is not included in the Catalogue of the Ancient Art in
the J. Paul Getty Museum by Cornelius Vermeule and Norman
Neuerburg (no city or publisher identified, 1973). The
Herculaneum bust is now in the Museo Nazionale, Naples, no.
5592. The bust from Perinthos is in the National Museum,
Athens, no. B 15187. All are illustrated in von Heintze,
Sappho, 1-2, 6-10. The Leningrad bust from the Golitzyn

Collection is in the Hermitage, no. 325. Except for the Getty head, these busts are also illustrated in Picard, Manuel III-2, 798-803, figs. 357-361.

[8]Statuette in Venice, Museo Civico, is Br-Br. 795 rechts; the Vatican statue, no. 2834, is fig. 1 in Br-Br. 795 rechts, text volume, 21; the Dresden copy is illustrated in Bieber, Hellenistic Age, fig. 40, and Rizzo, Prassitele pl. XVI-XVII.

[9]Metropolitan Museum, New York, no. 42.11.2. See Richter, Catalogue of Greek Sculpture in the Metropolitan Museum of Art (Cambridge: Harvard University Press, 1954), no. 94 and pls. LXXVI-LXXVII. Richter dates this female figure and the accompanying one ca. 320-310 B.C., largely by comparison with record reliefs; however, the problems of comparing a masterpiece of freestanding sculpture with an ordinary relief must be considered. Relief work can, of course, be freer in composition since it is supported by its background rather than its own form. Like most relief work on record steles, these are not of the highest quality; since less accomplished art usually depends upon the forms of earlier first-rate work, use of record reliefs loses importance as a fixed point for stylistic comparison.

[10]Illustrations in Richter, Sculpture and Sculptors are fig. 704 for "Peace and Wealth" ("Eirene and Plutos"), fig. 785 for Apollo Patroos, and figs. 811-813 for copies of the Tyche of Antioch.

Selected Bibliography

Orlandos, A.K. "Πειραιεὺς." Ἔργον (1959), 161-169.

Daux, Georges. "Chronique des Fouilles". BCH 84 (1960), 647-655.

Vanderpool, Eugene. "News Letter from Greece". AJA 64 (1960), 266.

Picard, C. Manuel IV-2, 1095, pl. xxvii and fig. 430.

von Heintze, Helga. Das Bildnis der Sappho. Mainz and Berlin: Florian Kupferberg, 1966.

Paraskevaides, Miltis. Ein Wiederentdeckter Kunstraub der Antike? Piräusfunde 1959. Berlin: Akademie-Verlag, 1966.

Hanfmann, George M.A. Classical Sculpture, no. 178.

Schefold, Karl. "Review of Das Bildnis der Sappho by Helga von Heintze." AJA 71 (1967), 205-6.

Steinberg, Arthur. "Joining Methods on Large Bronze Statues: Some Experiments in Ancient Technology." Application of Science in Examination of Works of Art, ed. by William J. Young. Proceedings of the seminar conducted by The Research Laboratory of the Museum of Fine Arts, Boston, Mass., June 15-19, 1970. Boston: The Museum of Fine Arts, 1973, 110-113.

Temporarily in the National Museum in Athens, soon to be
moved to the Piraeus Museum. Museum number not yet assigned.
Found July 25, 1959, during salvage excavation in sewer
construction in the Piraeus. Attributes missing from both
hands. Green patina. H.: 2.35 m. Th. of bronze ca. 0.003 m.
Figs. 13.1-5.

Description

Larger than life-size, the Athena stands as a caring,
gentle protector looking toward the spectator. Her right
arm is outstretched from the elbow, and the curved hand is
palm up to hold an object, now lost, that was attached to
a square hole on her thumb and an oval hole on her palm.[1]
Size and position of the holes are not logical for holding
a phiale.Both holes would work for either a nike or an owl,
two attributes often held by Athena. The curve of her hand,
however, is better designed for cradling an owl than supporting
a nike.

Her left arm is held in front of her; its limp pose
was designed to rest on a shield balanced between her first
two fingers on the outside of the shield and the thumb and
two small fingers on the inside. A spear stood against the
inside of her thumb fitting into an indentation still
clearly visible; it separated the two outside fingers which

supported it. A mass of lead in Athena's hand was used to
anchor both shield and spear; the lead is extant but it
has slipped down from its original position. One of the
two shields found in fragments with the statue probably
belongs with it.

Athena's head is inclined forward to the viewer and
toward her right, in the direction of her right hand and
what she held, but not exactly at it. Her gaze is designed
to make contact with the viewer.[2] On the crown of her head,
she wears a Corinthian helmet decorated in relief with owls
on the cheekpieces, prominently resting just above her
forehead. Griffins, also in relief, decorate the top of the
helmet, one on each side below the base of the center crest.
A snake, which is in high relief too, winds around the base
of the crest and meanders down the center of the helmet at
the back. The center crest is a representation of a metal
stand holding a thick shock of horsehair flowing down in
graceful curves over Athena's shoulders. Athena's hair is
parted in the center and softly combed into one tress at
the back, where it falls under the chiton.

Diagonally across her breast, Athena wears a narrow
aegis as though it were a diplomatic ribbon. It runs over
her right shoulder and her left arm but is hidden under

drapery in the back. Eight small three-dimensional snakes
decorated the edges of the aegis like bows tied at intervals.
The gorgoneion on it lies below Athena's left breast, toward
the center. The feather-shaped scales are modelled, but
details of the aegis have been emphasized by coldwork.

Her dress is arranged in an unusual way, which makes it
appear more complicated than it is. Actually, it is a simple,
one-piece peplos, folded around her left side so that the
two side edges open at her right. About a third of the
rectangular fabric is folded over at the top edge and
fastened under the fold at both shoulders. The overfold
(ἀπόπτυγμα) in front looks almost triangular or at least
trapezoidal at first glance, but it is only part of the
rectangular overfold which falls that way because it has
been pulled up over the shoulders into a shawl in the back.
The edge which runs diagonally from her right arm to her
left knee, therefore, is a continuation of the front side
edge which falls at her right. Two corners of the simple
rectangular fabric are at the ground on her right side, the
third is over her left knee, and the fourth is behind her
right shoulder.[3] The two upper corners are weighted with
small round balls. Crease folds on her skirt are like those
on the Apollo Patroos.[4] Although the fabric falls with the

weight of wool in the skirt, it clings to her breasts so
that her nipples are clearly outlined even under two layers
of material. The fabric could be either very fine wool or
linen. A simple belt around her waist can be seen at the
back, but it is covered by the overfold in front.

Drapery is fullest over her weight-carrying right leg;
it falls in strong, rich vertical folds from her waist to
her feet, giving the figure a sense of columnar strength.
Her bent left knee breaks the fall of the drapery and pulls
it to the side in a graceful curve which also gives greater
width and stability at the base.

Toes of her right foot protrude through the drapery
just off center. Her left foot is pushed beyond the skirt
at the side; the toes and the sandal under them are missing.
The sandal soles are ca. 0.025 m. thick.

Lead for a broken-off dowel can still be seen under
the large, heavy drapery fold near the front center of
her right foot. Traces of another dowel were seen by
Vanderpool at the time of excavation[5] but seem to have been
removed during cleaning.

Eyes and teeth were inset and are still in place,
although damaged. Whites of the eyes appear to be made of
white, fine grained marble; the irises are bluish gray,

probably glass paste; the pupils are missing. The eyes are
framed by bronze lashes. It is difficult now to see the
ivory teeth between the slightly parted lips; they must have
been more prominent before they were damaged and before the
metal corroded.

Although the stance is in the general tradition of
the Athena Parthenos as we know it from copies,[6] it differs
markedly from fifth-century contrapposto by the use of a
Polykleitan S-curve. This curve is dramatically clear at
the back of the statue where the hips and waist are not
covered by the chiton overfold (fig. 13.6).

A series of balances and counter-balances gives dignity
and stability while enlivening the statue with grace and
rhythm that are not at all static. The bent right arm
balances the bent left leg; the sweep of the drapery and
aegis to Athena's left is balanced by the slight turn of
her body to the right; the side step of the left leg and
the space for the shield below are countered by an outward
swing of the right hip and the bird cradled in the out-
stretched right hand. The diagonal lines of drapery from
the left shoulder are countered by the catenaries on the
lower corner of the overfold, which in turn would be echoed
by the curve of the shield. The basic form is a graceful

stable vertical shape, emphasized by the high-crested
helmet rotated slightly to the right, by the shield and
spear, and by the strong vertical frontal folds of the
drapery (fig. 13.7).

Identification

Identification of the statue is certain, of course,
because of the aegis and helmet. She is, however, a specific
expression or aspect of the goddess.

Arrangement of the peplos overfold into a shawl at the
back is so definite that it probably has iconographical
importance; perhaps it indicates a protecting, maternal
role. A Boeotian grave stele in Berlin shows a similar
drape of the chiton, but one so exaggerated that the shawl
actually becomes a veil over the head.[7]

The transverse aegis fastened over the right shoulder
occurs on a metope from the Temple of Zeus at Olympia, where
a bareheaded Athena sits on a rock receiving the Stymphalian
birds from Hercules.[8] In this and similar Early Classical
representations, the aegis also covers the left shoulder
and arm. By the mid-fifth century, the angled aegis bares
the left shoulder, as in the Athena of the Parthenon west
pediment.[9] If Furtwängler's generally-accepted identification

of a marble torso in Dresden and related figures as copies
of the Athena Lemnia is correct, Pheidias arranged the
aeigis obliquely on that representation, renowned for
beauty and the unarmed, peaceful aspect of the goddess.
(Even "unarmed", Athena usually carries a spear.) By the
fourth century, the diagonal aegis has narrowed to a
decorative symbol. The angled aegis also appears in vase
paintings.[10] In these fifth and fourth-century B.C.
representations, Athena wears her aegis obliquely when she
is in a peaceful activity or, as in the case of the Parthenon
west pediment, when the peaceful aspect is one of several
characteristics which may be indicated.[11] On the Piraeus
Athena the aegis is a decorative emblem, not a protective
breastplate.

In pose, the Piraeus Athena is related to the copies
identified with the Athena Parthenos (see note 6). The type
is also found in the Elgin statuette at the Metropolitan
Museum[12] and a statuette in the Walters Art Gallery[13].
Both statuettes show an owl in Athena's hand, re-enforcing
the suggestion, based on observations of the holes and curve
of the Piraeus Athena's hand made above, that the object
she held was an owl.[14]

R. Ross Holloway proposes that the owls on her helmet

(where ram heads more often appear in Corinthian helmets),
as well as one reconstructed for her to hold, identify the
statue as Athena Archegetis, "the natural patroness of the
Athenian cleruch."[15] If this identification is correct, as
seems likely, the statue probably was commissioned by and
for Athenian cleruchs. It might have been set up by cleruchs
on their departure from Athens, as we assume was the case
with the Lemnian Athena, or it might have stood in a temple
to Athena in a colony of the goddess' name-city, in the way
numerous colonists or foreign residents in places such as
Delos set up shrines and statues to their own special
deities.[16]

Certainly not a war-like representation either in
form or iconography, the Piraeus Athena is a gentle, protecting
nurturer. She is Athena as patroness of peaceful growth,
not military aggression. A statue probably commissioned by
Athenian colonists, it likely was a cult statue for a
temple to the goddess of their mother-city.

Technique

Like the other Piraeus bronze sculpture, the Athena was
cleaned and restored at the laboratory of the National
Museum in Athens. She is the best preserved of the group

and the only one that was not dried out in the oven. She
was cleaned by mechanical means only.

The statue was cast (and must have been modelled) in
separate pieces, which were fitted together in intricate
over-lays and under-lays; the joins are either logical parts
of design or are virtually invisible even now. The overfold
of the peplos, for example, is separate from the skirt so
the overfold falls over the skirt with the distinction that
exists naturalistically with two parts of fabric. The
restorers report that the skirt was made in several pieces
which can be distinguished only by the soldering ridges on
the inside of the skirt. (No record was made of the inside,
so definite information about the number of pieces in which
the statue was made will not be available until it is possible
to look inside it again.) These divisions should not be
confused with fold-mark designs on the outside of the
skirt, which have nothing to do with the casting divisions.

The head, helmet, and arms are hollow cast; the
helmet was cast separately from the head, and the division
between the two can now be seen. The drapery, however, is
too complex to make in a simple, single hollow cast mould;
the method used for it is sometimes called "piece casting",
in which the pieces are assembled to make a hollow form,

although the actual parts could be described as having been
cast in solid pieces. Making the model for such drapery
would be difficult. It is much more complicated than
contemporary marble sculpture. The extensive layering can
scarcely have been carved or modelled in one piece; the
joins of the thin overlapping drapery, for example, show no
thickening for support, as would have been necessary if the
model were a single piece of clay, wood, or even wax. The
original might have been made in separate sections of wax,
similar in technique to that of ancient Greek terra cotta
sculpture in which sections are designed to fit onto one
another. The sections could be put together while the
composition was being completed to be certain that the
form would work as one unit visually and to insure that the
model pieces (and, therfore, the metal castings) would fit
together; yet the sections could be easily separated to be
encased in separate moulds and cast in the regular lost
wax technique.

The owls on the helmet and the snakes on the aegis were
cast as separate units. Other decorative elements in relief,
the griffins and the snake on the helmet and the gorgoneion
on the aegis, were cast with the larger pieces on which
they appear.

Eyes and teeth were set into the head in different materials.
The upper row of teeth was carved from one piece of ivory
and is held together by a solid band at the top which was
wider than the teeth. The ends of the band were used as
struts so that the inset could be hung from an oval wire
support placed just above the mouth on the inside of the
head.Whites of the eyes appear to be marble; the irises
probably are glass paste; the missing pupils probably were
a black stone. Material representing the eyes was set into
envelopes of bronze, fringed at the edges to indicate
eyelashes. The teeth certainly had to have been placed in
position from the inside before the head was attached to
the body since they could not be fitted in through the
mouth from the outside. The eyes probably were inserted at
the same time, also from the inside.[17]

Analysis of the bronze alloy shows it to be 87 percent
copper, 11 percent tin, and 1 percent lead.[18]

The Piraeus Athena represents an extremely high
development in the making of monumental bronze sculpture.
The statue is a masterpiece of craftsmanship as well as of
design.

Attribution

Attribution of the Athena has frequently been made to Kephisodotos the Elder, partly on the grounds that Pausanias (i.1.3) saw a temple of Zeus and Athena in the Piraeus and that Pliny (xxxiv.74) recorded Kephisodotos as sculptor of an Athena in the port of Athens. These literary references, however, are from the first (Pliny) and second (Pausanias) centuries after Christ and cannot, therefore, be used to identify the statues found in the Piraeus in 1959 since the disaster which buried them can be dated to the first century B.C. (see p. 30).

Nevertheless, there is a general similarity in the composition of the Athena and the only certain copy of a work by Kephisodotos, "Eirene and Plutus",[19] which has given reason to continue the attribution of the Athena to Kephisodotos.[20] Both Athena and Eirene are mature young women in nurturing, maternal attitudes. They wear similar chitons and both stand with weight on one leg, which is more heavily draped than the other leg and which steps to the side and breaks the fall of the skirt with bent knee. The personal, intimate attitude associated with the fourth century is apparent in both. Too much comparison, even of drapery style, would be misleading since the Eirene is a

Roman copy and drapery is often changed considerably in
copies, as is clearly demonstrated by comparing the Athena
and the Louvre copy of her (see below, p. 225-229).

As Olga Palagia has pointed out, however, Athena's
stance is even closer to that of the Apollo Patroos, an
original marble work attributed to Euphranor. On the basis
of this comparison. she attributes the Athena to Euphranor,
observing that both

> adapt the polykleitan posture of the
> Doryphoros in a similar way of not
> bending the arm and leg of the same
> side...; they make a similar gesture
> (hands reversed though), and persistently
> incline the head to the right which is
> a polykleitan feature. They both seem
> to be created by the same artist who
> was consciously emulating Polykleitos,
> and still a contemporary and rival of
> Praxiteles.[21]

Information from Pliny (xxxiv.77-78) about the kind of work
Euphranor did supports the attribution. Of the eleven
recorded statues by Euphranor, six[22] are identified as
women (goddess, mortal, or female personification) in the
protective or nurturing role of a patroness. Tentative
connections of these listed statues have been made with
various copies,[23] but they cannot be considered more than
hypothetical; so only the Apollo Patroos can be used as
solid visual comparison. The evidence is not strong enough

to accept as certain the attribution to Euphranor, who is
dated by Pliny to the 104th Olympiad (ca. 364 B.C.), but
it is persuasive enough to assign the statue to him with a
question mark.

The Mattei Copy of the Piraeus Athena and Other Related Roman Copies

This Athena and a Roman copy of it in the Louvre are
of great importance: although thousands of ancient copies
were made of monumental Greek bronze statues, this is the
only instance in which we have both the Greek original and
a complete Roman copy.

The Louvre marble copy from the Mattei Collection
(figs. 13.8-10)[24] follows the composition of the Piraeus
Athena except in the lower right arm and hand, akimbo in
the copy. Fingers of the right hand are restored, but the
pose is known because the arm, hand, and thumb belong.
Position of the left hand, however, is unknown; that entire
hand and wrist are restoration. An outstretched arm is more
difficult to make in marble than in bronze, undoubtedly one
of the reasons for this change. In addition, the attribute
in Athena's right hand apparently had no significance for
the copyist or commissioner. The owls of the helmets, too,

were changed; the copyist made them into rams, which are
more usual for Athena's headpiece.

The head of the Mattei Athena is battered and was
broken off just under the chin. Its stilted angle, an
exaggeration of the relaxed inclination and the turn
to the right of the Piraeus head, may be the fault of the
restorer. Repair has also been made on the lower left cheek-
piece of the helmet and the forehead just below it. There
are losses from under the chin, the right side of the neck,
and hair at the nape. With only a few snakes and none of
the incised surface of the original, the Mattei aegis is
limp in comparison; some details might have been added
in paint to the copy but the forms still would lack vitality.
Drapery arrangement at the right side and back was not fully
understood by the copyist, who also made minor changes such
as transposing the round drapery weights into tassels. The
copyist increased the number of drapery folds everywhere so
that the distinction between skirt and overfold is lessened,
as is the strength of the columnar volumes.

The gentle, quiet strength and nobility of the fourth-
century goddess is lost in the vacant spirit of the copy.
Iconographical significance and identification of the
special aspect of this Athena is gone. Athena Archegetis is

translated into "Athena Agorais".[25] Instead, the Mattei
Athena is a quotation, rather out of context, from an
older time; it is a decoration attesting to its owner's
learning and affluence.

The similarity between the head of the Piraeus Athena,
as well as of the Mattei copy, and at least five other
general groups of Roman copies of Athena statues is surprisingly
strong. Especially striking is a comparison with the Ince
Athena[26] (fig. 13.11), which is so close that it might be
thought to be a copy of the fourth century bronze if the head
alone had been found. Comparable heads can be seen on
numerous Roman copies of Athena that can be grouped into
types represented by the Giustiniani Athena, the Hephaisteia
Athena, the Velletri Athena, and the Vescovali Athena.[27]
Facial features of these types are so much alike that the
heads could all be portraits of an actual being. All wear
the Corinthian helmet at the same angle, more as a visored
hat than a military head-piece; all have wavy hair parted
in the center, pulled across the ear tops of the ears and
gathered at the back. The Ince type also has the same
inclination of the head to the front and right. Drapery
arrangement is the major difference in the torsos. Only
the Mattei Athena is dressed just as is the Piraeus Athena,

but there are other characteristics which these types share
with it. Even though the Velletri and Ince types wear the
aegis as a collar, it is as narrow as that of the Piraeus
goddess. The aegis is transverse on the others, excepting
the Arezzo-Florence variation of the Vescovali type (which
is also unusual in being bronze).[28] All stand as does the
Parthenos, with weight on one leg and the other leg bent
at the knee and stepped to the side.

Except for the Mattei copy, these Roman marble versions
of Athena are generally accepted as echoes of fifth-century
majestic solemnity. The similarity of all these Roman copies
and the Piraeus Athena suggests that they all depend upon
one prototype. The fact that we have no record--except in
these variations--of such a statue does not rule out its
existence but only emphasizes the large number of important
pieces of Classical sculpture which have disappeared. If
there were such a prototype, we can assume that it was
famous to have been so influential and we can surmise,
from stylistic indications, that it was High Classical--
perhaps as early as the Athena Lemnia and the Athena
Parthenos or at least influenced by them. The fourth-century
Greek sculptor would have been influenced by such a proto-
type (and by others, such as the pose of the Athena Parthenos)

when he created his own statue in the Classical Greek
tradition and the fourth-century spirit; Roman copyists
seem to have used such a prototype as a favorite model for
Athena's head in many of their pastiches--virtually as a
portrait type.

The similarity of these representations of Athena and
the probability of their dependence upon one or more
earlier representations is not at all surprising; in fact,
it is what we should expect within the framework of Classical
sculpture. Like other Greek artists and architects, the
sculptor of the Piraeus Athena--whether or not he was
Euphranor or Kephisodotos--built upon the existing visual
vocabulary. Comparison with related Roman copies emphasizes
that the Piraeus Athena is an original statue in the Classical
Greek tradition and the fourth-century spirit.

Notes

[1]The hole on her thumb is ca. 0.01 m. square and
0.005 m. deep. The palm hole is oval--almost heart-shaped--
at the surface and goes into the hand in a tapered wedge
form; it is ca. 0.013 m. long, 0.01 m. wide, and at least
0.01 m. deep.

[2]Her glance is ca. $18°$ down from horizontal and ca.
$22°$ to her right of center.

[3]This arrangement is illustrated by Margarete Bieber
in Griechische Kleidung (Berlin and Leipzig: Walter de
Gruyter, 1928), pl. XLIV-1. Vase paintings, too, show how
an overfold can be angled by a pull, e.g., a stamnos in
Munich by the Kleophon Painter, the Museum Antiken Klein-
kunst no. 2415, illustrated by P.E. Arias and M. Hirmer,
Greek Vase Painting (London: Thames and Hudson, 1962), pl. 193.

[4]The most thorough publication of the Apollo is by
Homer Thompson, "The Apollo Patroos of Euphranor", Ἀρχαιολογικη
Ἐφημερίς 1953-54, part 3 (1959), 30-44; pl. II-a shows the
fold-marks clearly.

[5]"News Letter" AJA 64, 266.

[6]Copies of the Athena Parthenos are listed with
bibliography in Richter, Sculpture and Sculptors[4], 170.
Also see Neda Leipen, Athena Parthenos (Ontario: The Royal
Ontario Museum, 1971).

[7]K. Schefold, "Athene", AntK 14 (1971), 38-39. The
Boeotian grave stele of Polyxena is illustrated by Carl
Blümel in Die klassisch griechischen Skulpturen der Staat-
lichen Museen zu Berlin (Berlin: Akademie Verlag, 1966),
17-18, pl. 12.

[8]Lullies and Hirmer, Greek Sculpture[2], pls. 108-109;
also Ashmole and Yalouris, Olympia, pl. 153.

[9]Frank Brommer, Die Skulpturen der Parthenon Giebel
(Mainz: Philipp von Zabern, 1963), pls. 97-101.

[10]The name vase of the "Kekrops Painter", (Beazley, ARV2 1346, Kekrops 1) illustrated by Erika Simon in Die Götter der Griechen (Munich: Hirmer, 1969), 197, pl. 180, is one example.

[11]By the second century B.C., however, that arrangement may be used more for the sake of design than iconography, as in the Great Frieze of the Pergamon Altar, where Athena wears an angled aegis while battling with Alcyoneus.

[12]Inventory no. 50.11.1. See G.M.A. Richter, Handbook of the Greek Collection (Cambridge: Harvard University Press for the Metropolitan Museum, 1953), 81-82, fig. 61; dated ca. 460 B.C.

[13]Dorothy Kent Hill, Catalogue of Classical Bronze Sculpture in the Walters Art Gallery (Baltimore: Walters Art Gallery, 1949), no. 185, p. 86 and pl. 38; also Mitten and Doeringer, Master Bronzes, 96, no. 92.

[14]Although the Ince Athena is closely related to the Piraeus Athena, as we will see below, the owl in her hand cannot be used as evidence since that bird and the lower right arm are restorations.

[15]"Athena Archegetis in the Piraeus", AJA 67 (1963), 212. He sites the Scholiast on Aristophanes' Birds to support the connection between that aspect of Athena and her bird, "Athena Archegetis held an owl in the hand". See Scholia Aristophanica, Codex Ravennas, arranged and translated by William G. Rutherford (London: Macmillan, 1896), I, 463. The line is 516, not 535 as incorrectly printed in the AJA article. Also see R. Ross Holloway, A View of Greek Art (Providence, Rhode Island: Brown University Press, 1973), 174-5 and fig. 31.

[16]For a description of foreign residents in Delos and their deities, see W.A. Laidlaw, A History of Delos (Oxford: Basil Blackwell, 1933), 201-226.

[17]Since I have not been able to examine the inside of this head of Athena myself, I am especially grateful for verbal information from the restorers, who say that both the teeth and the eyes could have been set into their

respective braces only from the inside.

[18]Wet analysis made for Bruno Bearzi, published by Arthur Steinberg, "Joining Methods on Large Bronze Statues", Application of Science in Examination of Works of Art, William J. Young, ed. (Boston: Museum of Fine Arts, 1973), 108.

[19]Munich Glypothek 219 is the most complete copy. Illustrated by Richter, Sculpture and Sculptors4; pl. 704; also by Ohly, München, Skulpturen, 37-38, pl. 17.

[20]Papadimitriou described the statue as Attic, in the time of Praxiteles (noted by Orlandos in Ἔργον for 1959, 161-169, and by Daux in BCH 84 [1960] , 647). Proponents of the Kephisodotos attribution include A.A. Papajannopulos-Palaios," Πειραϊκή ἀρχαιολογία," Πολεμων Z' (1958/59), 30; Spyros Meletzis and Helen Papadakis, National Museum of Archaeology (Munich and Zurich: Schnell and Steiner, 1970), 11; Karl Schefold, "Athene", AntK 14 (1971), 40-41; and G.B. Waywell, "Athena Mattei", BSA 66 (1971), 378-380. Waywell realizes the statues we have and the ones mentioned by Pausanias and Pliny could not be the same, but he clings to the attribution to Kephisodotos by suggesting that the original (the Athena recovered in 1959) was replaced by a copy after the first-century destruction and that the literary references are to the copy, which continued to be connected with Kephisodotos. Waywell then dates the Athena ca. 375 B.C., which would fit with the only certain copy of a work by Kephisodotos, "Eirene and Plutos", dated ca. 375-370 B.C.

[21]Olga Palagia, "Εὐφρανορος Τέχνη." Ἀρχαιολογικά Ἀνάλεκτα ἐξ Ἀθηνῶν VI (1973), 323-329.

[22]Bronze statues by Euphranor listed by Pliny include an Athena ("The Minerva of Catulus"), Leto holding her new-born twins, a "Keybearer" (probably a priestess with a temple key), a colossal "Virtue", a colossal "Greece", and a woman in attitude of wonder and prayer.

[23]A. Furtwängler, Meisterwerke der Griechischen Plastik (Leipzig, 1893), English translation by Eugenie Sellers (New York, 1895), 348-364.

[24]Louvre no. 503. Discussed in relation to the
Piraeus Athena by K. Schefold, "Athene", AntK 14 (1971),
40, and by G.B. Waywell, "Athena Mattei", BSA 66 (1971),
373-382, pls. 66-72. Since archaeological and historical
evidence point so convincingly to 86 B.C. as the burial
date for the Piraeus cache, the Mattei copy must have been
made before that time if it is a direct copy. Enough
variations exist to show that the Mattei is not a mechanical
reproduction, but there is so much similarity that it is
logical to assume, as Waywell does, that it was made ca.
130-90 B.C. and is an early example of a Roman copy. Arguing
against this dating are the eyes of the Mattei statue,
which are drilled. A generally accepted rule of thumb has
been that drilled eyes do not appear until the second
century after Christ; however, the holes could have been
drilled at a later time--Roman or Renaissance, most likely--
to make the copy more stylish, as was done with other statues.
Another possibility is that the Mattei is copied from an
earlier copy of the Piraeus Athena.

[25]The Mattei Athena was first named "Athena Agorais"
by W. Fröhmer to denote her "market-place, gossipy expression."
See Notice de la Sculpture Antique du Musée National du
Louvre (Paris: Libraire des Imprimeries Réunies, 1899), I,
no. 121, p. 150.

[26]Ashmole, Ince, no. 8, pp. 8-9, pls. 10-11. The
original from which the Ince type is derived is generally
dated at the end of the fifth century B.C.

[27]Waywell has compiled a good list of various versions
of these types in his Appendix of Athenas that wear the
Corinthian helmet in "Athena Mattei", BSA 66, 380-382.

[28]W.H. Schuchhardt, Die Epochen der griechischen
Plastik (Baden-Baden: Bruno Grimm, 1959), pl. 96.

Selected Bibliography

Fröhner, W. Notice de la Sculpture Antique du Musee Imperial du Louvre I. Paris, 1869.

Orlandos, A.K. "Πειραιευς." Εργον (1959), 161-169.

Papajannopulos-Palaios, A.A. "Πειραϊκή αρχαιολογία." Πολεμων Z΄ (1958/59), 26-48.

Vanderpool, Eugene. "News Letter from Greece". AJA 64 (1960), 266.

Daux, Georges. "Chronique des Fouilles 1959". BCH 84 (1960), 647-655.

Holloway, R. Ross. "Athena Archegetis in the Piraeus". AJA 68 (1963), 212.

Picard C. Manuel d'Archéologie Grecque, La Sculpture, IV-2, 1095.

Paraskevaidis, Miltis. Ein Wiederentdecker Kunstraub der Antike? Piräusfund 1959). Lebendiges Altertum 17. Berlin: Akademie-Verlag, 1966, 32-36.

Hanfmann, George M.A. Classical Sculpture. London: Michael Joseph, 1967, no. 171.

Meletzis, Spyros and Papadakis, Helen. National Museum of Archaeology, Athens. Munich and Zurich: Schnell and Steiner, 1970.

Callipolitis, Vasilis G. "Nouvelles salles de sculpture au Musee National". AAA 4 (1971), 44-9.

Schefold, Karl. "Athena aus dem Piraeus.AntK 14 (1971), 37-42, pls. 15-16.

Waywell, G.B. "Athena Mattei". BSA 66 (1971), 373-382, pls. 66-72.

Kallipolitis, V.G. and Touloupa, E. Bronzes of the National Museum of Athens. Athens: Apollo Editions, (1971?).

Holloway, R. Ross. A View of Greek Art. Providence, Rhode
 Island: Brown University Press, 1973, 174.

Palagia, Olga. "Ευφρανορος Τεχνή." AAA 6 (1973), 323-329.

Steinberg, Arthur. "Joining Methods on Large Bronze Statues:
 Some Experiments in Ancient Technology". Application
 of Science in Examination of Works of Art, ed.
 William J. Young. Boston: The Museum of Fine Arts,
 1973, pp. 108, 110, 112, 113, 126.

Athens, National Museum, no. 15118. Netted in the Bay of
Marathon by fishers in 1925. Right foot broken apart at
instep, modern mend. Attribute missing from the right hand
and probably from the left hand. H.: 1.3 m. Th. of bronze:
0.003 m. Figs. 14.1-9.

The figure of a nude youth stands in a relaxed, S-curve
pose with his weight on his left leg. The statue is about
three-quarters the size of a full grown man.

Clear articulation of the body emphasizes the youthful,
softness of the physique, not yet developed into the body of
a mature man. Smooth, gradual transitions between the parts
of the slender body illustrate muscles not yet developed,
quite different in execution from the anatomical generalization
made by Archaic artists. The left hip tilts up with the
body's weight. The right leg is bent at the knee, and the
heel is lifted so that only the toes touch the base.

The youth's head is turned to his left and inclined
forward. His skull is capped with short, thick wavy locks,
represented in strongly three-dimensional shapes (fig. 14.4).
A fillet is tied around the head and knotted at the back; a
distinctive pointed-tongue ornament is centered at the front
of the band and curves forward. The mouth is relaxed and
the lips, apparently an inset of copper, are parted a little.

The brown irises survive in the inlaid whites of the eyes,
but the pupils are lost. The intense gaze is directed
toward the figure's left hand and the object which once
was there.

From a bend at the elbow slightly behind the waist,
the left arm extends forward horizontally. The palm is
turned up and held an article that was cast separately and
attached mechanically (fig. 14.5). Since the finger tips
and thumb are flattened to the edges and the lower wrist
appears to be unnaturally leveled, the object probably was
larger than the statue's palm.

The right arm is held out to the right and front of the
torso; the hand is higher than the head and out to the same
plane as the left hand. The position of the fingers (figs.
14.5-6) suggests that the figure was holding or pulling
something small or thin between the thumb and index finger.
The design of the right hand is particularly graceful; the
lyrical gesture expresses great sensitivity.

A mixture of intense concentration, expressed in the
gaze and attention drawn to the object once held on the
right palm, and the gentle and sensitive attitude, displayed
in the calm and graceful body, combine to portray a
sensitive and handsome youth absorbed in intellectual

curiosity. So great a gap is inflicted on the design of
the statue by the loss of whatever rested on the right hand
that what originally was the object of the youth's concern
must have appeared to be part of the youth himself.

Site

Since the statue was found in the Bay of Marathon
without its base, it probably comes from a shipwreck. No
official investigation of the site, however, has been made;
and further information about the context in which the
Marathon Youth was found awaits future excavation of the
underwater site.

Restoration and Technique

Heavy marine incrustations covered the statue when it
was discovered (figs. 14.8). Conservators at the National
Museum in Athens cleaned the statue and mended the front
part of the right foot. The arms are ancient, but the
possibility that they represent Roman work--perhaps repair
of early damage to the extended limbs--was raised during
the conservation process.[1]

Both the eyes and the lips are inset. The lips
probably are copper. The eyes are made of material of three

different colors to distinguish between the pupils (now
lost), the brown irises, and the whites. They are enframed
with lashes made of sheet metal.

Two openings in the bottom of the left foot (fig. 14.9)
would allow the insertion of dowels to attach the statue
to its base. The material filled in the openings and the
present dowel are modern.

Construction of the left hand (fig. 14.5) shows a
strong concern for anchoring the missing object, which
clearly was cast separately. It would be even more interesting
if further examination of the statue were able to establish
whether the arms are of the same date as the rest of the
statue.

Charbonneaux[2] reports that chemical analysis of the
bronze is different for the surface than for the interior
metal. The percentages he quotes for the crust are 89.6
percent copper, 7.6 percent tin, and 4.2 percent sulphur.
Charbonneaux describes the bronze itself as 88.5 percent
copper, 9.2 percent tin, and 2 percent sulphur.

Identification

While poses somewhat similar to that of the Marathon
Youth can be pointed out in other Classical figures, none

is close enough to be accepted as the same or even close
enough to identify the action of this statue.

At first glance, coins from Sicily with profile
representations of a river god[3] may seem to wear a diadem
like that of the Youth from Marathon. Closer examination,
however, reveals that the river god has two horns just
above his fillet rather than one pointed-tongue ornament at
the center of a fillet.[4]

Another possibility is that the Youth represents
Hermes.[5] The closest parallel I know for the unusual fillet,
however, is worn by Artemis in the Death of Aktaion scene
on the well-known bell krater by the Pan Painter in Boston.[6]

Both the pose and the fillet remain enigmatic, and the
identification of the statue is still a mystery.

The Marathon Youth has a soft, dreamy quality that
recalls the characteristics of Praxiteles,[7] so the statue
has been attributed to Praxiteles himself.[8] Whether or not
it is that master's work is a moot question, but certainly
the composition, the mode of representing subtle transitions
of planes, and the sensitive attitude of the Marathon Youth
can be compared with those of the Lizard Slayer.[9]

Like the Young Man from Antikythera, the Marathon Youth
is depicted in a spiral composition, which developed in the

last half of the fourth century probably under the influence
of Lysippos.

Most likely made in the third quarter of the fourth
century B.C., the statue cannot be definitely attributed
to a particular sculptor, but it does reflect the style of
Praxiteles.

Notes

[1] K.A. Rhomaios, " Ο ΕΦΗΒΟΣ ΤΟΥ ΜΑΡΑΘΩΝΟΣ," Δελτιον 1924-25, 145-187, pls. 2-4.

[2] Jean Charbonneaux, Greek Bronzes (New York: Viking, 1962), 23.

[3] Examples include a didrachm from Gela and a didrachm from Kamarina, published by G.K. Jenkins in Ancient Greek Coins (New York: G.P. Putnam's Sons, 1972), Nos. 384 and 426.

[4] Ibid., No. 424, for example.

[5] Reinhard Lullies discusses the Hermes identification in Lullies and Hirmer, Greek Sculpture[2], 93. The Hermes identification is also accepted by Hans Walter, Griechische Götter(Münich: Piper, 1971), 296 and fig. 276.

[6] Boston, Museum of Fine Arts, No. 10.185. See George H. Chase, Greek, Etruscan and Roman Art, revised with additions by Cornelius C. Vermeule III (Boston: Museum of Fine Arts, 1969), no. 90.

[7] For discussion of Praxiteles, see G.E. Rizzo, Prassitele (Milan/Rome: Treves, 1932), and G.M.A. Richter, Sculpture and Sculptors[4], 199-206.

[8] Rhys Carpenter, Greek Sculpture (Chicago: The University of Chicago Press, 1971), 171.

[9] For copies of the lost Lizard Slayer of Praxiteles, see especially the statues in the Vatican and the Louvre and the statuette in the Villa Albani, illustrated in Rizzo, Prassitele, as LIX, LX, and LXI respectively.

Select Bibliography

Rhomaios, K.A. "Ο ΕΦΗΒΟΣ ΤΟΥ ΜΑΡΑΘΩΝΟΣ." Δελτιου
 1924-25, 145-187, pls. 2-4.

_____. "Der Knabe von Marathon". Antike Denkmäler, IV,
 54-56, pls. 30-37.

Rizzo, G.E. Prassitele. (Milan/Rome: Treves, 1932), 43-44.

Lullies, R. and Hirmer, M. Greek Sculpture[2], no. 221-222
 and pl. VII.

Carpenter, Rhys. Greek Sculpture (Chicago: University of
 Chicago Press, 1960; second impression, 1971), 170,
 171, 175.

Hanfmann, G.M.A. Classical Sculpture, no. 157.

Ashmole, Bernard. Art of the Ancient World (New York:
 Abrams, 1973?), 345.

Now in the National Museum in Athens, to be moved to the
Piraeus Museum when it reopens. Museum number not yet
assigned. Found July 25, 1959, during salvage excavation
in the Piraeus. Badly corroded. Numerous pieces broken off,
including the left arm, have been re-attached; various
small pieces lost. Attributes missing from both hands.
H.: 1.55 m. Figs. 15.1-4.

Artemis II, the smaller of the two bronze statues of
this goddess from the Piraeus find, is slightly less than
life-size. She is oriented toward her right; her head is
turned toward and inclined in the general direction of her
outstretched right hand, emphasizing the gesture and the
object that she held, as well as indicating that this
probably was the principal or initial viewing point. From
this vantage point, the graceful S-curve and twist of her
body is most apparent.

Body and drapery are thoroughly naturalistic. Both arms
swing a little further away from the body than do those of
any other figures from the same find, and the quiver is
placed where it will project noticeably at a diagonal.
Restoration of a bow (see below, p.246) held horizontally
in her left hand (angled more and held out further than
that of Artemis I) would increase the space penetrated by

the statue and emphasize the diagonal swing. Basically the
statue is a self-contained erect cylinder, but the diagonal,
swinging rhythm and movement into space give a free, light
effect not usual in Classical sculpture until the late
fourth century.

The length of her elegant oval head is emphasized by
the upswept hair style, although it is now distorted by the
poor condition of the bronze. Her curly hair is expressed in
strongly three-dimensional strands and pulled up into a
knot at the top of her head. A center part from forehead to
nape separates the hair, but the division is blurred by
the lively curls and the knot. It is a hair style popular
in the last half of the fourth century, seen on both female
figures and Apollo.[1]

Eyebrows are defined by demarcation of the ridges above
the eye sockets, but there is no inserted material or
incised lines to describe them. Inlaid eyes of white marble
and brown stone (onyx?), from which the pupils are missing,
have been set into bronze envelopes with fringed edges which
form the lashes. The left is in better condition than the
right. Her long narrow nose has a bump at the tip above the
flaring nostrils. Behind her parted lips is a white
indistinguishable mass, the remains of inset teeth. Holes in

both ear lobes show that she wore earrings, and smooth
bands on both upper arms indicate that bracelets were there.[2]
Perhaps the jewelry was gilded bronze or gold.

Her right arm is extended in front and to the right;
it is bent at the elbow so that the lower arm is horizontal.
The right palm, held toward the viewer, is midway between
horizontal and perpendicular, as is that of the larger
Piraeus bronze Artemis. A portion of a curved rim remains
at the base of her thumb, which also is missing from the
first joint; there is a small (0.005 m.) hole in the center
of her palm for attaching the object she held. The fragmented
rim is similar to those still in the hands of the Piraeus
Apollo and the Piraeus Artemis I and, like them, probably
is part of a phiale rim.[3] Her left arm swings at her side,
straight to the elbow, then bends forward so most of the
hand is in front of her body. Reconstruction of a bow in
her left hand can be made on the basis of the tunnel formed
by the thumb and first two fingers. The last two fingers,
not needed to support the bow in this relaxed grip, curve
into the palm. The curved middle finger extends further than
the other fingers, as does the corresponding finger of
Artemis I, and looks as though it might once have held an
arrow parallel with her bow.

Artemis II wears a richly draped peplos, with an
overfold which covers her hips. A bunched cloak is wrapped
over her left shoulder, across her back, under then over
her right shoulder, returned to the back, and tucked under
itself.[4] It falls to mid-thigh at her left side over the
weight-carrying leg which is virtually hidden behind thick
peplos folds, counterbalancing her emphasized right leg
which is bent at the knee and stepped to the side. Part of
her right foot breaks the peplos hem. She wears a sandal
with medium thick sole; a metal crosspiece[5] remains between
and above the two big toes. Only one toe of her left foot
is extant; it is below the central heavy fold over that leg.

A belt tied in a square knot at the front encircles
her waist on top of the peplos overfold but under the cloak.
At least the knot and loose ends--and perhaps the entire
belt--were made separately from the torso by a hammering
and cutting technique. The curved left end of the belt
extends down at about a 45 degree angle and slightly out
for 0.09 m. past the square knot; the right end is lost.

A quiver strap crosses her chest from right shoulder
to left side of her waist, going over the cloak and part
of the belt as well as the peplos. Decorated with a meander
and dot pattern inlaid in silver[6], the quiver strap is one

of the best extant example of decorative metal inlay on ancient Greek large metal sculpture.

Originally the quiver may have been designed to fit a depression that is at a sharper angle and higher on the cloak than the position it now occupies is, but it was soldered into its present location in ancient times. The channel is about 30 degrees down from a central perpendicular axis; now the quiver is about 60 degrees down from a perpendicular axis. Perhaps early damage or a change in design prompted the present lower location. The quiver, a common fourth-century design,[7] still projects above the right shoulder.

Although the burial environment was the same as that of the well-preserved Piraeus Athena, in whose arms she was found (fig. 15.3), Piraeus Artemis II is most corroded of all the bronze statues from the 1959 find. Some of this bronze has crumbled, nearly disintegrating into powder, and elsewhere it has badly separated into layers, like a bar of soap left too long in water. An outer layer of bronze has broken from several areas on the arms; Kallipolitis, therefore, describes the arms as having been made in two layers.[8] Expansion of the bronze is particularly noticeable at the right side of her face, especially disfiguring from

the upper forehead, across the corner of her eye, to the ear. The left side of the face suffers from a wide crack running from the middle of the lower left side of her chin across to the cheek. Many losses, such as four toes of her left foot, appear to have occured as the result of disintegration rather than breakage. The statue is now held together and strengthened enough by infusion of an acetone solution to be displayed over a modern metal framework. This bronze corroded so differently from that of the other statues in the same find that its original alloy would appear to have varied from the composition of the bronze in the Piraeus Apollo, the Piraeus Artemis I, and the Piraeus Athena. Especially dramatic is the difference between the bronze of the Artemis II and that of the Athena since their burial environment was identical (fig. 15.3). Preliminary metallurgical analysis, however, indicates almost the same alloy. Bronze of the Piraeus Artemis II tests as 86 percent copper, 12 percent tin, and 1 percent lead; the alloy of the Athena tests as 87 percent copper, 11 percent tin, and 1 percent lead.[9]

The bronze walls were thin, perhaps even thinner in places than those of the larger Artemis I and the Athena, although accurate measurements are no longer possible

because of the poor state of preservations.[10] Like other
firmly documented Greek large bronze statues, Artemis is
made of separately cast pieces of bronze joined metallurgically
by lead solder. Like the Athena and the Artemis I of the
same find, overlapping drapery is depicted with much
naturalism by overlapping separate pieces of bronze. Her
inset eyes and teeth, although now badly damaged also seem
to have been made in the same technique as the corresponding
pieces of the larger Artemis and the Athena from the Piraeus.

Underneath deep cracks and breaks of the folded cloak,
the peplos can be seen, clearly demonstrating that the
statue is not a shell. This statue cannot, therefore, have
been cast in one piece and cannot have been made in the
negative technique from another statue or a whole model. It
would be possible to construct this form by the negative
method only if the model were a similar complicated form
of separate pieces made like a three-dimensional puzzle.
Kluge's widely-accepted concept of a wooden model sawed
into pieces could not produce this result.[11]

Similarity in construction and basic design but with
greater complexities closely links Artemis II to the
tradition of the other goddesses from the Piraeus, although
at a somewhat later time. Stylistic comparisons link her,

too, to the fourth century, but to the later part of it.
Artemis II can be safely assigned to the last third of the
fourth century. She shares grace with the Piraeus Athena
and Artemis I, but her expression of charm and lightness
contrasts with their serious compassion.

Notes

[1]This top-knotted hair style is found primarily on
statues assigned to the latter part of the fourth century
B.C. It is worn by the woman represented in an original
marble figure now in New York, that is thought to be from
a grave monument (Metropolitan Museum, No. 42.11.2; illustrated
in G.M.A. Richter, Catalogue of Greek Sculpture in the
Metropolitan Museum of Art, Cambridge: Harvard University
Press, 1954, no. 94 and pls. LXXVI-LXXVII. Two marble heads
in Athens (National Museum, nos. 191 and 192) which reflect
the style of the fourth century are coifed in the same
manner. Roman copies of fourth century Greek Apollo figures
with hair arranged in this way include the Apollo from
Antium (Rome, Terme Museum, No. 121302; illustrated in
Picard, Manuel IV-2, fig. 399) and a head in Venice from
the Grimani Collection (Picard, Manuel IV-2, figs. 400-401).

[2]Marks of the bracelet bands are difficult to measure
because of the poor preservation of the bronze; they seem
to be between 0.06 and 0.08 m. wide.

[3]See figs. 12.6 and 12.7 for models upon which to
base reconstruction of this statue, as well as the larger
bronze Artemis from Piraeus. The representation by the
Oinomaos Painter of a statue of Artemis with bow and phiale
is his name piece in Naples, Museo Archaeologico, 2200
(Beazley, ARV[2], 1440, Oinomaos 1). The gem in Leningrad is
published by J. Boardman, Greek Gems and Finger Rings
(London: Thames and Hudson, 1970), 290, pl. 533.

[4]An unpublished bronze statuette of Artemis found in
the sea off Mykonos in 1959 (Athens, National Museum,
No. 16790) wears a cloak in exactly the same way.

[5]The sandal sole is 0.015 m. thick; the vertical
arm of the metal crosspiece is 0.04 m. long and the short
arm measures 0.015 m.

[6]Identification of the silver has only been made by
sight; no chemical analysis has been made to determine the
alloy of the metal, which is well preserved. The metal was
cut into pieces to fit the holes and the meander sides,
the divisions of which can be easily seen. The dots are

0.005 m. in diameter; the sides of the meander are 0.012
m. across. Fragments of similar coldwork inset meander
decorations have been ·found at Olympia and are described
and illustrated in the forthcoming volume on fragments of
large bronze sculpture at Olympia by P.C. Bol in the
Olympische Forschungen series.

[7]The quiver with lid is 0.43 m. long and 0.05 m. in
diameter. A quiver like this one is worn by Artemis on
the great frieze of the Pergamon Altar, illustrated in
Bieber, Hellenistic Age, fig. 463. The statuette from
Mykonos (see note 4 above) is equipped with the same type
of quiver, as is the mid-fourth century Artemis seen in a
Roman copy at Dresden (Rizzo, Prassiteles, pl. XVII),
although the Roman copy has a tie at the center.

[8]V.G. Kallipolitis, "'Εθνικόν 'Αρχαιολογικόν Μουσεῖον,"
'Αρχαιολογικόν Δελτίον 26 for 1971 (1974), 6-7.

[9]See the analysis made for Bruno Bearzi, published
by Arthur Steinberg in "Joining Methods on Large Bronze
Statues: Some Experiments in Ancient Technology", Application
of Science in Examination of Works of Art, ed. by William J.
Young (Boston: The Museum of Fine Arts, 1973), 108.

[10]In its present swollen condition the visible
bronze walls vary between 0.005 and 0.02 m., depending
upon the fall and placement of the drapery, which is thickest
at stress and support points, such as the base.

[11]Karl Kluge, "Die Gestaltung des Erzes in der
archaisch-griechischen Kunst", JdI 44 (1929), 1-30.

Selected Bibliography

Orlandos, A.K. "Πειραιευς." Εργον (1959), 161-169.

Vanderpool, Eugene. "News Letter from Greece". AJA 64 (1960), 266.

Picard, C. Manuel IV-2, 1095, fig. 429.

Paraskevaides, Miltis. Ein Wiederentdecker Kunstraub der Antike? Piräusfund 1959. Berlin: Akademie-Verlag, 1966, 37-38.

Varousfakis, G. and Stathis, E.C. "A Contribution to the Study of the Corrosion of Ancient Bronzes". Metallurgia 83, No. 499 (May, 1971), 141-144.

Steinberg, Arthur. "Joining Methods on Large Bronze Statues: Some Experiments in Ancient Technology". Application of Science in Examination of Works of Art, Proceedings of the Seminar Conducted by the Research Laboratory of The Museum of Fine Arts, Boston, Mass., June 15-19, 1970. Boston: The Museum of Fine Arts, 1973, 108, 111.

Kallipolitis, V.G. "Εθνικόν 'Αρχαιολογοκόν Μουσεῖον. 'Αρχαιολογικόν "Δελτίον 26 for 1971 (1974), 6-7, pls. 2-3.

Agora Museum, Athens. Fragments of a gilded equestrian
statue were excavated in the northwest area of the Athenian
Agora during June, 1971, in a well that had been used as a
dump about 200 B.C.[1] Pieces of the life-size horseman--a
left leg, two pieces of drapery, and a sword--and of a
double palmette are dark green bronze with traces of gold
covering. A small winged Pegasos of solid bronze found with
the other fragments of the monument probably belongs with
them; its original surface is lost. The fragments are:

1. Leg, inv. no. B 1348; max. L. (from toe to broken top of
 thigh at front): 0.94 m.; L. of foot: 0.255 m.; max. W.:
 0.22; bronze th. at thigh: 0.03 m. (figs. 16.1 and 16.2).
2. First drapery piece, inv. no. B 1383; max. H.: 0.0405 m.;
 max. W,: 0.21 m.; bronze th.: 0.2 to 0.002 m. (fig. 16.3b).
3. Second drapery piece, inv. no. B 1385; max. L.: 0.555 m.;
 max. W.: 0.095 m.; bronze th.: 0.005 m. (fig. 16.3a).
4. Sword and scabbard, inv. no. B 1382; L.: 0.875 m.; W. at
 hilt: 0.15 m.; W. at blade: 0.055m.; th. of blade: 0.015
 m. (fig. 16.4).
5. Bronze strap, inv. no. not yet assigned (Excavation no.
 B 1764-B); L.: 0.221 m.; W.: 0.037; th.: 0.003 m.
 Photograph not yet available.
6. Larger palmette, inv. no. B 1386a; H.: 0.275 m.; W.:
 0.153 m.; th.: 0.005 m. (figs. 16.5 and 16.6).
7. Smaller palmette, inv. no. B 1386b; H.: 0.205 m.; w.:
 0.096m.; th.: 0.004 m. (fig. 16.6).
8. Palmette leaf, inv. no. not yet assigned (Excavation no.
 B 1763); H.: 0.11 m.; max. W.: 0.32; th.: 0.004.
 Photograph not available.

9. Winged Pegasos, inv. no. not yet assigned (Excavation no.
 B 1765); preserved H. to head: 0.07 m.; preserved H. to
 wing tip: 0.092 m.; preserved L.: 0.15 m.; preserved max.
 th. of body without wings: 0.03 m.; preserved max. th.
 of body with preserved wings: 0.09 m. Photograph not
 available.

Important evidence both for gilded statues and for monumental
equestrian statues in ancient Greece is available from these
fragments. They may yield valuable artistic information about
late Classical Greek sculpture, and even in their broken
condition, the pieces have great aesthetic worth.

The Leg and the Clothing

The leg is complete down from a break at mid-thigh.
Well-developed muscles indicate a powerful, mature man. The
leg carries no weight; the knee bends almost at a right
angle and the toes hang down further than the heel in the
relaxed position of a horseman.

A complex, multi-thonged sandal is the only covering
on his leg. A heavy-duty leather sole, which curves in
between the first two toes, is held firmly in place by a
mesh of thongs that encase the foot and ankle. The thongs
converge into two pairs that are knotted separately in

front, just above the ankle. There is no tongue over the
instep, but an elongated triangular one runs up the back
from the bottom of the heel to above the ankle. The center
lacing over the instep and the tie for the small spur at
the back are slightly wider (0.01 m.) than the other thongs
(0.004 m.). Sandals of this style were common from the mid-
fourth century through the third century B.C. Sandals of a
similar style are worn by Hades on a sculptured column drum
from the Temple of Artemis at Ephesos and by the statue of
Mausolos from the Mausoleum. Sisyphos I and Aknonios from
the Daochos group at Delphi wear the same style, and the
sandal of Sisyphos I also has a triangular tongue at the
back. A foot from the Antikythera wreck (cargo ranging from
fourth to first centuries B.C.) is shod similarly, but its
even wider central lacing suggests a slightly later date.
The closest comparison is found on a bronze statuette from
Herculaneum which probably is a Roman copy of an early
Hellenistic statue (fig. 16.7); it is identified as
Demetrios Poliorketes.[2]

The hollow-cast leg exists in the round from the foot
to the place where the swelling of the calf becomes
pronounced; there it is open on the inside where it would
have been touching the horse.[3] Edges of the cut-away section

are flat and parallel, so that they could lie flat against
the horse's flanks. Traces of lead solder still adhere
around the edges; it is thicker on the front side.

Part of a bronze flange still exists circling the thigh
at the rear edge and just below the edge at the front.[4] It
probably was used to attach drapery to the leg, holding the
drapery out from the body.

On the rough inside of the bronze wall, marks of a
flat-bladed chisel can be seen running horizontally along
the top front corner in an area which seems to be an ancient
patch which was too thick; chisel marks of the same kind
have worked a small area above the knee.[5] Other tool marks,
scarcely more than scratches, run horizontally down the leg;
they might have happened when the core was being removed.
Both the marks made by the chisel and by the pointed tool
appear to have been cut into the bronze itself as coldwork.

As it now exists, the leg probably represents two castings
joined by a lead weld. A ring of soldering material 0.23 m.
above the bottom of the foot indicates that the foot and
ankle (including the entire sandal) were cast separately
from the calf and thigh.

Both pieces of drapery seem to be part of a cloak which
hung from the rider's shoulders. The fabric is heavy and of

fine quality, probably wool. One fragment (fig. 16.3b)
represents the bottom edge of draped fabric closely gathered
at the top and spreading out to about two-thirds of its
width, which would be ca. 0.27 m. if it were flat; both
bottom corners have spherical weights. The longer and narrower
fragment (fig.163a) represents the side edge of the fabric,
falling in an S-fold. The material falls in the relaxed,
graceful manner familiar in fourth-century sculpture, which
at first glance may appear to be naturalistic but on closer
inspection is seen to be a careful design arranged by the
artist.

The Sword

The big sword in a scabbard is also life size and
was gilded. From a cylindrical pommel with flaring rims at
both top and bottom, the hilt swells to a wide cross-guard
that arches slightly over the wide blade. The sheath ends
in a chape nearly as wide as the cross-guard.

An actual sword of this type in iron (but without its
scabbard) was found in a tomb near the Mausoleum at
Halikarnassos.[6] Salvaged from the Antikythera wreck are two
sheathed bronze swords from statues which are almost
identical to the Athenian Agora sword and scabbard except

that the Antikythera ones have incised decoration instead
of gilding.[7]

This distinctively shaped big sword and scabbard is
a type which appears in the Greek world from the beginning
of the fifth century and continues through the first century
B.C. It was known to Attic vase painters in the early fifth
century B.C.: Euthymides shows it being carried by Peirithoos,
the Lapith chief, as he helps Theseus kidnap Korone;[8] the Berlin
Painter shows Memnon, a Trojan, wearing a similar scabbard
and brandishing a short sword in combat with Achilles;[9] and
the Pan Painter shows Actaeon, who was of Theban origin,
wearing one at his death.[10] In the east, important sculptural
reliefs from the fourth through second centuries B.C. show
a sword of this particular design: a winged figure on a
sculptured column drum from the Temple of Artemis at Ephesos
wears it, Ilias holds one in the lower register of the
Apotheosis of Homer relief from Priene, and it appears on
the Telephos frieze of the Pergamon Altar.[11] Continued use
and popularity of the design is attested into the second and
first centuries B.C. by coins from Pontus and Caria.[12]

Since Attic vase painters most often depicted this
type of sword--cruciform with a scabbard that ends
in a fat strawberry chape--as the equipment of non-Attic

figures, it probably was not a typical Athenian weapon.
The striking preponderance of eastern illustrations of this
type of sword and scabbard suggests that its use centered
in the Greek East.

The Palmettes

Both flaming palmettes are quarter-oval in shape and
have five S-shaped leaves which curve upward and inward at
the tips. Each leaf has slightly raised edges and a vein
down the center. The leaves are separated from each other
by grooves (0.003 m. wide and 0.002 m. deep), which are
part of the design and appear to have been made on the
model, although they would have been at least cleaned out
by coldwork.

Three holes for attachment, arranged in an L-shape,
occur on both palmettes. Holes in the larger palmette are
slightly bigger than those in the smaller one, but they are
in exactly the same position.[13] A groove on the front of
the larger palmette fits a ridge on the back of the smaller
one. Although cast separately and now broken apart, the two
palmettes are designed to fit together, the smaller one on
top of the larger. The shape of the palmettes conforms with
those dated to the last quarter of the fourth century B.C. by

Möbius in his basic discussion of comparable examples.[14]

Since the palmettes were the only other sizeable bronze objects found in the well and since they were gilded in the same way as the figure fragments, they surely belong with them. It is possible that they were ornament for the horse; however, the sculptured palmette is usually an architectural member, suggesting that the monument may have been more than a horse and rider. Flaming palmettes were especially popular decoration for stelai in the fourth century B.C., and these palmettes (completed by a mirror-image right half) may have been part of a stele identifying or describing the person or event honored by the monument. A late fourth-century stele in Athens offers an example for such a reconstruction.[15]

Technique

The bronze was never meant to be seen; it is the support for the gilded surface. Nevertheless, it was necessary to form the bronze as carefully as if it were the surface since the gold foil was a thin skin, the configuration of which was determined by the bronze. The statue would probably have been known as a golden one, rather than a bronze one.[16] Gold is too soft to use as the basic metal for a statue of

this size; in addition, of course, difference in the cost

of the metals would make a gold statue much more expensive

than a bronze one covered with gold. Even the foil was not

solid gold; it is gold-plated silver.[17]

All the fragments are covered with a network of grooves

(ca. 0.002 m. wide and 0.001 m. deep), some of which appear

to have been scratched on the surface after casting, while

others appear to have been cut into the model before casting.

The grooves were used to secure the gilded surface. Thin

sheets of gold (ca. 0.0005 m. thick) slightly larger than

each space outlined by the grooves were shaped around the

bronze and their edges tucked into the grooves. Shear

describes the technique:

> The edges of two adjacent plates would be
> bent into the same slot and locked in
> place by a strip of gold wire, measuring
> 0.0015 m. to 0.0025 m. in thickness.
> Much of this wire remains in place in the
> channels and can be seen most clearly
> around the ankle and along the edges
> of the sword. The arrangement of the
> channels and wire seams enables us to
> determine the number of separate gold
> plates used to cover each piece: 9
> for the leg, 5 and 6 respectively for
> the smaller and larger pieces of
> drapery, and no less than 23 for the
> sword. The size and shape of the plates
> seem to have been determined largely
> for technical reasons. While two large
> plates sufficed to cover the nearly

> cylindrical mass of the lower leg, four
> smaller plates of irregular shapes
> were used to gild the more complex
> modeling about the thigh and the bend
> of the knee. In the case of the sword,
> not only the surface of each face but
> the narrow edges as well were sheathed
> with separate plates often of very
> small size. Three or four of the actual
> plates are preserved intact along the
> edges of the hilt.[18]

In some places the gold which remains in the grooves is so

thick that it forms ridges above the bronze surface. Some

of the thin gold skin remains in places where it was difficult

to remove--such as around the ball weights for the fabric

and between the sandal thongs--and in triangular patches

where it was torn, but most of the gilding was ripped off

before the pieces of the broken statue were thrown down the

well.

Since the placement of the grooves was determined by

whatever shape and size would fit the gilder's purposes,

not by the artistic design, we know that the covering was

not meant to be removable as was true in fifth-century

figures such as the Athena Parthenos and the Agora Nike.

Unlike them, this statue did not represent part of a gold

treasury but rather a lavish expenditure.

Superb craftsmanship is represented in these statue

parts. The weld between the foot and calf and the patch at
the upper front of the thigh are invisible from the outside.
Such thin yet strong walls of bronze reflect a metal-working
tradition of great skill and knowledge. Construction
combining hollow-cast and piece-cast parts is in the Classical
Greek tradition. Gilding technique is developed from that of
the fifth century, but its "permanent" application tells of
a change of attitude toward the city's treasury as well as
about the glorification of a mortal person.

Equestrian Figures in Greek Art

　　　Equestrian figures are found in Greek art in both
painting and small sculpture, as early as Geometric times.
Half and three-quarter life-size horsemen in marble are
known from Archaic and Early Classical times (the most famous,
of course, being the Rampin Rider), and both extant statue
bases and literary references tell us of horse and rider
representations in Classical and Hellenistic times. From a
later Hellenistic sculptor, we have the famous find from the
sea near Artemision, the boy jockey who has recently been
reunited with his horse.[19] The Agora Equestrian, however, is
the earliest extant example we have of a fully life-size

horseman in Greek art. In addition, it is the earliest
example yet found in the tradition of monumental bronze
equestrian statues, gilded or ungilded, a widespread and
unchanged form of honorary monument which continued until
the twentieth century of our era.

We know little about monumental equestrian portrait
statues before the second century B.C. It is certain,
however, that the form definitely was used in Athens by the
late fourth century B.C. Equestrian statues are recorded of
Demetrios of Phaleron, who was in power in Athens between
318/7 and 308/7 B.C.; Diogenes Laertius reports,[20]

> Demetrius, the son of Phanostratus, was
> a native of Phalerum. ...by his speeches
> in the Athenian assembly he held the
> chief power in the State for ten years
> and was decreed 360 bronze statues,
> most of them representing him either on
> horseback or else driving a chariot or
> a pair of horses.

Even if the number is exaggerated to suggest that a statue
of Demetrios was erected for every day of the year at a
time when the year contained 360 days,[21] the story gives
evidence for late fourth century B.C. equestrian portraits.

Three monumental equestrian statues are recorded in
the Athenian Agora before 200 B.C.; all are from the last

years of the fourth century and the first years of the
third century B.C. Asandros, Macedonian satrap of Caria who
brought ships and troops to aid Demetrios of Phaleron in
Athens, was granted permission in 314/3 B.C. to erect a
bronze statue of himself in the Agora. After Demetrios
Poliorketes liberated Athens with his father in 307 B.C.,
he was paid extravagant honors which included erection of
two statues of him in the Agora, one of which was an
equestrian monument voted by his "volunteer picked troops",
ca. 304 B.C. The third was of Audoleon, king of the Paionians,
who was voted various honors including a bronze equestrian
monument in 285/4 B.C. as appreciation for his donations to
the temples and troops of Athens and his gift of a vast
amount of wheat to the city.[22]

There is, therefore, clear evidence that the equestrian
portrait was established in Greece by the end of the fourth
century B.C. and was a popular monument form in the last
years of the fourth century and first years of the third
century B.C.

Dating

Archaeological evidence sets a terminus ante quem of
ca. 200 B.C. for this statue because pottery found in the

well is of that time.[23] Epigraphical and literary records,
together with historical conditions and knowledge of early
equestrian monuments, point to a date at the end of the
fourth century or the first decades of the third century
B.C. for this statue. Stylistic and technical information,
as well as the design of the sandal and sword, support this
early Hellenistic dating.

Identification

The equestrian character of the statue is confirmed
by the position of the leg and the cutaway construction
enabling the leg to fit against a horse flank. Since the
early Hellenistic equestrian portraits which we know
represent contemporary political leaders, we could assume
that this one does, too. Since it was found in the Athenian
Agora and probably stood there, it must represent someone
who was an Athenian leader or benefactor. Since we know of
only a few, important men honored by such a major monument,
the person commemorated by this statue must have been of
considerable importance.

Although not enough has been found of this statue to
allow positive identification of the person it represents,
there are four strong candidates: Demetrios of Phaleron,

Asandros, Demetrios Poliorketes, and Audoleon. Even if

the actual number of statues decreed for Demetrios of

Phaleron were only half as many as "360" recorded by Diogenes

Laertius, it is possible that at least one of them stood in

the Athenian Agora. Equestrian statues in the Agora of the

other three men are known from epigraphical evidence

described above (p. 225-227).

 Violent destruction of the bronze statues of Demetrios

of Phaleron took place at the time of Demetrios Poliorketes.

In the account of Diogenes Laertius,[24]

> For all his [Demetrios of Phaleron's]
> popularity with the Athenians he
> nevertheless suffered eclipse through
> all-devouring envy. Having been
> indicted by some persons on a capital
> charge, he let judgement go by default;
> and, when his accusers could not get
> hold of his person, they disgorged
> their venom on the bronze of his
> statues. These they tore down from their
> pedestals; some were sold, broken up
> to make bedroom utensils [chamberpots]
> Only one is preserved on the Acropolis.
> In his Miscellaneous History Favorinus
> tells us that the Athenians did this
> at the bidding of King Demetrius
> [Demetrios Poliorketes].

Although the willful destruction of the Agora Horseman would

seem to match that of the bronze statues of Demetrios of

Phaleron, the context in which the Agora fragments were

found is one hundred years later than what would fit with
the late fourth-century demolition date for the Demetrios
of Phaleron statues.

Time and place of destruction favor the statue's being
of an ancestor of Philip V. Disgusted with Philip by 200 B.C.,
the Athenians decreed that "all statues and pictures as well
of Philip as of all his ancestors in both the male and
female line should be taken and destroyed..."[25] Surely
statues of Demetrios Poliorketes,[26] great-grandfather and
most colorful ancestor of Philip, would have been among
the first attacked. It is possible, of course, that the
statues of Asandros and Audoleon were destroyed at the same
time since they were Macedonians, too; but it is not as
certain since neither were ancestors of Philip and both,
in fact, were honored for acts hostile to his ancestors.

Of the three equestrian statues known to have stood in
the Athenian Agora before the second century B.C., two--those
of Asandros and of Audoleon--are known from inscription to
have been of bronze,[27] a description not made of that of
that of Demetrios Poliorketes and not fitting for a gilded
statue.

Since gilded or "gold" statues were usually made only
of the gods in Classical times, the very fact that the Agora

statue was gilded also argues in favor of an identification
as Demetrios Poliorketes. He and his father were the only
deified rulers of Athens during the range of time in which
this statue was erected. Demetrios gladly accepted and
promoted his role as a divinity, which is illustrated by
his imitation of Alexander's adoption of the ram's horns of
Zeus Ammon in having himself depicted with the horns of a
bull.[28] His flamboyant style of living makes it easy to
believe that he would encourage erection of golden statues
of himself. We know that the Athenians permitted the erection
of at least one gilded statue of Demetrios--the only other
certain gold monument from this time--and it is quite
conceivable that they included a second in the honors
heaped upon their deified king in residence, which ranged
from naming a tribe for him to allowing him to use the
Parthenon as his residence.

Identification of the statue is closely narrowed by
what we have established about it: the early Hellenistic
dating and the destruction date of ca. 200 B.C., the sword
especially popular in the Greek East during the fourth and
third centuries, sandals of a mid-fourth through third-
century style with closest parallel in a statuette identified
as Demetrios Poliorketes, the armed equestrian pose, and the

medium of gold. All of these characteristics are appropriate
for one person in particular, Demetrios Poliorketes. The
added force of the equestrian inscription makes a strong
case for identifying this earliest example of an honorary
equestrian monument as Demetrios Poliorketes and dating it
ca. 304 B.C.

Attribution

Notable Greek sculptors probably active at the end of
the fourth century include Silanion, Sthennis, Eukleides of
Athens, and Aristodemos. In addition, there were at least
five important sculptors from the school of Lysippos:
Lysistratos, Eutychides, Chares, Euthykrates, and Teisikrates.
Although the exact dates of the leading fourth-century
sculptor of bronze are uncertain, Lysippos himself is known
still to have been active during the last decade of the
century.[29]

The composition of a statuette in Naples, which probably
is a copy of a figure from the Granikos monument by Lysippos,[30]
and what we know of the composition of the Athenian Agora
equestrian statue are strikingly close. The position of the
left leg, the style of the sandal, and the arrangement and
description of the drapery are virtually identical.

Even though we have only fragments of the Agora statue, there can be no doubt that the quality of both the artistic form and the metalworking technique represents the work of a master. Nevertheless, I believe there is not now sufficient evidence available to attribute the Agora Horseman with certainty to a particular artist.

Conclusion

Although only fragments have been found of the gilded Agora Equestrian, they are some of the most interesting pieces of ancient Greek sculpture in metal which are known to us. They provide us with definite knowledge that the Greeks did gild monumental statues in a permanent way, not just in removable gold plates of the kind which were on the Agora Nike and major monuments such as the Athena Parthenos; they also provide much technical information about such gilding. These pieces are the only extant visual evidence we have which can be connected with inscriptions of portraits of living people or with life-size equestrian statues in ancient Greek times. We have been able to establish that the monument dates to the end of the fourth or perhaps the first years of the third century B.C. and it must have been destroyed about 200 B.C. Despite the fact that we have such a small

amount of the monument and do not have the head, we can

tentatively identify it as representing Demetrios Poliorkete

On the bases of the time in which the monument was made,

the high quality of workmanship, and the artistic style,

the sculpture can be connected with the School of Lysippos,

perhaps as the only extant work by that master himself. In

view of what we have been able to learn from these important

and excellent pieces, we should strongly hope that more of

the monument will come to light in another well in the

Athenian Agora.

Notes

[1]T. Leslie Shear, Jr., "The Athenian Agora: Excavations of 1971", Hesperia 42 (1973), 165-168 and pl. 36.

[2]See Bieber, Hellenistic Age[2], fig. 67 for the "Hades" at Ephesos illustration and fig. 249 for the statue of Mausolos. The Daochos group figures are illustrated by Tobias Dohrn in "Marmor-Standbilder des Daochos-Weihgeschenks in Delphi", Antike Plastik VIII (1968), pls. 26 and 30-31. The Antikythera sandal is illustrated by Bol, Antikythera, pl. 56, figs. 5-6. The statuette of Demetrios Poliorketes is fig. 149 in Bieber, Hellenistic Age[2]; the attribution is also accepted by Richter in The Portraits of the Greeks (London: Phaidon, 1965 and 1971), III, 256, and Supplement 21. As Shear has pointed out, the sandal type (called a krepis) is almost a shoe; see Konrad Erbacher, Griechisches Schuhwerk (Würzburg: F. Staudenraus, 1914), 39-43, fig. 10. The chronology of sandal types set up by Mary Wallace in "Sutor supra crepidam", AJA 44 (1940), 213-221, can be moved somewhat earlier in light of discoveries made since her work.

[3]The cut-away begins 0.33 m. up from the bottom of the foot; it widens to 0.22 m. (almost the full diameter at mid-thigh) at the top.

[4]The flange around the thigh is 0.003 m. thick; its extant width varies from 0.014 to 0.004 m.

[5]The chisel strokes are 0.008 m. wide and average about 0.03 m. long. The ancient patch at the top forward corner is 0.16 m. long and ca. 0.04 m. wide. The vertical area is 0.025 m. in diameter and 0.07 m. from the top edge.

[6]No. 270a, fig. 94, in A Guide to the Exhibition Illustrating Greek and Roman Life, 3rd ed. (London: British Museum, 1929).

[7]Athens, National Museum, inv. nos. 15102 and 15103; Illustrated by J.N. Svoronos, Τό 'εν 'Αθήναις 'Εθνικόν Μουσεῖον (Athens: Μπεκ και Μπαρτ 1903), pl. V, 6-7. and by Bol, Antikythera, pls. 18, 3 and 19, 1-2. The more complete of these, inv. no. 15103, is the closest comparison to the Agora sword.

[8]Amphora in Munich, Antiker Kleinkunst inv. no. 2309; Beazley, ARV[2], Euthymides 4, p. 27; illustrated by J.P. Hoppin, Euthymides and His Followers (Cambridge: Harvard University Press, 1917), pl. III and by Charles T. Seltman, Attic Vase-Painting (Cambridge: Harvard University Press, 1933), pl. 19.

[9]Volute Krater in the British Museum, inv. no. E 468; Beazley, ARV[2], Berlin Painter 132, p. 206; illustrated by Eduard Gerhard, Auserlesene Griechische Vasenbilder, III (Berlin: G. Reimer, 1847), pl. 204.

[10]A krater in Boston, Museum of Fine Arts, inv. 10.185; Beazley, ARV[2], Pan Painter I, p. 550; illustrated by R.N. Cook, Greek Painted Pottery (London: Methuen, 1972), no.44.

[11]The sculptured column drum from the Temple of Artemis at Ephesos is illustrated in A.H. Smith, A Catalogue of Sculpture (London: The British Museum, 1900), II, no. 1206, pl. XXIII; a side view is shown in Richter, Sculpture and Sculptors[4], fig. 751. The most recent publication of the Hellenistic relief of the Apotheosis of Homer is Doris Pinkwart, Das Relief des Archelaos von Priene und die "Musen des Philiskos" (Kallmünz: Michael Lassleben, 1965), 57-58, pl. 1; the sword is easier to see in the line drawing published in Smith, Catalogue of Sculpture, III, no. 2191, p. 245, fig. 30. For the Telephos frieze, see Hermann Winnefeld, Die Friese des Groszen Altars, Altertümer von Pergamon, vol. III, 2 (Berlin: Georg Reimer, 1910), Beilage 6.

[12]Coins with a representation of this sword have been brought together conveniently by L. Anson in Numismata Graeca (London: Anson, 1911), II, 68-69, nos. 711-730 and 732-733, pl. 13.

[13]On the larger palmette the diameter of the two left holes are 0.005 m. and that of the right one is 0.004 m. On the smaller palmette, the diameter of the left holes are 0.005 m. and the right one is 0.002 m. All four left holes are 0.037 m. from the right edge; the two right holes are 0.011 m. from the right edge.

[14]Hans Möbius, Die Ornamente der griechischen Grab-stelen, klassicher und nachklassischer Zeit (Berlin: Heinrich

Keller, 1929; also reprint, Munich: Wilhelm Fin, 1968),
42-43, pls. 28a-29b.

[15]Athens, National Museum, no. 1022; also see an
epikranion in the same museum, no. 2308; both are published
by S. Karouzou in National Archaeological Museum, Collection
of Sculpture (Athens: General Direction of Antiquities and
Restoration, 1968), 89 and 110. Another close comparison is
an akroterion in New York, Metropolitan Museum No. 07.286.107;
published by G.M.A. Richter, A Catalogue of Greek Sculptures
(Cambridge: Harvard Press for the Metropolitan Museum of
Art, 1954), 64, no. 95, pls. LXXVIII-b and LXXIX-b. Also
see A. Conze, Die attischen Grabreliefs, III (Berlin: Georg
Reimer, 1906), especially nos. 1535-1546.

[16]Gilded bronze and "golden statues" are discussed
on p. 336.

[17]I am indebted for information about the gold-
plated silver foil to Lucy Weir, who examined the fragments
with a stereomicroscope and showed the structure to me.

[18]Shear, Hesperia 42 (1973), 167.

[19]For an excellent survey of ancient horsemen, see
Harald von Roques de Maumont, Antike Reiterstandbilder
(Berlin: Walter de Gruyter, 1958). Hellenistic equestrian
statues, including those of the late fourth century B.C.,
are discussed by Heinrich B. Siedentopf, Das hellenistische
Reiterdenkmal (Waldsassen/Bayern: Stiftland, 1968). The
bronze statuettes of horsemen from the sanctuary at Dodona
are collected by Semni Karuzou, "Ὁι Ἱππεις της Δωδωνης,"
Theoria, Festschrift für W. H. Schuchhardt (Baden-Baden:
Bruno Grimm, 1960), 231-250. The recent reuniting of the
boy jockey and horse from Artemision is discussed by V.G.
Kallipolitis, "Ανασυγκρότησις τοῦ χαλκοῦ "Ἱππου τοῦ 'Αρτειμιζίου,"
AAA V:3 (1972), 419-426.

[20]Diogenes Laertius, Lives and Opinions of the
Philosophers, 5. V, Demetrius. 75, translated by R.D. Hicks
(The Loeb Classical Library, 1925), 527. Also see Strabo·
ix.1.20 (398); Plutarch, Precepts of Statecraft 27 (820 E);
and W.F. Ferguson, Hellenistic Athens (London: Macmillan,
1911), 59. An inscribed base for an equestrian statue of

Demetrios of Phaleron was recently found in Attica not far
from the village of Koropi in the foothills of Mt. Hymettos;
see Athena G. Kalogeropoulou, "Base en l'Honneur de Demetrius
de Phalere", BCH 93 (1969), 56-71. This reference was
brought to my attention by Professor Eugene Vanderpool.

[21]Pliny, xxxiv, 27.

[22]The inscription granting permission for an equestrian
statue to Asandros is I.G., II2, 450. Record of an equestrian
statue for Demetrios Poliorketes is published by N. Kyparissis
and W. Peek, Ath. Mitt., LXVI (1941), 221, no. 3, and pl. 74.
The inscription of Audoleon's honors is I.G., II2, 654. All
are listed in R.E. Wycherley, Literary and Epigraphical
Testimonia, The Athenian Agora, vol. III (Princeton, New
Jersey: The American School of Classical Studies at Athens,
1957), p. 208, nos. 278, 692; p. 210, no. 696.
A precise date has not yet been given to this Demetrios
inscription, but since his troops voted it in Athens, the
date must be between 307 B.C. (his first entry to the city)
and 288 B.C. (his final loss of power in Athens). His three
military entries to Athens provide the most likely occasions
for such a monument. Of these, the second is most probable:
his first appearance in Athens was a joint victory with
his father, for which a joint golden monument was erected; the
second triumphal entry (304 B.C.) preceded his long and
most extravagant, showy stay in Athens; but by 294 B.C.
when he made his last military entrance into Athens, his
popularity and resources had waned and he did not stay there
long.
For further evidence of early Hellenistic equestrian
statues, see Siedentopf, Das hellenistische Reiterdenkmal, 12-(

[23]Shear, Hesperia 42 (1973), 133 and 166.

[24]Diogenes Laertius, Lives, 5.V.77. The same information
is given by Strabo, ix.1.20 (398), and Plutarch, Precepts
of Statecraft, 27 (820 E).

[25]Livy, xxxi.44.

[26]For information about Demetrios Poliorketes, one of
the most important and colorful figures in Early Hellenistic
history, see Plutarch, Lives: Demetrios; Diodorus of Sicily;

Julius Kaerst, "Demetrios", Pauly-Wissowa (Stuttgart:
Metzerscher, 1901), 2769-92; W.S. Ferguson, Hellenistic
Athens (London: Macmillan, 1911); W.W. Tarn, Antigonos Gonatas
(Oxford: Clarendon Press, 1913); E.T. Newell, The Coinages
of Demetrius Poliorketes (London: Oxford University Press,
Humphrey Milford, 1927); and Hans Volkmann, "Demetrios",
Der Kleine Pauly Lexikon der Antike (Stuttgart: Alfred
Druckenmüller, 1964), I, 1464-5.

[27]I.G., II2, 450, and I.G., II2, 654.

[28]These horns are apparent in portraits of Demetrios
on his coins and in sculpture. For coins with this portrait,
see Newell, Coinages of Demetrius, pls. VII-XVI, XVIII.
Picard has identified two marble heads as portraits of
Demetrios, one from Kyme (Rev. Arch. 1944-II, 26, fig. 6)
and another from Delos (Mon. Piot 41 (1946), 71-90, fig. 3
and pl. VIII). For Roman copies of his portraits, see the
herm and the statuette from Herculaneum which are now in
Naples, Museo Nazionale nos. 6149 and 5026 respectively; see
Bieber, Hellenistic Age2, 50-51, figs. 145-6, 149, and
Richter, Portraits of the Greeks, I, 37; III, 256; and
Supplement 21.
 That the horns are symbols of Demetrios' "divinity" is
uncontested, although they have been seen as references to
both Poseidon, from whom he claimed descent, and Dionysos,
since he was acclaimed the "new Dionysos". Eckhel (Doctrina
Numorum, ii, 122), followed by Bieber (Hellenistic Age2, 50),
believe the reference is to Dionysos; but Newell (Coinages
of Demetrius, 72-3) presents a convincing case for the
reference being to Poseidon, reminding us of the close
association of Poseidon and the bull which was pointed out
by Farnell (Cults of the Greek States Oxford: Clarendon
Press, 1907 , vol. IV, 14, 24-26, 33, 43, 47, 56-7, 95) as
well as the close relationship Demetrios claimed with
Poseidon.

[29]Evidence about the life of Lysippos is compiled and
discussed by Franklin P. Johnson, Lysippos (Durham, North
Carolina: Duke University Press, 1927), 73. Also see Erik
Sjöqvist, "Lysippos", The Encyclopedia of World Art, IX, 357,
who agrees that Lysippos was active in the last decade of
the fourth century but does not believe the evidence is strong
enough to think that he continued into the third century B.C.

[30]Naples, Museo Nazionale, Ercolano inv. 4999. See
Arnold Ruesch, Guida del Museo Nazionale di Napoli, 2nd ed.
(Naples: Richter, 1911), 353-4, no. 1487; Johnson, Lysippos,
225-6 and pl. 48-a; Bieber, Hellenistic Age[2], 48, note 86
(with bibliography); and Alfonso de Franciscis, Il Museo
Nazionale di Napoli (Novara: Istituto Geografico de Agostini,
1971), 62-63, no. 53.

Bibliography

Shear, T. Leslie, Jr. "The Athenian Agora: Excavations of
 1971". <u>Hesperia</u> 42 (1973), 165-168 and pl. 36.

What did the ancient Greeks commemorate in bronze
sculpture?

Bronze statues of the gods are well documented in
ancient literature. One of the most famous is the Athena
Promachos by Pheidias, which Pausanias (i.28.2) says was
made from the spoils taken from the Persians at the Battle
of Marathon and which stood prominently on the Athenian
Acropolis. The abundance of bronze statues of the gods is
illustrated by the description of Olympia given by Pausanias
(v.21.2-v.25.1), listing a plethora of images of Zeus,
which were dedicated by the people of cities throughout
Greece and by private individuals, and also made with money
fined from athletes who dishonored the Games.

Statues of athletic victors stood throughout the
sanctuaries where the Games took place: an especially
lengthy account by Pausanias (vi.1.1-vi.18.7) of the victors'
statues at Olympia illustrates the vast number of such
honors. Pausanias describes statues of the winners as being
granted as part of their prize (v.21.1), although he also
notes inscriptions on some monuments--such as those
commemorating victories by Hieron of Sicily (v.27.1, vi.12.1,
and viii.42.8)--that were set up by the victor himself, in
fulfillment of a vow or as a thank-offering to a god.

Intellectual excellence was also honored by monumental
bronze statues; Socrates, for example, was portrayed by
Lysippos, as we know from Diogenes Laertius (2.43) in a
statue that stood in the Pompeion at the Kerameikos.

Bronze monuments were erected to political heroes in
Classical Greece;[1] Aristogeiton and Harmodios, who became
heroes as the Tyrannicides, were commemorated by a monument
composed of statues of both men. The original statues by
Antenor were looted by Xerxes (Pausanias 1.8.5) when the
Persians sacked Athens in 480 B.C. So valued was the
monument that one of the first acts of the Athenians in
the rehabilitation of their sacked city was to commission
Nesiotes and Kritios to make a replacement of the Tyrannicides
monument for the Agora.

The beauty of Phryne was immortalized at Delphi in a
statue by Praxitiles, described by Pasusanias (x.14.4).

Occasionally the Greeks made statues of animals, such as
the figure of a wolf that stood at Delphi (Pausanias x.14.4);
the wolf killed the man who plundered gold from the temple
of the god, then howled at the citizens of Delphi until
they followed him up the wild slopes of Parnassos to the
place where the gold was hidden. Classical Greek large-
scale bronze representations of animals often appear to

honor a virtuous deed performed by a particular animal or
acknowledge the generic value to man of a particular
animal, as may be true of the famous statue Myron made of
a cow.[2]

The surviving Archaic and Classical Greek monumental
bronze statues, discussed in this project, illustrate a
surprisingly wide range of the kinds of statues known from
literary evidence.

Seven of the number are of divinities: the Piraeus
Apollo, the Livadhostro Poseidon, the Artemision God--be he
Zeus or Poseidon, the Chatsworth Apollo, the Piraeus Athena,
and the two statues of Artemis from the Piraeus. The Youth
from Selinus probably is a divinity, too, since the pose is
similar to the canonical position for early representations
of Apollo (see above, note 1.26).

The Delphi Charioteer monument was dedicated to Apollo
by Polyzalos and most likely represents Polyzalos himself as
the victorious charioteer.

The head of the Cyrene "Berber" is a distinct,
individualized portrait, but no clues have been found to
identify the reason this man was immortalized.

Four statues represent political-military leaders or
heroes. The early bronze head from the Athenian Acropolis

surely represents a strategos, probably Xanthippos. The two
nude male figures newly discovered near Riace Marina
represent generals or other political leaders. The Agora
Horseman most likely is a statue of Demetrios Polioketes.

Two enigmatic figures, the Young Man from Antikythera
and the Marathon Youth, have been identified as divinities
by some modern people and as mortals by others. Although the
question is not yet solved, it presents an interesting
illustration of the Greek concept of gods in human guise.

Literary sources tell of the ancient Greek sculptors'
concern with living forms--gods, heroes, mortals, and
animals. The random sample of surviving monumental bronze
sculpture represents those categories in numbers which
conform to the literary evidence that most freestanding
bronze statues were of gods, the next largest number were of
heroes and military-political leaders, a smaller number of
statues were erected of individuals, and fewer still of
animals. Most monumental bronze statues clearly were of
human forms.

These statues in human form represent much more than
human beings. They honor excellence and virtue; they
commemorate deeds, achievements, and ideals. Attributes
identify the gods; otherwise, they might have been seen as

especially fine human beings. The anthropomorphization of both gods and ideals illustrates Greek humanism. The similarity between gods, heroes, and mortals is expressed in powerful, rhythmic forms with beauty.

Notes

[1]Evidence about fifth century bronze portrait statues
of political and military leaders is not completely clear.
Ancient literary descriptions of portrait statues often do
not specify whether statues were made of marble or metal.
Demosthenes reports (Aristokrates xxiii, 196) that the
Athenians did not honor individual people with bronze
statues between 477 and the end of the fifth century B.C.,
from the erection of the Tyrannicides until the time of
Konon. Demosthenes' statement might be accepted if we
understand it to mean that Athens did not commission public
monuments in Athens to specific people during that time
(see above, pp. 77 and note 3.8). As Richter demonstrates
(Portraits, I, 5), however, statues of specific men were
set up in the fifth century on the Athenian Acropolis;
these statues could, of course, be private dedications.
Further, there is no record of a similar policy against
honorary bronze statues elsewhere in the Greek world. A
monument dedicated at Delphi from the tithes of Marathon,
a group comprised of individual statues by Phidias (Pausanias
x.10.1), probably was of bronze, and it certainly included
a portrait statue of Miltiades. In any event, there certainly
were bronze portrait statues of leaders during at least
part of the fifth century and the fourth century at various
places throughout the Greek world.

[2]The numerous ancient references to Myron's cow are
collected in J.J. Pollitt, The Art of Greece, Sources and
Documents (Englewood Cliffs, New Jersey: Prentice-Hall,
1965), 63-64.

Ancient disasters that buried sculpture are responsible
for all of the monumental bronze statues from Classical Greece
that have survived. Six of the statues in this study have
come from the sea, and ten from land sites (fig. 17.1);
most of them have been chance finds.

Seven of these statues were found in what we can assume
was the vicinity of their original site. Although there is
virtually no information about the archaeological context in
which the Poseidon of Livadhostro was found, the inscription
on the base firmly attached to the statue is universally
accepted by epigraphers as Boeotian; therefore, the original
site of the statue must have been in Boeotia, probably near
its findspot if not immediately inshore from it. The Athenian
Strategos, found buried on the Athenian Acropolis, must
have stood in Athens, probably on the Acropolis itself. The
Charioteer was set up in the sanctuary of Apollo at Delphi.
The Youth formerly displayed in Castelvetrano is from Selinus.
The Chatsworth Apollo probably stood at the ancient site of
Tamassos in central Cyprus, near its findspot. The physical
characteristics of the Cyrene "Berber" indicate that the
statue not only stood in Cyrene but represented a person
with some physical characteristics more typical of North
Africans than of Greeks. The Agora Horseman can be assigned

to the Athenian Agora. All of these statues appear to have
stood in or near ancient sanctuaries or civic centers. The
range of original locations indicates the large expanse
of the Classical Greek world.

Nine of the statues in this study appear to have been
buried while they were being moved from one location to
another. The Artemision God was found off the north coast
of Euboea with the Hellenistic Boy Jockey and Horse[1] in a
shipwreck that can be dated to about the time of Christ.[2]
The wreck has been spoiled by looters, so it may be impossible
to established the route of that ship, which might have
suggested the original location of the statues. Equally
enigmatic is the findspot of the "Generals" discovered off
the sourthern Italian coast near Riace Marina, although
that area has not yet been fully explored so hope remains
that additional information will be discovered. A similar
situation exists for the Youth found in the Bay of Marathon,
and information relating to that statue may be discovered
when the site is excavated. Careful study of the cargo from
the shipwreck found off Antikythera establishes a first
century B.C. date for that disaster and gives evidence for
believing that the ship came from the south-central coast
of Turkey or the southeastern Greek islands, most likely

Rhodes and Kos. The Young Man from Antikythera, therefore, probably was made for a site in the Greek east. The four statues found in the Piraeus were stored near the docks in a warehouse destroyed in the first century B.C., probably during Sulla's sack of 86 B.C. We should not assume that these four statues came from some place in Attica just because they were found in the port of Athens; it is indeed a possibility, but the Piraeus was an international port and goods being sent throughout the eastern Mediterranean could have been stored there in the process of transfer. Evidence from the find suggests that it may be loot from Delos[3] that was taken to Athens by Aristion and Archelaus in 88 B.C.[4] Even though the exact original sites of these nine statues buried during transit is uncertain, indications of the general areas from which they may have come reconfirms the widespread expanse of the Classical Greek world and the presence of major monumental sculpture throughout it.

Minor variations exist in the statues—such as the facial features of the Cyrene "Berber"—but no significant differences about the statues can be established on the basis of findspot. The opposite, in fact, is true; the similarity of the sculpture is remarkable, and the statues clearly are parts of one tradition. All but one might have

been made in the same place. That one exception is the
Youth from Selinus, whose provincial character emphasizes
the unity among the other statues. (The considerably
smaller size of the Selinus Youth should be kept in mind;
it is possible to argue that the statue from Sicily is
not properly a "monumental" statue.) With the counterpoint
of provincial work illustrated by the Selinus Youth, the
findspots of the surviving statues indicate that there were
not easily distinguishable regional schools of style or
technique for monumental bronze sculpture in Classical
Greece.

Bases of only two of the statues of this study have
survived, and those exist now only in part. A portion of
the inscribed stone base of the Delphi Charioteer remains to
identify Polyzalos as the dedicator of the monument. The
bronze plinth to which the Livadhostro Poseidon is attached,
too thin to give solid support for the statue, probably was
attached to a large stone base; the inscription identifying
the statue as a dedication to Poseidon is cut into the floor
of the plinth. These two fragmentary bases belonging to
surviving statues, augmented by the evidence of hundreds of
bases that have survived without the statues that they once
supported,[5] illustrate that large freestanding bronze statues

usually stood upon inscribed stone bases,[6] which identified
them.

Since no bases were found in shipwrecks with bronze
sculpture, the heavy stone bases undoubtedly were left
behind when the statues were robbed. The numerous bases
found at ancient sites without statues (see above, note 5)
confirms the separation of statue and base in later times.

In the manner of a bronze statuette, the Livadhostro
Poseidon was actually cast with its base. All other statues
in this study, however, were cast without an attached base
and appear to have been affixed to their supports by dowels.
The dowels were made in two ways: some were cast with the
figure but more often dowels were made separately and inserted
into holes in the soles of the feet of the statues. Open
spaces on the soles of the feet are found on all of the
male statues wherever the foot would have been in direct
contact with the base. The cut-away areas follow the foot
to appear to stand flat,and they provide a convenient place
to insert necessary dowels. Where the foot is raised, as in
the case of the right heel of the Young Man from Antikythera,
a dowel cast directly with the foot provides a less obvious
support. The three statues of goddesses apparently were
supported by dowels attached to the hems of their skirts,

best exemplified in the Piraeus Athena. Feet of all three
statues of females are completely open at the bottom, so
those feet were not designed to hold dowels. Both feet of
the earliest statues—the Piraeus Apollo, the Livadhostro
Poseidon, and the Delphi Charioteer, as well as the
provincial Youth from Selinus—stood flat on their bases.
The right heel is raised, however, on all other standing
male statues where the feet are extant—the Artemision God,
the two "Generals" from Riace Marina, the Young Man from
Antikythera, and the Marathon Youth. These statues standing
in contrapposto, therefore, are balanced on three points:
two under the flat left foot and one under the ball of the
right foot. The complex engineering problems of such a
delicate balance are dramatized by the difficulty with which
the Young Man from Antikythera was restored.

Surviving monumental bronze statues tell us disappointingly
little about their original settings. Recent studies of
statue bases have been more fruitful. Even though the Athenian
sites have been disturbed many times since the Classical
period, archaeological evidence supports ancient literary
references to a proliferation of bronze statues atop the
Acropolis and across the Agora.[7] Careful study of bases
at Olympia[8] attests to a comparable number of freestanding

bronze statues erected throughout the temenos, especially
along major avenues.

Studies of the many bases still extant at ancient sites
(see above, note 5), show that bronze statues often stood in
the open air. In some instances, they appear to have been set
up in ordered arrangements;[9] in other instances, they seem to
have stood in a relatively casual array. Some cult statues may
have been erected inside temples, as illustrated by the
representation of a cult statue of Apollo (fig. 1.12). Some
statues were single figures, as was the famous lost Athena
Promachos by Pheidias, which stood on the Athenian Acropolis;[10]
others, such as the Delphi Charioteer and the comparable
monuments known from literary references that were erected by
the brothers of Polyzalos (see note 5.28), were groups.

To summarize: monumental bronze sculpture stood throughout the
Greek world in sanctuaries and civic centers. Freestanding
statues, usually on stone bases, stood both inside temples
and in the open air. Even though sixteen statues is a
relatively minuscule sample of the ancient Greek monumental
statues, this extant group includes examples from far-flung
areas and indicates that sculpture of the highest quality (and
some provincial examples) stood in many parts of the ancient
Greek world.

Notes

[1]Restoration of the Boy Jockey (Athens, National Museum, No. 15177) with the horse from the Artemision shipwreck was difficult because the horse was so badly fragmented. For discussion of the problems of the reconstruction, which was completed in October, 1972, see V.G. Kallipolitis, "Ἀνασυγκρότησις τοῦ χαλκοῦ ἵππου τοῦ Ἀρτεμισίου," AAA V.3 (1972), 419-426.

[2]George Bass, "Eighteen Mediterranean wrecks investigated between 1900 and 1968", Underwater Archaeology: a nascent discipline (Paris: UNESCO, 1972), 37-39. In a paper presented at the Xth International Congress of Classical Archaeology (Izmir, October, 1973), Bass reported that the Artemision wreck has been looted so badly that future excavations may not be worthwhile.

[3]Suggestion that the Piraeus cache came from Delos has been noted previously by Evelyn Harrison in Archaic and Archaistic Sculpture. The Athenian Agora XI (Princeton: The American School of Classical Studies at Athens, 1965), 127.
 Three of the large bronze statues are of Apollo or Artemis, and the fourth is probably Athena in the role of Archegetis, patroness of colonists who kept their citizenship in their native city. The other statue, a smaller marble figure, has also been identified as a representation of Artemis (see above, note 1.5). Cult statues of Apollo and Artemis would, of course, be most appropriate on Delos, the island sacred to them. A statue of Athena Archegetis would also be particularly appropriate for Delos since throughout the Classical period the island was closely connected with—and often controlled by—Athens, and numerous Athenian colonists lived on the island.
 The two herms (see above, note 1.6) also point to a Delian origin. Delos is well known as a production center for sculpture in the first century B.C., and there were so many herm-makers on the island that they had a separate guild. (See Roussel, BCH XXXIV 1910, 110-115; also W.A. Laidlaw, A History of Delos Oxford: Basil Blackwell, 1933, 205). Delos is, therefore, a likely source for first century B.C. herms. Trying to distinguish between the style of sculpture done on Delos and that made in Athens during the first century B.C., however, is likely to be unfruitful since virtually

all of the leading sculptors on Delos at that time were
Athenian by both birth and citizenship (see W.S. Ferguson,
Hellenistic Athens, [London: Macmillan and Co. Ltd., 1911;
reprint edition, Chicago: Ares, 1974], 376, 409-410.) The
herms found in the Piraeus, whose unweathered condition
po_nts to a carving shortly before burial, could well
represent new work from the Delian sculpture workshops.

The objects in the Piraeus find, therefore, are especially
appropriate to Delos. The looting of Delos by the generals
of Mithradates is told by Strabo (x.5.4) and discussed by
W.A. Laidlaw, A History of Delos (Oxford: Blackwell, 1933), 170.

[4] See W.S. Ferguson, Hellenistic Athens (London:
Macmillan and Co., Ltd., 1911; reprint edition, Chicago:
Ares, 1974), 477. Ferguson's account relies upon the
contemporary Stoic historian Poseidonius of Apamea.

Aristion took the dictatorship of Athens for himself
that year and worked with Archelaus, commander of Mithradates'
advance guard, to ally the surrounding Greeks to the side of
Mithradates against the coming of Sulla and to prepare for
the inevitable war. Sulla arrived in the summer of 87 B.C.
Distribution of sculptural loot surely had a low priority
at that time. It is probable, therefore, that the Piraeus
cache was at the port stored in the warehouses on its
arrival from Delos. If it were going to be shipped anywhere
just before 86 B.C., the destination would more likely
have been east to Mithradates rather than west to Rome
and Sulla.

Since the coin found with the Piraeus cache is of
Mithradates, the connection between Pontus and the Piraeus
find is strengthened.

The historical evidence supports and augments that of
the physical objects to point to Delos as th site where
the group of objects buried in the ancient Piraeus warehouse
stood originally.

[5] See particularly Anthony E. Raubitschek, Dedications
from the Athenian Acropolis (Cambridge, Mass.: Archaeological
Institute of America, 1949); Margrit Jacob-Felsch, Die
Entwicklung griechischer Statuenbasen und die Aufstellung
der Statuen (Waldsassen/Bayern: Stiftland-Verlag, 1969);
F. Eckstein, Anathemata: Studien zu den Weihgeschenken des
strengen Stils im Heiligtum von Olympia (Berlin: Gebr. Mann,
1969); and B.S. Ridgway, "The Setting of Greek Sculpture",
Hesperia 40 (1971), 336-356.

[6]The statue bases discussed in references given in
the preceeding note are of stone, as are all surviving
bases for monumental sculpture. Bronze bases also existed
in Classical times, but they were unusual enough to warrant
special comment from Pausanias (v.25.12), who relates that
both the base and the image of a Herakles at Olympia made
by Onatas of Aegina were of bronze.

[7]Bases from the Athenian Acropolis are discussed
by Raubitschek, Dedications; those from the Agora are
published by R.E. Wycherley, Literary and Epigraphical
Testimonia, The Athenian Agora, III (Princeton, New Jersey:
The American School of Classical Studies in Athens, 1957).

[8]Eckstein, Anathemata.

[9]Ibid.

[10]Pausanias i.28.2. Bibliography for the surviving
pieces is given with a discussion of the pieces themselves
by B. Merritt, Hesperia V (1936), 362-377 and by Raubitschek
and Stevens, Hesperia XV (1946), 107-114.

Long before recorded history, bronze was known in
ancient Greece. Copper was used first by itself, so the
transition period from the Stone Age to the Bronze Age is
sometimes called the Chalcolithic. By approximately 3000
B.C. people in the eastern Mediterranean discovered that
they could change the character of copper by alloying tin
with it, making a metal we call bronze.[1] Although we
distinguish between copper and bronze, neither the ancient
Greeks nor the Romans did. A single word in each language
—χαλκός in Greek and aes in Latin——is used to name both
the element and its alloy with tin.[2]

Bronze is harder than copper; and it is more readily
melted than copper, so it is easier to cast. (Bronze is
also harder than iron, but tin is not as readily available
in the eastern Mediterranean as iron is.) The advantages of
bronze for weapons and tools were well understood in the
eastern Mediterranean by the second millenium B.C. Knowledge
about the first use of bronze for sculpture is lost to us,
but surviving figures from the Bronze Age show that men also
used bronze for sculpture as early as the second millenium
B.C. (see below, p. 303).

Bronze alloys obviously need to vary according to the
use of the object being made. Coins and weapons, for

example, need to be strong and durable, so should be made of at least 85 percent copper because an alloy with more than 15 percent tin loses strength. Mirrors, on the other hand, need to be reflective rather than strong, so may require a larger percentage of tin.[3] Studies of alloys used for other categories of objects, therefore, may not be directly applicable to bronze used for monumental sculpture. The demands of monumental sculpture[4] are for strength with enough malleability to allow coldworking.

Surprisingly little is known about Classical Greek bronze from contemporary literary sources.[5] Aristotle (Meteorologica iii-iv) does describe properties and characteristics of metals, but his idea that they are composed of varying mixtures of the elements earth and water indicates a lack of precise knowledge about specific metals and their alloys.

Roman literary descriptions of alloys used in Greek bronze sculpture give a colorful picture of the statues. For example, Plutarch (Quaestiones Conviviales, v.1, 2, p. 674-A) praises a statue of Iokaste "given a deathly pallor" by the artist who "mixed the bronze with silver". A comparable account of bronze alloy used for sculpture is told by Pliny (xxxiv.140), who records a statue in Rhodes made by

Aristonides of Athames, for which Pliny says Aristonides
mixed iron with bronze so that rust would tint the brightness
of the bronze and give the statue a blush. These colorful
stories might indicate that bronze sculpture was tinted,
perhaps painted as marble statues were. The accounts of
the alloys, however, are not accepted as technical
possibilities by any modern expert in metallurgy.[6]

Pliny (xxxiv.95-98) records various recipes for bronze,
which he said varied according to geographical area; the
character of Corinthian bronze was particularly noted in
Roman times.[7] Further study is necessary before that suggestion
can be explained. Studies of localized bronze formulae
based on analyses of coins, weapons and tools, or even of
statuettes may not be relevant, however, for the bronze
used for monumental statues.

Metallurgical analyses of seven of the statues in this
study have been made in the 20th century; the results are
summarized below, p.303. Differences in method and date of
the analyses preclude precise comparison of the results,
but the general composition of the bronze alloy clearly is
a simple one that ranges from approximately 91 to 85 percent
copper and 14 to 8 percent tin. Other elements appear in
the tests in such small amounts that they probably are only

accidental impurities. These analyses suggest no significant
difference in alloys that can be attributed to ancient
locations; in fact, they are remarkably close, especially
for tests made under such a variety of conditions.

Comparisons with statuary alloys from other times and
places emphasizes how uniform is the composition of bronze
in the fifth- and fourth-century Greek monumental statues.
For example, the figure of Pepy I, from the VI Dynasty of
the Old Kingdom of Egypt,[8] is primarily copper. Samples of
Etruscan and Roman bronze statues[9] suggest a conscious
addition of lead to the bronze formula in amounts up to 25
percent, in contrast to the Classical Greek statues that
contain virtually no lead.

The modern chemical analyses of bronze used for
Classical Greek monumental statuary, are too scanty and
the testing condition too varied to permit precise conclusions
about the alloy, but they give a clear picture of a
consistent use for Classical Greek monumental statuary bronze
of a basic alloy composed of about one part tin to eight
parts copper.

Statue	Content by Percentage			Source
	Copper	Tin	Other	
Piraeus Apollo	91	8	lead, 1	A
Piraeus Apollo	87	10	oxygen, 2	B
Chatsworth Apollo	89	10	traces	C
Cyrene "Berber"	90	10	traces	C
Antikythera Young Man	84.74	14.29	--	D
Piraeus Athena	87	11	lead, 1	A
Marathon Youth, crust	89.6	7.6	sulphur, 4.2	E
Marathon Youth, inside	88.5	9.2	sulphur, 2	E
Piraeus Artemis	86	12	lead, 1	A

Key to Sources on Following Page.

A. Wet chemical analyses done for Bruno Bearzi, published
by Arthur Steinberg, "Joining Methods on Large Bronze
Statues: Some Experiments in Ancient Technology,"
Application of Science in Examination of Works of Art,
ed. Wlliam J. Young. Boston: The Museum of Fine Arts, 1973.

B. G. Varoufakis and E.C. Stathis, "A Contribution to the
Study of the Corrosion of Ancient Bronzes", Metallurgia
83, no. 499 (1971), 141.

C. The British Museum Research Laboratory. Published by
Denys Haynes, "The Technique of the Chatsworth Head",
Revue Archeologique 1/1968, 110.

D. O.A. Rhousopoulos, published in P. Diergart, Beiträge
aus der Geschichte der Chemie dem Gedächtnis von George
W.A. Kahlbaum gewidmet (Leipzig and Vienna, 1909), 187.

E. From Jean Charbonneaux, Greek Bronzes (New York: Viking,
1962), 23.

Notes

[1]A study of the early development of copper, tin, and bronze is published by James David Muhly in Copper and Tin: the Distribution of Mineral Resources and the Nature of the Metals Trade in the Bronze Age, Transactions published by the Connecticut Academy of Arts and Sciences (March 1973), 155-535 (Hamden, Connecticut: Archon Books, 1973).

[2]Muhly, ibid., includes discussion of the ancient words for copper, 171-179.

[3]The problems of different alloys are summarized by Jean Charbonneaux, Greek Bronzes (New York: Viking, 1962), 19-23.

[4]Modern lack of knowledge about the alloys used in ancient bronze sculpture is lamented by Karl Kluge in his standard work on monumental bronze technique, Die antike Erzgestaltung (Berlin and Leipzig, 1927), 217. The problems of identifying chemical composition of bronzes used by the Greeks and Romans are discussed by Earle R. Caley, "Chemical Composition of Greek and Roman Statuary Bronze", Art and Technology, ed. by Doeringer, Mitten, and Steinberg, 37-49.

[5]An excellent compilation of ancient literature on bronzes is contained in the introduction to H.B. Walters, Catalogue of the Bronzes: Greek, Roman, and Etruscan, in the British Museum, revised by A.S. Murray, Cecil H. Smith, and Arthur H. Smith (London: The British Museum, 1899), xiii-lxx.

[6]Charbonneaux, Greek Bronzes, 21.

[7]Pausanias (ii.3.3) implies that Corinthian bronze was a different color from other Greek bronzes. Dorothy Kent Hills suggests that "Corinthian bronze" might be artificially patinated bronze made in Roman times; see "Bronze Working" in The Muses at Work, ed., Carl Roebuck (Cambridge: MIT Press, 1969), 64. E.R. Caley specifically discusses Pliny's recipes in "Chemical Composition of Greek and Roman Statuary", Art and Technology, 46-49. R.J. Forbes proposes that Corinthian bronze was tempered to a greater degree because of a high tin content, thereby

giving it the distinctive quality noted by the Romans;
see Studies in Ancient Technology, IX, 2nd ed., rev.
(Leiden: Brill, 1972), 159. For additional information,
see Caley, "Critical Evaluation of Published Analytical
Data on the Composition of Ancient Metal", Application
of Science in Examination of Works of Art (Boston: The Museum
of Fine Arts, 1967), 167-171; Caley, "The Corroded Bronze
of Corinth", Proceedings of the American Philosophical
Society 84 (1941), 689-761; and Humfry Payne, Necrocorinthia
(Oxford: Oxford Press, 1931), 349-350.

[8]Cairo, Egyptian Museum, no. 230. See William
Stevenson Smith, The Art and Architecture of Ancient Egypt,
Pelican History of Art (Baltimore: Penguin, 1958), 80, and
Kazimierz Michalowski, The Art of Ancient Egypt, 187. There
is a difference of opinion about the metal used for the
figure of Pepy I and the small figure that accompanies it;
some writers describe the metals as bronze and others call
it copper. The source for the bronze identification is a
test made by Mosso and quoted by Maspero (G. Maspero, Guide
to the Cairo Museum, 1910 English translation, 73). Three
other tests, however, report the presence of tin to be
doubtful; see J.H. Gladstone in W.M.F. Petrie, Dendereh
(London and Boston: Egypt Exploration Fund, 1900), 61-62;
C.H. Desch, "Report on the Metallurgical Examination of
Specimens for the Sumerian Committee of the British Ass."
Report of the British Ass., 1928, quoted by Harris (see
next entry), 214; and A. Lucas, Ancient Egyptian Materials
and Industries, 4th ed., rev. and enlarged by J.R. Harris
(London: Edward Arnold, 1962), 214.

[9]Tables of the chemical composition of bronze in
Roman and Etruscan statues are published by Denys Haynes in
Revue Archéologique, 1968, 110, and E.R. Caley in Art and
Technology, ed. by Doeringer, Mitten, and Steinberg, 42-44.

The Early History

Bronze can be shaped by two basic methods: it can be
worked in a solid state by mechanical means such as hammering
(which may be combined with annealing) or it can be cast in
a molten state. The ancient Greeks used both methods.[1]

Since bronze is strong, hammering or beating is most
effective on sheet metal, a technique the Greeks called
σφυρήλατον. Hammering can be done from either side of the sheet
and is most effectively used to make concave configurations;
a predetermined shape can be achieved by the use of a form.
Many modern scholars follow Kurt Kluge's assumption that
the sphyrelaton method of working involved hammering sheets
of bronze into a shape over a wooden core;[2] however, there
is not enough evidence to accept this belief as fact. Our
knowledge about Greek sphyrelaton technique is still
fragmentary.

Casting molten bronze into a predetermined shape
requires furnaces capable of heating the metal to a very
high temperature (usually about 1000 to 1200° C., but variable
according to the proportions of copper and tin used),
mechanical devices for pouring the molten metal, as well as
moulds to dictate form.

Both basic methods can be used to make sculpture. Solid, cast bronze statuettes are relatively easy to produce; examples of statuettes created during the Bronze Age survive throughout the eastern Mediterranean.[3] Working in bronze on a monumental scale, however, presents a more complex situation. Solid bronze large statues would be impractical for technical as well as economic reason; making the statues hollow circumvents these primary problems. Bronze statues can be made as shells by using the sphyrelaton technique or by casting the surface of the statue in bronze while making the interior of a lighter, cheaper material or by leaving the interior void.

Monumental sculpture in metal was made in Egypt during the Old Kingdom as early as Dynasty II,[4] and an image of Pepy I with his son, made in Dynasty VI (ca. 2300 B.C.) survives in the Cairo Museum.[5] The corroded condition of the metal makes study of the larger-than-lifesize statue of Pepy I difficult; some scholars accept the torso, arms, and legs as beaten bronze, and some think the hands and feet and perhaps the face were cast.[6] Metal rivets join separate sheet metal parts of the statue; the extremities, perhaps cast, seem to be welded to the whole. Monumental sculpture

was cast in Mesopotamia as early as the second millenium
and perhaps as early as the late third millenium B.C.,
witnessed by the head of an Akkadian ruler from Kuyunjik,
now in the Iraq Museum in Baghdad.[7]

Pausanias (viii.14.8) states, "the first smelters of
bronze and casters of statues were the two Samians, Rhoikos,
son of Philaios, and Theodoros, son of Telekles", sculptors
who can be dated to the sixth century B.C.[8] Pliny (xxxiv.15-
16) reports that sculpture in bronze began with Pheidias in
the 83rd Olympiad (448 B.C.), however, that date cannot be
accepted as a literal one in view of surviving physical
evidence.

The earliest Greek large bronze sculpture extant is a
bust, probably of a siren, which survives at Olympia with
one wing.[9] Likely made in the early sixth century B.C., the
siren appears to have been beaten into shape. Pausanias
(iii.17.6) reports that the sphyrelaton technique was used
for the "oldest of all bronze statues", a figure of Zeus on
the Spartan Acropolis, which he says was

> not cast in bronze in one piece, but
> each part was made of beaten bronze
> and then fitted together and all held
> in place with bolts. They say the
> statue was made by Klearchos of Rhegion.

Well known large bronze statuettes made of beaten bronze
sheets provide parallels dated to about the mid-seventh
century B.C. from documented excavations at Dreros on Crete.[10]

Perhaps large statues in bronze existed during prehistoric
times in Greece;[11] certainly they were made in Archaic Greece.
Early archaeological evidence for a large hollow-cast bronze
statue in Greece is the fragments of a mould for an Apollo
about 1.1 meters high, found in the Athenian Agora.[12] The
earliest surviving Greek monumental statue in bronze, the
Piraeus Apollo (1), can be dated to the end of the sixth
century. The tradition of large statues cast in bronze,
therefore, is established in Archaic Greece during the sixth
century B.C.

Examples of monumental bronze sculpture in the Near
East and Egypt may have inspired the Greek sculptors. The
likelihood of such influence is increased by the traditional
crediting of the first cast bronze statues to men from Samos,[13]
which stands at the eastern edge of the Greek world on the
important eastern Mediterranean trade routes. The degree
of the influence is difficult to assess since the making
of monumental bronze sculpture may also have been a logical
development from bronze statuettes, particularly in a

society that made many life-size marble figures as well as
bronze armor remarkably similar in configuration to the
bodies of the Archaic marble kouroi. Further, the tradition
of bronze-working was well established and highly developed
by the Archaic period in Greece.

Most modern scholars who have written about ancient
Greek bronzeworking technique have depended heavily on the
pioneering scholarship of Kurt Kluge and Karl Lehmann-
Hartleben.[14] The Kluge and Lehmann-Hartleben research, as it
stands, depends primarily on Roman material rather than
Greek. They planned another volume for their project, which
was to be written by Lehmann about Greek bronze sculpture,
but the project was disrupted when Lehmann fled Nazi Germany.[15]
Lehmann's multiple interests led him to other tasks, and a
thorough study of Greek bronze-working technique remains to
be made.

An examination of the surviving Greek statues reveals a
difference between the physical evidence provided by the
statues themselves and the theories offered by Kluge or other
explanations based on Kluge's work.

Fortunately, important new studies are being made.
Especially interesting is the work Denys Haynes is doing in

conjunction with the personnel of the Research Laboratory at
the British Museum; Haynes plans a book on the results.[16]
Study of foundry material discovered at ancient Greek sites
will also add greatly to our understanding of the technical
aspects of monumental Greek sculpture.[17] Even though these
studies are not completed, preliminary work indicates that
much of what is now generally accepted will have to be
revised. Publication of the new conclusions will be invaluable.

In the meantime, a few observations can be made about
the techniques used by the ancient Greeks in the construction
of these monumental bronze statues.

The Models and the Casting

All of the statues in this study[18] are hollow and were made in pieces. (There is a very remote possibility that the figure of the Piraeus Apollo might have been cast as one piece, but his bow and phiale were clearly made separately.)

The pieces generally are logical, relatively self-contained units; heads, for example, are usually cast separately from the torso. In cases where there is drapery, the joins usually are designed at places where representations of cloth and flesh meet or where one piece of cloth would naturally fall over another; for example, on the Piraeus Athena (figs. 13.2-13.7), the overfold of the peplos is cast separately from the skirt. The joins also are placed to give good structural support; the arms, for example, are often joined in the upper biceps (e.g., fig. 5.5a-b, which illustrates the arms of the Artemision God) rather than at the juncture of arm and shoulder. Smaller pieces, too, were sometimes cast separately, illustrated by the free-hanging curls (figs. 5.2 and 5.3) of the Artemision God.

Units that naturally would be distinct from a figure —such as the helmets once worn by the Athenian Strategos (fig. 3.1), "General A" from Riace Marina (fig. 8.1) and the Piraeus Athena (fig. 13.1)—are obviously cast separately.

The Models and the Casting

The attributes originally held by the figures, such as the
bow that can be reconstructed for the Piraeus Apollo (fig.
1.11) and the mysterious object once in or near the grasp
of the Young Man from Antikythera (figs. 11.1-11.2), were
also made separately.

The famous Foundry Cup in Berlin (fig. 5.18a-b) gives
a picture agreeing with information from surviving statues
about the way bronze statues were made in pieces, and we
can accept it as a valid illustration of a sculptor's
workshop in Classical Greece.

The bronze shells of these statues vary in thickness,
showing wider walls at places of greatest stress. The bodies
of the larger early statues—the Piraeus Apollo, which is
1.9 m. high, and the Delphi Charioteer, which is 1.8 m.
tall—are the thickest, averaging about a centimeter at
non-stress points. The shorter Poseidon from Livadhostro,
which is 1.18 m. high, has proportionately thinner walls of
about half a centimeter in thickness. The bronze walls of
the bodies of the statues assigned to the middle and later
fourth century—the Antikythera Young Man, the Piraeus
Artemis I, the Piraeus Athena, the Marathon Youth, and the
Agora Horseman—are all close to 0.003 m. thick. (The walls

The Models and the Casting

of the Artemis II are too badly corroded to give an accurate
measurement.) These thin walls show virtually the same con-
figuration on the inside as on the outside.

Every one of the surviving Greek monumental statues
studied in this project was cast by the lost wax (<u>cire</u> <u>perdu</u>)
method, in which the bronze replaces a model of wax.[19]

Lost wax bronze casting from a model is known to us in
two basic methods: one technique, "The Direct Process", is
to cast directly from the model; the other technique, "The
Indirect Process", is to make a mould of the model. Both
methods have been used since the Renaissance, and scholars
have assumed that the ancients could have used either one.
(The lost wax process is now widely replaced by electro-
plating.)

In the Direct Process of hollow casting, the basic
shape of the statue is modelled, usually in a plastic
medium such as clay that may be supported or
strengthened by an armature. The basic shape, which will
become the core of the statue, is covered with a layer of
wax that is worked to the exact form desired for the
statue. Wax rods are attached to make passages through
the encasement, which will be added next. Some of the

passages will serve as escape vents for wax and air "risers",
and others as pouring channels, "runners", for molten metal.
The model is encased in clay, through which the wax rods
protrude. Metal pins or rods, called "chaplets", are
inserted through the wax to link the core to the encasement
so the core will keep its established position with the
encasement even when the wax is removed. The entire mould
is heated, melting the wax which is drained away through
the vents; molten bronze is poured into the space previously
occupied by the wax. When the bronze hardens, the encasement
is removed. A bronze statue made directly from the original
model in wax is a unique work since the technical process
destroys the model.

In the Indirect Process of lost wax casting, a
negative mould is made of the model; therefore, the model
can be of any material. The model is not destroyed by the
process and multiple copies can be made. If the model is
at all complex, the mould must be openable so that it can
be removed from the model; the greater the complexity of
the form, the larger must be the number of pieces in which
the mould is divided. The pieces of the mould can be
reassembled at this point or after the next step. The

inside surface of the mould is coated with wax, which
usually is poured or brushed in liquid state over the
interior or is pressed into place in strips that are often
called "lasagna" after Cellini's description of their
appearance. If the negative mould is reassembled before
the wax is applied, melted wax might be advantageous; if
wax is affixed to the pieces of the mould before it is
rejoined, solid strips of wax might be easier to handle.
A core of material such as terra cotta or plaster can be
introduced into the interior void to serve as a core. A
variation can be made in the preceeding stages of the
Indirect Process by assembling the pieces of the mould
around—but not touching—a core, then pouring melted wax
into the space between the mould and the core. In either
case, the next step is to make risers and runners, then
cover the negative model with a nonporous coating so that
it becomes a part of the actual casting mould or to remove
it from the positive wax impression (in which case it could
be reused) and replace it by a solid clay mantle. The
process then continues in the same manner as the Direct
Process with the insertion of chaplets, the displacement
of the wax by the molten bronze, and the removal of the

The Models and the Casting

outside casting when the metal is hard.

Objects made by the Indirect Process are likely to have positive drip marks or "lasagna" division lines visible on the inside of the cast surface, reproducing the inside of the wax coating configuration, unless the core is made and inserted before the wax is added.[20] The interior surface of statues cast by the Direct Process, on the other hand, reproduces in the negative the modelled clay core around which the wax is formed.

Denys Haynes observes a "lasagna" pattern left on the inside of the Chatsworth Apollo head by strips of wax;[21] the configuration is seen now in the bronze form that took the shape dictated by the lost wax. Haynes points out that the wax strips probably were laid into a mould, taken from a model made of an unidentifiable medium; he presents a strong case, therefore, for believing that the head was made in an openable mould. On the other hand, could the wax strips have been laid over a core equally well and still retain the marks of the edges of the strips? The ears of the Chatsworth Apollo were cast with the skull, as Haynes proves beyond doubt by observing the concave form of the ears on the inside of the head. Clusters

The Models and the Casting

of curls which hang over the ears were cast separately,
surely by the Direct Method, and hard-soldered to the
head. On the left side, where the curls have been lost
(fig. 7.2), the artist's complete articulation of the ear
is evident, even in this place where the form was never
meant to be seen. In short, the Chatsworth Apollo head was
cast in one basic spherical form opening into a neck. The
"lasagna" design suggests that a mould was made of the
original model, that the technique was the Indirect Process
with an openable mould. Curls cast separately by the
Direct Process were welded to the head. The Apollo appears
to be the result of a pragmatic combination of working
methods, which we categorize as separate techniques.

The "Direct Process" of lost wax bronze casting must
have been used for the Piraeus Apollo since the pieces of
terra cotta core found inside it still retain positive
impressions of the sculptor's fingerprints,[22] which shows
that the core was built first and that the casting
reproduces the actual model. The Piraeus Apollo, therefore,
is the only casting made from the model.

Pieces of iron rods found inside the Piraeus Apollo
have been identified as armature for the clay core. The

restorers who cleaned the statue report that the iron rods were found in an apparently haphazard formation; I could see no areas where any of the rods, which are of several diameters, might have joined another rod. Perhaps, therefore, the rods served as strengthening devices for the core rather than as actual armature. Iron rods in the hooves of the horses from the Charioteer monument[23] appear to rise through the center of the foot as though they were armature for the legs, which should be especially appropriate for thin supporting forms; if so, however, that is not proof that the body was formed around an armature, too. Unfortunately, the pieces of "armature" from inside the figure of Polyzalos were thrown away.

Since no large sections of core from a monumental Greek statue has survived, we do not know exactly how the cores were made. The general assumption has been that cores for statues made by the Direct Process were solid terra cotta built around a metal armature; the very concept of an armature presupposes such a working method, which has been standard for centuries. We have assumed that the ancient Greeks worked in this manner, too. But is that necessarily so?

Because the configuration of the thin walls of the
monumental statues are virtually the same on the inside as
the outside, any clay core must have been formed almost as
carefully as the actual model itself. Perhaps the large terra
cotta sculpture made by the ancient Greeks provides a clue to
the making of clay cores. All the ancient Greek pieces of
monumental terra cotta sculpture that I have been able to
examine, however, are definitely not solid.[24] None of the
figures appear to have been completely hollow; they are
reinforced by a system of interior walls. There could be
several advantages of making clay cores for monumental
sculpture in the same technique as that used for monumental
terra cotta figures: the core would be lightened and the
clay would have interior space for expansion and contraction
when it was fired and when the molten metal hit it, which
should provide a safety factor. If this suggestion were
correct, the iron rods found inside the Piraeus Apollo and
the Delphi Charioteer pieces probably served to strengthen
the core rather than to be an armature for it.

The simple outline and self-contained form of the
Piraeus Apollo figure might have been made from a one-piece
model, even though his bow and phiale were separately made.

The Models and the Casting

The Polyzalos figure from Delphi, cast in seven parts,
has so many overlapping and projecting forms that it could
not have been made from a one-piece model that was cut apart
or from piece moulds cut apart from a solid model. Most
likely, the figure of Polyzalos was made by a variation of
the simple Direct Process of lost wax casting from a seven-
piece model that could be fitted together to be certain the
castings would join but also could be separated like building
blocks for casting purposes. If there were armature and
solid core inside the figure of Polyzalos, it would have to
be self-contained in each casting unit.

So intricate are the undercuttings and overlappings of
the drapery of the goddesses from the Piraeus that the forms
appear almost impossible to produce by piece moulds taken
from one model. So naturalistic are the drapery folds on
these statues that the drapery might have been modeled—or
nearly draped—in sheets of wax or perhaps sheets of stiffened
cloth.[25] Since pure beeswax melts at a low temperature, it
undoubtedly would have to be stiffened with some added material
to be practical for a freestanding construction. Cloth
coated in wax could be used for an Indirect casting; but, if
a Direct casting were to be made, the stiffening material

would have to be something like powdered chalk that could
be lost with the wax.

Clearly none of the draped figures in this study was
cast from a one-piece model, as is proved by the precise
distinctions between representations of cloth overlapping
cloth, as well as representations of cloth overlapping flesh.
In addition to the clear example of the arms of the figure
of Polyzalos (figs. 4.5 and 4.6), the overlapping forms are
evident in the portions of the peplos of Artemis II that
originally were hidden by her cloak but can now be seen
through damage to the outer garment (figs.15.1 and 15.4);
the peplos has a distinct form of its own, even where it
would have been covered by the cloak.[26] The peplos of the
Piraeus Athena (figs. 13.2 to 13.5) also illustrates this
technical process: the skirt has a precise configuration all
the way to the waist, even where it lies beneath the overfold.
The pieces of drapery, therefore, obviously were modeled and
cast separately; they were not made from one model that was
cut apart. The same fitting together of independent volumes
is evident on the edges of the leg of the Agora Horseman,
which lay against the horse flank and was covered by cuirass
straps; all these forms were separately cast and could not

The Models and the Casting

have been made from a single model. Even the two palmettes
of the Agora Horseman monument were modeled and cast in two
parts (figs. 16.5 and 16.6), grooved to fit together.

In short, these Greek monumental statues do not seem
to be made according to either of the basic techniques of
lost wax bronze casting used since the Renaissance. Undoubtedly
one of the reasons the method by which they were made has
been so baffling to modern eyes is our dependence upon
seeing ancient Greek techniques in terms of what is known and
used today.

Exactly how the ancient Greeks did model and cast
monumental statues is still not certain. Examination of these
surviving statues, however, does establish that a sculptor in
Classical Greece did _not_ make a one-piece model, then use it—
either whole or cut into pieces—to cast monumental bronze
statues. The intricate overlapping relationship of volumes
evident in ancient Greek large bronze statues, which are
especially obvious in drapery and hair and exist even in
underlying configurations not meant to be seen, could only
have been made in separate pieces that were separate from
the beginning. These distinct parts undoubtedly could be
fit together, like building blocks. This conclusion is

reinforced by numerous chisel marks still visible on the inside of several of these monumental statues[27] in areas where one bronze section lies over another, such as the place on the inside of the leg of the Agora Horseman where it would have touched the horse; the separate parts apparently were made thinner so they would lie together more closely.

There is no reason to believe that all parts of every statue were modeled or cast in the same way; for example, a head might have been made in an openable mould, yet drapery for the same figure might have been modeled more freely in several interlocking or overlapping wax constructions to be used for a Direct casting.

Although these observations conclude that the models for ancient Greek monumental sculpture were made in pieces, this theory is not the same as the proposal advanced by others[28] that the Greeks used "piece-molding", which is a step in the modern concept of the Indirect Method of casting that depends upon either moulds cut apart from a one-piece original model or moulds made of pieces of an original model that had itself cut apart.

The method I have suggested of making a model in pieces could be a variation of the Direct Process of casting if the

The Models and the Casting

parts were made in wax; or if the parts were modeled in

another medium, from which megative moulds would be made

for positive wax impressions, the technique could fit into

our category of Indirect Process. It is doubtful, however,

that the ancient Greeks used these categories that we have.

Trying to fit ancient Greek modeling and casting

practices into modern knowledge of and vocabulary for

bronzeworking methods understandably led to confusion.

Careful observation, however, of the surviving Classical

Greek monumental statues clears up much of the earlier

misunderstanding.

The Cold Work and Insets

Once the cast bronze forms have hardened and are removed from their moulds, the black crust (the "casting skin") that covers all bronze after casting must be removed. Holes remaining from the casting process must be repaired; the ancient Greeks made a rectangular incision around the area to be mended and filled it in with a matching piece cut from sheet metal. Many of these rectangular plugs, which range from about one to two centimeters in length and width, are still visible on these statues.

Grooves cast in the surface of the bronze may need to be sharpened (e.g., the hair of the Artemision God, figs. 15.3 and 15.4), but only a few fine lines (e.g., the eyebrows of the Cyrene "Berber", fig. 10.2) appear to be articulated completely by point tools used to work the metal in its cold state.

On the fillet of Polyzalos (fig. 4.1) and on the quiver strap of Piraeus Artemis II (fig. 15.1), the meander pattern is represented by insets of a different metal (probably silver) cut to fit into incisions in the bronze surface. The inset pieces are small, the size of the dots and of each straight side of the meander design.

With the possible exception of the Piraeus Apollo and
the Selinus Youth, nipples of all the bare-breasted statues
in this group were inset in a metal of a different color,
probably pure copper to give a naturalistic reddish hue.

Again with the possible exception of the Piraeus Apollo
and the Selinus Youth, all these statues had lips made of a
different metal, also undoubtedly copper. The report of
the second restoration of the Antikythera Young Man[29]
contains the most complete information about an inset mouth
unit (see figs. 11.19 and 11.10); it was cast separately
and included a structure behind the lips to support a row
of teeth.

Although the earliest monumental heads we know in
bronze have closed mouths, the lips of the statues were
slightly parted as early as the Delphi Charioteer. All of
these statues assigned to the fourth century B.C. clearly
do have parted lips that reveal inset teeth. In most cases,
the teeth are damaged; those of the Antikythera Young Man
(fig. 11.11), the Piraeus Artemis I, and the Piraeus Athena
are still held in place by their original struts (e.g., figs.
11.9 and 11.10). The men at the National Museum in Athens
who restored the Piraeus Artemis I and the Piraeus Athena

inform me those teeth are represented in ivory. Denys
Haynes kindly confirms that the tests of the mass behind the
lips of the Cyrene "Berber" do report the presence of
silver in that instance, which seems to be unique in this
group.

In some of the earlier statues, eyebrows are also inset
with a different metal. Eyebrows of the Livadhostro Poseidon
as well as those of the small head of a Youth from the
Athenian Acropolis (Athens, National Museum, No. 6590;
fig. 6.5), still appear red, suggesting they too, are made of
copper. The corroded eyebrows of the God from Artemision are
about the same color as the surrounding bronze skin now,
but the outline of the same inset brows is still distinct.
The inset eyebrows of the Selinus Youth are lost.

Of all the individual parts of the statues, the eyes
surely are the most dramatic. Every Classical Greek statue
in this basic group, except the Archaic Apollo from the
Piraeus, had inset eyes. The eyeballs were made of
stone or glass in three parts: white for the whites, brown
or gray-blue for the irises, and black for the pupils. The
eyeballs were set into a bronze envelope,[30] probably made
in two pieces and hinged at the back; at the front, the

sheet metal was fringed and extended out from the eye to
represent eyelashes. Even in the damaged condition that some
survive, the naturalistic representation of eyes gives an
intense and lifelike effect to the statues.

Certainly the elaborate mouth-and-teeth units and the
eyes that are suspended on interior struts must have been
set inside a head before it was joined to a torso. Most
of these other inserts probably were also made while the
statues were still in the separate pieces in which they
were cast since the smaller size would be easier to handle.

Much more about the actual materials used for these
various insertions undoubtedly will be known when laboratory
tests can be made of them.

The Joins

All of the statues in this study were made in pieces.
The separate pieces were welded together,[31] a process that
Pausanias (x.16.1) believed was invented by Glaukos of Chios,
who lived about 600 B.C. On the inside of the statues, the
edges of the pieces are outlined by excess welding material,
but the parts are welded with such skill that it is usually
difficult—often virtually impossible—to distinguish
separate units by looking at the exterior.

Globs of gray granular material in the left hands of
the Piraeus Artemis I and the Piraeus Athena suggest that
their attributes were soldered in place; however, analyses
have not yet been made on the cementing material. The objects
anchored by these metallurgical joins are now separated from
the figures.

In other instances, such as the right hand of the
Piraeus Athena and the left hand of the Marathon Youth,
holes in the palm of the hand indicate the use of mechanical
joins to anchor objects to the statues. A hole in the head
of the Athenian Strategos implies that his helmet was

affixed to his head with one or more pins.

Heavy corrosion around the broken shaft of the bow and the rim of the phiale held by the Piraeus Apollo makes it difficult to determine how they were attached; perhaps they were connected by a stronger method than were the phiales and bows of the Piraeus Artemis statues since parts of both objects remain attached to the Apollo but are lost in the statues of these goddesses.

In some cases, objects may have been held in place by little more than the form of the figure. The right hand of the Delphi Charioteer (fig. 4.10), for example, is constructed to hold reins, which might be held in place by the grip of the hand.

In short, the parts of the figures themselves were welded together. Attributes or other distinct units were added with less permanence; apparently some may only have rested on the figure, some were attached mechanically, and others anchored metallurgically.

Maintenance of sculpture was important to the ancient
Greeks. An inscription of 279 B.C. at Delos establishes a
salary not only for the sculptor and painter, but also for
the care (κόσμησις) of a statue.[32] The descendants of
Pheidias, who were entrusted with the care of the cult
statue at Olympia, were called the Polishers (φαιδρυνταί)
of the Statue, according to Pausanias (v.14.5). There is also
a record of at least two offices of "Polisher" in Athens:
one in the service of Demeter and Persephone and the other
in the service of the Olympeion Zeus.[33] Of such prestige
were these offices that special seats in the theatre were
reserved for the two caretakers of the statues of Zeus.[34]

Visual evidence provides persuasive proof that the
ancient Greeks polished monumental bronze statues. The
surviving statues themselves show clear evidence of intricate
metal insets. If the copper lips and nipples and the silver
inset designs were not polished, they would, of course, soon
tarnish and the expense and effort of making them would
scarcely be worthwhile. Further evidence is provided in a
sherd from a bell krater of about 380-70 B.C. by the Birth
of Dionysos Painter (fig. 1.12 and note 1.35), which shows
a gleaming statue of Apollo; the statue is represented as

being in a style of at least a hundred years earlier than
that of the vase and the painting, so the artist must be
portraying an old statue, still brightly shining.

The large number of bronze mirrors made in ancient
Greece also attests to the polishing of the metal, which
would lose its reflective character if allowed to tarnish.
Sponges and powdered pumice, often found with ancient
mirrors,[35] probably were used for polishing them and may
also have been used to polish statues. Another polishing
agent might have been wood ash, a traditional metal polish.[36]

In addition to being polished, the statues probably
were covered with a protective coating to prevent or retard
tarnish. The Delian inscription of 279 B.C. (see above, note
32) also lists linen, oil, and wax among the required
materials for maintenance. Any agent which seals metal from
contact with air will, of course, help prevent oxidation or
tarnishing.

The oil referred to in the Delian inscription probably
is olive oil, which could be used as a coating against
oxidation.[37] According to Vitruvius (De arch. vii.9.2-4),
Punic wax is clarified wax; see the recipe given by Pliny,
xxi.84.) Wax is so effective for protecting bronze sculpture,[38]

that it is the substance used today by the Conservation
Department of the Fogg Museum to coat Henry Moore's Upright
Motive No. 8, which stands in the Harvard Yard where it needs
reliable safeguarding. It seems reasonable to assume that
the Classical Greeks may have used oil and probably used
wax as coating material for their monumental bronze statues.

In Roman times, pitch was used to preserve bronze
"from the injurious effects of time and rust" (Pausanias
i.15.4). Pliny (xxxiv.15) states, "The ancients painted their
statues with bitumen or mineral pitch ...I do not know
whether this is a Roman invention, but there are no ancient
examples of it in Rome"; he also says (xxxiv.99) that the
best way to preserve bronzes is to coat them with "liquida
pice". The standard translation of liquida pice is simply
"liquid pitch".[39] Massive amounts of liquid pitch or bitumen
are nearly black, but in thin layers it is brown or even
transparent. Exactly what Pliny or other ancients meant by
liquida pice, however, has not yet been determined; Earle
R. Caley raises the interesting possibility that the substance
to which Pliny refers is likely a fluid asphaltum, perhaps
even petroleum.[40] The question is an especially interesting
one because it relates to the problem of artificially

staining or patinating statues, which may have been done
by the Romans. Many of the Greek statues undoubtedly
became naturally patinated by Roman times. Visitors to
Delphi, in Plutarch's De Pythiae oraculis (395.2-4), comment
on the bright blue hue of a group of bronze statues standing
in the sanctuary of Apollo; Plutarch's characters discuss
the patina and decide it is the natural result of time, which
isn't surprising since Classical Greek statues would have
been hundreds of years old by Plutarch's time, the second
century after Christ.

One way to insure a shiny golden surface would be to
gild the statue. That was done in the case of the Agora
Horseman, the latest statue in this group and one that might
more properly be termed "Hellenistic". Pausanias (v.10.4)
says Nikes of gilded bronze made by Paionios (mid-fifth
century B.C.) stood on the ends of the gable of the Temple
of Zeus at Olympia and the Nike head from the Athenian
Agora[41] is generally accepted as an example of fifth-
century gilded bronze, but there is no evidence of gilded
monumental Greek statues earlier than the Horseman from
the Athenian Agora. The fascinating subject of gilded statues
is a complex one not yet fully explored; this group of

The Surface

surviving statues from the fifth and fourth centuries B.C.
indicates, however, that the practice of gilding monumental
bronze statues came to Greece at the beginning of the
Hellenistic period.

The alloy used by the ancient Greeks in the Classical
period for monumental sculpture was a simple one of about
eight parts copper to one part tin. The metal was cast by
the lost wax method, apparently most often by the Direct
Process or a variation of it, indicating that multiple
castings were made only seldom, if ever. The statues were
cast in pieces; the welded joins are so expert that they
cannot be easily detected on the outside even today. Insets
of stone, glass, and other metals were important: the eyes
of all these Classical statues (except for the Late Archaic
Piraeus Apollo) were made of stone or glass and set into
eye holes cut through the bronze walls, lips and bared nipples
were represented in redder copper, and teeth were set behind
parted lips. Meander designs on the ribbons or straps of
two of these statues were articulated in inset metal (silver?)
pieces cut to fit incisions in the bronze surface. The
surface was polished, so it gleamed in the golden color
of sun-bronzed skin.

From shadowy Archaic beginnings, the Classical Greeks
developed the practice of making monumental sculpture in
bronze and quickly evolved sophisticated techniques for
working bronze, which achieved results that have never been

A Summary

surpassed. High technical standards are evident throughout
the Classical period. From these surviving statues, an
ever increasing understanding and control of bronze working
is evident during the fifth and fourth centuries B.C.

The Early History

Notes

[1]For a history of metal-working techniques in the
ancient world, see R.J. Forbes, Metallurgy in Antiquity,
Studies in Ancient Technology, VIII (Leiden: Brill, revised
1971). Also see discussions by Arthur Steinberg, in "Techniques
of Working Bronze", in Mitten and Doeringer, Master Bronzes
from the Classical World (Mainz: Philipp von Zabern, 1967,
9-15; "Technical Note", Art and Technology, ed. by Doeringer,
Mitten, and Steinberg, 107-108; and "Joining Methods on
Large Bronze Statues: Some Experiments in Ancient Technology",
Applications of Science in Examination of Works of Art, ed.
by William J. Young (Boston: The Museum of Fine Arts, 1973),
103-138.

[2]Kluge's opinion about casting methods used by the
ancient Greeks for statues is published in "Die Gestaltung
des Erzes in der archaisch-griechischen Kunst", JdI 44 (1929),
1-30. His ideas, widely accepted as the standard reference
work on the subject, influenced the writings of such
authorities as Stanley Casson, The Technique of Early Greek
Sculpture (1933; reprint ed., New York: Hacker, 1970), 148-
166. Dependence upon Kluge's views contributed to Rhys
Carpenter's mistaken idea that monumental bronze sculpture
is glyptic rather than plastic in character; see Carpenter,
Greek Sculpture (Chicago: University of Chicago Press,
1960), 74-75.

[3]Among the earliest figurines in bronze are those
of a man and a woman from northern Syria, now in Boston
(Museum of Fine Arts, Nos. 49.118 and 49.119), probably made
about 2900 B.C.; published by Edward Terrace, Art of the
Ancient Near East in Boston (Boston: The Museum of Fine Arts,
1962), nos. 1 and 2. These statuettes were brought to my
attention by David Mitten.

[4]Smith, Art and Architecture of Ancient Egypt, 80.

[5]Cairo, Egyptian Museum, No. 230; see note 8 above
in the discussion of Bronze: The Alloy pp. 302 and 306, note 8.

[6]The corroded condition of the metal makes study of
the larger-than-lifesize statue of Pepy I difficult; the
technique by which it was made has not been established. The

excavators thought the figures were hammered over a wooden core; see J.E. Quibell and F.W. Green, Hierakonpolis II, (London: B. Quaritch, 1900-1902), 46-47. Their theory, which may have influenced Kluge's ideas (see above, note 2), is accepted by Smith, Art and Architecture of Ancient Egypt, 80, and Michalowski, The Art of Ancient Egypt, 187. Quibell and Green do not, however, report having found any wood inside the figures, although wood survives in Egypt from as early as Dynasty III (see A. Lucas, Ancient Egyptian Materials and Industries, 4th ed., rev. and enlarged by Harris, p. 430). Harris, ibid., 214-215, gives a concise discussion of the questions about the technique by which the figures of Pepy I and his son were made.

[7]See Henri Frankfort, The Art and Architecture of the Ancient Orient, 4th ed., rev., the Pelican History of Art (London: Penguin, 1969), 41 and pls. 42-43.

[8]G.M.A. Richter, Sculpture and Sculptors[4], 115 and 151.

[9]Olympia Museum, no. B.6500. Preliminary note of the sculpture has been made by A.H.S. Megaw, "Archaeology in Greece", JHS, 1965, 13-14, fig. 15, and by Georges Daux, "Chronique des Fouilles, 1965, Olympia," BCH 90 (1966), 812 and fig. 1 on p. 813. Archaeological context establishes the early sixth century date, which is stylistically appropriate. Information about the excavation was shared with me by the excavators. The bust will be published by Kunze.

[10]Published by S. Marinatos in AA 51 (1936), cols. 217-227 and in BCH LX (1936), 485.

[11]The mould for the lost wax casting of a life-size (0.16 m. long) clenched fist and wrist, discovered in the second palace phase at Phaistos, is published by Clelia Laviosa, "Una forma minoica per fusione a cera perduta", Annuario della Scuola Archeologica di Atene 45-46, N.S. 29-30 (1967-68), 499-510. David Mitten kindly brought this reference to my attention.

[12]Homer A. Thompson, "Buildings on the West Side of the Agora", Hesperia 6 (1937), 82-83, and T. Leslie Shear, "The Campaign of 1936", Hesperia 6 (1937), 343-344. Also see above, note 1.16.

[13]Egyptian and Near Eastern influences at Samos are
dramatically illustrated by the bronze excavated at the
Heraion of Samos, recently published by Ulf Jantzen,
Agyptische und orientalische Bronzen aus dem Heraion von
Samos, Deutsches Archäologisches Institut, Samos, VIII,
Herausgegeben im Auftrage des Instituts von Ernst Homann-
Wedeking (Bonn: Rudolf Habelt Verlag, 1973). Also see G.M.A.
Hanfmann's review of Jantzen's publication, Bibliotheca
Orientalis XXX, 3/4 (May/June, 1973), 198-200.

[14]Kurt Kluge and Karl Lehmann-Hartleban, Die antiken
grossbronzen, herausgegeben und erläutert, 3 vols. (Berlin
and Leipzig: W. de Gruyter and Co., 1927), see especially
vol. 1, "Die antike Erzestaltung" by Kluge; Kurt Kluge,
"Die Gestaltung des Erzes in der archaisch-griechischen
Kunst", JdI 44 (1929, 1-30.

[15]I am indebted to Phyllis Williams Lehmann for this
information, given to me verbally, which explains the
dependence of the Kluge and Lehmann-Hartleben work upon
Roman objects, even though the research has been widely
accepted for Greek technique, too. Considerable differences
do exist between Greek and Roman techniques for making
monumental bronze statues, as is illustrated by the
distinctive chemical composition of bronze sampled from
Greek statues, which varies considerably from Roman
statuary bronze (see above, p. 302).

[16]Work already published by Haynes includes "The
Bronze Priests and Priestesses from Nemi: Appendix", RM
67 (1960), 45-47; "Some Observations on Early Greek Bronze
Casting", AA 77 (1962), cols. 803-807; "The Technique of
the Chatsworth Head", RA 1968/1, 101-112; and "Ancient
Bronze-casting Methods", AA 85 (1970), 450-452.

[17]Archaeological evidence for foundries and foundry
remains are being studied by Carol Mattusch; her doctoral
dissertation, Large-scale Bronze Casting Technique in Greece
from the 6th century B.C. to the Hellenistic Period, is
being written for the University of North Carolina.

The Models and the Casting

[18]These observations on modeling and casting techniques used in Greek monumental sculpture are based on what I was able to see in the surviving sculpture. The observations do not include information based on the Selinus Youth since that smaller statue was extensively restored many years ago, without record, and the interior filled with cement; therefore, generalizations about the other statues might not be applicable to the Selinus Youth.

[19]For a modern description of lost wax bronze casting techniques, see Arthur Beale, "Materials and Techniques", in J. Wasserman, J. Luckach, and A. Beale, Daumier Sculpture: A Critical and Comparative Study (Cambridge: Fogg Art Museum, Harvard University), 1969. While Beale's essay is directed toward Daumier's practice, it also describes lost wax bronze casting techniques in general.

[20]Denys Haynes demonstrates that the Chatsworth Apollo was made by the "lasagna" technique; see "The Technique of the Chatsworth Head", RA 1968, 101-112. Haynes also illustrates positive drip marks in "Some Observations on Early Greek Bronze Casting", AA 77 (1962), cols. 803-807.

[21]Haynes, RA 1968, 101-112.

[22]I am grateful to Dr. Nicholas Yalouris, Director of the National Museum in Athens, for granting me permission to see this material and to the personnel of the National Museum Laboratory for assistance.

[23]Unfortunately, a view which shows the iron rods in the hooves is not illustrated by Chamoux in L'Aurige.

[24]A study of terra cotta statues found at Corinth is being made by Dr. Nancy Bookides, which will illustrate the walled interiors; her publication is delayed because of the unfortunate fire in 1972 in the Corinth excavation house, which destroyed much of her preliminary work. A similar shell construction is seen in three large terra cotta figures at Olympia, the striding headless warrior, the head of "Athena", and the Zeus and Ganymede. I do not know of a publication that discusses or illustrates their construction, but their hollow form is easy to see and even apparent in photographs;

e.g., see Lullies and Hirmer, Greek Sculpture[2], pls. V and
1-5 for good views of the Zeus and Ganymede. Much of the
large terra cotta sculpture in Magna Graeca appears to have
somewhat thicker walls than those of comparable sculpture in
the Peloponnese and, therefore, it is more difficult to
see the shell construction in ordinary photographs; examples
published by Langlotz and Hirmer in Ancient Greek Sculpture
of South Italy and Sicily, includes No. VII, the Head of a
Goddess from Agrigentum (ca. 500 B.C., Palermo, Museo
Nazionale Archeologico, No. 3450), No. 124, one of the
Dioscuri on Horseback that is said to be from the temple in
Contrada Marafioti near Locri (late fifth century B.C.,
Reggio, Museo Nazionale), and No. XII, the Head of a Goddess
from Tarentum (early fourth century B.C., Taranto, Museo
Nazionale, No. IG 4006). That the Etruscans followed the
same practice of making large terra cotta statues hollow is
illustrated by the Goddess and Child made about 500 B.C.,
now in Rome at the Museo di Villa Giulia; see Hanfmann,
Classical Sculpture, pl. IV.

[25]Steinberg suggests that the models were built of
"stiffened cloth, disassembled, and cast separately", a
Renaissance practice discussed by Biringuccio in V. Pirotechnia
(Venice, 1540; trans. by C.S. Smith and M. Gnudi; Cambridge:
MIT Press, 1966, p. 231); see A. Steinberg, "Joining Methods",
Application of Science in Examination of Works of Art (Boston:
The Museum of Fine Arts, 1973), 108.

[26]Steinberg, ibid., 107-108, correctly notes that
the long vertical drapery pieces of Artemis I and Athena
were not taken from piece molds, but he seems to imply that
the other sections were.

[27]For the best published illustration of these
chisel marks, see Steinberg, ibid., fig. 8, of the Piraeus
Athena. I have also seen the same kind of chisel marks on
the Piraeus Artemis I, the Agora Horseman, and also on the
Hellenistic "Lady of the Sea" in Izmir, published by B.S.
Ridgway, "The Lady of the Sea", AJA 71 (1967), 329-334.

[28]See Kluge, note 2 above, and Steinberg, "Joining
Methods", 108 and his note 14.

The Cold Work and Insets

[29]Christos Karousos, ArchEph., 1969, 59-79.

[30]Good illustrations of both a separated bronze leaf from an envelope for an eye and of a detached eye still inside a bronze envelope are given by G.M.A. Richter, Korai (London: Phaidon, 1968), fig. IV-e.

The Joins

[31]Welding techniques used by the ancient Greeks are discussed by Herbert Maryon, "Metal Working in the Ancient World", AJA 53 (1949), 93-123, and by Arthur Steinberg, "Joining Methods on Large Bronze Statues", 103-138. Steinberg, who generously discussed his article with me, reports that there is still work to be done before our knowledge of ancient Greek welding practices can be accepted as definite.

The Surface

[32]Th. Homolle, "Des Temples Déliens en l'année 279", BCH XIV (1890), 495-497. Also see Richter, Sculpture and Sculptors⁴, 129-130.

[33]The ancient references to Polishers are conveniently collected by J.G. Frazier in Pausanias's Description of Greece (London: Macmillan, 1898), III, 560-561.

[34]Ibid.

[35]George Savage, A Concise History of Bronzes (London: Thames and Hudson, 1968), 74.

[36]P.R. Lowery and R.D.A. Savage, "Scriber, Graver, Scorper, Tracer: Notes on Experiments in Bronzeworking Technique", Proceedings, Prehistoric Society, 37, part 1 (1971), 167-182.

[37]This use of the oil listed in the Delian inscription was suggested by Earle R. Caley in a letter of May 13, 1974, in response to my inquiry.

[38] Malvina Hoffman, _Sculpture Inside and Out_ (New York: Bonanza, 1939), 292.

[39] See, for example, H. Rackham, _Pliny, Natural History_, IX, 201, The Loeb Library, 394 (Cambridge: Harvard University Press, 1952).

[40] In his letter of May 13, 1974, Caley also reports:

> Natural asphalts and bitumen were the
> same in ancient times as they are today.
> When massive they are black, or
> nearly so, but in thin layers they
> are brown and transparent. I rather
> doubt that the _liquida pice_ of
> Pliny xxxiv.99 was a vegetable pitch
> as translated by Rackham. It seems
> more likely to me to have been a
> fluid asphaltum, perhaps even
> petroleum.

Mr. Rutherford J. Gettens agrees that the term "pitch" has been used loosely. In a letter of May 9, 1974, in response to an inquiry from me, Dr. Gettens says,

> The term "pitch" has no precise meaning.
> It has been applied both to the
> various asphaltic and bituminous
> materials found in the neighborhood
> of oil deposits. The term is applied
> not only to bituminous products
> but also to the resinous exudation
> of pine and some other species of
> trees. Materials described as pitch
> are usually viscous when melted and
> brittle when cold, and when cold
> they break with a characteristic
> conchoidal fracture. I am sure
> there are no clear bituminous pitches;
> they are all brown or black. Pine
> pitch, however, may be fairly clear
> when fresh.

[41]Athens, Agora Museum No. B 30. See Dorothy Burr Thompson, "The Golden Nikai Reconsidered", *Hesperia* XIII (1944), 173-209, with earlier bibliography; also, Marie Farnsworth and I. Simmons, "A Unique Cement from Athens", *Hesperia* XXIX (1960), 118-122.

Monumental statues in bronze are a part of and evolve from the ancient Greek sculptural tradition. Their development is related in varying degrees to bronze statuettes, to large terra cotta figures, to chryselephantine statues, to paintings, and to lifesize marble statues.

The production of bronze figurines, made in great numbers during Archaic Greek times, diminished considerably in the Classical Greek period. Traditional poses used by the makers of the small bronze are continued by the sculptors of the monumental bronzes, as is illustrated by the Avenging God stance used for both the small figure from Dodona of Zeus (fig. 5.14) and the monumental Zeus or Poseidon from Artemision (fig. 5.1). The knowledge of bronze working acquired by the Archaic craftsmen—makers of armor and vessels as well as of statuettes—was a foundation for the Classical sculptors who worked in large-scale bronze. There does not, however, appear to be a direct one-for-one relation between the small bronze figures and the large statues. I have not been able to find even one statuette that is either a copy of or a direct model for a monumental bronze statue.

Large terra cotta figures would seem to be closely related to large bronze statues, since they both are

modelled. Close stylistic similarities are evident, between
the early bronze statues and large terra cotta figures made
about the same time, as is witnessed by comparing the bronze
Livadhostro Poseidon (figs. 2.1 and 2.2) with the terra
cotta figure of Zeus carrying Ganymede at Olympia (illustrated
by Lullies and Hirmer, Greek Sculpture[2], pl. V).

Bronze statues are also related to the opulent
chryselephantine statues in that the metal of both seems to
have been cast, probably by a form of the Direct method of
lost wax casting. The moulds for gold drapery found in the
workshop of Pheidias at Olympia (illustrated by G.M.A.
Hanfmann, Classical Sculpture, fig. iv) may be the best
parallel for the technique in which the drapery of monumental
bronze statues were made. The small bronze Nike from the
Athenian Agora (see above, Bronze Working note 41), keyed
for gold plating in a way that does not destroy the design
when the gold is removed, may offer the best model for the
way in which the chryselephantine figures of the Athena
Parthenos and the Olympian Zeus by Pheidias were designed
to enable the removal of their gold plating.

Since virtually every important sculptor in Classical
Greece worked in both bronze and marble, it is logical to
expect that sculptural style developed simultaneously in

both media, as indeed it appears to have done. Both the head
of the Athenian Strategos (fig. 3.1) and the comparable
head of a helmeted warrior from Aegina (fig. 3.5) might have
been executed in either medium with virtually no stylistic
changes. Bronze, however, can be shaped in freer forms than
is possible with marble; therefore, bronze probably was
chosen for the more open compositions and undoubtedly led
to the development of outspread form. It is difficult, for
example, to imagine the design of the God from Artemision
being conceived by a sculptor who worked only in marble.
How much of its impact the statue would lose if it were
executed in marble with the supporting struts that would be
required to hold the cantilevered arms!

The desire to break out of the confines of the closed
compositions of Archaic sculpture must have been a primary
impetus in the development of bronze as a medium for
monumental sculpture. Bronze gave sculptors much of the
freedom to represent open form that they could see painters
use. The rapid and widespread acceptance of bronze as the
most frequently used medium for lifesize sculpture in the
Classical period goes hand in hand with the development of
Classical style. The style demands the medium and technique,
and the medium and technique make the style possible.

The most dramatic development in surviving monumental bronze sculpture occurs at the very beginning. The Piraeus Apollo and the Livadhostro Poseidon are closed compositions that might have been made in marble. The potential of the medium is quickly apparent to the Classical artists, who achieved with equal speed the technical mastery for making bronze sculpture. A composition similar to the Delphi Charioteer might have been executed in marble, but only with considerable difficulty. The composition of the God from Artemsion depends upon characteristics of bronze.

Many stylistic characteristics begun in the early fifth century are highly developed by the end of the fourth century B.C. The subtle counter-twist stance of the Delphi Charioteer (figs. 4.2 and 4.3) evolves into a pronounced spiral in the Marathon Youth (fig. 14.1). Representations of individual identities move from abstract generalizations (seen in the Athenian Strategos; fig. 3.1), to more individual but still symbolic figures (seen in the Delphi Charioteer, which probably is a "portrait" of Polyzalos, but one with idealized features that may have no bearing on that man's actual physical countenance; figs. 4.1 to 4.9), to specific, individualized portraits even of the divinities (seen for example, in the Piraeus Artemis II; figs. 15.1 and

15.2).

The degree of geometric order imposed upon design
steadily decreases and the amount of naturalism increases
from the fifth to the fourth century B.C. For example, the
hair of the Charioteer is represented in a precise, flat
symmetrical design on the top of his head (figs. 4.8 and
4.9); the hair of the God from Artemision is depicted with
a greater degree of plasticity and natural pattern; and the
hair of the Young Man from Antikythera (figs. 11.4 and 11.5)
and the Marathon Youth (figs. 14.1 and 14.4) are fully
three-dimensional and the forms appear to be almost random
in comparison with the geometric stylization of the early
fifth century designs.

Solemnity and majestic strength are important expressions
of the early fifth century figures, exemplified by the
Delphi Charioteer (figs. 4.1-4.9) and the God from Artemision
(figs. 5.1-5.9). That emphasis, however, changes to qualities
of gentleness and compassion in the graceful statues of the
fourth century B.C. This change should not be confused with
weakness: the potential physical strength is relaxed but
not diminished, and artistic vitality remains powerful. The
simple faith and self-confidence evident in the early fifth-
century forms grows into a quieter attitude of introspection
and compassion.

The characteristics common to these Classical figures, however, is much stronger than their differences and gives us an enriched view of Classical Greek art. The value of this view, based on original statues rather than copies, is emphasized by the difference between the Piraeus Athena (figs. 13.1-13.5) and the Mattei Athena (figs. 13.8-13.10), the only case in which we have both an original Greek freestanding bronze statue and a Roman copy of it.

Architectural sculpture, which adorned temples in ancient Greece, was part of a public program and appropriately devoted to stories related to the divinity of the temple. Greater individual freedom is possible in freestanding statues, which could be either private or public commissions. Evidence for portraits, therefore, quite logically exists in these examples of independent, freestanding sculpture.

These early portraits reflect emphasis on virtues and the accomplishments of deeds rather than on the cult of the individual. Polyzalos, for example, might erect a monument in the temenos at Delphi celebrating his victory in the Games, but not simply for himself as a person. Xanthippos, if indeed the Athenian Strategos represents him, could erect a monument of himself as a Strategos to commemorate his service to the people, but it is unlikely that a statue of him

would have been allowed on the Acropolis if he served only
his own interest rather than those of Athens. Honored for
ideal achievement, the Classical Greek was represented in
ideal form.

The cult of the individual clearly had begun, however,
at the end of the fourth century B.C., when Demetrios
Poliorketes took Athens, proclaimed himself divinity, and
lived in the Parthenon, the house of his "sister", Athena.,
If the fragments of the Agora Horseman Monument do indeed
represent Demetrios Polioketes, they mark the beginning of
a new concept in Greek portraiture, one with emphasis on
the individual himself rather than the personification of
virtues.

The esteem in which the Greeks held the entire human
body is clearly demonstrated by these figures. The heads
are represented as part of the whole body; even though only
the heads survive in several of our examples, they are
broken away from the body. The figure of Polyzalos was
dressed in the special costume of a charioteer (fig. 4.1)
and the Agora Horseman (fig. 16.1) apparently was clad in
the cuirass costume common to the men of Alexander, like
that of the comparable statuette in Naples (fig. 16.7). The
other male bodies in this group are represented nude without

self-consciousness. Bodies are bare with the same acceptance
of physical forms as bare faces. Nudity is as natural in
these figures as it was for the men in ancient Greece who
had no sense of shame or guilt about their bodies and who
were accustomed to being nude not only in the palestra but
also during much of their daily life. The handsome athletic
forms are sensual in their nudity, but not erotic in
nakedness. Man's body is seen as part of his whole being,
not simply a trunk for his exposed head.

The concept of unity of mind and body is made visible
in these statues. The physical aspect is an important part
of the complete man: physical ability is represented as
well-developed, but not over-developed. Thoughtful and
intense expressions of intellectual character are clearly
evident in every figure, even in the victorious athlete. Both
mental and physical capacities are realized, but not to the
neglect of the other. The potential for physical power is
increased and made more human by mental control, and the
desires and powers of the mind may be more easily realized
by physical capacity.

Devotion to the human form and the anthropomorphization
of gods, of ideals, of virtues, and of accomplishments is
visual expression of faith in human capacity. The immortalized
form created by the Classical Greek sculptor is idealized;

it is the ideal human with capacities developed and
disciplined, a person as people should be.

Balanced forms and calm stances express ideals of
self-control and equilibrium. Animal instincts, passions,
and force lie beneath the disciplined surface, giving
vitality to the visual forms. The outward expressions of
serenity and equilibrium are the result of a precarious
balance imposed by human control upon chaos. Centaurs and
Lapiths lived in every Greek. The equilibrium of Classical
Greek sculpture gives visual form to the victory, sometimes
the precarious victory, of civilization and human reason.

A bibliography for each statue included in this group
is given at the end of the study of the statue. Publications
related to matters discussed in the Conclusions are noted
at the relevant places.

Books cited frequently are included in the following
list; other publications are cited with full bibliographical
information at the first reference to them in each chapter
and abbreviated in subsequent citations.

Frequently cited periodicals are also abbreviated,
although the full name is given where necessary for clarity.
Most of the abbreviations used here are those recommended
in "Notes for Contributors and Abbreviations", American
Journal of Archaeology 74 (1970),

Arias, P.E. and Hirmer, Max. A History of a Thousand Years
 of Greek Vase Painting. rev. by B. Shefton. New
 York: Abrams, 1961.

Ashmole, Bernard. A Catalogue of the Ancient Marbles at
 Ince Blundell Hall. Oxford: Clarendon Press, 1929.

Ashmole, Bernard; Yalouris, Nicholas; and Frantz, Alison.
 Olympia: The Sculpture of the Temple of Zeus.
 London: Phaidon, 1967.

Beazley, John Davidson. Attic Black-figure Vase Painters.
 Oxford: Clarendon Press, 1956.

_____. Attic Red-figure Base Painters. Oxford: Clarendon
 Press, 1963.

Bieber, Margarete. The Sculpture of the Hellenistic Age.
 2nd rev. ed. New York: Columbia University Press, 1961.

Chamoux, Francois. L'Aurige. Fouilles de Delphes IV:5.
 Paris: Boccard, 1955.

Charbonneaux, Jean. Greek Bronzes. Translated by Katherine
 Watson. New York: Viking, 1962.

Comstock, Mary and Vermeule, Cornelius. Greek, Etruscan,
 and Roman Bronzes in the Museum of Fine Arts, Boston.
 Greenwich, Connecticut: New York Graphic Society, 1971.

Doeringer, Suzannah; Mitten, David Gordon; and Steinberg,
 Arthur, eds. Art and Technology: A Symposium on
 Classical Bronzes. Cambridge: MIT Press, 1970.

Hanfmann, George M.A. Classical Sculpture. Greenwich, Conn.:
 New York Graphic Society, 1967.

Kraay, Colin M. and Hirmer, Max. Greek Coins. New York:
 Abrams, 1966.

Lippold, Georg. Die Griechische Plastik. Handbuch der
 Archäologie, III. eds. Walter Otto and Reinhard
 Herbig. Munich: C.H. Beck, 1950.

Lullies, Reinhard and Hirmer, Max. Greek Sculpture. rev.
 and enlarged ed.; English translation by Michael
 Bullock. New York: Abrams, 1960.

Mitten, David Gordon and Doeringer, Suzannah F. Master
 Bronzes from the Classical World. Exhibition
 catalogue, The Fogg Art Museum, 1967-1968. Mainz:
 P. von Zabern, 1967.

Picard, Charles. Manuel d'Archeologie Grecque, La Sculpture.
 4 vols. Paris: Picard, 1935-1963.

Pausanias. Guide to Greece. English translation with
 commentary by J. Frazer (London: Macmillan,1913);
 also Peter Levi (London: Penguin, 1971).

Pliny the Elder. Natural History. English translations by K.
 Jex-Blake and E. Sellers (London:Macmillan ,1896)
 and by H. Rackham (The Loeb Library; Cambridge:
 Harvard University Press, 1952).

Richter, Gisela M.A. Kouroi: Archaic Greek Youths. 3rd ed.
 London: Phaidon, 1970.

_____. The Portraits of the Greeks. London: Phaidon, 1965.
 Supplement, 1972.

_____. The Sculpture and Sculptors of the Greeks. 4th ed.
 rev. New Haven: Yale University Press, 1970.'

Ridgway, Brunilde Sismondo. The Severe Style in Greek
 Sculpture. Princeton: Princeton University Press, 1970.

Rizzo, G.E. Prassitele. Milan and Rome: Fratelli Treves, 1932.

AA: Archäologischer Anzeiger.

AAA: Athens Annals of Archaeology.

AJA: American Journal of Archaeology.

AM: Mitteilungen des deutschen Archäologischen Instituts, Athenische Abteilung.

AntK: Antike Kunst.

ArchEph: Archaiologike Ephemeris.

BCH: Bulletin de correspondance hellenique.

BrBr: Brunn-Bruckmann, Denkmäler.

BSA: British School at Athens, Annual.

CRAI: Comptes rendus de l'Académie des inscriptions et belles lettres.

CVA: Corpus Vasorum Antiquorum.

Deltion: Archaiologikon deltion.

IG: Inscriptiones Graecae.

JdI: Jahrbuch des k. deutschen archäologischen Instituts.

JHS: Journal of Hellenic Studies.

MdI: Mitteilungen des deutschen archäologischen Instituts.

MonPiot: Monuments et memoires publ. par l'Academie des inscriptions et belles lettres, Fondation Piot.

RA: Revue archeologique.

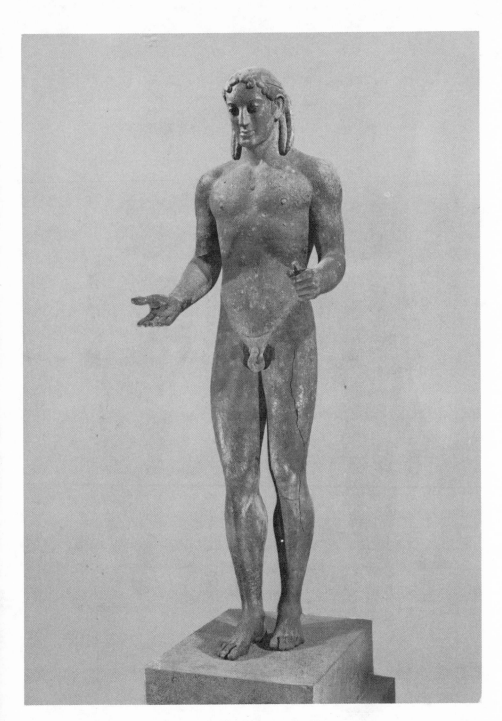

1.1 The Piraeus Apollo

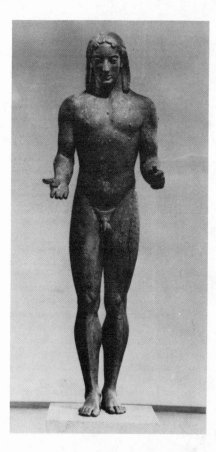

1.2 The Piraeus Apollo

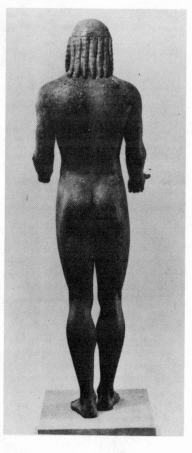

1.3 The Piraeus Apollo

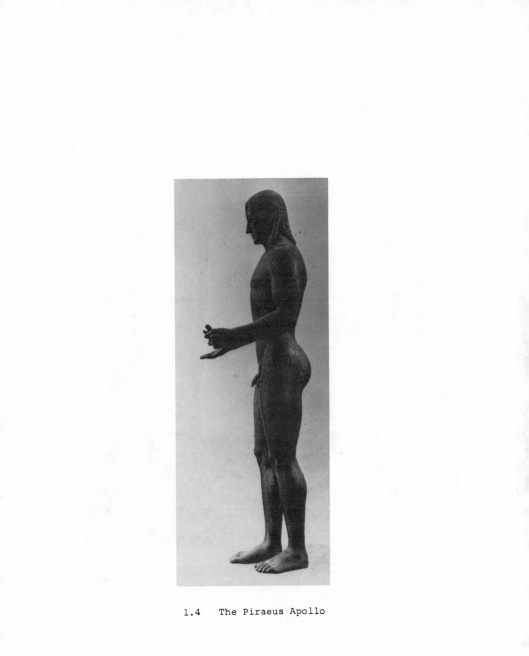

1.4 The Piraeus Apollo

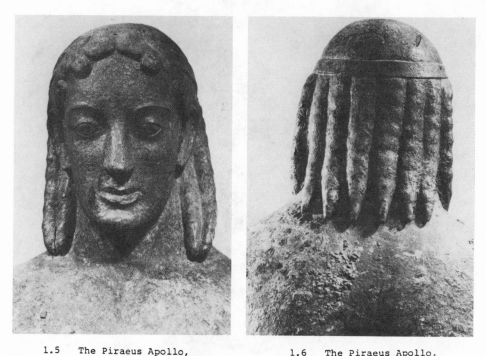

1.5 The Piraeus Apollo,
 detail of face.

1.6 The Piraeus Apollo,
 back of head.

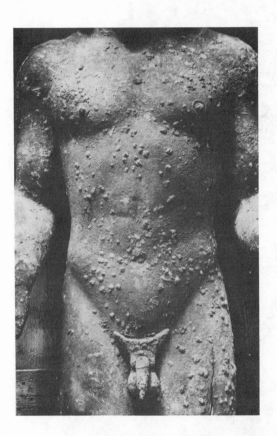

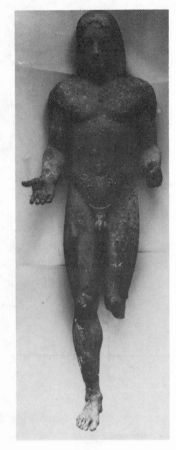

1.7 The Piraeus Apollo,
torso before cleaning

1.8 The Piraeus Apollo,
during conservation with
left leg detached.

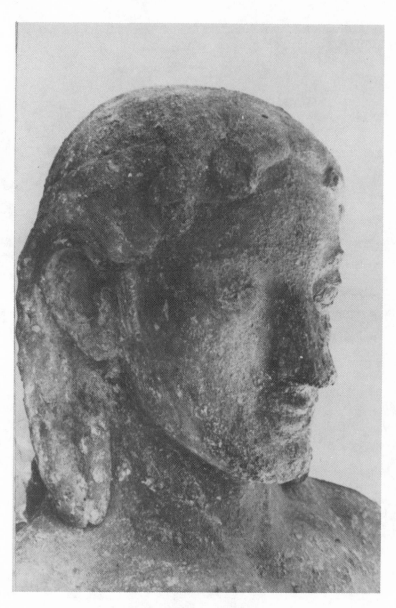

1.9 The Piraeus Apollo, head before cleaning

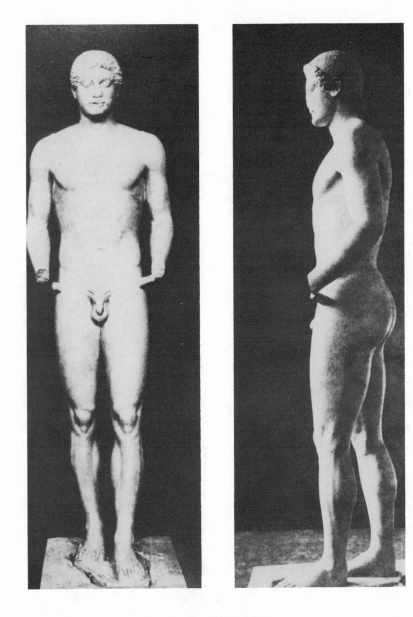

1.10 Aristodikos

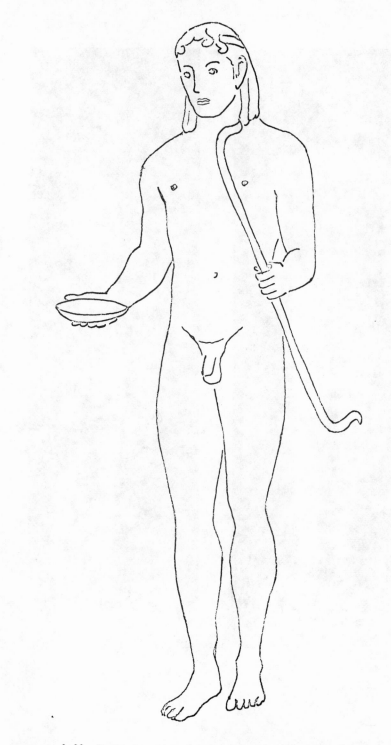

1.11 Reconstruction drawing of the Piraeus Apollo

1.12 Temple of Apollo, sherd in Amsterdam

2.la, b, c Livadhostro Poseidon

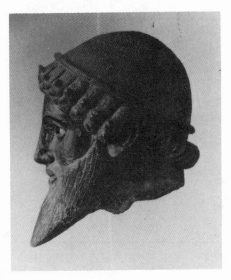

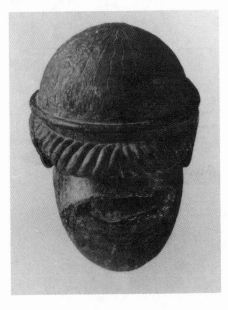

2.2a, b, c Livadhostro Poseidon

2.3 Drawing. Inscription on the base of the Livadhostro
 Poseidon

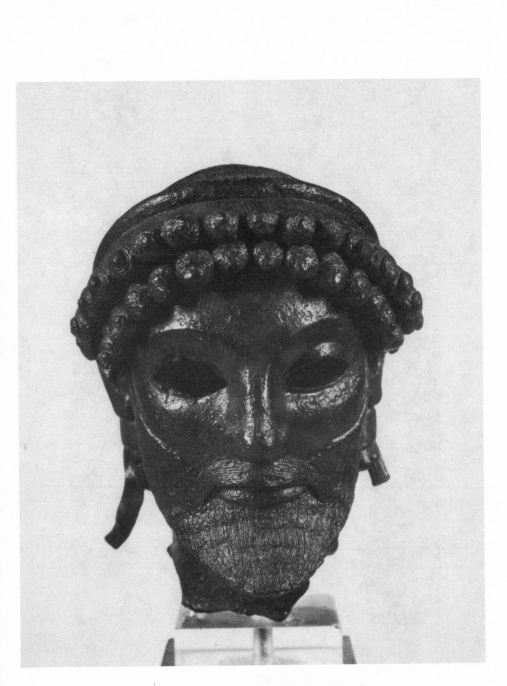

2.4 Bronze head (Zeus?) from Olympia.

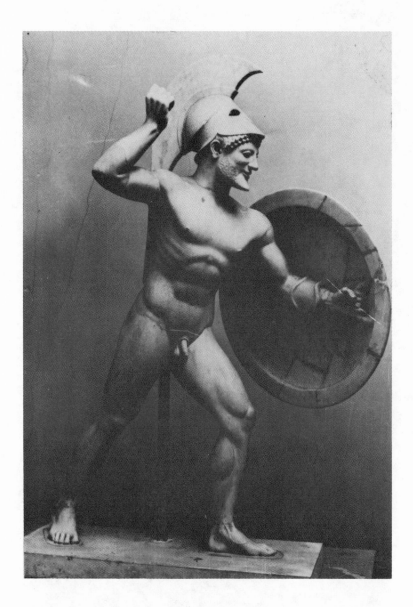

2.5 Warrior from Aegina

2.6　Drawing of the Livadhostro Poseidon, shaded areas
　　　representing losses. CH.

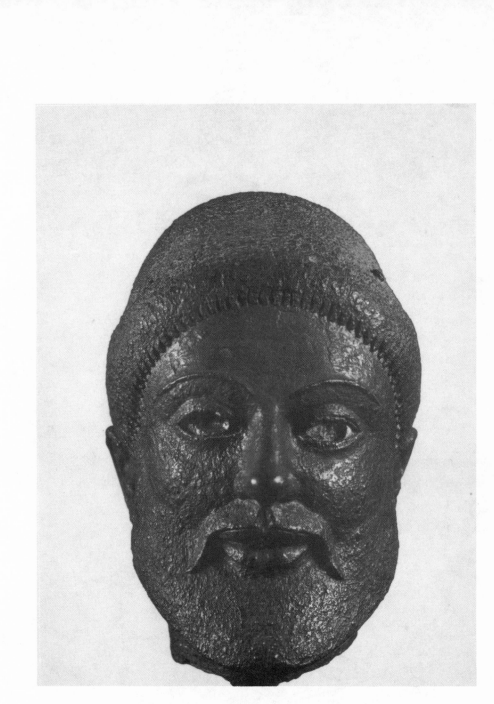

3.1 Athenian Strategos.

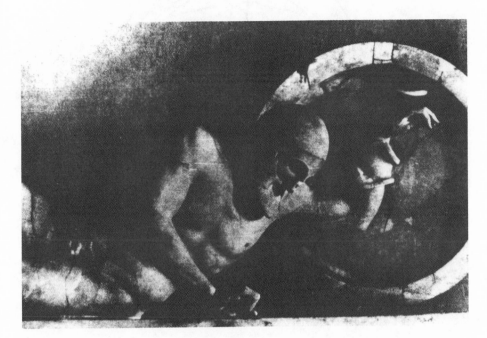

3.2 Warrior from Aegina.

3.3　Drawing of the Athenian Strategos reconstructed with helmet.

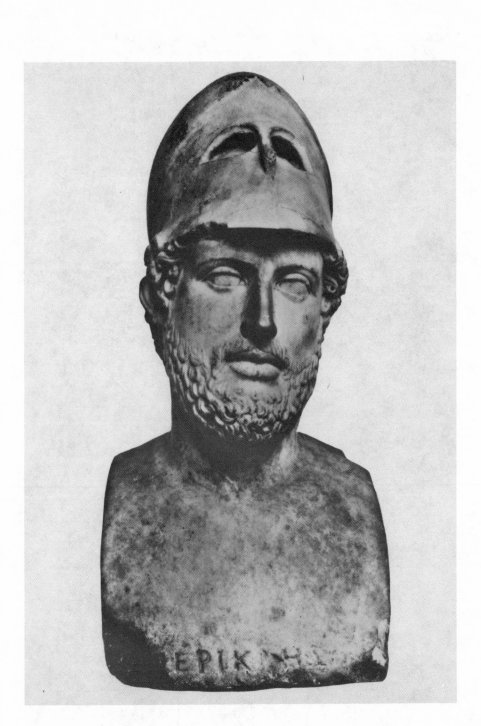

3.4 Bust of Pericles, Roman copy.

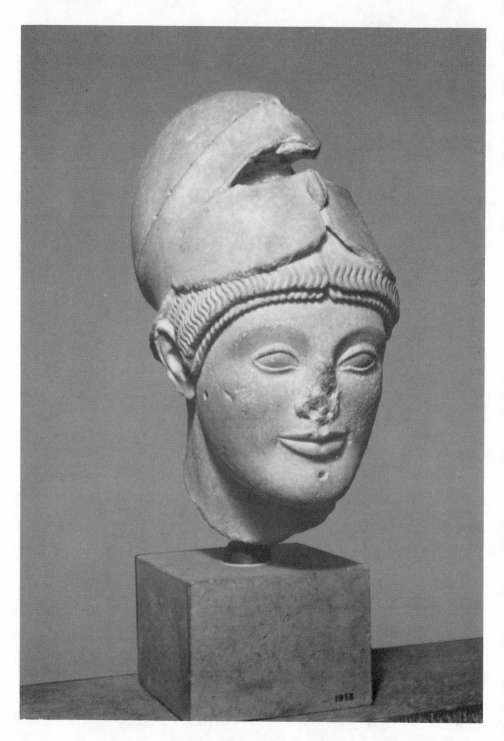

3.5 Warrior from Aegina.

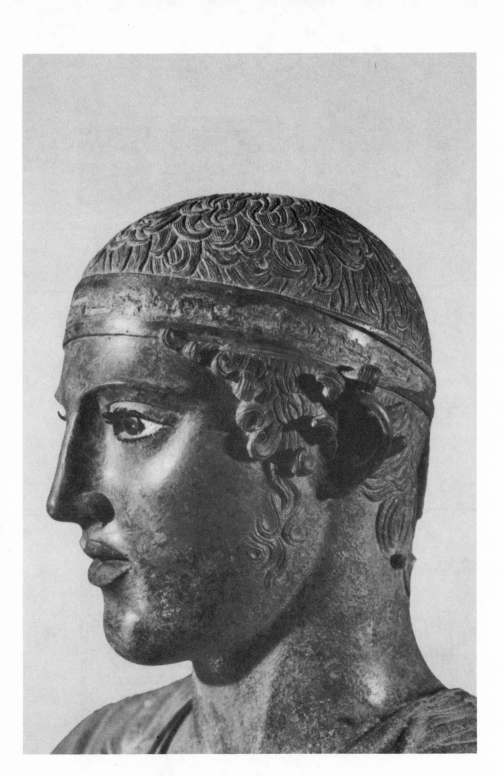

4.1 Polyzalos, the Delphi Charioteer.

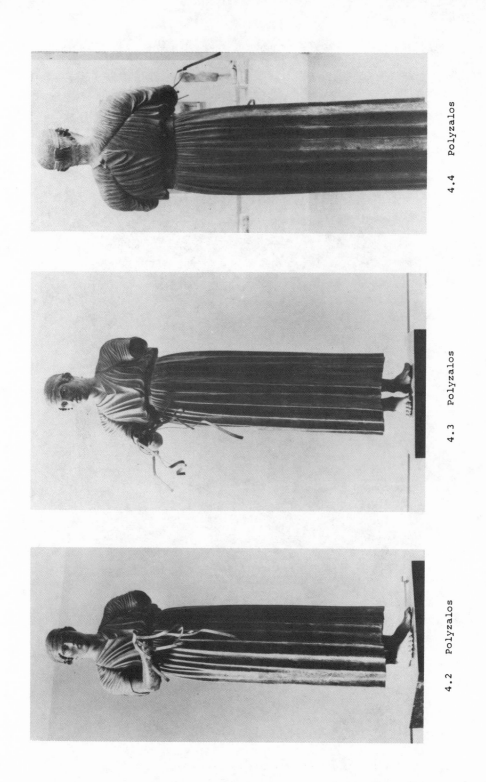

4.2 Polyzalos

4.3 Polyzalos

4.4 Polyzalos

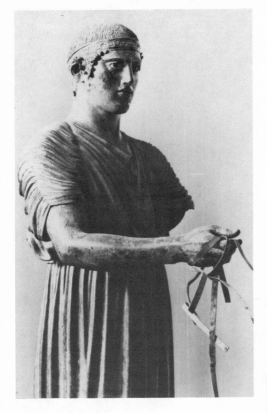

4.5 Polyzalos

4.6 Polyzalos, torso

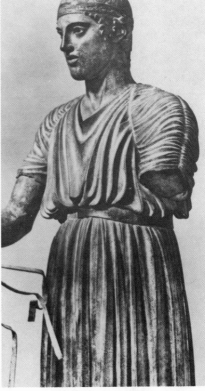

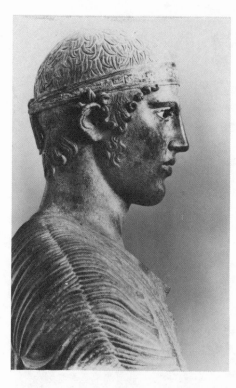

4.7 Polyzalos

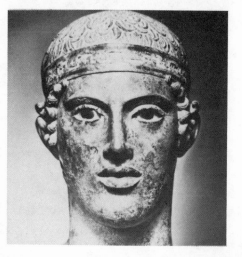

4.8 Polyzalos

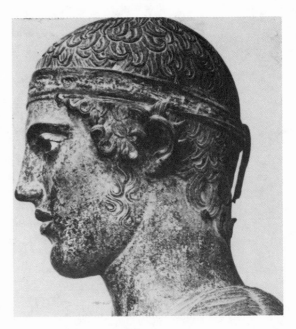

4.9 Polyzalos

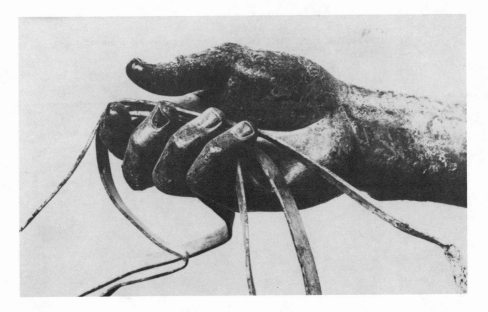

4.10 Polyzalos

4.11 Drawing of first and second inscriptions on base of
 Charioteer monument. Chamoux.

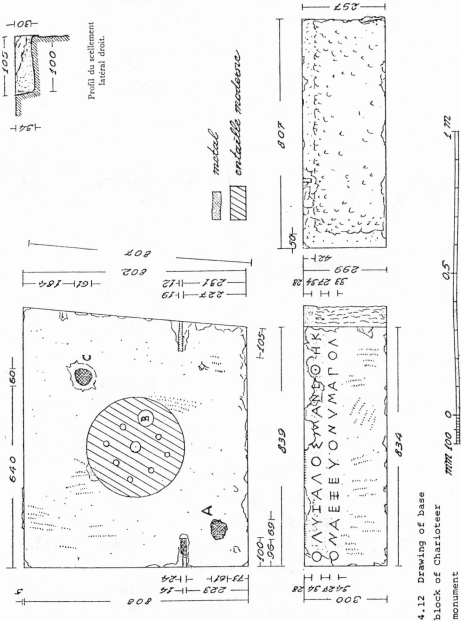

4.12 Drawing of base
block of Charioteer
monument

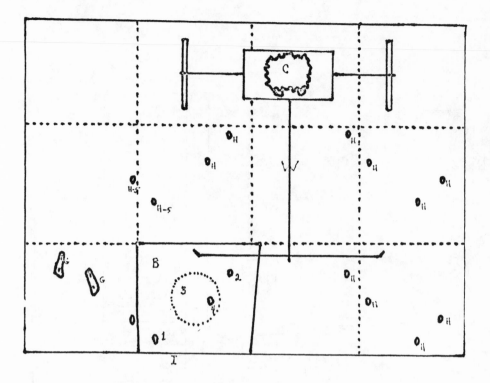

GROUND PLAN FOR PROPOSED RECONSTRUCTION OF
DELPHI CHARIOTEER GROUP 4.13

BASED ON F. CHAMOUX, "L'AURIGE," FOUILLES DE DELPHES IV.5 (1955)

 C. CHARIOTEER

 B. BLOCK, INV. NO. 3517, INSCRIPTION ON FRONT, AT "I"

 1. HORSE HOOF WHICH FITS INTO EXTANT HOLE

 2. EXTANT HOLE FOR HORSE HOOF

 3. SOCKET CUT IN LATER TIMES FOR REUSE OF BASE.

 4. HOLE FOR HOOF, THOUGHT TO EXIST HERE BEFORE LATER CUTI

 G. POSITION OF FEET OF GROOM (?) TO WHICH EXTANT ARM BELO

 H. POSITION OF OTHER HORSE HOOFS

 5. PLACE FOR EXTANT REAR LEGS OF A HORSE

 W. PLAN OF A CHARIOT, A FEW PIECES OF WHICH EXIST

 THE DOTTED LINES SUGGEST OUTLINE OF BLOCKS WHICH MADE THE BASE

CH.

4.13 Reconstruction of base of Charioteer monument, floor
 plan for the sculpture. CH, based on Chamoux.

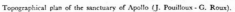

Topographical plan of the sanctuary of Apollo (J. Pouilloux - G. Roux).

4.14 Findspot of Charioteer monument at Delphi.

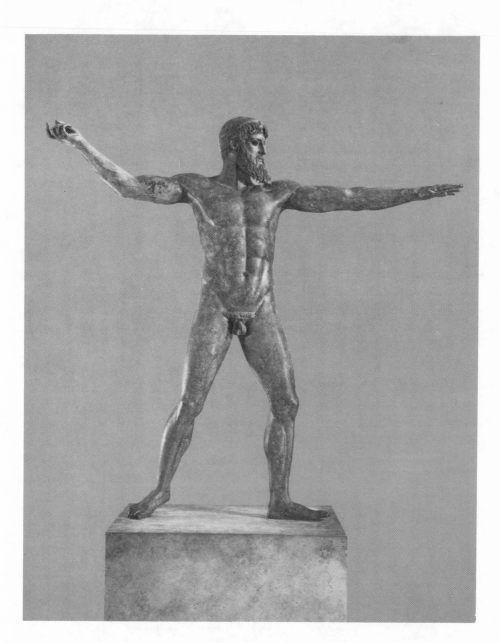

5.1 Artemision God.

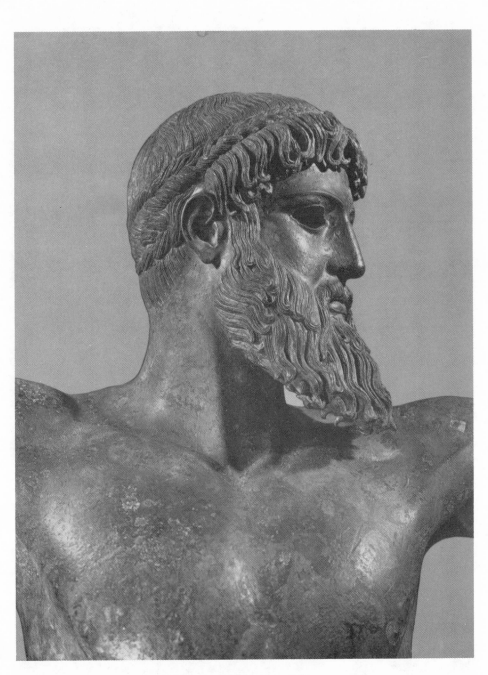

5.2 Artemision God

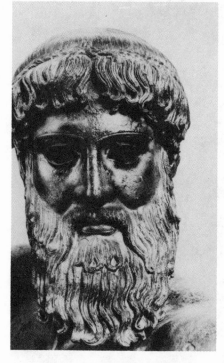

5.3 Artemision God

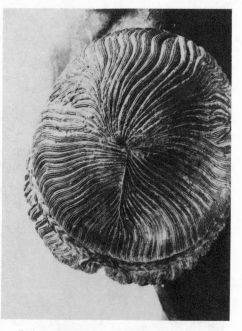

5.4 Artemision God, top of head

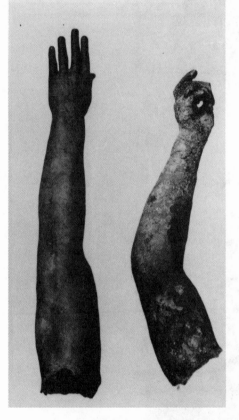

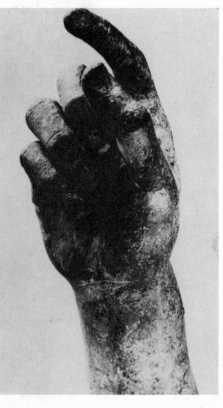

5.6 Artemision God, right hand

5.5 a-b Artemision God, detached
arms during restoration

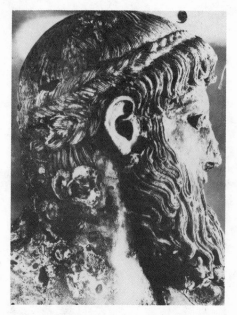

5.7　Artemision God, right profile
before restoration

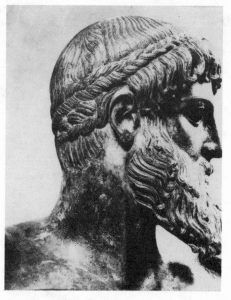

5.8　Artemision God, right profile
after restoration

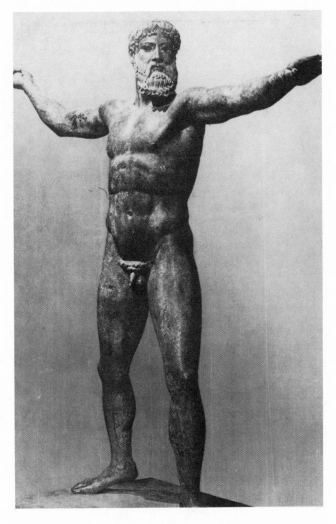

5.9 Artemision God. Charbonneaux.

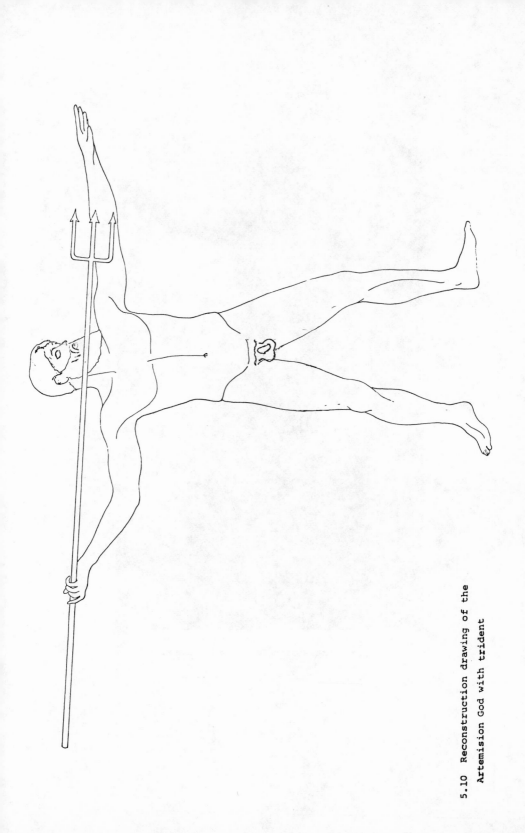

5.10 Reconstruction drawing of the
Artemision God with trident

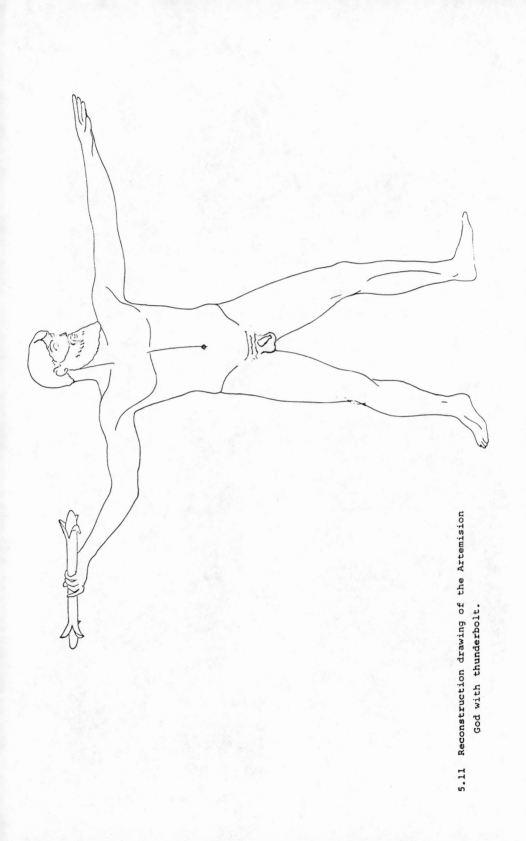

5.11 Reconstruction drawing of the Artemision
 God with thunderbolt.

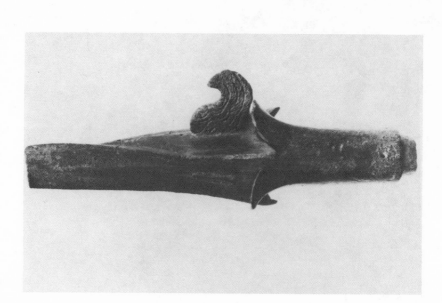

5.12 Fragment of a bronze thunderbolt

5.13 Zeus slaying giant,
from Corfu

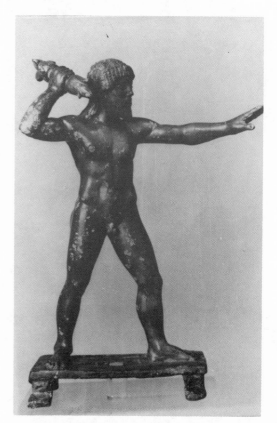

5.14 Zeus from Dodonna

5.15 Zeus, lekythos by Hermonax

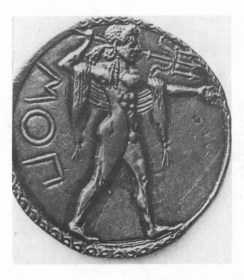

5.16 Stater from Poseidonia

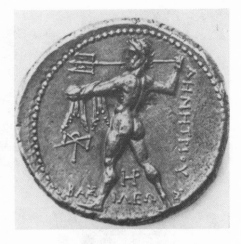

5.17 Tetradrachm from Macedon

5.18 a-b Drawing of the Berlin Foundry Vase

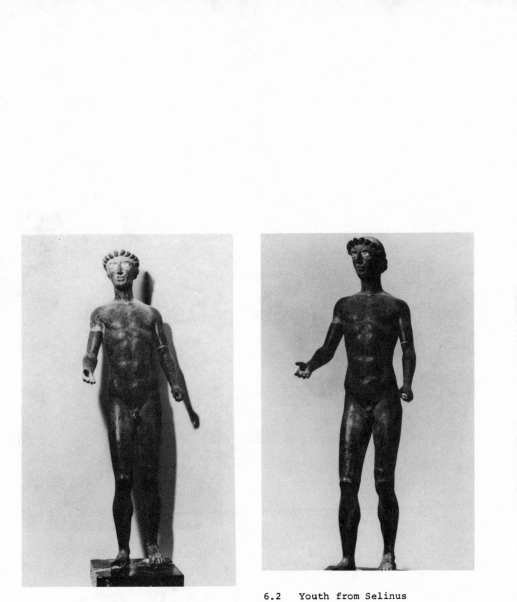

6.2 Youth from Selinus

6.1 Youth from Selinus

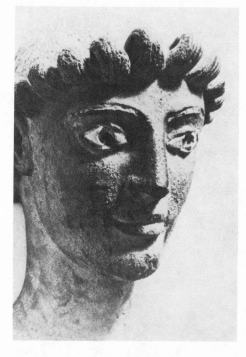

6.3 Youth from Selinus

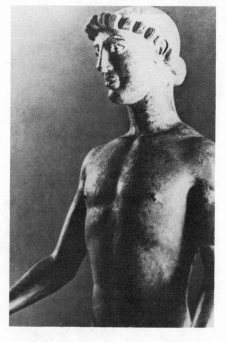

6.4 Youth from Selinus

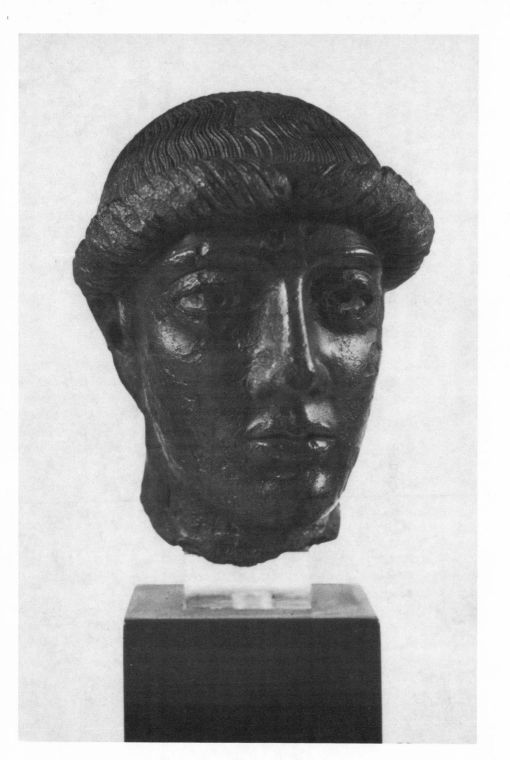

6.5 Young Man from the Athenian Acropolis

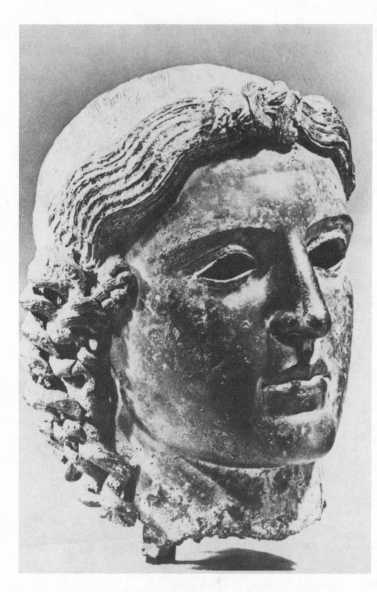

7.1 Chatsworth Apollo

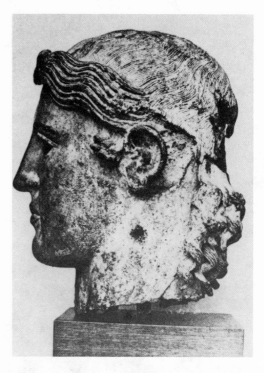

7.2 Chatsworth Apollo

7.3 Chatsworth Apollo

7.4 Apollo of "Kassel type", Roman copy

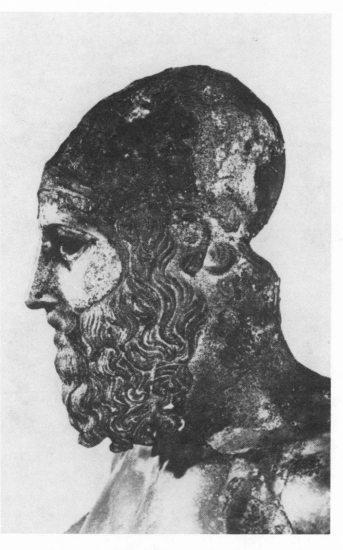

8.1 "General A" from Riace Marina

8-9.2 Lapith and Centaur battle by Polygnotos, Brussels

8-9.3 Warrior from Aegina

10.1 Cyrene "Berber"

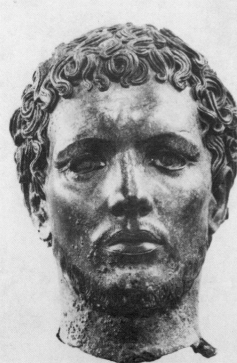

10.2 Cyrene "Berber"

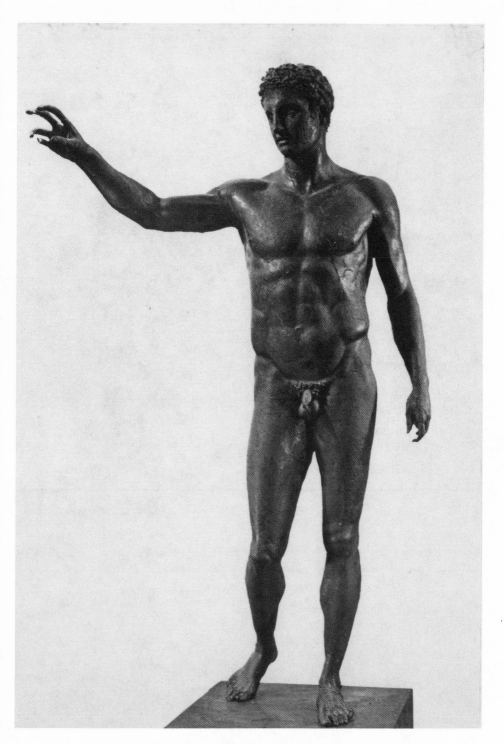

11.1 Young Man from Antikythera

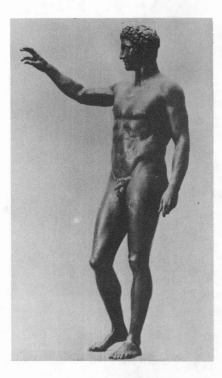

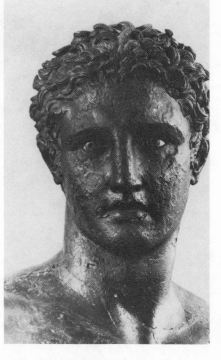

11.2 Young Man from Antikythera 11.3 Young Man from Antikythera

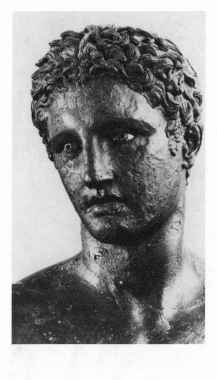

11.4 Young Man from Antikythera

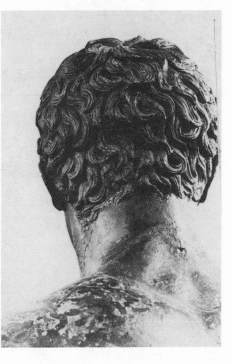

11.5 Young Man from Antikythera

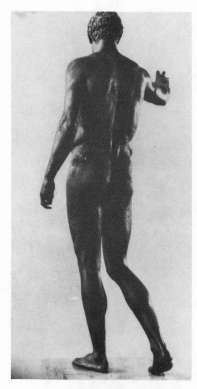

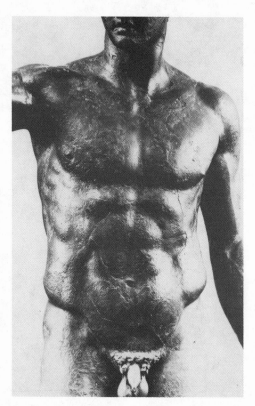

11.6　Young Man from
　　　Antikythera.

11.7　Young Man from Antikythera.

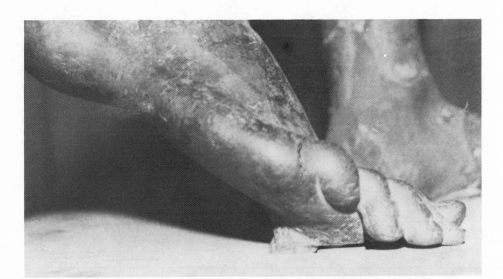

11.8 Young Man from Antikythera, detail of right foot

11.9 Drawing of the interior of
the head of the Young Man
from Antikythera

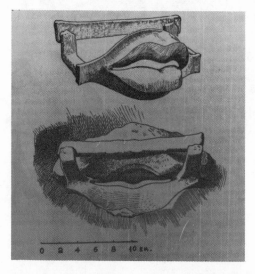

11.10 Drawing of the lips and
teeth unit of the Young Man
from Antikythera

11.11 Drawing of teeth of the
Young Man from Antikythera

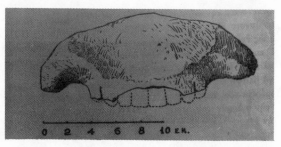

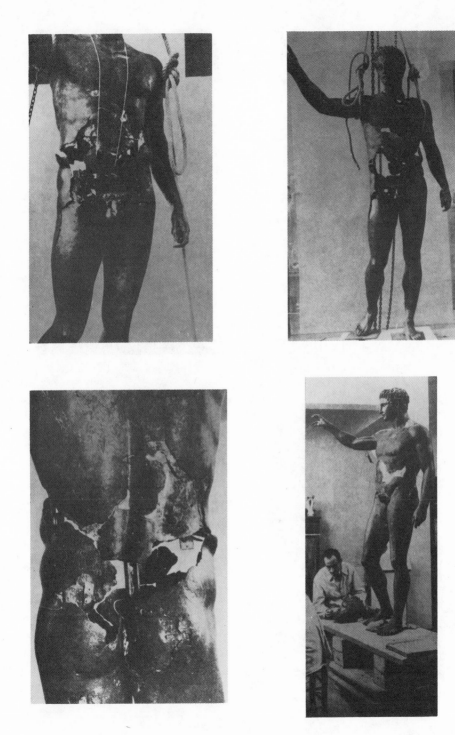

11.12 a, b, c, d Young Man from Antikythera during second
reconstruction with losses visible.

11.13 Young Man from Antikythera, right thigh

11.14 Young Man from Antikythera, right sole

11.15 Young Man from Antikythera, left sole

12.1 Piraeus Artemis I

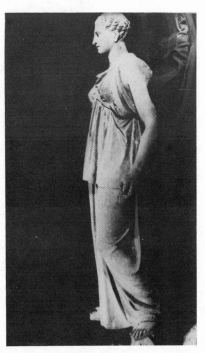

12.3 Piraeus Artemis I

12.2 Piraeus Artemis I

12.4 Drawing, back of Artemis I

12.5 Arezzo Athena in Florence

12.6　A statue of Artemis on a krater by Oinomaos

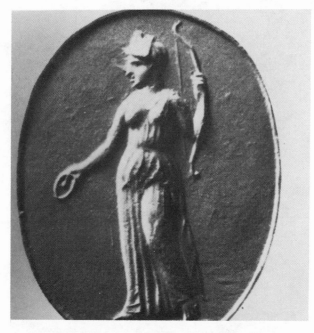

12.7　A representation of Artemis on a scaraboid in
Leningrad

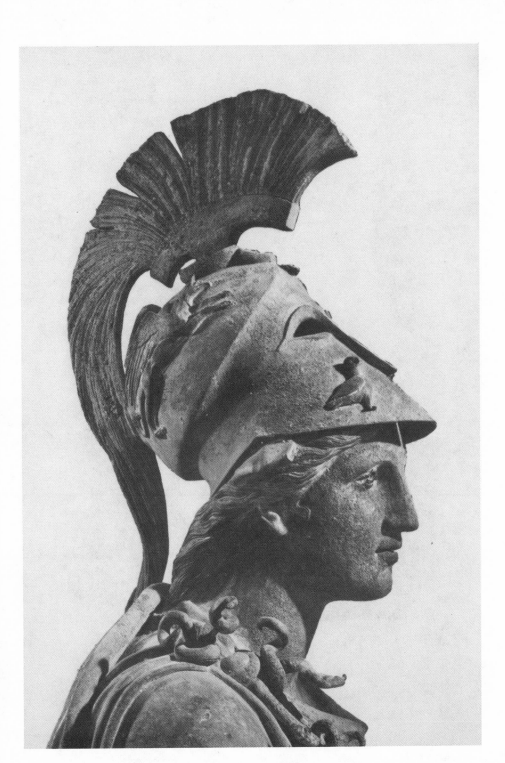

13.1 Piraeus Athena

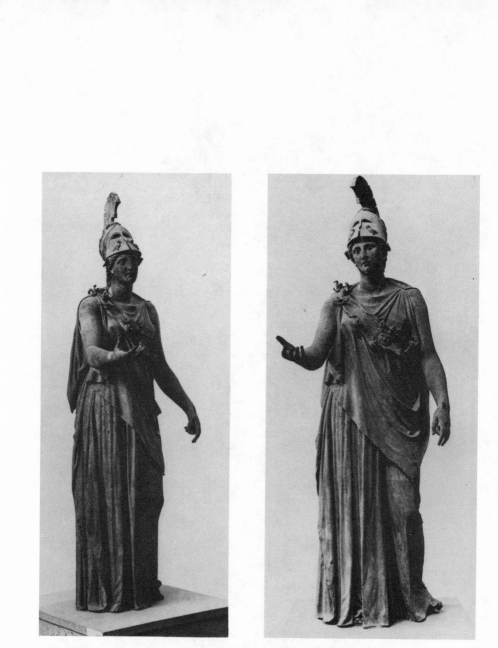

13.2 Piraeus Athena. 13.3 Piraeus Athena

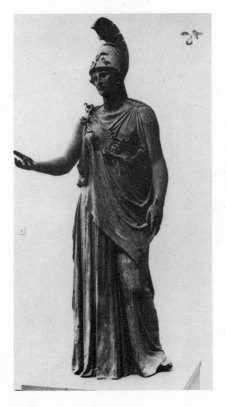

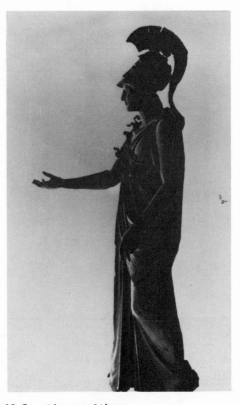

13.4 Piraeus Athena 13.5 Piraeus Athena

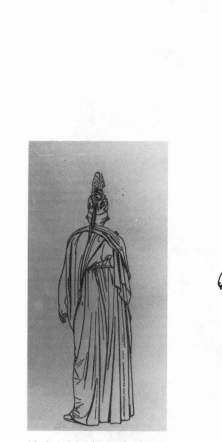

13.6 Drawing of Piraeus
Athena, back

13.7 Reconstruction drawing of the
Piraeus Athena

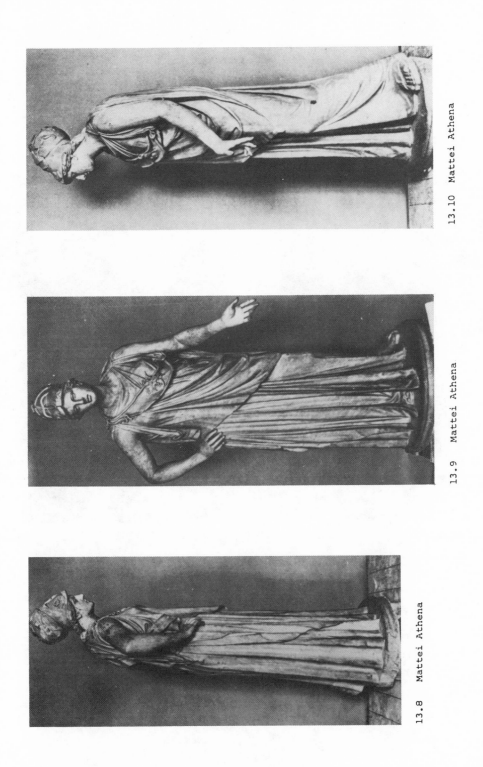

13.8 Mattei Athena

13.9 Mattei Athena

13.10 Mattei Athena

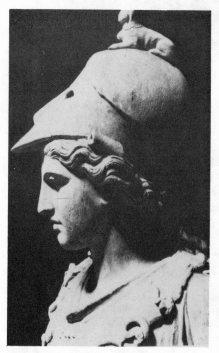

13.11 Ince Athena

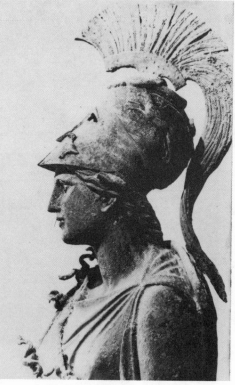

13.12 Piraeus Athena

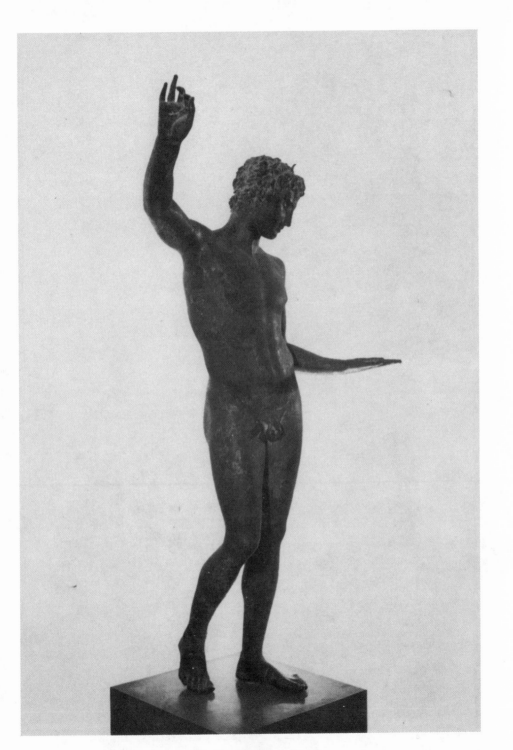

14.1 Marathon Youth

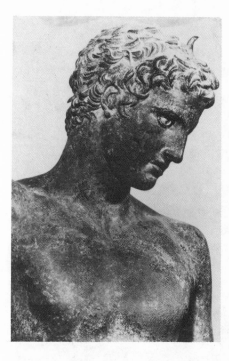

14.2 Marathon Youth

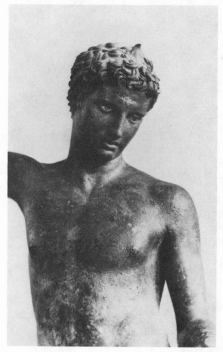

14.3 Marathon Youth

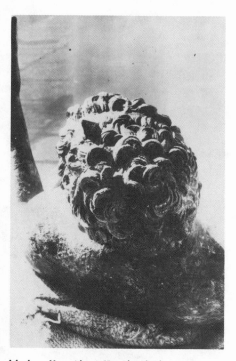

14.4 Marathon Youth, hair

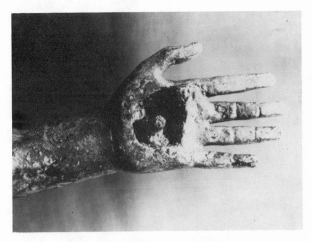

14.5 Marathon Youth,
left palm

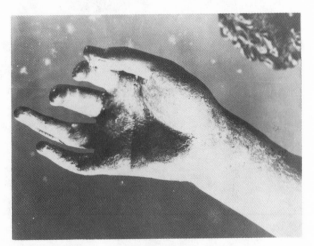

14.6 Marathon Youth,
right hand

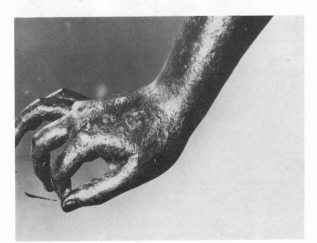

14.7 Marathon Youth,
right hand

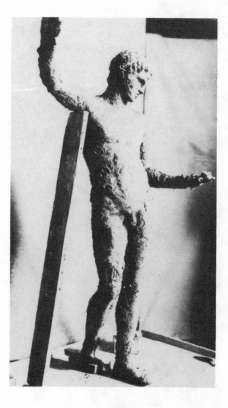

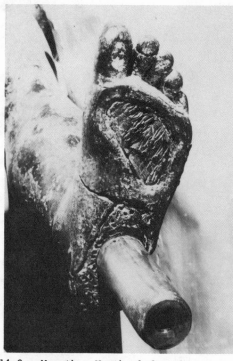

14.9 Marathon Youth, left sole

14.8 Marathon Youth
before cleaning

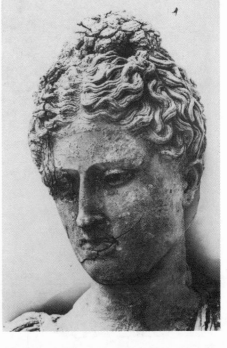

15.1 Piraeus Artemis II 15.2 Piraeus Artemis II

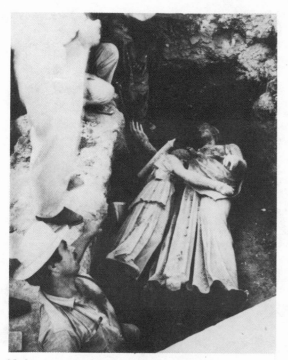

15.3 Excavation of Piraeus Artemis II
 and Piraeus Athena

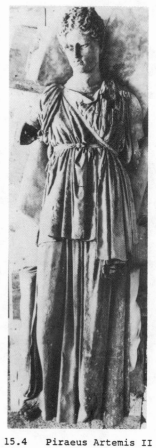

15.4 Piraeus Artemis II
 before restoration.

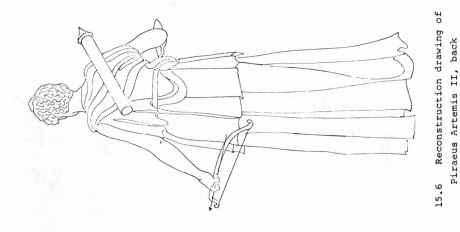

15.6 Reconstruction drawing of
Piraeus Artemis II, back

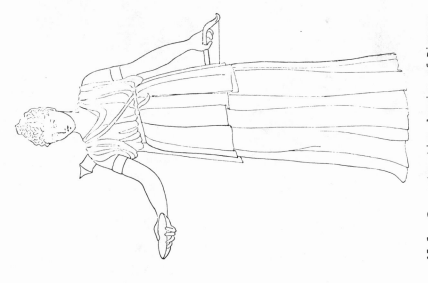

15.5 Reconstruction drawing of Piraeus
Artemis II, front

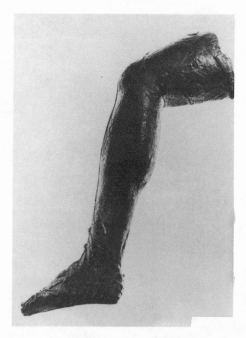

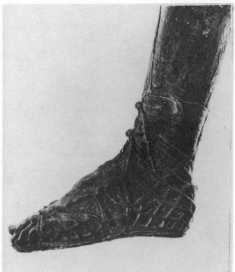

16.1 Agora Horseman, left leg 16.2 Agora Horseman, left foot

16.3 a-b Agora Horseman, drapery

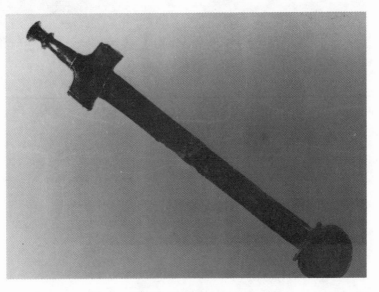

16.4 Sword of the Agora Horseman

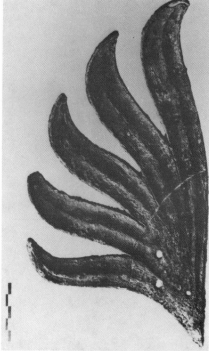

16.5 Flaming Palmette of the
 Agora Horseman Monument

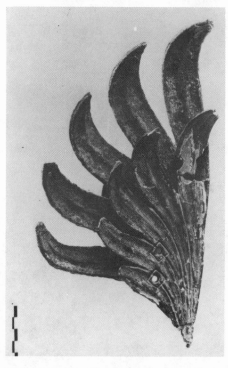

16.6 Double Flaming Palmette of the
 Agora Horseman Monument

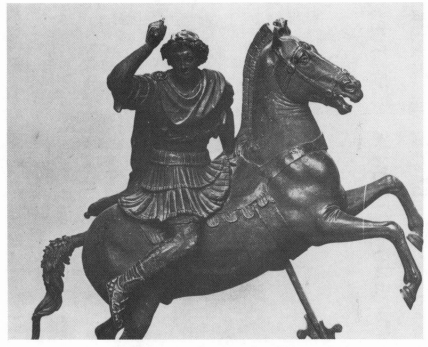

16.7 Horseman statuette from Herculaneum, Roman copy.

FINDSPOTS OF CLASSICAL GREEK MONUMENTAL BRONZE STATUES

STATUE FOUND AT OR NEAR ORIGINAL SITE

STATUE FOUND IN TRANSIT

TAMASSOS

ARTEMISON

ATHENS

MARATHON

DELPHI

PIRAEUS

ANTIKYTHERA

LEVADHOSTRO

CYRENE

RIACE MARINA

SELINUS

MEDITERRANEAN SEA

MILES
100 200

KILOMETERS
0 100 200 300

17.1 Findspots of
Statues in this
Study.